Style and Solitude

Style and Solitude
The History of an Architectural Problem

Mari Hvattum

THE MIT PRESS
Cambridge, Massachusetts . London, England

To Kester and Carla
*—my style icon*s

Introduction

In his 1908 essay "The Problem of Style" the German sociologist Georg Simmel described style as a place where "one no longer feels alone."[1] Against contemporary conceptions of style as a mark of individuality—be it personal or epochal—Simmel understood it as a commonplace. It is an intriguing proposition. If style can be understood less as an epochal characteristic and more as a principle of communality and continuity across time and space, its relevance might be greater than critics have granted. *Style and Solitude: The History of an Architectural Problem* explores that possibility.

It is something of an untimely undertaking. Style has fallen spectacularly out of fashion in recent years, not least among architectural historians. Once a conceptual key to understanding architecture's inner workings, style now seems to be associated more with superficiality, formalism, and obsolete periodization; a grand narrative past its sell-by date. But how did the concept of style actually work? How was it used, what did it mean, and how did its adoption into architectural thinking in the late eighteenth century affect the way architecture was understood and made?

This book studies conflicting conceptions of style and traces their impact on architecture in the modern period. I concentrate on German architectural thinking in the first half of the nineteenth century, a period when the modern concept of style was being negotiated and minted. *Style and Solitude* is about those negotiations. It moves from Johann Joachim Winckelmann's invention of the period style to Gottfried Semper's intriguing but incomplete attempt at establishing a generative style theory for architecture—all read against an inverted backdrop of twentieth-century style debates. Tracing the contradictory uses and interpretations to which style has been subjected, this book examines the historicist concept of style and its modern afterlife.

A Word to Avoid?

Style figures among modern architecture's most reviled concepts. From Ludwig Mies van der Rohe equating style with formalism to Rem Koolhaas parroting Le Corbusier's "The 'styles' are a lie" in his *S,M,L,XL* glossary, style has been viewed with suspicion by architects and critics alike.[2] Architectural historians, too,

have largely abandoned style as a historiographic tool, choosing instead to structure their narratives by type, material, mediation, construction, use, and a host of other categories—anything to avoid the s-word. And while the matrix of epochs and styles may survive in the odd survey course, students are soon taught to distrust it. If style plays any role at all in contemporary architectural history, it is as a kind of scaffold: an unsightly structure to be dismantled as soon as possible. Style, as George Kubler states, "is a word to avoid."[3]

The critique notwithstanding, style was for centuries a way of dealing with meaning in architecture and a subtle vehicle for thinking about architecture's referentiality and historicity. "The origin of style, the mechanism at work in its transformation, the causes for its changes and shifts, its relationship to *Volk* and *Zeitgeist*, constituted a *locus classicus* for the field," writes Alina Payne in her formidable style study *From Ornament to Object*.[4] Adopted from classical rhetoric, the concept of style fully entered architectural parlance in the late eighteenth century. Its significance was hardly unequivocal, however, and the concept went through some fascinating and contradictory transformations in the first decades of the nineteenth century. If in classical rhetoric, style was a matter of choice among established genres, in nineteenth-century architectural discourse it was often taken as a destiny: an involuntary outcome of certain epochal conditions. And if eighteenth-century philosophers understood style as referring to the ideal essence of art, a century or so later it came to denote art's (and architecture's) most fickle aspects. The fact that style has tended to merge with a series of other aesthetic concepts such as manner, genre, character, and taste has not lessened the confusion. Over the last three centuries style has been considered, in turn, universal and relative; essential and superficial; an ideal and an abomination. Signifying different things to different people and in different periods, it is, as the 1771 edition of *Encyclopaedia Britannica* dryly stated, "a word of various significations."

It may seem unfair to claim that style has been abandoned by historians. Art historians have agonized profoundly over style, and authorities from Susan Sontag and Willibald Sauerländer to Christopher S. Wood and Éric Michaud have problematized its historical and historiographical function.[5] Architectural historians have also revisited the topic, if a bit more cautiously.

Nineteenth-century style revivals have been thoroughly studied, and players and positions in historicist and modernist style debates have been chronicled.[6] Wolfgang Herrmann's collection *In What Style Should We Build? The German Debate on Architectural Style* (1992) introduced German nineteenth-century style thinking to an English readership, an effort continued by Alina Payne, Harry Francis Mallgrave, and Barry Bergdoll, to mention but a few.[7] Caroline van Eck, Klaus Jan Philipp, Martin Bressani, and others tackle the question of architectural style with renewed vigor in their scholarship, and even architects such as Farshid Moussavi have recently turned an eye to style.[8] Despite this new interest, there are few synthesizing accounts of style in architecture. If architectural historians have tended to focus on the revival of particular historical styles, *Style and Solitude* looks at the conceptual transformations that made those revivals possible.[9] Rather than avoiding style, then, I try to figure out what it meant and how it worked.

Style—A User's Manual

There are caveats. I do my best—though not entirely successfully—to stick to style in architecture. The most obvious reason for this has to do with capacity. Style is a tricky issue and tends to drag its interpreters into deep and murky waters. A disciplinary delimitation seemed one way to avoid drowning. But there is another, more interesting reason. While art history and architecture adopted the concept of style at the same time and from much the same sources, its impact on the two disciplines has been different. The invention of the period style had particularly fateful consequences for architecture, affecting both its practice and its history writing. "It is only in architecture that the concept of 'style' has such an iridescent quality, and it is only in architecture that this concept formed the focal point of theoretical discussion throughout the nineteenth century," writes Georg Germann, himself a keen explorer of architectural style.[10] The following chapters will hopefully bring out some of that iridescence.

Another self-imposed stricture is to focus on the German-speaking world. Again, it is a matter of capacity—the German debate happens to be the one I am most familiar with. But it also has to do with substance. The concept of style played a very particular role in German architectural discourse, where it became a vehicle for both idealist and historicist modes of thinking. More than anywhere

else, style here remained a philosophical as well as an architectural concern, making the debates over it doubly fascinating and trebly fraught. Of course, German style thinking did not exist in isolation, so I do my best not to be dogmatic. When tracing the development of style prior to the eighteenth century, for instance, it was necessary to discuss the Latin context. When studying style's adoption into architectural parlance in the eighteenth and nineteenth centuries, theorists such as Antoine-Chrysostome Quatremère de Quincy and Eugène-Emmanuel Viollet-le-Duc were unavoidable, as were Henry-Russell Hitchcock and Philip Johnson in my brief foray into twentieth-century style debates. Nonetheless, it is what went on in places like Berlin, Munich, Karlsruhe, Dresden, Wörlitz, and Wilhelmsbad—as well as in the journals, books, pamphlets, exhibition catalogs, newspaper articles, debate proceedings, competition briefs, gardens, and buildings that came out of them—that is at the forefront of the inquiry.

For although style lives in buildings, it is also, as Hans Ulrich Gumbrecht points out, a discursive element, shaped through public exchange.[11] That recognition led me to base the book mainly on published sources (an unexpected blessing when Covid made travel impossible and archives inaccessible), and I have spent an awful lot of time tracking debates, lectures, journal articles, essays, and a host of other public utterings—buildings and images included. In fact, much of the book consists simply of patiently reading primary sources, trying to bring out the gist— the profundities as well as the absurdities—of the material. The task proved unexpectedly entertaining, for although German nineteenth-century writing is reputed to be rigid and convoluted, it is actually brimming with humor and wit. To retain that sparkle in translation has been a challenge, which is why the original quotes are given in footnotes when no previous translation exists—surprisingly often, it does not. It should be stated from the outset that I am not aiming to give a comprehensive overview of the German style debate—given its scale and complexity, that would be futile. But I do try to identify key positions in the early nineteenth-century debate and follow the notion of style through some of its considerable conceptual transformations.

The style debate took place mainly within the intellectual horizon of historicism, but that does not make it less of a modern problem. To get that point across I have devised an unusual chronology. Starting more or less in the present, *Style and Solitude*

moves backward through the twentieth century, leapfrogs to the late eighteenth century, and then proceeds forward again to the 1850s and 1860s, by which time style had become a fully established architectural and historiographical system. Because I am more interested in the formation of that system than its hegemony, the book does not go on to discuss the grand style systems of historians such as Jacob Burckhardt, Heinrich Wölfflin, or Alois Riegl, nor does it tackle late nineteenth-century eclecticism. Instead, it ends with Gottfried Semper and his attempt to supplement—even supplant—the art historical style system with an altogether different understanding of architectural style.

For all its quirkiness and gaps, the idiosyncratic chronology has helped me to see the problem of style less as a slightly comical quibble between guests at a historical costume party, and more as an ongoing inquiry into the way architecture relates to time and place. Despite persistent attempts to get rid of it, the concept of style still lurks in modern architectural discourse, a fact my back-to-front structure aims to capture.

Here is how the argument goes. Chapter 1 explores architects' love–hate relationship with style in the twentieth and twenty-first century, arguing that both the vehement critique of style and its surprising conceptual obstinacy compel us to find out how style has been used and understood. Chapter 2 skips back in time, tracing the transformation of rhetorical style into the late eighteenth-century notion of period style. The art historian Johann Joachim Winckelmann is a key figure here, introducing style as an epochal index, useful for sorting and comparing architectural expression across time and space.

The period style served not only to taxonomize the past, but also to appropriate it emotionally. That is the topic of chapter 3. Looking at works by eighteenth-century garden theorists such as Christian Hirschfeld and Johann Gottfried Grohmann, eccentric noblemen like the Freiherr of Racknitz, and architects such as Karl Friedrich Schinkel, this chapter explores style as harbinger of atmosphere and association.

If Winckelmann edged toward a relative understanding of style, chapter 4 investigates a different take: style as an absolute ideal. For the Weimar classicists, style denoted an ideal correlation between idea and form, constituting, as Johann Wolfgang von Goethe put it, "the highest level of art." This idea would live on in nineteenth- and twentieth-century architectural thinking

from Schinkel to Le Corbusier and beyond, prompting various attempts at reconciling absolute and relative style. Here, I look particularly at the philosopher August Wilhelm Schlegel's musings on style versus the styles that anticipated Viollet-le-Duc's famous distinction by half a century, but also at the legendary (and highly amusing) debate between the *Kunstblatt* editor Ludwig Schorn and the contrary baron Carl Friedrich von Rumohr.

Chapter 5 looks at one particular assumption underlying the notion of period style, namely the idea of a necessary correspondence between epochal conditions and architectural form. This "principle of correspondence" prompted a number of attempts at defining the factors of style, with Heinrich Hübsch's *In welchem Style sollen wir bauen?* (1828) being probably the most famous. The principle of correspondence affected the judgment of not only the past but also the present, for if past styles reflected their particular epochal conditions, should not the present style do so, too? The idea of match and mismatch was a seminal impulse behind the modern cry for a "style of our own," steadily increasing in volume throughout the nineteenth century. Chapter 6 investigates an early version of this cry in the form of King Maximilian II of Bavaria's 1850 competition for a new architectural style. Dreaming of an architecture that fully reflected its time, the king's competition captured nineteenth-century zeitgeist thinking in a nutshell.

The nineteenth century's most energetic theorist of style was probably Gottfried Semper, and the last chapter is dedicated to him. Semper was not particularly interested in period style or in art historical taxonomy, insisting that style theory and art history were two different things. Instead, he used style as a vehicle to probe into the creative architectural process. Focusing on the notion of making as the locus of style, this chapter examines Semper's generative theory of style and his particular conception of historical continuity.

Meandering through a miscellaneous material, *Style and Solitude* pits several contrasting notions of style against each other. One is the period style, according to which style is the artistic character of an era or a culture—a sentiment that fuels the historicist cult of the zeitgeist as well as the various modernist attempts at finding a new style for a new age. It is a notion of style that leaves each epoch curiously isolated—"alone in an immense void,"

as Karl Bötticher once put it.[12] Another is a more complex and cosmopolitan conception in which style denotes architecture's capacity for continuity across time and space. This kind of style, as Simmel sharply observed, does not lock the era to a singular self-expression but transcends historical divides, acting as an antidote to the solitude of epochal experience. To examine both these notions of style—including the iridescent array of positions that exists in between—is the aim of this book.

Acknowledgments

Style and Solitude has been long in the making and has benefited from input and support from innumerable individuals and institutions. My first thanks go to my husband Christian and my colleagues at the Oslo School of Architecture and Design (AHO), especially Mari Lending, Victor Plahte Tschudi, and Tim Anstey, who have been my supporters, interlocutors, and critics. The unnamed readers of the book proposal and the first draft helped to sharpen the argument and cut out dead wood, for which I am grateful indeed. The research projects *The Printed and the Built: Architecture and Public Debate in Modern Europe* (2014–2018) and *Printing the Past. Architecture, Print Culture, and Uses of the Past in Modern Europe* (2016–2019) have been crucial for developing the book's argument, and I thank the research team Caroline van Eck, Maarten Delbeke, Maarten Liefooghe, Barbara Penner, Adrian Forty, Olivia Horsfall Turner, Anne Hultzsch, Maude Bass-Krueger, Helge Jordheim, Gro Ween, and Alice Thomine-Berrada; our distinguished contributors Alina Payne, Barry Bergdoll, Stephen Bann, Hilde Heynen, Richard Taws, Wallis Miller, and Richard Wittman, as well as the project PhDs Eirik Bøhn, Nikos Magouliotis, Ben Vandenput, Miranda Critchley, Iver Tangen Stensrud, and Sine Halkjelsvik Bjordal for an inspiring collaboration. I am grateful to the Norwegian Research Council and the European research program *Humanities in the European Research Area* (HERA) for financial support, and to AHO for generous research time.

I am fortunate to have been invited to speak about style on various occasions, and I thank Sonja Hildebrand at Università della Svizzera Italiana in Mendrisio; Eeva-Liisa Pelkonen at Yale University; Philip Ursprung at ETH Zurich; David Leatherbarrow and Ge Ming at Southeast University, Nanjing; Christian Illies and Martin Düchs at Otto-Friedrich-Universität Bamberg; Marie-Louise Monrad Möller at the Institut für Kunstgeschichte in Munich; Frank Schmitz at Hamburg University; Petra Brouwer and the Lorentz Centre in Leiden, and Bente Solbakken at the Norwegian National Museum in Oslo for the opportunity to discuss my favorite topic with attentive audiences. At the 2017 SAH conference in Glasgow and the 2018 EAHN conference in Tallin I chaired panels related to style, and I thank the speakers Lucia Allais, Deborah Asher Barnstone, Martin Bressani, Ole Fischer,

Emma Jones, Sigrid de Jong, and Laura Martínez de Guereñu (as well as Mari, Caroline, and Richard mentioned above) for valuable input. Style was the topic also of a graduate seminar at AHO in 2019, where I undoubtedly learned as much as the students. Warm thanks to all of them, and also to Øivind Andersen, Ina Blom, Arnfinn Bø-Rygg, Ingmar Meland, Eyjólfur Emilsson, and the late Stian Grøgaard for their contributions.

Research—like so many things in life—depends on random acts of kindness. The generosity of scholars, architects, and institutions that I have emailed out of the blue has been extraordinary. Thanks to Cathelijne Nuijsink, Yosuke Fujiki, Eric Garberson, Torsten Lüdecke, Katherine Harloe, and Daniel Orrells for patiently answering unlikely questions from Oslo. I am indebted to librarians and archivists at the Kupferstichkabinett, Berlin; Bayerisches Hauptstaatsarchiv—Geheimes Hausarchiv, Munich; Kulturstiftung Dessau-Wörlitz; Architekturmuseum der TU Berlin; Architekturmuseum der TU Munich; Hessische Hausstiftung; the RIBA; Canadian Centre for Architecture; Getty Research Institute; British Museum, and a host of other institutions. Particular thanks to the AHO librarians for their ability to hunt down even the most obscure piece of style literature. Thanks also to *Architectural Histories—Journal of the EAHN* for allowing me to reuse extracts from previously published essays.

And needless to say: the book would not have seen the light of day without the enthusiasm and rigor of my MIT Press editor Thomas Weaver and his team, not least the marvelous copy editor Pamela Johnston.

1 *"The 'Styles' Are a Lie"*

Ask a contemporary architect about the style of his or her work and you will quickly realize you have posed the wrong question. When Andrew Zuckerman put it to the Danish architect Bjarke Ingels that his work lacked "a certain cohesive style," Ingels was flattered:

> I would definitely take it as a compliment, because I would normally say that having a style is almost the sum of all of your inhibitions. It's like a straitjacket that keeps you confined to who you were and inhibits you from who you could become.[1]

While critics and journalists sometimes speak of an architect's "unique style," architects themselves want none of it. "We have never aspired to anything that might be called a typical style of our own," says Jacques Herzog of Herzog & de Meuron, insisting that their architecture is based on "strategies, not styles."[2] "MVRDV does not have a fixed style," proclaims Dutch architect Winy Maas; "every project is unique."[3] American architect Steven Holl joins in: "With all projects, I explore deeply to find an original idea that can drive a design, an idea that can make the

building mean more than it would if I was making a kind of style that I move from one site to the next…. Each project is unique."[4] Only a brazen megalomaniac would speak willingly of his or her own style, it seems, let alone attempt to identify a style for contemporary architecture. When Zaha Hadid's Patrik Schumacher proclaimed parametricism "a new global style," critics jumped on many things, but his invocation of style was passed over in silence.[5] It was just too embarrassing.

The embarrassment with style is not a recent phenomenon, nor is it confined to architects. Asked to write an essay on style for a 1970s edited collection, art historian Svetlana Alpers admitted that the request had led to "a certain amount of squirming."[6] Twentieth-century historians of architecture have shared Alpers's unease, allowing it at times to develop into blatant animosity. Not only does style represent an outdated classification system, it seems, it also denotes a kind of conceptual prison. Metaphors of confinement are surprisingly prevalent whenever style gets mentioned, and more often than not the aim is to break the "fetters," escape the "tyranny," or, as Sarah Goldhagen puts it, "wriggle out of the straight-jacket of style."[7]

So what is the matter with style? First of all, it means many different, even contradictory, things. Even the scant statements quoted above use style in a number of different senses. If in everyday parlance, style denotes something uniquely individual ("Gehry's style"), Steven Holl and Jacques Herzog see it as a threat to that very uniqueness. And if Winy Maas speaks of style as the unifying feature of an architect's oeuvre, Patrik Schumacher (as well as some squirming historians) have it expressing entire epochs. Style, it seems, is both individualizing and universalizing, holding things together and setting them apart on many levels and in a variety of ways.[8]

This chapter explores the ambivalence toward style in twentieth-century architectural culture. For while style has been ridiculed, reviled, and written off for much of the century, it keeps lurking like a "subterranean paradigm" and seems difficult to do without.[9] The strange combination of omnipresence and rejection that marks twentieth-century thinking on style makes it not only a fascinating topic in its own right, but also a good place to start when trying to figure out where this ambivalence came from. "Why is the style-based paradigm so tenacious, so difficult to escape?" sighs Goldhagen.[10] I will try to find out.

Japan Architect, summer 1992, announcing the Shinkenchiku Residential Design Competition "House with NO STYLE." *Japan Architect*/Shinkenchiku-sha Co., Ltd.

Wriggling Out of the Straitjacket

In the autumn and winter of 1992–1993, the Dutch architect Rem Koolhaas led a competition for the architectural magazine *Japan Architect* as part of their Shinkenchiku Residential Design Competition series. Titled "House with NO STYLE," the competition invited participants to envision "design-free zones" where all recent clichés, including acute angles, curves, and color were to be avoided. The aim, Koolhaas stated emphatically, was the "elimination of style."[11]

Koolhaas was the sole juror, and a gloomy one at that. Though it attracted a record 732 entries, the competition left him sad, lamenting the "overwhelming addiction to form, style, aesthetics, which in itself really represents a *disease*. ... Most of these projects were not style-less but thought-less."[12] There were exceptions, however. Koolhaas found some of the entries truly excellent, presenting "serious research about how style could be shed, how the narcissistic automatism of form-making could be interrupted, how new exploration of content could be injected into an exhausted profession."[13]

Competition participants responded to the challenge in various ways. The third prize won because s/he insisted on being anonymous, a gesture Koolhaas found to be an effective reminder

25

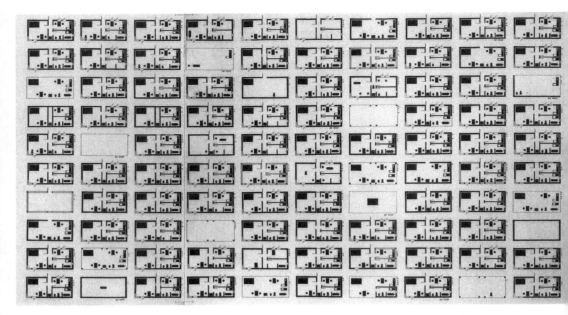

Yosuke Fujiki, first-prize project in the 1992 Shinkenchiku Residential Design Competition "House with NO STYLE." Yosuke Fujiki.

of "the increasingly unbearable chasm between the issues that preoccupy the profession, including... the issue of style/no style."[14] The second prize team, Mitsugu Okagawa and Yutaka Kinjo, presented a photomontage in which images of naked human bodies and highrise modernist buildings were superimposed onto a map of Tokyo. The accompanying text made reference to the AIDS epidemic and the Eden project, envisioning a floating Eden hovering over the Japanese metropolis. Whether this was a nod to Nicholas Grimshaw's Cornwall blob or to Henry-Russell Hitchcock's claim that "there were no 'styles' in the Garden of Eden" (or both) is unclear.[15] Unlike Koolhaas, however, Okagawa and Kinjo did not believe that architecture could shed style:

> A house with no style is an impossible proposition as long as human beings are individuals. Style is a form of the desire of the individual. After the modern age, the human being lost God, and today the house degenerates to a package of style, a mounting of identity. Nobody can escape from the prison of style of today.[16]

26

The prison of style may be difficult to escape, but the winner of the first prize made a concerted effort. Yosuke Fujiki's catalog of defective houses presented one hundred nearly identical dwellings with assorted flaws—no windows, no walls, doors that could not be opened—all to "free us from fixed ideas of housing" and help "make original life styles."[17] Koolhaas hailed the project as brilliant and thought Fujiki understood the issue better than the jury: "The systematic suppression of elements triggers spectacular panoramas of use, uselessness, of predictable categories. It recharges 'what we have' and at the same time destabilizes the entire notion of the house in an absolute anti-aesthetic way."[18]

Neither the competition brief nor the project descriptions actually defined what was meant by style, but it is plain that for Koolhaas, style was form, and form was formalism. The competition was in fact a campaign against what he saw as a deeply formalist tendency in contemporary architecture: a new "ism" launched with much pomp and eloquence under the banner of deconstructivism a few years before. Its promoters shunned talk of form, let alone formalism, yet Koolhaas found deconstructivism ultimately decorative, based on a "banal analogy between... irregular geometry and a fragmented world."[19] So while the competition material for the "House with NO STYLE" rang heavy with poststructuralist hyperbole, Koolhaas attacked deconstructivist architecture for having degenerated into a formal game. Despite Mark Wigley's protestation that deconstructivism "is not a new style," for Koolhaas, it had become just that.[20]

Koolhaas's equation of style with formalism drew on a long tradition in twentieth-century architectural thinking. Already in 1902, the architect and diplomat Hermann Muthesius launched a pointed attack on both. Like Koolhaas, Muthesius condemned what he saw as strong formalist tendencies in the architecture of his time.[21] His slim book *Stilarchitektur und Baukunst* summed up the critique, attacking the vacuously decorative Jugendstil and calling for a more measured—*sachlich* was Muthesius's term—approach. The argument followed a line that will pop up several times over the course of this book. It goes like this: During the nineteenth century, architecture gradually lost contact with living tradition and degenerated into academicism and formalism. Conceiving of architecture solely as "formal and abstract works of art," the style-making academicism of the late nineteenth century emptied historical form of its meaning, causing a kind of aesthetic

First and second edition of Hermann Muthesius's *Stilarchitektur und Baukunst*, 1902 and 1903.

inflation.[22] Together with a general decline in handcraft as well as in public taste, historicist formalism had polluted modern building practices, creating a situation of chaos and confusion.[23]

The way out of this formalist "style machine" was to ignore form as much as possible, concentrating instead on contemporary conditions and tasks. Muthesius envisioned an architecture based strictly on new principles of construction, new materials, new economic conditions, new transportation systems, and new building types; crucial factors for an emerging new architecture. That meant not only abandoning the historicist reliance on past styles but also shunning the invention of a new one:

> The world lies under the spell of the phantom "style-architecture." It is hardly possible for people today to grasp that the true values in the building-art are totally independent of the question of style, indeed that a proper approach to a work of architecture has absolutely nothing to do with "style."[24]

Instead of pursuing style, contemporary architecture had to regain an organic connection to its own time, becoming "a result of contemporary developments."[25] Proposing to ban the term style altogether, Muthesius wanted to turn the attention from form to more pressing issues in modern society. Only then would true form emerge, not as a new style, but as an organic expression of the time. A new architecture will not arise in outward appearance but as a vital presence, wrote Muthesius. "Architecture... must seek its essence in content."[26]

Both Muthesius and Koolhaas found contemporary architecture to be imprisoned by style, and both made elaborate escape plans: Koolhaas to his design-free zones; Muthesius to a styleless *Sachlichkeit*. Both reacted against what they saw as formalist tendencies—Koolhaas, against a decorative deconstructivism; Muthesius, against a disingenuous Jugendstil which he found every bit as bad as nineteenth-century eclecticism. "What good does it do us if the old acanthus is replaced by a linear squiggle?" he asked, accusing Jugendstil architects of simply repeating "the old miseries of style and ornament."[27] Only an architecture capable of responding to the contemporary conditions in a free and objective manner, without any formal prejudice, would be worthy of its name. Muthesius summed up his argument in a last, bombastic proclamation:

> When will our architecture be ready to assume this responsibility? In any case, no sooner than when she has arisen to a new golden freedom, free from the stylistic chains in which she has lain bound for a century; no sooner than when she leaves behind a shadowy style-architecture and becomes again a living building-art.[28]

Both Koolhaas and Muthesius defined style in predominantly formal terms. Paradoxically, that brings them close to one of the most famous invocations of style in the twentieth century, namely Henry-Russell Hitchcock and Philip Johnson's International Style. While one party rejected style and the other celebrated it, they all pretty much agreed about what it was, namely a set of formal features characterizing the architectural production of a certain period.

The International Style was the title of a book published to coincide with the opening of the MoMA exhibition *Modern Architecture:*

Henry-Russell Hitchcock and Philip Johnson, *The International Style: Architecture since 1922*, 1932.

International Exhibition in February 1932. Both the exhibition and the book—as well as a catalog accompanying the exhibition—were products of an enthusiastic collaboration between the young Johnson, the far more senior Hitchcock, and MoMA's director Alfred H. Barr Jr. The aim was to familiarize a US audience with new European architecture and to outline "the aesthetic principles of the International Style."[29] Barr introduced the concept already in the catalog foreword, hailing progressive architects whose ideas had "converged to form a genuinely new style which is rapidly spreading throughout the world.... Because of its simultaneous development in several countries and because of its world-wide distribution it has been called the International Style."[30]

If the catalog mentioned style, the book made it the main issue. In the introduction, titled "The Idea of Style," Hitchcock and Johnson set out to reclaim the notion of style, ridding it of the "bad name" it had been given by nineteenth-century eclecticism. The nineteenth century had failed to create a true style of architecture because it "was unable to achieve a general discipline of structure and of design in terms of the day," indulging instead in the superficial imitation of past forms.[31] Fin-de-siècle architects had not made things better, for their extreme individualism did not contribute to the formal unity necessary in a proper style.[32]

30

Style required discipline, even sacrifice, if modern architecture was to rival the styles of the past:

> The idea of style, which began to degenerate when the revivals destroyed the discipline of the Baroque, has become real and fertile again. Today a single new style has come into existence.... This contemporary style, which exists throughout the world, is unified and inclusive, not fragmentary and contradictory like so much of the production of the first generation of modern architects.... It may fairly be compared in significance with the styles of the past.[33]

The unity that Hitchcock and Johnson were after was of a predominantly formal kind. "Of course, the criticism will be purely aesthetic," Johnson wrote to J.J.P. Oud in 1930, adding that this was "much to the distress of our German sachlich friends who think of nothing but sociology."[34] Unapologetically limiting their idea of style to formal aspects, the authors described the new style as being about volume rather than mass, about regularity rather than symmetry, shunning "arbitrary applied decoration."[35] The rest of the book was dedicated to describing, analyzing, and not least illustrating these characteristics. The historian must "label things to understand them," Johnson wrote in his foreword to *The International Style*'s third edition in 1995.[36] Hitchcock and Johnson's taxonomy of modern architectural forms did precisely that.

The critique of the International Style—though perhaps more of the term than the tendency—began immediately. The attack came from two sides. Practicing architects found the notion of style stifling; an outmoded restriction on their creative freedom. "I am not a stylist," protested Rudolph Schindler, though his dismay did not prevent him from begging to be included in the LA version of the show in July and August 1932.[37] The LA-based Danish architect Knud Lønberg-Holm invoked Mies van der Rohe's weighty style critique from 1923 ("even the will to style is formalism"[38]) and poked fun at Hitchcock and Johnson's pompous proclamations on the new style, comparing them with the Standard Sanitary Manufacturing Company's promotion for its "Neo-Classic" bathroom suite.[39] And while Johnson later tried to assure his colleagues that style was "a springboard" rather than a set of rules or shackles, the likes of Walter Gropius, Frank Lloyd Wright, and Mies van der Rohe were unconvinced.[40] In retrospect, Johnson empathized with

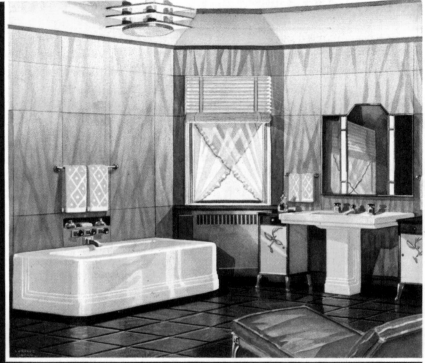

NEO-CLASSIC

Home builder, home modernizer, architect, interior decorator—all have welcomed the Neo-Classic form, newly created for "Standard" Plumbing Fixtures by a designer of preëminent authority. Like all of this designer's work, the Neo-Classic form is characterized by that artistic restraint which ensures permanent worth. Its individuality is grounded in the tradition of simplicity, a simplicity which is at once classic and modern. Here is a new decorative note in plumbing fixtures, which, because it is not over-emphasized, is a true part of the functional form and contributes appreciably to its beauty. You may have the Neo-Classic ensemble—bath, lavatory and closet—in white, black or any of eight colors of exquisite purity. The Neo-Classic fittings are finished in non-tarnishing Chromard. The Neo-Classic bath models are available in regular and Acid-Resisting Enamel; the lavatory and closet in vitreous china. A copy of the book "Standard" Plumbing Fixtures for the Home will be mailed on request, but only a visit to a "Standard" showroom can reveal the true beauty of the Neo-Classic designs.

Standard Sanitary Mfg. Co. BESSEMER BUILDING, PITTSBURGH
Division of AMERICAN RADIATOR & STANDARD SANITARY CORPORATION

"Standard"
PLUMBING FIXTURES

them. "Had I been a practicing architect then, even I would have objected," he wrote in his 1995 foreword.[41]

If practicing architects felt restrained by style, theorists had even more profound objections. Sigfried Giedion, undoubtedly the weightiest of them, lashed out against the International Style in the introduction to *Space, Time and Architecture*:

> There is a word we should refrain from using to describe contemporary architecture—"style." The moment we fence architecture within a notion of "style," we open the door to a formalistic approach. The contemporary movement is not a "style" in the nineteenth-century meaning of form characterization. It is an approach to the life that slumbers unconsciously within all of us.[42]

Under the subtitle "Confusion and Boredom," Giedion described the "International Style" (always in quotation marks) as a harmful fashion and a rootless cardboard architecture whose label had "never been accepted in Europe."[43] For all the vehemence of his critique, however, Giedion's position was more nuanced than it may seem.[44] While denouncing style as formalism, his own idea of modern architecture carried all the hallmarks of German style thinking. He was, after all, a student of perhaps the most influential style theorist ever, Heinrich Wölfflin.[45] To grasp Giedion's complex relationship to style, and perhaps even shed light on Koolhaas's and Muthesius's aversions, a very different way of thinking about style must be examined, noticeable not least in German architectural theory in the first half of the twentieth century.

The Will to Style

In 1927, five years before Hitchcock and Johnson's MoMA exhibition, the Berlin-based architect and critic Walter Curt Behrendt published his own paean to a progressive architecture.[46] An active member of the Werkbund—and editor of the Werkbund journal *Die Form* in 1925–1926—Behrendt was an enthusiastic promoter of functionalism. Like Giedion and Muthesius (and later Koolhaas), he warned against formalist tendencies in contemporary architecture and was particularly annoyed with the decorative functionalism seen at the 1924 Werkbund exhibition *Die Form ohne Ornament*.[47] Behrendt did not, however, associate this formalism

33

Standard Sanitary Mfg. Co.'s promotion for its "Neo-Classic" bathroom suite. *Country Life*, 1931.

with style. On the contrary, he considered style to be an antidote to formalism and the telos of modern architecture. The title of his book, *Der Sieg des neuen Baustils* (The victory of the new building style), testifies to this teleology and, as Detlef Mertins observes, hints at how Behrendt's "holistic model of culture led him to revise, rather than reject, the term style."[48]

Before this "victory" came a long battle for style, outlined by Behrendt in his earlier publication, *Der Kampf um den Stil im Kunstgewerbe und in der Architektur* (The struggle for style in the decorative arts and in architecture). Behrendt had begun this work already in 1912, intending it as a "guide to the contemporary."[49] The contemporary being turbulent at the time, the book's completion had to wait until after the war. Neither nineteenth-century historicism nor turn-of-the-century Jugendstil had much to contribute to the ongoing struggle, he thought, for their "utopia of style" no longer accorded with the modern zeitgeist.[50] A new style had to emerge spontaneously from modern life, for only when "a dominant lifestyle has been formed, will the preconditions for the emergence of an art style be fulfilled."[51] Behrendt described this longing for unity between life and form as the "will to style," likening it to a religious force:

> A new, still indeterminate, but no less vital longing for redemption is growing in dissatisfied hearts.... Only when a new spiritual atmosphere is established through the transformed role of religion in spiritual life as a whole, will a new... style, for which we have fought so long in vain, emerge by itself.[52]

By 1927, the heady, Nietzschean language of *Der Kampf* had been replaced by more economical prose. *Der Sieg des neuen Baustils* is not without drama, though. Opening with an unmistakable nod to Gottfried Semper, Behrendt evoked the birth of a new style as a cosmic battle:

> Influenced by the powerful spiritual forces in which the creative work of our time is embodied, the mighty drama of sweeping transformation is taking place before our eyes. It is the birth of the *form of our time*. In the course of this dramatic display—amid the conflict and convulsion of old, now meaningless traditions breaking down and new conventions

34

Walter Curt Behrendt, *Der Kampf um den Stil im Kunstgewerbe und in der Architektur* (1920) and *Der Sieg des neuen Baustils* (1927).

of thinking and feeling arising—new, previously unknown forms are emerging. Given their congruous features, they can be discussed as the elements of a new style of building.[53]

Behrendt described these "congruous features" with great precision. The new building style was characterized by "simple, austere form and a clear organization, with smooth, planar walls and always with a flat roof and straight profiles," lacking "any kind of exterior ornament."[54] The clarity of formal characteristics did not mean that the new style was primarily about form, however. Behrendt warned repeatedly against the specter of formalism and insisted, as he had done in *Der Kampf*, that the new style heralded a "spiritual movement, not a fleeting artistic fashion or some new 'ism.'"[55]

A very different notion of style is at work here. If Muthesius (and Koolhaas) saw style as a formalist hang-up, Behrendt presented it as a result of the long-awaited concord between spirit and matter, and hence the very opposite of formalism. Behrendt described this concord as an organic unity characterizing every true style in the history of architecture, all closely attuned to the contemporary zeitgeist. A genuine style could only emerge directly from the new reality of the modern age, he thought. This new reality consisted of new tools, new construction methods, and new materials, but even more importantly it entailed a spiritual upheaval by which architecture might become "a true expression of our new sense of life."[56]

Behrendt agreed wholeheartedly with Muthesius that architecture should become "an expression of inner nature," but for Behrendt, that expression was style.[57]

Behrendt was not alone in revising rather than rejecting the notion of style in the early 1920s. The first issue of the journal *Die Form*, published in 1922, was dedicated to the topic of *Zeitstil* (style of the time). This was far from a formalist enterprise, the editor Walter Riezler assured his readers, for form and style penetrated to the core of architecture:

> We have nothing to do with formalist aesthetics.... For us, "form" does not signify the outward aspect of art. "Form" is not surface, but is as much core; not the opposite of expression, but itself an expression of inner life. Indeed, it is life itself.[58]

The world was slowly recovering from a long and profound crisis, wrote Riezler. Only now was humanity becoming aware of a "new path, prescribed to it by the world spirit." At the end of that path, he stated prophetically, "is the new style."[59]

Not all the contributors to *Die Form*'s *Zeitstil* issue were convinced about the achievability (or indeed the appeal) of a new style. Deborah Asher Barnstone has shown how the main fault line ran between Peter Behrens and Hans Poelzig on the one hand, and Richard Riemerschmid, Otto Bartning, Wilhelm Kreis, and Riezler himself on the other.[60] Behrens and Poelzig were generally skeptical toward talk of a new style, not so much because they dismissed style as such, but because they found it unattainable under the prevailing conditions. "A creative artist... does not ask about the style of his time," wrote Behrens. It was impossible to discern the style of the present, let alone design it at will, so one might as well put aside the question altogether and concentrate on the concrete task.[61] Riemerschmid took a slightly different stance. Style represented an expression of life that could not be suppressed or ignored. Human creations inevitably mirrored their creators' attitude to life, and "this mirror is style." Style, then, was not created by individual artists but by life itself—"It is not made, it grows."[62]

Riemerschmid touched on a key issue in the debate, namely whether style can be consciously created, or must instead emerge organically and unselfconsciously from the age itself. This had

been discussed already by Muthesius, for whom the problem with a modern style lay precisely in the contrived efforts at conjuring it. "A great part of contemporary architectural production fails completely," thought Muthesius, "for its creators remain imprisoned in their efforts at a style."[63] Twenty years later, Peter Behrens similarly suggested that a genuine modern style could only arise if architects stopped thinking about style and got on with the job at hand. Even Riezler, who clearly thought a great deal about style himself, warned contemporaries against "even thinking" about it.[64]

Contemplating style, then, involved a certain risk, threatening to destroy the spontaneity with which a new style was meant to burst forth. The nineteenth century's self-conscious pursuit of style was likened to the expulsion from the garden of Eden; a fateful robbing of the tree of knowledge that did away with the unforced creativity of previous ages.[65] Walter Curt Behrendt was well aware of this risk. "[A] style is not invented, it emerges, and can only do so when 'an altered state in the collective consciousness calls it forth.'"[66] It was the self-conscious attempt at inventing a new style that had caused the demise of Jugendstil architecture, Behrendt thought, for although he admired fin-de-siècle architects such as Henri van de Velde (to the extent that he had him write the preface to *Der Kampf*), he ultimately dismissed Jugendstil as utopian and formalist.[67]

The warnings against thinking about style cannot have had much effect, for the decades between the First and Second World Wars thronged with style debate. Already in 1914, the young Walter Gropius recognized "a longing for a unified form, a style" and pondered whether the time was finally ripe for a new style.[68] Bruno Taut hoped for a new "unity of style" in modern architecture. Adolf Behne proclaimed "[w]e have to come closer to the style of our times,"[69] and while he would ultimately conclude—much like Mies van der Rohe—that "style in its highest sense is no longer possible," both Behne and Mies agreed that modern architecture had to tap into the spirit of its own time and regain the lost unity between spirit and form.[70] Even Muthesius and Giedion, who both rejected the term vehemently, spoke of architecture as "an expression of... inner nature" and the product of "an approach to the life that slumbers unconsciously within all of us."[71] As such, they remained deeply embedded in a tradition that saw architecture as the embodiment of the zeitgeist—precisely what Behrendt & co. called style.

MAANDBLAD VOOR DE MO-
DERNE BEELDENDE VAKKEN
REDACTIE THEO VAN DOES-
BURG MET MEDEWERKING
VAN VOORNAME BINNEN- EN
BUITENLANDSCHE KUNSTE-
NAARS. UITGAVE X. HARMS
TIEPEN TE DELFT IN 1917.

Detail of the first issue of
De Stijl, 1917, designed by
Vilmos Huszár.

The perhaps most ecstatic twentieth-century invocation of
the style-as-zeitgeist formula was that of the Dutch artists' group
De Stijl, operating in the aftermath of World War I. Their lineage
is longer still, for Hendrik Petrus Berlage's pre-war texts form the
basis for *De Stijl*'s style theory. Berlage's position was in many
ways comparable to that of Behrendt, recognizing that a new
style relied on new social and cultural conditions: "If we accept
that a great style is possible only if it is an expression of a cul-
ture, and that culture can be obtained only if there is a harmony
between spiritual and material needs, [then] a great style cannot
be expected until the social relationships have been changed so
much that this harmony is indeed achieved," Berlage wrote in a
1908 essay.[72] Underlying Berlage's notion of style, as Iain Boyd-
Whyte points out, is a vision of cultural restoration, healing the
depredations of capitalism and industrialization.[73] Unlike his
contemporary Muthesius, Berlage believed that this unity was

achievable and that it could indeed be talked about as style. "A great style may be expected in coming times," he enthused.[74]

But what exactly is style, as far as Berlage was concerned? In the essay "The Likely Development of Architecture" from 1905, he defined it as "a tectonic reflection of the entire spiritual life," explaining that "Style is nothing but the material form of a global idea, the product of a communal spiritual ideal."[75] Berlage equated style with truth, beauty, equality, and spirituality; an antidote to the deceit, egotism, materialism, and formalism of the time.

> [W]hat is the purpose of this? It is to have a style once more! Not only a kingdom, but all of heaven itself for a style! This is the despairing cry, the great, lost happiness. It is a matter of fighting the sham art—the lies—to regain the essence instead of the appearance.... We architects, therefore, must try to return to truth, to seize once again the reality of architecture.[76]

Nineteenth-century revivalism had reflected a "general spiritual emptiness," Berlage wrote, but the new century would once more fuse spirit and form into a genuine style for the modern age, though it might take "quite a different form that we are not yet

De Stijl no. 2, 1922, with the first part of Theo van Doesburg's "Der Wille zum Stil."

able to define."[77] The "yearning for style" was so irresistible that it would inevitably break through.

Berlage's idea of style would live on in the *De Stijl* circle.[78] Theo van Doesburg dedicated the *De Stijl* magazine (of which he was the editor) to the pursuit of a new aesthetic consciousness, pledging to uphold "the logical principle of a ripe style, based on the pure relationship between the zeitgeist and the means of expression."[79] He developed these ideas further in the essay "Der Wille zum Stil. Neugestaltung von Leben, Kunst und Technik" (The will to style. Reorganization of life, art, and technology), originally a talk given during his lecture tour to Jena, Weimar, and Berlin in 1921, and published in German in *De Stijl*, February and March 1922. The text is ambitious to say the least, aiming to describe the cultural evolution of humanity and map the entire contemporary art scene. Doesburg started by outlining the struggle between nature and spirit as a constant polarity in human culture. This struggle forms the universal subject of art, the latter understood as "the collective expression of a people—a style."[80]

To illustrate this constant striving for balance, Doesburg presented a diagram consisting of three parallel horizontal lines with

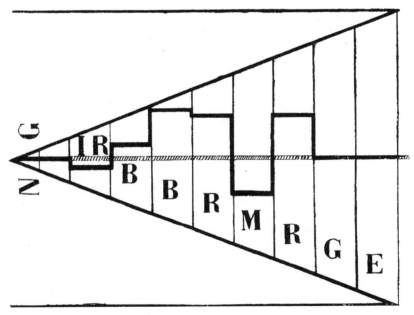

Theo van Doesburg, diagram of cultural and stylistic development. "Der Wille zum Stil," *De Stijl* no. 2, 1922.

an inserted triangle and a stepped line in the middle. The triangle was divided into columns to be read from right to left, each with a letter indexing the main periods of western culture: "E = Ägypter, G = Griechen, R = Romanen, M = Mittelalter, R = Renaissance, B = Barock, B = Biedermeier, IR = Idealismus-Reformation, NG = Neue Gestaltung."[81] Each period strove in different ways to create a balance between spirit and nature, a factor indicated by the black line stepping up and down inside the triangle. If ancient Egypt and Greece had achieved a perfect equilibrium, other periods privileged one over the other. The Middle Ages yielded to an almost pure spirituality, Doesburg thought, while the Renaissance and the baroque were oriented toward the material. Only at the very last stage, at the peak of the recumbent pyramid, was the balance restored. "The physiognomy of each art period shows vividly the extent to which man has succeeded in creating an expression, a style, a balance between the extremes mentioned above."[82]

Doesburg's quasi-Hegelian diagram was intended to show how culture strove toward balance and harmony and how this striving manifested itself as style. Such harmony was achieved only through struggle, however. Doesburg paraphrased Nietzsche's "revaluation of all values," which he considered a prerequisite for a new style. The struggle was always collective, never individual, a conviction that made him skeptical toward the artistic avant-garde (especially the cubists), who had failed, in his view, to create a "universal, collective expression; a style."[83] Instead of individual genius, Doesburg turned to the machine, describing the task at hand as "the appropriation of the mechanical for the new style."[84] While the new style would be entirely different from any historical style, it rested on the same principle of equilibrium; a stage it would reach through social liberation and technology. The modern will to style, consequently, was not restricted to monuments or traditional artworks, but was manifested in "literature, jazz bands, and cinema" as well as utilitarian objects.[85]

Having looked at some of the many diverging positions on style in twentieth-century architecture (and I could go on), it is becoming clear that the debate did not simply pitch "style haters" against "style lovers"; rather, there was a range of subtly differentiated positions whose agreements and disagreements ran along different lines. Muthesius, for instance, whose anti-style rhetoric is often seen as the polar opposite of the pro-style positions of Berlage, *De Stijl*, and Behrendt, agreed wholeheartedly with

them that modern architecture had to spring organically from the inner conditions of modern society. What they disagreed on was whether or not this organic unity should be called style. In that respect, Muthesius came close to Behne and Taut, who both recognized style as an ideal but thought it something of a lost cause, no longer available to modern society. Giedion and Mies van der Rohe, too, while categorically denouncing the term, continued to evoke the unity between spirit and matter that is the hallmark of German style thinking, for which style, as Arthur Schopenhauer put it in 1851, is the "physiognomy of the spirit."[86] At the other end of the spectrum you have Koolhaas, Hitchcock, and Johnson, who—although they disagreed on whether or not style was desirable—were in reasonable agreement as to what it was, namely a set of formal characteristics that could be used to identify and describe specific tendencies within architectural practice. The for-or-against arguments, then, were crisscrossed with other distinctions. Perhaps the most important of these was the one between style and the styles.

Style and the Styles (I)

Doesburg's diagram provides a good introduction to the persistent duality built into the modern style concept. On the one hand, style was presented as a universal ideal; an expression of a perfect equilibrium between spirit and matter. On the other, it was cast as a conventional, descriptive category denoting different historical expressions—Greek, Roman, Renaissance, Biedermeier, and so on. The diagram gave graphic expression to this duality. If the vertical columns charted the different stylistic epochs, the stepped line indicated the extent to which these epochs lived up to the ideal of style. Together, the diagrammatic elements established a two-vector instrument for registering style's dual existence.

The duality between style as an ideal correlation and style as a historical category can be found in almost all the texts examined above. Berlage, for instance, who celebrated style as a spiritual ideal, spoke disparagingly about the "so-called historical styles" of the nineteenth century, which he considered products of a spiritual vacuum.[87] If style proper was the "tectonic reflection of the entire spiritual life," nineteenth-century revival styles were sham art and lies.[88] The difference between style and the styles was thus one

42

between truth and lies; essence and appearance. Architects must "return to truth," Berlage proclaimed.[89]

Underlying the distinction between true style versus sham styles is the notion of a necessary correspondence between cultural conditions and architectural form. If true style displayed the perfect unity between the two, sham styles bore little or no relation to their time and place. The distinction is often expressed by the term organic, frequently encountered in the texts above, particularly in Muthesius and Behrendt. Nineteenth-century revival architecture was "entirely uprooted and robbed of any natural tradition," Behrendt wrote in *Der Kampf*; it lacked, in other words, an organic connection to its own time and history.[90] He found the Bavarian king Maximilian II's competition for a new architectural style in 1850 (to which we will return) a grotesque example of this; a futile attempt to produce style by conscious invention rather than organic coherence.[91] Muthesius, too, distinguished between a true, organic building tradition and a false tradition out of sync with its own time, but unlike Behrendt, he reserved the term style for the latter. The organic unity between spirit and form was threatened by a false style architecture, wrote Muthesius, lashing out against the hungry herd of architects rushing to plunder "the formal treasury of old art":[92]

> Architectural formalism appeared most distinctly in the
> stylistic hunt that began with the German renaissance
> of the 1870s and cursorily rushed through all the styles
> of the last four hundred years. This was nothing other than
> a jingling of forms in which a disastrous error was taken
> for "architecture."[93]

Muthesius "qualified the quest for a new style by a critique of style as such," observes Detlef Mertins.[94] Gropius did something similar, for although he recognized style as an ideal in his 1914 essay, he actively banned the "history of styles" from the 1919 Bauhaus curriculum.[95] "Academic and historical styles have been abandoned," Behne declared, but that in no way deterred him from pursuing "the style of our times."[96] In other words, one could dream of a new style while at the same time denouncing the disingenuous styles, and, conversely, one could consider a new style unattainable while admiring the styles of the past. The fact that

the styles at times referred to ostensibly genuine historical styles (Greek, Gothic) and at other times to revivalist "sham" styles (neo-classicism, neo-Gothic) did not make the matter any easier. The battle of style in twentieth-century architectural discourse was a battle, not only over which style to build in, but over what the term itself was supposed to mean.

An interesting variation on the style-versus-the-styles distinction came in Hitchcock and Johnson's *The International Style*. "The revived 'styles' were but a decorative garment to architecture," they declared, "not the interior principles according to which it lived and grew."[97] Barr elaborated on the distinction in his foreword to the exhibition catalog. Whereas just ten years before, the Chicago Tribune competition had "brought forth almost as many different styles as there were projects," he now discerned a convergence around a "genuinely new style" in modern architecture—the International Style.[98] "The confusion of the... past century may shortly come to an end," Barr wrote: modern architecture was finally moving from the styles to Style, in singular and with a capital S. And although Hitchcock and Johnson cringed slightly at this typographical fetishization (they themselves preferred to use style in lower case), they put up with it.[99] In a retrospective essay, Johnson dated the transition specifically to 1923, as the year when "the revolution toward a style, away from individual styles" took place.[100]

It is tempting to attribute Johnson's conspicuously precise dating of this "revolution" (which, notably, does not coincide with the exhibition's 1922 starting point) to the publication of Le Corbusier's *Vers une architecture*—perhaps the most famous articulation of the distinction between style versus the styles:

> The "styles" are a lie. Style is a unity of principle that animates all the work of an era and results from a distinctive state of mind. Our era fixes its style every day.[101]

The styles, for Le Corbusier, were historical formal systems that modern architects had abused through mindless imitation. Style, on the other hand, captured the ideal match between an age and its architectural expression, and was consequently a viable principle for the modern age. Like Berlage, van Doesburg, and Behrendt, Le Corbusier considered style a moral ideal and telos of modern architecture. In 1923, the realization of this goal seemed

44

to be right around the corner, happening "every day," as he wrote. A few years later, that optimism had dissipated: "In a century's time we can begin to talk of 'a style.' To-day we dare not. All we can do is to think OF STYLE in itself—that is to say the moral probity of every work that is truly and genuinely creative."[102] The modern age might have failed to produce a style proper, but it ought to strive nonetheless to produce works with a true connection to its time—to produce, that is, in style.

I will spend much time on the distinction between style and the styles in the following chapters, tracing it to Eugène Emmanuel Viollet-le-Duc and Antoine-Chrysostome Quatremère de Quincy, but even more to turn-of-the-century German thinkers such as August Wilhelm Schlegel and Johann Wolfgang von Goethe. For now, it is enough to note that the distinction has had a notable afterlife in late twentieth-century architectural thinking, cropping up, for instance, in Koolhaas's above-mentioned *S,M,L,XL* glossary. Uneasily tucked in between "STUPID" and "SUICIDE" are not just one but two entries on style, both in the plural. "STYLES 1" muses on stylistic change in general and its links to changes in the social and intellectual fabric, while "STYLES 2" quotes Le Corbusier's "The 'styles' are a lie."[103] Even Koolhaas doesn't quite manage to wriggle out of the straitjacket of style, though not for want of trying.

Excavating a Subterranean Paradigm (or: Why We Need to Talk about Style)

So why is the "style-based paradigm" so difficult to escape? Sarah Goldhagen, who posed the question in her 2005 article "Something to Talk About. Modernism, Discourse, Style," put it down to laziness. Defining style as a constellation of formal tropes, she criticized architectural historians for relying on oversimplified formal categorizations.[104] If we could only start talking about modernism as a discourse rather than a style, the problem would go away. Yet even the few texts examined above demonstrate that style is more than a formal trope; that it is indeed, as Gumbrecht puts it, a discursive element.[105] They also show that, far from being a straitjacket forced by conservative historians over the head of an unruly material, style is at the core of the material itself. Functioning both as a historiographic principle and a creative ideal, style (and the styles) form an intrinsic part of modern architecture—its history, creation, and reception. And despite

attempts to keep style (as a creative ideal) and the styles (as a historiographical principle) neatly apart, they tend to get entangled.

Goldhagen is not the only historian trying to escape the "tyranny of style."[106] In fact, the dismantling of the "style-based paradigm" has been a major drive in twentieth- and twenty-first-century scholarship on art and architecture. The attacks have come from many fronts. Authorities such as Ernst Gombrich warned against the physiognomic fallacy built into art history's notion of style; that is, the assumed correlation between a period's cultural conditions and its artistic expression.[107] Jan Bialostocki lamented style's equivocality, proposing to replace it with the rhetorical concept of modus, while Meyer Schapiro, who otherwise found style to be a useful historiographical tool, admitted that it resisted systematic classification and clear-cut definition.[108] And if Schapiro defended the postulate that a period can have only one style, later art and architectural historians have taken it upon themselves to uncover repressed styles, schools, and tendencies within seemingly hegemonic periods. "[N]o style can entirely fill any period," wrote George Kubler, challenging the style historians' monolithic zeitgeist thinking.[109]

Not everyone has been content with modifying the use of style. Svetlana Alpers admitted to avoiding the term as much as possible, while Willibald Sauerländer called it an "ambivalent hermeneutical 'construct'... corresponding to a very peculiar and alienated attitude towards the arts of the past."[110] More recently, art historian Éric Michaud has pointed out the racial bias underlying much style-based art history, showing how stories of epochs and styles easily become stories of race and blood.[111] Style has been associated with formalism, determinism, Eurocentrism, and racism—altogether a word to avoid.

But there are other sides to style, too. By far the most frequent defense of style in art and architectural history is that it seems almost impossible to do without. Gombrich, while warning against potential fallacies, never ceased to see it as an indispensable historiographical tool. "Style is any distinctive, and therefore recognizable way in which an act is performed or an artifact made," he noted, acknowledging that without such recognizability it would be hard to imagine a history of art (or architecture) at all.[112] Vincent Scully wrote fondly about the "eye for resemblances," describing style as a sort of family likeness

46

between works that allows us to make sense of them.[113] Adding to the indispensability—and complexity—of style in architectural history is that it is both a method and an object of investigation; both a diagnostic means and the thing being diagnosed. You may study a style, the baroque, say, or you may study an early seventeenth-century church façade in light of the theory of style, comparing it, for instance, to Renaissance or mannerist precedents. Style is both the "what" and the "how," observed Nelson Goodman shrewdly, noting how the concept tends to cut across facile distinctions between appearance and substance, form and content.[114] That is true not only for the style of an object, oeuvre, or epoch, but also for style as a historiographical principle. In the history of architecture, as we shall see in the following, style appears as both an optics and an object, making it a slippery but indispensable concept.

One way of escaping style's "dangerous essentialism" is by subjecting it to a Kantian turn of sorts, that is, by shifting it from a property of the studied object to a faculty of the perceiving subject.[115] Alois Riegl was onto something like that, noting how different generations perceive different things in the art and architecture of the past, making style formation as much a question of the observer's sensibility as the object's constitution.[116] Wilhelm Worringer called his famous *Abstraktion und Einfühlung* (1911) a "psychology of style," reminding his readers that "we forever see the ages as they appear mirrored in our own spirits."[117] In later historiography this turn has taken many forms. An interesting variant is James Ackerman's essay "A Theory of Style" from 1962. Ackerman acknowledges the many problems involved in style history—its inbuilt determinism; its false teleology; its tendency toward essentialism. But rather than rejecting it, he rethinks it. Style is not about essences, but about relationships, he writes, and it is not discovered, but created.[118] As such, it establishes "various kinds of order out of what otherwise would be a vast continuum of self-sufficient products."[119] While these kinds of order will always remain provisional, they are nonetheless necessary, giving the historian "factors which at once are consistent enough to be distinguishable and changeable enough to have a 'story.'" The attempts to abandon style are not only futile but also potentially dangerous, Ackerman hints, for they may make us less attentive to the way we construct history:

47

Although we cannot work without a theory of style, and although we continue to speak of classical, baroque, or painterly forms, we have allowed the systems that give meaning to these terms to slip into the unconscious, where they operate without the benefit of our control, as the barrier against new perceptions.[120]

Not investigating style might make us fall prey to style history's most reductive assumptions, Ackerman argues. Failing to problematize style—letting it "slip into the unconscious," as he put it—might paradoxically help to cement outdated notions of style, allowing them to lurk as unquestioned prejudices in research and teaching. Pondering Ackerman's point with respect to architecture, I am tempted to go a step further. Without understanding style—the way it has been used and the way it has been thought about—we cannot understand modern architecture.

2 *Inventing the Period Style*

Whether for or against, critical or enthusiastic, twentieth-century practitioners, historians, and theorists of architecture understood style first and foremost as an expression of historical circumstance—a tectonic reflection of spiritual life, as Berlage put it.[1] They may have disagreed on which style was appropriate for what, or whether a coherent style was achievable (or indeed desirable) for modern architecture, but the fundamental connection between style and epoch remained mostly unquestioned. All the more intriguing, then, to discover that this connection is relatively recent, and that style had a long and complicated history even before it was taken hostage by the zeitgeist. "[W]e have lost the ability to see just how artificial the connection between time and style is—how original," observes Alina Payne.[2] This chapter is about that connection and how it came to be.[3]

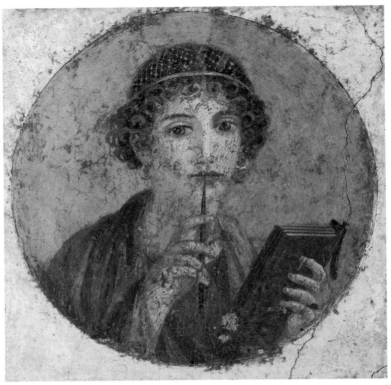

Woman with wax tablet and stilus. Roman fresco from Pompeii, ca. 50 CE. Museo Archeologico Nazionale di Napoli.

The Pillar and the Pen

Studies of style tend to begin with the term itself, which has long been a favorite subject of etymologization. From Quatremère de Quincy to Gombrich and beyond, the term has been traced from the Greek *stylos* or the Latin *stilus*, originally a pointy instrument used to write on wax tablets. From there, the sources tell us, the term was absorbed into classical rhetoric as a mode of expression, be it oral or written, before finally making its way into the vocabulary of art and architecture.[4]

The story is as neat as it is convincing, and as so often with neat and convincing etymology, it is not entirely true. First of all, the relationship between stylos and stilus is contested. In Greek, stylos originally meant pillar or column, and reputable lexicographers seem to think it has little to do with the stilus. "[T]he connexion in etymology with στῦλος (whence the spelling stylus) is mistaken,"

54

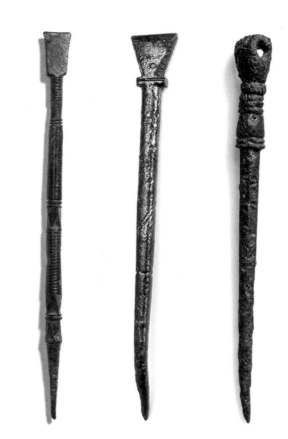

Stilus as stylos. From left: Roman bronze stilus (British Museum); medieval iron stilus (NumisAntica); undated bronze stilus (Bergen University Museum).

stated the 1890 *Dictionary of Greek and Roman Antiquities* under the entry "Stilus."[5] The more recent *Digitales Wörterbuch der deutschen Sprache* is equally categorical, attributing the stilus–stylos link (and hence the practice in many European languages to spell style with a y rather than an i) to a misunderstanding. "The spelling Styl— conventional until the beginning of the nineteenth century— derives from (as the Fr. and Eng. style) an orthographic variation emerging from an erroneous connection of this word with the Gr. stýlos (στῦλος) 'column, pillar,'" the *Wörterbuch* concludes.[6]

Misunderstanding or not, the pillar and the pen formed a powerful conceptual pair in architectural thinking on style.[7] Antoine-Chrysostome Quatremère de Quincy elaborated the connection in the *Encyclopédie méthodique* of 1825, an entry later recycled for his 1832 *Dictionnaire historique d'architecture*:

STYLE. The etymology of this word, whose use in French has deviated from its original meaning, is the Latin word *stylus*, or the Greek word *stylos*. In each of these two languages the word designated either a round body such as a column, or an engraver's point, round like a pencil, sharp on one end and flattened on the other, which was utilized to write on wax-coated sheets.... [T]he idea of the mechanical operation of the hand or the instrument that traces signs was applied by metonymy to the operations of the mind, in the art of expressing one's thoughts with the signs of writing.[8]

Quatremère de Quincy's conflation of the pen and the pillar undoubtedly made a lot of sense to a tradition that had for centuries linked style to the orders through the vocabulary of rhetoric. Already Vitruvius presented the architectural orders as analogous to the different styles of speaking, establishing a powerful precedent for later architectural thinking.[9] The term he used was not stilus, however, but *genus*—class or kind—describing for instance how the Doric and Ionic orders engendered a third genus, the Corinthian.[10] That points to another curious thing about the etymologization of style, namely the fact that, more often than not, the precedent for the modern notion of style is not stilus (let alone stylos) but a host of other categories, Vitruvius's genera among them. Even in rhetorical treatises from antiquity, stilus is hard to find in the sense of mode of expression. To be sure, Cicero praised orators for having "one tone and a consistent style" (unus enim sonus est totius orationis et idem stilus[11]) and admired speeches using "the best and most excellent style of elocution" (stilus optimus et praestantissimus dicendi).[12] Yet dictionaries such as Lewis & Short point out that the use of stilus to refer to modes of expression was rare in antiquity.[13] Cicero, like Vitruvius, was more likely to speak of genus than stilus when discussing different modes of speech, and his five-point instruction on how to prepare a persuasive talk used *elocutio*, not stilus, for the category today commonly known as style.[14] Rather than one continuous etymological lineage, the modern notion of style boasts a multitude of origins. Its hybrid genealogy continues to reverberate throughout the modern period, making style an unstable and multivalent concept but also, as we shall see, a profoundly useful one.

56

Tab. VIII.

1818 copy of the destroyed *Hortus Deliciarum* (ca. 1180), showing philosophy with the seven liberal arts. Rhetoric with a stilus in the upper right corner. Collection Bibliothèque Alsatique du Crédit Mutuel, Strasbourg.

Genera, Maniere, Ordini

While not necessarily derived from stilus, style—understood as the way in which something is spoken or written—was undoubtedly a key issue in classical rhetoric. Different authors operated with different stylistic categories, but most were variations over a three-part division into grand, plain, and intermediate style (genus grande, tenue, and medium).[15] A speaker must choose his style according to the occasion, wrote Cicero, who considered the ability to gauge the appropriate style as the orator's foremost skill. He presented this decorum-based style theory succinctly in book 3 of *De Oratore*:

> [N]ow let us consider the subject of appropriateness, that is, what style is most suitable in a speech. Although one point at least is obvious, that no single kind of oratory suits every cause or audience or speaker or occasion. For important criminal cases need one style of language and civil actions and unimportant cases another; and different styles are required by deliberative speeches, panegyrics, lawsuits, and lectures.... And so at this point it does not in fact seem possible to lay down any rules except that we should choose a more copious or restrained style of rhetoric, or likewise the intermediate style that has been specified, to suit the business before us.... and in every case while the ability to do what is appropriate is a matter of trained skill and of natural talent, the knowledge of what is appropriate to a particular occasion is a matter of practical sagacity.[16]

For Cicero, style was not an added ornament but an integral part of what was being said. Style had to do with both appearance and content—beauty and utility. In this, style in language functions much like in architecture, he proposed, for both are composed with respect to utility as well as beauty.[17] This was the tradition Vitruvius drew upon when he spoke of the architectural orders as genera, suited to different occasions and judged according to decorum.[18] Doric is appropriate for temples to Minerva and Mars; Corinthian for temples to Venus and Flora; while Ionic is suitable for Juno and Diana.[19] This rhetorical sense of appropriateness applied not only to the individual orders but to entire architectural ensembles, for instance in the way tragic, comic, and satyric stage sets required different architectural

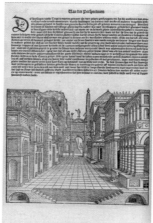

Sebastiano Serlio, comic, tragic, and satyric stage sets. *Five Books on Architecture*, book 2, edition from 1550/1553. The Metropolitan Museum of Art, New York.

attributes.[20] Paralleling the *genera dicendi* with architectural modes and orders, the Vitruvian tradition relied on a rhetorical system of architectural expression.[21]

Caroline van Eck has shown how the rhetorical system constituted a framework for creating, interpreting, and categorizing architecture well into the modern period.[22] Leon Battista Alberti, for one, based his architectural system on the methodological and structural model offered by classical rhetoric, aligning the genera dicendi with the genera of architecture.[23] Other writers pursued a similar analogy by other terms. Raphael, Sebastiano Serlio, Giorgio Vasari, and Daniel Barbaro spoke about *maniere* rather than *genera*, equating, as van Eck points out, "the *maniere del dire*, the styles of rhetoric, with the *maniere del edificare*, the ways of building."[24] Like Alberti's genera, the maniere were closely linked to the orders; in fact, as Alina Payne shows, manner and order were used more or less synonymously in Renaissance texts.[25] Raphael described the orders alternately as *ordini* and *maniere*, and Serlio spoke both of "le cinque maniere de gliedifici" and of "del l'ordine Dorico."[26] Vasari spelled out the analogy between ordini and maniere in the second edition of *Lives of the Artists* (1568), explaining that "as many do not recognize the differences between order and order [ordine], we will discuss individually each style [maniera] or manner [modo]."[27]

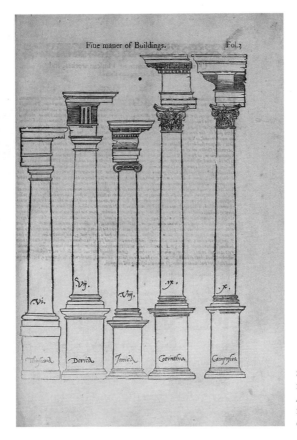

Sebastiano Serlio, the
five orders. *Five Books on
Architecture*, book 4, edition
from 1611. Glasgow School
of Art Library.

Vasari is an interesting case. In most of his *Lives of the Artists* he
used maniere to describe individual artistic styles—Michelangelo's
manner differs from that of Correggio; Giotto is different from
Cimabue, and so on. In the sections on architecture, however,
maniere—through the close link with ordini—took on a different
meaning. Payne observes:

> Personal style—the cornerstone of Vasari's system—never
> came up in architectural discussions. Indeed, the pattern
> was so established that not even Vasari, who was more
> than usually attentive to this issue, used personal style
> as a category to describe the oeuvre of the architects....
> Apparently the connection *maniera/ordine* was so powerful in
> architecture that another, parallel meaning for the term style
> could not be conceived.[28]

Architectural maniere, then, were understood less as individual manners and more as articulations of a larger order. We will see how this latent schism became an important distinction in the late eighteenth century, when Goethe and others tried to distinguish true style from mere manner. In Renaissance writing, no such hierarchy existed, yet the subtle differentiation between maniere as individualizing traits and maniere as adherence to a predefined order points to themes that would reverberate in nineteenth-century architectural thinking.

These are superficial observations on a long and complex history, but two points may be gleaned. First, the brief excursion into early modern architectural thinking shows style to be a hybrid and equivocal concept. Its genealogy seems more like a bundle than a line, made up from multiple and somewhat tangled strands. What united the bundle, however—and this is my second point—was that many of its strands and much of its structure came from the rhetorical tradition. Genera, maniere, and ordini were linked to a rhetorical theory of expression, adopted by architectural discourse to characterize different ways of building. The orders were particularly suited to this analogy, and the intimate link between style and the orders lasted well into the eighteenth century. Stilus and stylos may be etymologically unrelated, but the pen and the pillar nonetheless belong firmly together in early modern architectural thinking.

"Schreibart; Styl"

Though Renaissance theorists rarely used the term style in connection with art and architecture, there were exceptions. Germann notes that Filarete used the term stile to describe a distinguishing trait of an artist, and that Camillo Bolognino, commenting on Palladio's design for San Petronio in Bologna in 1578, remarked that "it would be better to follow the style [il stilo] of modern Christian churches than that of heathen temples."[29] But these seem to be rare instances. It was really only in the eighteenth century that the term style—in various languages and etymological derivations—made its way into common parlance. And when it did, it was still mainly to describe the art of speaking and writing. In Johann Heinrich Zedler's sixty-four volume *Grosses vollständiges Universal-Lexicon aller Wissenschafften und Künste* (1731–1754), style does not have an entry, but stylus does, defined as an ancient writing tool and manner of writing

(*Schreibart*) respectively.[30] Zedler was in line with contemporary usage in French and English. The first edition of the *Encyclopédie* defined style as "manière d'exprimer ses pensées de vive voix, ou par écrit" and placed it in the categories of grammar, rhetoric, eloquence, and belles-lettres.[31] The first *Encyclopaedia Britannica* defined it as "a particular manner of expressing one's thoughts agreeable to the rules of syntax."[32] This meaning seems to have been dominant at least into the 1790s, for when an authority like Karl Philipp Moritz published his *Vorlesungen über den Styl* in 1793, he took style quite unproblematically to mean the art of speaking and writing well.

Eighteenth-century excursus on style followed for the most part the rhetorical division into grand, plain, and intermediate styles, as well as into different genres ranging from legal and political speech to poetry. Encyclopedias typically spent pages listing and describing the "dramatic," "lyrical," and "bucolic" styles, alongside a host of more fanciful (and not necessarily recommended) categories such as the "equivocal" (*aequivocus*) or "kitchen" (*culinarius*) styles.[33] Behind this diverse taxonomy, however, lay a Cicero-like understanding of style as a mode of linguistic expression, chosen by the author to suit the topic, occasion, and audience. The choice of style was governed by decorum—an understanding of which mode of expression would be most appropriate for a particular situation.

If style in eighteenth-century texts was mostly linked to language, its use slowly expanded. Zedler's *Universal-Lexicon* mentioned style in music, a sense that made its way into the *Allgemeines Lexicon der Künste und Wissenschaften* in 1767, as well as the 1778 edition of *Encyclopaedia Britannica*. One of the first German dictionaries to use the term in relation to art more generally seems to be the 1817 edition of the *Conversations-Lexicon oder encyclopädisches Handwörterbuch für gebildete Stände* (otherwise known to generations of German speakers as the *Brockhaus Enzyklopädie*), which mentions "Styl in der Mahlerei, Bildhauer- und Baukunst."[34] Yet it was only in 1827 that Brockhaus added a separate entry for "Styl der Kunst," of which architecture was a part.[35]

In France, the term made its way into architectural discourse somewhat earlier. Van Eck shows how architects such as Germain Boffrand and Jaques-François Blondel systematically applied rhetorical concepts in their theoretical works, and

how the concept of style became a linchpin for new theories of architectural expression. She quotes Boffrand from his 1745 *Livre d'architecture*:

> Through its composition a building expresses, as if in the theatre, that the scene is pastoral or tragic; that this is a temple or a palace.... [A]ll... buildings must proclaim their purpose to the beholder. If they fail to do so, they offend against expression and are not what they ought to be. The same is true of poetry: this, too, has its different genres; and the style [le stile] of one does not suit another.[36]

Style, here, is closely linked to genre, describing architecture's expressive potential. Jacques-François Blondel used the two terms more or less synonymously, defining style in architecture as "the true genre which one must choose with respect to the motive which led to the construction of the building."[37] Seeing style as "the poetry of architecture," Blondel's and Boffrand's architectural thinking was closely patterned on the rhetorical tradition by which the speaker/architect had several modes of expression at his or her disposal, to be chosen according to decorum.

The gradual expansion in the use of style—from the domain of language to that of art and architecture—can be found in the German sphere, too, though the process took a little longer. Christian Ludwig Stieglitz did not include an entry on style in his *Encyklopädie der bürgerlichen Baukunst* appearing from 1792 onward, preferring, like Immanuel Kant in the *Critique of Judgment* (1790), to speak of taste and character.[38] Stieglitz did however use the term *Bauart* (manner of building), defining it as "the particular taste in the ornamentation, and in all that belongs to beauty, by which the buildings of different peoples may be distinguished from each other."[39] The philosopher Johann Georg Sulzer, on the other hand, frequently used style in his two-volume *Allgemeine Theorie der Schönen Künste* (1771–1774), a work organized as a dictionary with alphabetically ordered entries. Expanding the rhetorical notion of style, Sulzer compared the genres of speech with different styles of painting:

> Just like the art of speaking, painting adopts soon the elevated, passionate tone, soon the tone of ordinary

everyday life, or stays in the middle between the heroic and the quite ordinary. Hence arises in painting, as in speech, a threefold style.[40]

Sulzer's loyalty to the rhetorical tradition shows itself not least in the double entry "Schreibart; Styl," where he defined the two terms jointly: "The particular mark imprinted onto the work by the character and the mindset of the artist seems to be what one counts as the manner of writing, or the style."[41]

Although Sulzer and his French contemporaries applied the concept of style to art forms such as painting and architecture, their use remained closely aligned with the rhetorical tradition. This was changing rapidly, however. From being a heterogeneous but seemingly uncontroversial concept taken from classical rhetoric, style was propelled to the center of late eighteenth-century aesthetic debate, becoming the operative concept in an entirely new form of architectural history.

Title page of Johann Joachim Winckelmann's *Geschichte der Kunst des Alterthums*, 1764. Universitätsbibliothek Heidelberg.

Historicizing Style

After the relentless listing above, I will slow down to consider what is perhaps the single most important contribution to the modern notion of style in architecture, namely Johann Joachim Winckelmann's *Geschichte der Kunst des Alterthums* (1764). The claim may seem unreasonable, for Winckelmann was hardly a profound architectural thinker. Compared to his evocative observations on sculpture, his writings on architecture are usually considered dry and uninspired with few original insights.[42] Yet the theory of style put forward in Winckelmann's *Geschichte* had a more profound effect on architecture than on any other discipline, I will argue. Seeping from historiography into architectural practice, Winckelmann's style became a means not only of understanding history, but of making it.

Winckelmann set out his project already on the first page of the *Geschichte*:

> The history of the art of antiquity that I have endeavored to write is no mere narrative of the chronology and alterations of art, for I take the word history in the wider sense that it has in the Greek language and my intention is to provide a system.... The history of art should inform us about the origin, growth, change, and fall of art, together with the various styles of peoples, periods, and artists and should demonstrate this as far as possible by reference to the remaining works of antiquity.[43]

While Winckelmann promised to examine the styles of both periods and artists, he was not really interested in individuals, marking his distance from the Vasari/Bellori tradition. His system was to account for art rather than artists; to examine, as the title of the first chapter put it, the "origin of art and reasons for its diversity among peoples." The ambition belonged to a well-established Enlightenment tradition. Montesquieu had published *De l'esprit des lois* in 1748, Voltaire his *Essai sur les moeurs et l'esprit des nations* in 1759, both pondering cultural diversity and its causes. Winckelmann was inspired by these and looked, like his Enlightenment role models, to climate as an important such cause. Setting out to study "the way in which countries' differing localities, their particular weather patterns and foods, affected their inhabitants'

appearance no less than their way of thinking," Winckelmann presented art as an index of its time and its place.[44]

Climate affects art in more ways than one in Winckelmann's schema.[45] The air, the temperature, the soil, and the food produced from it, shape human physiognomy and facial features; an important factor for a historian who saw sculpture—the imitation of the human body—as the original art. Nature and art are intimately related, for mild climes produce more beautiful people and beautiful people produce greater art because they have better models to imitate. The Greeks were privileged in this respect, Winckelmann thought, with their perfectly temperate climate and correspondingly beautiful bodies:

> The influence of climate must invigorate the seed from which art is to germinate, and Greece was the preferred soil for this seed.... Nature, after having passed step by step through cold and heat, established herself in Greece, where the weather is balanced between winter and summer.... Where Nature is less enveloped in clouds and heavy vapors, she gives the body a riper form earlier... and in Greece she will have perfected its people to the finest degree.[46]

Climate not only shaped the human body, it also conditioned manners and mores, ways of thinking and making.[47] The effects were not always predictable. The Phoenicians, inhabiting the fairest coasts on the Mediterranean Sea, were prompted by their advantageous climate to pursue science and art, while in the Campanians, the mild climate and fertile soil instilled voluptuousness.[48] As a rule, however, a better climate meant better, braver, and more beautiful people with a more sophisticated art and culture.

But there were other factors shaping cultural development: "For external circumstances affect us no less than the air that surrounds us, and custom has so much power over us that it even shapes the body and senses instilled in us by nature in a particular way." Among these "external circumstances" Winckelmann emphasized social and political organization, especially education, constitution, and government.[49] Greek art was a product not only of a temperate climate but of a particular political culture based on freedom. "With regards to the constitution and government of Greece, freedom was the chief reason for their art's

superiority," he pronounced.[50] Climate and culture interacted in complex ways within Winckelmann's system. The Greek body was the product of a benign climate, but also of a culture that encouraged physical exercise and nudity. The Greek polis was based on a political principle of freedom that was itself a product of the Mediterranean soil. "Much that we might imagine as ideal was natural for them," Winckelmann wrote of the Greeks, emphasizing the subtle interaction between "internal" and "external" circumstance in the development of Greek culture.[51]

Winckelmann was hardly original in emphasizing climate and topography as causes for a variety of human practices. But the conclusion he drew from it was novel, especially on behalf of art. If the ideals and sensibilities of a culture were shaped by its particular conditions—natural and historical—then the product of these sensibilities, for instance art and architecture, would be unique to this culture alone. Just as human physiognomy reflects the climatic and cultural conditions that formed it, so art expresses the circumstances of its making, rendering it a reliable index to the "character of the nation."[52] The term Winckelmann used to pin down the outcome of these particular circumstances was style.

Winckelmann pursued style most methodically in part one of the *Geschichte*. Here, he described the preconditions of art in different cultures, searching for the "probable cause for the nature of their art."[53] The different chapters were structured in roughly the same way. First, he mapped the internal and external circumstances shaping the culture in question, then he described the resulting style. His favorite genres for defining these stylistic features were drawing and sculpture, but style pervaded all art forms. The rigid character of early Egyptian drawing, for instance, is also found in Egyptian buildings and sculpture of the period. "We find this style also in their architecture and in their decoration," he wrote; "their figures therefore lack grace... and painterlyness, as Strabo says about their buildings."[54] Style, for Winckelmann, is a result of particular conditions, and different conditions produce different styles. That makes style not only a means to recognize the particular character of a culture's art, but also an analytical tool to explain why it had turned out the way it did. The stiff Egyptian figures reflect a rigid mentality, a disposition Winckelmann put down to Egypt's harsh climate and hierarchical social order. The idea that one can judge the character of a culture from

Vignette to the preface of Winckelmann's *Geschichte der Kunst des Alterthums*, 1764. Universitätsbibliothek Heidelberg.

the visual characteristics of its art—something Gombrich, two centuries later, would dismiss as the physiognomic fallacy—is one of the lasting legacies of Winckelmann's *Geschichte*.[55]

But there is yet another axis in Winckelmann's style system. If a nation's "internal and external circumstances" explain stylistic difference across space—the difference between the Greeks and the Etruscans, say, or the Phoenicians and the Egyptians—one must also understand its development over time. For art changes, even when climate and physiognomy stay the same. To understand such change, Winckelmann introduced a series of stylistic stages through which the art of any country or culture evolved. His nomenclature differs slightly from culture to culture, but mostly he spoke about early, succeeding, and late style, a kind of historicized version of the old rhetorical triad. He described the development as a move from necessity, via beauty, to superfluity, a cycle he considered "the three principal stages of art."[56]

Winckelmann's analysis of the growth and decline of art culminates in his excursus on ancient Greece. He divided Greek art into "ancient style," "grand or high style," "beautiful style," and "the style of the imitators," before tracing its decay in the Hellenistic period.[57] The character of each stylistic stage pervaded all

68

art forms, a coherence that was useful for identifying and dating artworks. A relief he encountered in Villa Albani is a case in point. It depicts a procession of three figures facing a winged Nike. The stiff posture of the figures might mislead you into thinking they were Etruscan, Winckelmann wrote, yet the Corinthian temple in the background convinced him that the relief was a late Greek work.[58] Though later scholars have concluded that the relief is neither Greek nor Etruscan, but Roman, that does not detract from the logic of the argument.[59] Like cross bearing navigation, Winckelmann's two-vector system of historical and geographical style allowed him to locate artworks in time and space.

If style gave clues to interpret individual works, it also invited more overarching conjecture. Winckelmann's style analysis revealed not only the particular status of a work, but also the developmental level of the culture that produced it. The high style of Greek art thus coincided with the peak of the Greek polis, while late styles tended to reflect political and cultural decline. And although the notion of history as a cycle of birth, growth, and decay is an ancient one, Winckelmann's keen eye for the individuality of each cycle gave it a very different meaning, not least with respect to art and architecture.[60] He drew on, among others, Anne Claude Philippe de Tubières, Comte de Caylus, who in his six-volume *Recueil d'antiquités égyptiennes, étrusques, grecques, romaines et gauloises* (1752–1767) had set out to view monuments as "the proof and the expression of the taste which reigned in a particular epoch and place."[61] Caylus did not use the term style (speaking instead of the *goût*, *esprit*, or *génie* of nations) but he did apply stylistic analyses of sorts, not only to describe individual works but also to capture the spirit of past cultures. The idea that the arts bear the character of the nations that created them was an insight keenly adopted by Winckelmann, who, as Katherine Harloe shows, turned Caylus's tentative style theory into a fully-fledged cultural history.[62] Perhaps one could say that if Caylus wrote the history of art by means of culture, Winckelmann wrote the history of culture by means of art, for his new concept of style made art and architecture key to understanding the historical circumstances of its becoming. It was a twist that would grant the art historian a privileged position as an interpreter of culture. As Sauerländer acutely observes:

> Winckelmann forges here with seducing ingenuity a chain
> of associations which leads to one of the great fascinations,

Vignette to part I, chapter 1 of Winckelmann's *Geschichte der Kunst des Alterthums*, 1764.
Universitätsbibliothek Heidelberg.

promises but also illusions of art history... the notion of
bygone styles as the mirror of history and the art historian as
the initiated exegete of the past.[63]

A poignant illustration of the historicization going on in Winckel-
mann's work is the vignette he prepared for the first chapter in
part one of the *Geschichte*. It is a curious image, a fact Winckel-
mann seemed to acknowledge, for he spent an unusual amount of
time justifying it in his "Legends for the Engravings." Unlike the
other images in the book, this one was not based on a particular
work of art. "[N]o representation was to be found whose import
suited this chapter," he explained, choosing instead to juxtapose
several of "the most ancient works of sculpture and architecture"
in one image. To the left stands a fluted Doric column from Paes-
tum, partly submerged in the ground. Winckelmann had visited
Paestum already in 1758 and considered its temples something
of a Greek ur-type, "older than any building that has survived in
Greece itself."[64] Lying on the ground between the column and an
empty plinth behind it, is a full-length figure "in the most ancient
Egyptian style." A small relief lies half broken underneath it, as if

crushed by the Egyptian figure. It is difficult to make out its motif, but the crouching woman next to the towering man with an outstretched arm might lead one to think of the expulsion from paradise. Winckelmann left both the relief, and the small pile of coins or gems lying on the ground next to it, uncommented. But he had more to say about the rest of the composition. At the center of the image, above the Egyptian figure, lies a bearded sphinx with garlands on its back. Winckelmann referred to his 1760 catalog *Description des pierres gravées du feu Baron de Stosch*, where the sphinx was described as a Roman work from the Imperial period.[65] To the right is a painted vase showing a freestanding Ionic column and two male figures by an urn—an Etruscan funerary motif, Winckelmann explained.

For a chapter dealing with the "origins and diversity of art," this is indeed a suitable illustration. It presents the principal art forms—architecture, sculpture, painting, and numismatics—genres Winckelmann elsewhere described as his "evidence."[66] It visualizes the main (as far as Winckelmann was concerned) epochs of ancient civilization—Egyptian, Etruscan, Greek, and Roman. And while the text presents ancient Greece as the pinnacle of art, the image establishes no such hierarchy, instead showing all epochs hovering equally uneasily within the skewed perspective of the drawing. Whether the effect is a product of poor draftsmanship or iconographic profundity is hard to judge. Winckelmann admonished his unknown draftsman for getting the column's entasis wrong, a sign he was not entirely happy with the composition.[67] The image is nonetheless an apt illustration of the emerging relativism of Winckelmann's system. Many years later, Leopold Ranke formulated the quintessentially historicist dictum that all historical epochs are "immediate to God."[68] Winckelmann's historical assemblage expresses a similar sentiment, letting the epochs of history, each represented by its particular style, float side by side.

Presenting style as a relative outcome of historical circumstance, Winckelmann anticipated historicism's most central insight. For although he wholeheartedly defended Greek art as a universally valid ideal, his particular *way* of defending it turned it, as Alex Potts notes, from a "'timeless' model of classic excellence into a historical phenomenon."[69] Style was the vehicle for that historicization, fixing art to a particular point of origin in time and space. "[I]t was Winckelmann who for the first time

applied the idea and the perspective of rising historicism... to the treatment and the discussion of the fine arts," writes Sauerländer, and continues:

> In order to achieve this, Winckelmann had to transform the traditional normative concept of style into an hermeneutical instrument flexible enough to serve the new historical interpretation of varying aesthetic experiences. Style became now the keyword for the bridge leading from visual perception to historical insight.[70]

This idea of style set Winckelmann firmly apart from the rhetorical tradition. If style in rhetoric was about choosing between a pre-established range of expressive possibilities, according to decorum, Winckelmann's style was an outcome of historical circumstances.[71] More a destiny than a choice, style had become the obedient servant of the zeitgeist. It had become, in short, period style.

The Winckelmann Effect

Winckelmann's style-based system impressed his eighteenth- and nineteenth-century readers. Johann Gottfried Herder hailed him as "a divine interpreter," and Georg Wilhelm Friedrich Hegel credited him with opening "a new organ and totally new modes of treatment" in the field of art.[72] While the old antiquarians "saw only one fact and object after another, and had no sense of the connection between them," Winckelmann offered "the coherence of a regular plan," enthused Quatremère de Quincy.[73] More than admiration, however, Winckelmann's novel notion of style lent itself to use. As an expression of the way art and architecture respond to the relative character of time and place, Winckelmann's style concept allowed the history of these disciplines to be seen as a succession of epochs, each of which was the product of specific conditions and manifested through a distinct style. And more than that: as a condensed expression of a particular time or place, style could be seen to express not only the relative status of any given civilization, but also its inner ethos; its unique, inimitable historicity. Style was the expression of an individual, epochal unit, indexing a series of internal and external factors that made each historical moment different from any other.

An early use of the new period style was in the emerging field of cultural history. The historian Justus Möser emphasized style

as key to a new kind of history writing, dealing not merely with facts, but with the inner connections between historical phenomena. "The style of all the arts, even the... love-letters of a Duc de Richelieu, stand to one another in a single relationship," he wrote in 1773, emphasizing how a period's customs, constitution, laws—even wars—were infused with the same "tone" or "coloring."[74] Herder, in whose *Von Deutscher Art und Kunst* Möser's piece was first published, similarly adopted Winckelmann's relativizing concept of style for his own account of world civilizations. Herder wrote of Indian, American, Chinese, and African cultures, arguing like Winckelmann that monuments, manners, religion, and dress could be seen as outcomes of particular historical circumstances. "Everywhere on our earth, that which can be will come to be, partly in keeping with the location and needs of the place, partly according to circumstances and opportunities of the time, partly in line with the innate or developing character of the peoples," he wrote.[75] Style was key to recognizing and understanding such variables. Persian culture, for instance, was "confined by climate and the constitution of the kingdom, by religion, customs, and external circumstances: through these it gained—as much in objects as in artistic style—its own shape."[76] Ancient Egypt, likewise, was conditioned by everything from its class system to its climate to produce its distinctive sphinxes and obelisks. "[O]nly a constellation of such conditions in such an age made possible monuments such as these," Herder proclaimed.[77]

Architectural monuments had a privileged position in this new, style-based history writing, for unlike other kinds of artworks, architecture could be considered representative of the epoch as a whole.[78] "[O]n the basis of what we know up to now of India's monuments," wrote Herder in 1792, "it follows that the style that prevails in them, as well as their entire purpose, reflects extremely local as well as national characteristics, so that, regardless of where the seeds of art and religion may have come from to the Ganges, they have assumed along its banks an entirely distinctive nature."[79] And just like the zoologist cannot allow herself to prefer the elephant over the sloth, the historian of human culture should not idealize one style over another.[80] All styles are testimonies to their own historical origins, Herder thought, and as such they are equally valuable.

A particularly interesting example of architectural style as an index of historical civilizations is found in the work of the

Arnold Heeren, *Ideen über die Politik, den Verkehr und den Handel der vornehmsten Völker der alten Welt*, 1793–1796. Edition from 1815–1818. Oslo University Library.

Göttingen historian Arnold Heeren. Student (and later son-in-law) of Winckelmann's great promoter, Christian Gottlob Heyne, Heeren was linked to Winckelmann in more ways than one. In fact, the influence from Winckelmann has been seen as a distinguishing feature of the Göttingen historians around the turn of the eighteenth century.[81] The new concept of style was at the heart of this connection, and Heeren used it frequently. In his much-read *Ideen über die Politik, den Verkehr und den Handel der vornehmsten Völker der alten Welt* (1793–1796, with many subsequent editions), Heeren wrote of the "eigenthümlichen Styl" of the temples of upper Egypt, which he considered vital to understanding the entire nation.[82] Systematically covering Carthage, Ethiopia, Phoenicia, Babylon, Persia, Scythia, India, and China (among others), Heeren used architectural style to elucidate both the material culture and the spiritual disposition of his cases. Consider his analysis of Persian architecture:

> The columns of Persepolis strive upwards, slender yet firm, still showing the image of the palm tree from which they most likely derived. Just as among the Egyptians everything is covered and repressed, here everything is open and free; in beautiful harmony with the character of the people who

74

made the sun, the elements, and the open vault of the sky the objects of their worship![83]

Monuments and peoples belong together in "beautiful harmony," and architectural style can consequently reveal not only the monument's age and place of origin, but even the beliefs, hopes, and dreams of the civilization that produced it.

Heeren would become a favorite reference for architects and architectural historians in the early nineteenth century, cited by everyone from Stieglitz to Semper.[84] The Göttingen-based architect, engineer, and historian Carl Friedrich von Wiebeking, for instance, adopted Heeren's interest in the relationship between monuments and mores in *Von der Einfluss der Bauwissenschaften oder der Baukunst auf das allgemeine Wohl und die Civilisation* (1816–1818), in which style became a central category. Another diligent reader of Heeren (and Winckelmann) was Aloys Hirt, who in *Die Baukunst nach den Grundsätzen der Alten* (1809) and *Die Geschichte der Baukunst bei den Alten* (1821–1827) used style as both a dating device and a means to grasp the spiritual and aesthetic unity of particular epochs.[85] An epoch is held together by its style—not as

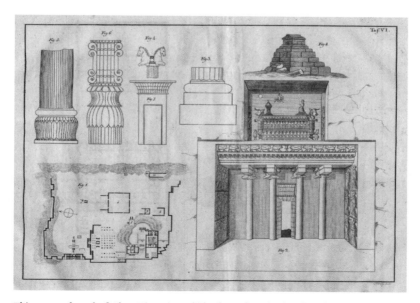

This page and overleaf: Aloys Hirt, *Die Geschichte der Baukunst bei den Alten*, 1821–1827, *Atlas*. Universitätsbibliothek Heidelberg.

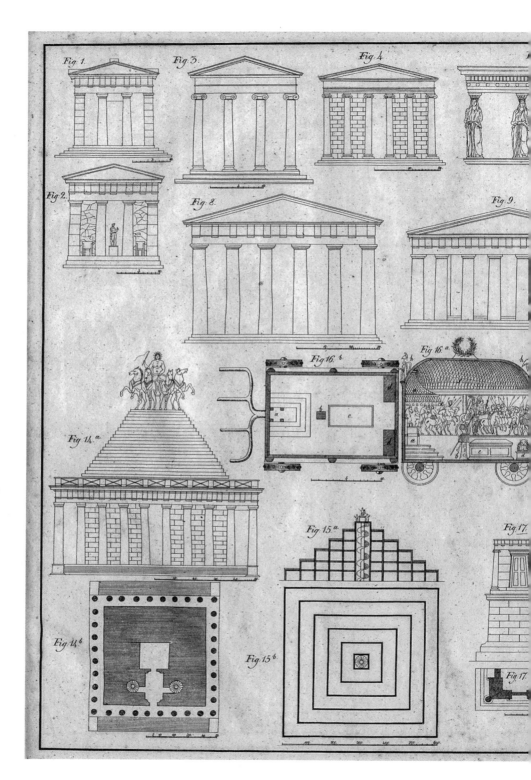

Fig. 1. Fig. 3. Fig. 4.

Fig. 2. Fig. 8. Fig. 9.

Fig. 14.ᵃ Fig. 16.ᵇ Fig. 16.ᵃ

Fig. 14.ᵇ Fig. 15.ᵃ Fig. 17.

Fig. 15.ᵇ Fig. 17.

Taf. X.

Fig. 6.

Fig. 7.

Fig. 10.

Fig. 11.

Fig. 12.

Fig. 18.ᵇ

Fig. 19.

Fig. 20.ᵃ

Fig. 20.ᵇ

Herwig sculp.

a superficial garb, but as an expression of its inner spirit, thought Hirt, describing how in ancient Greece "[e]verything emanates the same character, the same spirit."[86] And not only in antiquity: with the exception of the modern, every epoch and civilization displayed a similar unity. Style is the means by which such epochal unities can be recognized, making it an indispensable tool not only to catalog but also to comprehend and commune with the past.[87]

Hirt is often presented as a reactionary bore, desperately clinging to an outdated neoclassicism. In fact, he was acutely aware of both the necessity and the difficulty of the new historicizing outlook. In the third volume of *Die Geschichte der Baukunst* he described his own intellectual evolution from the aesthetic absolutism of the *Grundsätze* to the new historical awareness of the *Geschichte*:

> In the *Baukunst*, I established the principles by which the
> Greeks and Romans, in their magnificent periods, constructed
> their buildings. This was followed, ten years later, by the
> *Geschichte der Baukunst bei den Alten*, in which I traced the
> beginning, the development, and the peak; the general fall
> and decay of this art.... The climate, the place, the use, and the
> traditions, just as much as religion, civic structure, education,
> way of life, games and entertainment, general ability, and even
> the material—all exercise a decisive influence and cause more
> or less important changes; and time does the same.... What
> counted as appropriate and even magnificent for the fathers,
> is no longer so for the sons and grandsons.[88]

This is hardly the reactionary straw man that Heinrich Hübsch would lash out at in his manifesto *In welchem Style sollen wir bauen?*, published only a few months after the last volume of Hirt's *Geschichte*. While upholding the classical as an ideal, Hirt was profoundly aware of architecture's need to relate to its own time. Style was the manifestation of architecture doing precisely that, and different styles had thus an inviolable integrity and worth. "Who would want to complete a Gothic cathedral in a Greek style," he asked polemically, presenting the two as incompatible but equally true systems.[89] If style expressed the spiritual unity of any epoch, it had—even for the conservative Hirt—been rendered firmly into the plural.

Julius Caesar defending himself with a stilus. Ludwig Gottlieb Portman after Jacques
Kuyper, 1801. Rijksmuseum, Amsterdam.

The transition from rhetorical style to period style represented a "fateful moment" in the history of art, writes Sauerländer.[90] Having traced the dramatic transformation that the notion of style underwent in the late eighteenth and early nineteenth century, we have an inkling of what he means. The period style may well have opened new possibilities for systematic art historical studies, but the epochal determinism lurking in its postulated coherence between historical circumstances and artistic expression has bugged the discipline ever since. The effect has been especially keenly felt in the field of architecture. While fine art (in the periods when such a thing existed) seemed to depend too much on the talent of the individual artists to be considered a reliable epochal index, architectural monuments could be seen as pure reflections of the age; the zeitgeist incarnate, so to speak. It was an idea that would leave nineteenth-century architects struggling in vain to live up to the perceived responsibility—paralysis-inducing in its ambition—to embody the epoch.

Eighteenth- and nineteenth-century theorists were in no way blind to the perilous side of style. Quatremère de Quincy, for one, pondered both the possibilities and the hazards of style in his encyclopedia entry from 1825. In the middle of an enthusiastic account of the possibility for a systematic style history, he suddenly took off on a more ominous tangent:

> Style... was considered in certain cases to be a pen or a
> pencil; but sometimes it was also quite a deadly weapon,
> and ancient history tells of many an example of the use and
> abuse of the stylus, either for defence in the case of attack, or
> for suicide. Now, this dangerous use is still confirmed by the
> name stylet, given to the kind of dagger which is known in
> modern times.[91]

Quatremère's attention to the murderous aspects of style foreshadows the ambiguous role the concept would play in nineteenth-century architectural discourse, where it represented not only a promise but also, as we shall see, quite a considerable threat.

3 *Style and Stimmung*

Splendid Effects: Style in the Garden

In the early 1780s, the Kiel professor Christian Hirschfeld visited the gardens at Wilhelmsbad by Hanau. Among the many attractive scenes in this early German exemplar of an English garden, one sequence particularly appealed to him; the walk between a large tholos-type carousel and a ruinous mock-medieval tower:

> One goes from here to the castle. This is a half ruined Gothic tower in a truly remarkable style, excellently built after the prince's drawing. The rough natural stone, the bold masses, the strange Gothic shape, the visible marks of the destruction of time, the angular as well as the rounded, the openings, the windows; the whole outer appearance announces a work from centuries past. Its situation amongst

85

Overleaf: Anton Wilhelm Tischbein, *Wilhelmsbad Burg and Carousel*, 1783. Hessische Hausstiftung, Museum Schloss Fasanerie.

venerable oaks—who seem to ask their neighbor if they are not of the same age—contributes not a little to the splendid effect of its exterior.[1]

The Wilhelmsbad "Burg" had been built between 1779 and 1781 by Electoral Prince Wilhelm, later Elector Wilhelm I of Hessen-Kassel. Although it looked like a ruin from the outside, it was highly habitable, containing the prince's private residence, complete with a Louis-Seize style ballroom. But the main purpose of the building was to create a mood—a *Stimmung*—in the garden, a purpose for which historical styles were indispensable. Transporting the visitor to a bygone era, architectural style in the eighteenth-century garden was a trigger of atmosphere and association, contributing, as Hirschfeld put it, to the splendid effect of the place.

Architecture's capacity to evoke moods and feelings had not gone unobserved in eighteenth-century architectural theory. French architects such as Jacques-Germain Soufflot, Germain Boffrand, and Nicolas Le Camus de Mézières explored the emotional affinity between buildings and observers, attributing distinct psychological effects to various architectural *caractères*.[2] German architectural debate was profoundly influenced by these ideas. Substantial parts of Camus de Mézières's *Le génie de l'architecture, ou l'analogie de cet art avec nos sensations* (1780) was translated into German in Gottfried Huth's *Allgemeines Magazin für die bürgerliche Baukunst* in 1789, and the notion of *caractère* —defined by a contemporary German author as "the property of a building by which it exercises a distinct effect on our hearts"—was eagerly adopted into the German discourse, where it gradually merged with the notion of style.[3] The most important impulse for the new aesthetic associationism came not from France, however, but from Britain, where the connection between historical styles and particular moods and atmospheres had long been explored in the English garden and theorized by philosophers such as Joseph Addison, David Hume, and Edmund Burke. It was this new fashion that Hirschfeld—a professor of philosophy and aesthetics at the University of Kiel—took it upon himself to disseminate to a German audience through his five-volume work *Theorie der Gartenkunst* (1779–1785). In the hands of Hirschfeld and his fellow garden enthusiasts, architectural style became a subtly coded medium for Stimmung.[4]

88

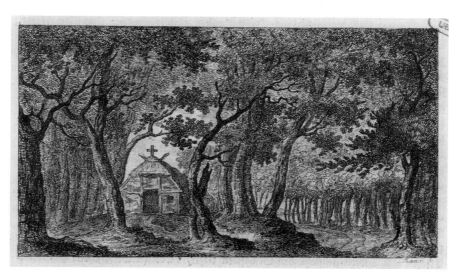

Style as Stimmung in Christian Hirschfeld, *Theorie der Gartenkunst*, 1779–1785.
Universitätsbibliothek Heidelberg.

Hirschfeld adopted an unflinchingly associationist view. "[B]eauty dwells in the property of the objects, and these arouse our sensual pleasures," he argued, spending most of his five volumes trying to pin down the exact correlation between these objects and their corresponding pleasures.[5] In the landscape garden, this relationship could be tuned with great precision:

[N]ature creates regions of different characters and effects. These natural characters can also be strengthened in a variety of ways by the hand of man. For example, a cheerful region can be significantly enhanced by a shepherd's hut or a country house. A melancholy region gains similarly from a monastery or an urn, a romantic region from a Gothic ruin, a solemn region from a temple, or—as at Montserrat—from an abundance of hermitages. When these buildings and monuments are placed in the regions naturally suited to them, they communicate their powers to each other, their characters are better defined, and a union of concepts and images emerges that has a determinate and forceful effect upon the soul.[6]

The task of the landscape designer, then, was to heighten the landscape's natural atmosphere by means of architectural style. Architecture evokes emotional responses and associations, Hirschfeld argued, an effect further enhanced by the interplay between the building and its surroundings.[7] Style played a particular role in this process. As harbingers of distinct spiritual content, different historical styles could evoke different moods and atmospheres capable of transporting the viewer into different mental states. It was a way of thinking that lent new legitimacy to stylistic pluralism, for as long as even the imperfect or monstrous might elicit emotions, no style is out of bounds. Presenting the garden as a place to explore this pluralism to the full, Hirschfeld went through the typology of garden buildings one by one ("Temples, Grottoes, Hermitages, Chapels, Ruins"), providing his readers with an overview of their emotional potentials. Greek temples are characterized by beauty and dignity and belong only "in scenes that endorse this character."[8] Grottoes and caves, on the other hand, evoke the sublimity of wild nature as well as the primitive origins of man, imparting to the viewer an impression of nature and man in their original state.[9] And while Gothic ruins and hermitages contribute to the "intensification of the impression made by quiet and melancholy settings," chapels—preferably executed in a simplified medieval style—"touch the soul with their gravity and solemnity."[10] Systematically tracing the correspondence between style and Stimmung, Hirschfeld compiled a veritable index of emotional associations, ready to be applied by aspiring garden patrons.

It is no coincidence that a modern theory of style emerged in a work on gardens. The eighteenth-century landscape garden was an architectural laboratory in which the affective power of style could be tested with almost scientific precision. The stroll through the garden, carefully orchestrated by the situation and appearance of the structures in it, exposed the visitor to a series of shifting tableaux designed to trigger specific emotions.[11] By tapping into the emotional potential of different historical epochs, architecture could add beauty and meaning to its contemporary context, argued Hirschfeld, allying himself with English and anglophile French garden theorists such as Thomas Whately, Claude-Henri Watelet, and Jean-Marie Morel.[12] "If we look attentively at different landscapes, we can easily see the affective power of buildings on the regions surrounding them," he wrote, particularly recommending artificial ruins for their capacity to tune the landscape and the spectator alike:[13]

> Their general effects are the recollection of past times and a certain feeling of regret mixed with melancholy.... [T]he ruins of a mountain fortress, a monastery, or an old country estate all awaken very different emotions, each heightened by contemplating the era and other circumstances that in themselves can be so very diverse. One moves back into the past, for a few moments one lives again in the centuries of barbarism and feuding, but also of strength and courage, in the centuries of superstition but also of piety, in the centuries of savagery and lust for the hunt, but also of hospitality.[14]

The ruin affects us not merely through its form, but by evoking associations with a remote past. Each historical epoch has its unique mood, Hirschfeld suggested, and historical styles are consequently effective emotional triggers. This is not an archaeological use of style, intended to impart knowledge of a particular historical moment, but a use in which the historical content is sublimated to an aesthetic experience. In an interesting discussion on the use of mythological subjects in architecture, Hirschfeld argued that depictions of this kind were permissible precisely because they turned the past from something dead and remote into a pure atmosphere with an immediate, emotional appeal:

Wilhelmsbad, ca. 1780. From Adolph Knigge, *Briefe eines Schweizers über das Wilhelmsbad bei Hanau.* Bayerische Staatsbibliothek.

It is true that a temple dedicated to an ancient god or hero can no longer be of religious or national significance, for there is no similarity between then and now or between that country and ours. Nevertheless, the beauty of these structures earns them a kind of universal citizenship, makes them accepted with pleasure everywhere, so that the sight of them transports us to a place where the imagination is enraptured by beautiful images.... We ponder, we make comparisons, we concentrate on an image that seems to belong to us; from the vast store of mythological ideas we isolate one that speaks to this century, to every sensitive observer.[15]

The atmosphere of past epochs can be liberated from its particular historical significance and turned into a trigger for the present. Architecture, then, can extract emotionally saturated images from history, "clean" them of their historical content and translate them, as it were, into pure, affective form. Hirschfeld's recommendation to rename religious temples with human virtues such as "happiness," "repose," "forgotten sorrows," and so on, is indicative of this operation. He discussed building types strictly in terms of their emotive effect, describing a chapel, for instance, as a means of heightening the sublime character of a woodland landscape, rather than as a place of Christian worship.[16]

Transforming the romantic fascination with gardens into a fully-fledged manual of style, Hirschfeld turned history into a reservoir of emotional effects.

At Wilhelmsbad, this manual was put to good use by Prince Wilhelm and his architect Franz Ludwig Cancrin. Against the classical symmetry of the main building ensemble, the garden, with its stylistically varied fabriques, established a rich palette of moods. An etching from around 1780 presents the two worlds as dialectical opposites. Above, the lucid order of the Enlightenment; below, a quixotic world of ever-changing ambiances. Strolling along winding paths, between classical temples and pyramids, medieval ruins and hermitages, exotic trees and carefully planned flower gardens, visitors could partake in an emotional journey through time and space—all by means of style.[17]

Hirschfeld's associationism may have been inspired by English gardens and thinkers, but it also resonated with an emerging German romanticism. The Sturm und Drang generation was profoundly interested in the connection between architectural form and inner emotion. Think of Goethe's epiphany in front of Strasbourg cathedral in 1772:

> What unexpected emotions seized me when I finally stood before the edifice! My soul was suffused with a feeling of intense grandeur which, because it consisted of thousands of harmonizing details, I was able to savor and enjoy, but by no means understand and explain.[18]

The past cannot be accessed through rational explanation, Goethe implied, it can only be *felt*, as a living totality with its own unique spirit and expression. Herder dropped similar hints. A Gothic church is a testimony to the Gothic spirit, he wrote, describing how the epochal spirit saturates the architectural ensemble from the smallest detail to the largest whole, eliciting awe, even horror, in the modern viewer. "[M]onstrous Gothic structure!, over-freighted, oppressive, dark, tasteless—the earth seems to sink beneath it—but how great!, rich!, roofed over with thought [*über-dacht*]!, mighty!—I am speaking of a historical event! A miracle of the human spirit."[19] Style, here, becomes a privileged means to empathize with the past; an essential tool for the historian to "feel [himself] into everything," as Herder urged.[20] Such emotional encounters with historical monuments became a topos in

Karl Kunz, west façade of the Gothic house in Wörlitzer Park, ca. 1797. Österreichischer Nationalbibliothek.

German romantic literature, sparking new ideas on cultural and national heritage. Testimony to this is Georg Forster's awe in the face of the unfinished yet sublime Cologne cathedral in 1790, Friedrich Gilly's Marienburg essay from 1796, or Friedrich Schlegel's "Grundzüge der gotischen Baukunst" from 1803, among many other examples.[21] Like a Portkey to the past, architectural style allowed one to penetrate history's spirit and mood.

If the perceived link between architectural style and emotional experience altered the view of old monuments, it also changed the way architecture was thought about and made in the present. Just as Goethe published his eulogy to the Gothic cathedral and Herder pondered the medieval spirit, Prince Leopold III Friedrich Franz von Anhalt-Dessau began constructing his Gothic house in the park at Wörlitz—another early German example of an English garden. The park itself was planned from the mid-1760s on, inspired by the prince's visits to England. Together with his architect, Friedrich Wilhelm von Erdmannsdorff, Prince Leopold created the largest and earliest example of an English garden on mainland Europe, which—among its temples, grottoes, bridges, hermitages, Chinese pagodas, and even an artificial volcano—featured Germany's allegedly first neo-Gothic building.

East façade of the Gothic house in Wörlitzer Park. Undated postcard, photographer unknown.

Fabriques in the eighteenth-century garden were part of carefully composed vistas, created to be seen from particular angles as the visitor moved around the landscape. The Gothic house at Wörlitz takes part in two very different sequences of this kind. It is part of the view across the Wolf canal from the west, where a formal axis stretches from the temple of Flora to the western façade of the Gothic house. But it can also be seen between clumps of trees from the east, where a network of winding paths crisscross the artfully informal woodland. To cater for these different atmospheric requirements, the prince and his architects devised a radical solution.[22] Between 1773 and 1790, taking an existing gardener's house as a point of departure, they created a building with two entirely different faces.[23] From the west, the spectator sees something akin to a late medieval Venetian church, flanked by towers and side buildings in light, rendered masonry. From the east, the building presents itself in the exuberant guise of Tudor Gothic, its red brick body almost dissolved by a lacelike Gothic ornament and large pointed windows. Art historians have traced their precedents in the fourteenth-century Santa Maria dell'Orto in Cannaregio and Horace Walpole's Strawberry Hill respectively, but more important than particular models are the

95

emotional associations put into play.[24] The Venetian side presents a picturesque urban enclave appropriate for the open vista to the west, while to the east the building appears as a folly in the forest, an exotic surprise designed to astonish and thrill. The planting was carefully chosen to fit the changing moods, with dark conifers surrounding the eastern part and a parklike landscape with deciduous trees fronting the western façade.

The Gothic house was no mere garden folly. The prince used it as a retreat for himself and his collection of medieval art, as well as a home for his morganatic wife Luise Schoch (daughter of the gardener) and their joint children. Yet the main purpose of the house—and the key to its design—was to establish atmospheres in the garden by evoking specific historical associations. Just like Goethe's essay, Leopold's Gothic house invited the visitor to enter into an immediate, emotional encounter with the past. "He built the Gothic house and gathered therein everything that could serve to transfer his soul to the past," wrote August von Rode in his 1818 guidebook to Wörlitz.[25] The prince's exquisite collection of medieval stained glass must have contributed greatly to this transferal, adding color and light to the interior. To transport the visitor back to the atmosphere of a past era—not by archaeological evidence but by emotional affinity—was the main purpose of these garden fabriques, buildings that according to art historian Alfred Neumeyer existed "solely by virtue of their appearance value [*Erscheinungswert*] in the landscape and their mood value [*Stimmungswert*] in the imagination."[26] It was precisely such values that the new concept of style lent itself to expressing.

Catalogs of Association

The examples from Wörlitz and Wilhelmsbad indicate how the meaning of architectural style was changing around 1800. If Winckelmann had used the term primarily in a taxonomic and descriptive sense, late eighteenth-century garden designers turned it into something far more instrumental. Hirschfeld was part of this project, but he was not alone. The architectural historian Klaus Jan Philipp shows how an entire industry of German architects, writers, engravers, and publishers around 1800 were dedicated to exploring architecture's expressive potential, contributing to a new stylistic pluralism.[27] Garden architecture played a key role in that exploration, both in situ and in print. A good example is *Ideenmagazin für Liebhaber von Gärten, englischen*

Anlagen und für Besitzer von Landgütern published by Johann Gottfried Grohmann between 1796 and 1802 (reappearing briefly in 1806 as *Neues Ideenmagazin*). Like Hirschfeld, Grohmann was a philosopher, but his magazine did not indulge in aesthetic speculation. It was a practical-minded affair, geared to ease the choice and widen the repertoire of prospective garden owners by presenting "selected projects for garden buildings, pavilions, temples, huts, farm buildings, hermitages, grottoes, promenades, plantings, ruins, memorials and tombs, resting places, bridges, islands, cascades, etc." in different styles and characters.[28]

Ideenmagazin was predominantly visual, presenting projects in plan and perspective, sometimes elevation, with short descriptions in German and French. Grohmann's own taste seems to have leaned toward the classical, but he clearly considered it his duty to present his readers with a wide stylistic variety. His ambition, as the magazine's subtitle spelled out, was to "improve and ennoble gardens and landscapes... in the most original English, Gothic, Chinese manners of taste [*Geschmacksmanieren*]."[29] Over the years, the repertoire expanded to Egyptian, Persian, Russian, North American, and "Morgenländischer" (eastern) buildings and elements. The examples were sometimes actual buildings, often taken from English gardens, but just as often they were projects drawn up by architects in Grohmann's circle. *Ideenmagazin* became something of a hotbed for a new generation of German architects, with Carl Haller von Hallerstein, Gottfried Klinsky, Johann August Heine, and many others using the journal to widen not only garden patrons' choice but also the accepted stylistic repertoire of German architecture.[30]

Though Grohmann's texts were brief, he took care to emphasize emotional effect and atmosphere. "There are moods in the soul," he wrote, that may be brought into "a certain indescribable analogy" with the surroundings through the choice of style: "As it is proven that the moods and motions of our souls very often depend on the objects with which we surround ourselves, then one might be able—through the arrangement and decoration of a room... to open a source of a peculiar play of emotions."[31] To express this "indescribable analogy" between architectural objects and emotions, Grohmann commissioned intensely atmospheric illustrations in which building, landscape, and the general mood were in perfect accord. Klinsky developed a particularly effective composition technique that would become something of a signature for *Ideenmagazin*: full-page illustrations with

Gottfried Klinsky (attr.), designs for garden building in *Ideenmagazin für Liebhaber von Gärten, englischen Anlagen und für Besitzer von Landgütern*, 1796. Universitätsbibliothek Heidelberg.

an atmospheric perspective on top and a clean, technical plan at the bottom, the latter often slanted to match the oblique angle of the perspective.[32] Like Hirschfeld prescribed, architectural style was carefully matched with vegetation and topography. Rustic log cabins were placed in wild gorges and surrounded by looming spruces; classical tombs were set among weeping willows in melancholy clearings in the forest. Chinese pavilions seem to have posed a challenge when it came to their appropriate context, so Klinsky tended to place them against fairly generic clumps of trees, adding some vaguely eastern-looking pines or acers to conjure the right mood. Klinsky's compositions combined atmosphere and buildability with striking visual economy, making each Stimmung available for reproduction by anybody capable of reading a plan. Staunchly practical and intensely emotional at the same time, Grohmann's *Ideenmagazin* constituted a catalog of architectural atmospheres and associations.

Grohmann's "cosmopolitan style pluralism," as Philipp coins it, makes him an early example of the new stylistic relativism emerging around 1800.[33] It was a contextual and decorum-driven eclecticism, choosing style according to setting, situation, and purpose. At times, however, *Ideenmagazin* slipped into a more radical eclecticism. In the very first issue, for instance, Grohmann showed three little pavilions in different styles, all based on the same plan. Which one to choose depended on individual taste and the character of the landscape or surrounding buildings, he instructed, leaving it up to the patron to make the connection.[34] The tendency toward decontextualization would grow stronger after Grohmann's death in 1805. Johann August Heine's 1806 presentation for *Neues Ideenmagazin* is symptomatic: four garden buildings in different styles, all based on a square plan. Unlike Klinsky, Heine did not indicate any setting for the follies, presenting the choice of style as a matter of individual preference rather than contextual propriety.

Grohmann's texts provide instructive examples of how the term style was used around 1800 and the conceptual apparatus it was part of. He applied the term freely, as a mark of quality (good style), as a traditional genre category (rural style, noble style), and as a historical and geographical category (Gothic style, Chinese style, modern style). But he also wrote of *Bauart*, character, taste, and manner (sometimes in combinations such as *Geschmacksmanier*), treating them mostly as synonyms. In rare instances he

Left: Unknown architect, cattle trough in three different styles, *Ideenmagazin*, 1796. Right: Johann August Heine, garden buildings in four different styles, *Neues Ideenmagazin*, 1806. Universitätsbibliothek Heidelberg.

drew distinctions. In a presentation of an Egyptian garden room, for instance, he pointedly described it as being in Egyptian style, *not* in Egyptian taste: "after much consideration we do not say in Egyptian taste, for the Egyptians, as their surviving works of art prove, had no taste in art."[35] Taste, here, seems to be the prerogative of high civilization, while style denotes the unconscious expression of a culture, regardless of its civilizational standing. A similar ambiguity exists between style and character. While mostly used interchangeably, style sometimes seems to be understood as an attribute of the architectural structure while character pertains to the scene as a whole. "The first figure on this sheet contains a garden niche in a good style, for a scene of serious, solemn character," Grohmann wrote of a print, echoing a distinction also hinted at by Hirschfeld.[36] Neither of them carried through these distinctions, however, continuing to use character, style, taste, and manner more or less indistinguishably.

Two tendencies might be gleaned from this brief encounter with Grohmann and his magazine. One is that while he often relied on a traditional, decorum-based notion of style and character, the two concepts were gradually historicized and psychologized into an associationist index of historical expressions and emotional effects. The tendency can be seen in Hirschfeld as well,

but Grohmann's catalog-like setup makes it all the more striking. The other thing to notice is that the rhetorical tradition's contextual idea of style and character is gradually weakening, opening up a more radical kind of eclecticism. And while Grohmann was far from laissez-faire when it came to the choice of style, *Ideenmagazin*'s comparative tableaux hint at a new attitude in the making.

A History of Taste

The late eighteenth-century appetite for stylistic variety was not confined to the garden. The same year that Grohmann launched his *Ideenmagazin* in Leipzig, another enterprising project came out of nearby Dresden, namely Joseph Friedrich Freiherr zu Racknitz's *Darstellung und Geschichte des Geschmacks der vorzüglichsten Völker in Beziehung auf die innere Auszierung der Zimmer und auf die Baukunst* (Presentation and history of the taste of the leading nations in relation to the interior decoration of rooms and to architecture), which came out in four installments plus an atlas between 1796 and 1799. It is a remarkable document, and not just for its

Die verschönerte Natur

"We present here a landscape, not simply to present a landscape, for the garden artist can apply such ideas very rarely or almost never. The intention is rather to show different useful objects in the beautification of a garden, and to place them next to each other in a pleasing totality. This landscape presents a rural building in Gothic style, a heroic tomb, and a garden pavilion next to a bridge in the Chinese manner, each of which can easily be applied." *Ideenmagazin*, no. 3, 1796. Universitätsbibliothek Heidelberg.

Plan of Schloss Moritzburg, in whose interiors Count Racknitz hoped to lay out the entire history of style. Staatliche Schlösser, Burgen und Gärten Sachsen.

spectacular illustrations. Not simply a history of taste, *Darstellung* was a manifesto on the creation of a modern style.

A nobleman by birth, Racknitz spent most of his adult life at the Saxon court, rising to the position of Court Marshal around 1800. In 1792, he was commissioned by Elector Friedrich August III to redecorate Schloss Moritzburg (later a famous location for the film *Three Wishes for Cinderella*), a Renaissance palace northwest of Dresden. The project lay unheeded in the Saxon state archives for centuries but was recently recovered by Hendrik Bärnigshausen and Margitta Çoban-Hensel and analyzed by Simon Swynfen Jervis in his sumptuous English edition of the *Darstellung*.[37] Racknitz's proposal gives Winckelmann's schema of epochs and style an interesting twist. Under the headline "Design for the Arrangement and Furnishing of Schloss Moritzburg for the Presentation of the History of Taste of Several Ancient and Modern Nations, Principally in Regard to the Interior Decoration

of Buildings and Rooms," he presented nothing less than a philosophy of history, with style—or taste, as was his preferred term—as its key concept. The palace's four first-floor apartments were to display the history and geography of style, containing 1) the ancient civilization of the Egyptians, Chinese, and Etruscans; 2) Greek, Roman, and Moorish taste; 3) the decay of art in the form of Gothic, old German, and old French taste, and 4) "the taste of the present age," which in this case meant "simple English taste," "the taste of the discoveries of Herculaneum and Pompeii," and "the taste of Raphael's arabesques."[38] In addition, Moritzburg's distinctive round corner towers were to show "parallel branches of the history of taste" and be decorated in Persian, Turkish, Mexican, and Tahitian taste respectively.

Racknitz's Moritzburg scheme came to nothing, but the history of taste continued to preoccupy him. Teaming up with the artist Christian Friedrich Schuricht (who had provided illustrations also for Hirschfeld's *Theorie der Gartenkunst*) and a number of engravers, he set to work. In 1795, his publisher issued a prospectus in several leading German magazines, announcing a publication that was to present the taste of different peoples, both primitive and civilized, past and present, demonstrating "how every taste can be put to use as a stirring interior decoration."[39] *Presentation and History of Taste* came out in four installments but did not replicate the fourfold taxonomy from the Moritzburg project. In fact, Racknitz seems to have given up on order altogether, be it chronological or geographical. His publisher was clearly aware of the problem, for he suggested that readers could rearrange and bind the volumes in chronological order themselves.[40] Racknitz, for his part, allowed the different tastes and styles to exist in random simultaneity. Volume one enlisted Egyptian, Etruscan, arabesque, noble Roman, and Chinese taste, in addition to "The taste derived from the discoveries of Herculaneum, Pompei, and Stabia." Volume two added Greek, old German, modern Persian, English, French grotesque, and Tahitian taste, while volume three presented "Greek taste as it approached its decadence," Moorish, Turkish, old French, Kamchatkan, and Mexican taste. The last volume was no less heterogeneous, offering glimpses into ancient Persian, East Indian, Siberian, Gothic, "Modern, Supposedly Antique," and "Jewish or Hebrew" taste.

But what exactly was taste, in Racknitz's sense of the word? As discussed previously, *goût* was an established category among

104

"Mexican" (top left), "Jewish" (bottom left), and "Siberian taste" (above), from Joseph Friedrich Freiherr zu Racknitz, *Darstellung und Geschichte des Geschmacks*, 1796–1799. Getty.

French eighteenth-century intellectuals, as was *Geschmack* among Germans. Yet Racknitz's *Geschmack* had less in common with Kant's judgment of taste, say, than it had with Winckelmann's *Stil*, insofar as he used it to describe not only the inner disposition or predilection of peoples and periods, but also—like Grohmann—their artistic output. Style and taste are treated synonymously in Racknitz, whose history of taste is for all intents and purposes a history of style.[41]

Darstellung und Geschichte des Geschmacks was nothing if not eccentric. The different essays took widely varied approaches, ranging from general histories of architecture to highly detailed anthropological accounts, building reviews, technical analyses, and musings on the origins of architecture. Racknitz drew freely on a number of sources and traditions, and apart from constantly asking the reader to forgive his digressions, he showed few qualms

"New Persian taste," from Joseph Friedrich Freiherr zu Racknitz, *Darstellung und Geschichte des Geschmacks*, 1796–1799. Getty.

about the unsystematic nature of his work. For despite the inconsistencies, he did hold onto certain ideas, not least that of affect.

A basic presupposition for Racknitz—as it was for Hirschfeld or Grohmann—was that architecture had to elicit emotions. This might be the cheerfulness prompted by an interior in the arabesque taste, the "noble pure feelings" instilled by an ancient Persian monument, or the sublime emotions evoked by a Gothic cathedral.[42] The artist and architect had to study these emotions and consider "the reasons why one form or another awakens a pleasurable or negative feeling in him." This was particularly important for the architect, for if he sought to achieve more than "functional buildings" he had to learn to "inspire wonder, astonishment, solemnity, calm, or gaiety, as he wishes, through... external composition, and through... interior planning and decoration." In short, he had to

> explore what emotion the whole arouses in him—be it astonishment, admiration, pleasure, etc.,—but then also the reasons why these emotions are aroused, and let him base his concepts of what is noble, beautiful, and graceful on the results.[43]

This is indeed a radical approach to aesthetic judgment. The rule-based aesthetics of the Vitruvian tradition, with its interest in proportion, symmetry, and harmony, is here replaced by a subjectivist and associationist model whereby value is judged by the emotional effect of the work. And although Racknitz himself had quite conservative taste (generally disliking Gothic, for instance), his notion of aesthetic effect opened the door to eclecticism. Racknitz considered this a sign of modern progress: "our taste is so cultivated and our artistic sentiments, based on principles, have so far risen above prejudices, that we take pleasure in the imitation and adaptation of artistic models of both antiquity and modern times, of both neighboring and foreign nations, and use them in the decoration of our buildings."[44]

Racknitz paradoxical eclecticism culminated in his idea of a modern German style or taste. That no such thing seemed to exist was a source of great regret for the nobleman, and he blamed the lack on everything from the disjointed structure of the German states to the excessive modesty of the German

character.[45] A true German taste had to reflect German climate and character, he thought, but should also involve a "free and intelligent" imitation of foreign models.[46] He found a promising precedent in Erdmannsdorff's palace at Wörlitz, a soberly neo-classical building in "a wholly good and noble taste."[47] "Germans are noble and good, and as opposed to trivial gossip as they are to splendor and show; and thus their style of architecture must avoid a trivial, playful taste," he explained, seeing neoclassicism as the style for the job.[48]

Unlike the young Goethe (and from around 1800 pretty much everyone else), Racknitz did not claim Gothic for the Germans. The Gothic style had originated in Arabic and Moorish regions, he thought, considering it essentially a foreign style of dubious aesthetic merit.[49] Over the three years it took to complete the *Darstellung*, however, Racknitz revised his position. In an essay on the Gothic taste published in the last volume, he granted that "[t]here is something grand, majestic, fine, and bold in the very construction of Gothic architecture." The Gothic style lacked order and harmony, however, and should preferably be modified by classical principles: "If it were possible to retain the virtues of Gothic architecture and at the same time graft onto them the Greek architectural style, a new architecture uniquely adapted to our climate and our needs would perhaps arise from this combination."[50]

Racknitz, here, takes style a considerable step away from its Winckelmannian origin, and even from Hirschfeld's and Grohmann's eclectic practices. If Winckelmann held that unique historical circumstances produce unique artistic styles, and Hirschfeld and Grohmann used these historical styles to evoke emotions and associations in the modern viewer, Racknitz proposed that the combining of historical styles might elicit a new style in harmony with the modern era. Such a synthesis would certainly be risky and involve "irreconcilable dissonances," he admitted. But it would be worth the trouble, promising a true German style for the modern age.[51] Introducing the notion of a "style of our own" and suggesting that the way to get to it was through the manipulation of historical styles, Racknitz anticipated key themes in nineteenth-century architecture.

Tuning Architecture

Karl Friedrich Schinkel, *Kirche im gotischen Stil hinter Bäumen*, 1810. bpk/Kupferstichkabinett,
SMB. Photo: Jörg P. Anders.

"Attempt to express the yearning beauty of the melancholy which fills the heart as the sounds of holy worship ring out from the church."[52] This was the inscription on Karl Friedrich Schinkel's lithograph of a Gothic church, displayed at the Berlin Academy Exhibition in 1810. The church itself is barely visible behind a large oak throwing its somber shadow on an old cemetery in the foreground. But the crisp turrets and tracery make it clear that this is not a ruin but a fully intact church; the congregation is already on its way up the stair. The freshness of Schinkel's scene stands in stark contrast to another Gothic vision shown at the 1810 Academy exhibition: Caspar David Friedrich's *Abtei im Eichwald*. If Friedrich's medieval past appears dead and lost, with all the melancholy such a loss entails, Schinkel's Gothic is intact, bristling with life like the overwhelmingly lush tree in front of it.[53] Christian architecture has yet to be brought to completion, wrote Schinkel that same year, hinting that to him the Gothic existed as much as a future possibility as a historical reality.[54] If Friedrich—like Hirschfeld and Grohmann—used architectural style to tap into the emotional reservoir of the past, Schinkel used it to project a historically saturated future.

Schinkel's image indicates how much the appreciation of Gothic had changed since Racknitz's ambivalent praise in 1799. There were several reasons for this. A flood of new scholarship had promoted the value and beauty of Gothic architecture, seeing it as a distinctly German art of building.[55] The French campaign of 1806–1807, during which Berlin had been looted, Prussia halved, and its royal family forced into exile, had increased the enthusiasm for all things Prussian and—by extension—German. The new political realities made Racknitz's dream of a German style more relevant than ever, even as the idea of what that entailed would undergo profound change. A new generation of architects would dedicate itself to reformulating those ideas, turning the light-hearted *Stimmungsarchitektur* of eighteenth-century gardens and boudoirs into a political and national project.[56]

Yet another work from the 1810 Academy exhibition illustrates these new ambitions, namely Schinkel's memorial chapel for Queen Luise of Prussia. Even in her lifetime, Luise von Mecklenburg-Strelitz, queen to King Friedrich Wilhelm III of Prussia, was revered as an embodiment of national virtue. In death, she became the subject of a full-blown cult. Her untimely passing on July 19, 1810, at the age of thirty-four (having given

Caspar David Friedrich, *Abtei im Eichwald*, 1809–1810. bpk/Nationalgalerie, SMB. Photo: Andres Kilger.

birth to ten children), sparked a national outpouring that has been compared to the public mourning for Diana, Princess of Wales, nearly two centuries later.[57] Luise died, so the myth goes, worn down by worries over her adopted fatherland, making her a martyr not just of Prussia but also, prophetically, of a future German nation.[58] The fact that her son Wilhelm went on to become the first emperor of a united Germany ensured her a lasting legacy as the mythical mother of the nation.

Already in the summer of 1810, however, Luise's death was considered a national tragedy. "She is dead! Dead is the first among the world's women, our sublime, our adored queen!" declaimed the contemporary press.[59] The mourning king immediately started the planning of a mausoleum in the gardens of Charlottenburg, a small Doric temple sitting at the end of a conifer-lined path. The identity of the main architect for the temple has been long debated, but Eva Börsch-Supan argues convincingly that Schinkel, as newly appointed *Oberbauassessor*, played a key role.[60] She also solves another much-discussed mystery related to the mausoleum. For although the Charlottenburg project was well underway by the late summer of 1810 (the queen's body was interred there on December 23 that same year), Schinkel presented a different mausoleum project at the Academy exhibition that opened on September 23. In three drawings and a lengthy explanation in the exhibition catalog

111

54/3

Karl Friedrich Schinkel, memorial chapel for Queen Luise of Prussia, 1810.
bpk/Kupferstichkabinett, SMB. Photo: Reinhard Saczewski.

he showed a chapel in an intensely romantic Gothic style. The timing of this "second" project has long puzzled historians, many concluding that Schinkel meant it as a utopian vision never to be built.[61] Börsch-Supan puts them straight. The Gothic project was made before the classical, she concludes, and at the king's explicit request.[62] When the king changed his mind—going for a less controversial style—Schinkel took his Gothic project to town. It constituted not only a homage to the queen (whom he had known personally) but a highly personal reflection on the historical development and contemporary role of architectural style.

The project is well known. A small three-isle chapel elevated on a base, its interior divided by eight compound pillars. The entrance is shrouded in darkness, in striking contrast to the bright interior, where large pointed windows on three sides illuminate the tomb. The raised sarcophagus is guarded by angels— two by her head, one kneeling by her feet—while the entire space is arched by an intricate fan-vault ceiling, radiating from each of the slender columns. Schinkel described it lyrically:

> A multi-vaulted room... arranged so as to arouse the sensation of a beautiful palm grove, surrounds the elevated resting place, scattered with leaves, lily and rose petals.... The light falls through the windows from the three niches surrounding the resting place on three sides. The glass is rose-red in color, spreading a soft red twilight over the entire architecture, which is executed in white marble. In front of this hall is a porch, shaded by the darkest of trees. One climbs up the steps and enters its darkness with a gentle shudder; looks through three tall openings into the lovely palm hall where, in the bright, morning-red light, lies the resting woman, surrounded by divine genius.[63]

"I wanted everyone to feel well in this hall," Schinkel elaborated, aiming for a style that matched the memory of the queen. The emotionally charged architecture should affect and elevate the visitor, making him or her a better and more complete person. "Everyone should be tuned therein," he wrote, describing how each visitor would "acquire images of the future which would enhance his being and compel him to seek completion."[64]

Schinkel's iconography reflected contemporary tropes. Queen Luise was frequently associated with angels and imagined

in the rosy light of dawn—a fitting setting for a queen who died in the early morning and at the dawn of her mature reign.[65] "Denket mein im Blumenflor / Denket mein im Glanz der Bäume, / Wenn der Nachtigallen Träume, / In der Morgenröte sterben; / Morgenröte mir begegnet," Achim von Arnim had the dead queen exclaim in a cantata performed after her first interment on August 18, 1810.[66] Arnim described an imaginary monument that would capture the queen's presence and "keep her near to us," ever present in her subjects' hearts. Schinkel, a close friend of Arnim, devised just that.[67] As opposed to the "cold and meaningless architecture of early Greek antiquity," he wrote, the transcendent yet sensuous spirituality of the Gothic captured both the otherworldly and the worldly, speaking of the queen's eternal soul but also of each individual's spiritual journey.[68] The redemption did not take place through religious rite; despite its name, Schinkel's chapel contained no altar. Rather, it was the historical and

Karl Friedrich Schinkel, *Der Abend*, 1811. Kupferstichkabinett, SMB.

emotional associations elicited by the architecture that did the job. "Emotions replace liturgy," as Philipp Demandt aptly notes.[69]

Schinkel's catalog essay gave a thorough explanation for his choice of style. It is a surprising little text—somewhere in between a manifesto, a project description, and an architectural history. Architecture, he insisted, requires a higher freedom than is granted in contemporary culture. It is not just about material requirements but about ideas and spirit, the striving for an organic totality of spirit and matter. And just as the organic world is endless in its variety, so must architecture evolve and change, bringing forth "ever new forms."[70] The history of architecture implies a gradual victory of spirit over matter, Schinkel maintained, seeing the Christian architecture of the Middle Ages as a preliminary high point in this process. Here, the vault—originally a Roman invention—for the first time fulfilled its true spiritual potential as it was put into the service of a new idea—Christianity—and by a new people—the Germans:

> [T]he thoroughly innovative idea of Christianity... finally took hold of a true primitive people, the Germans, who had never surrendered unconditionally to antique influences and who—from their own sense of freedom and by picking up earlier forms—gave rise to a unique world of spirit and life. The art of vaulting had been practiced for a long time in architecture, but partially and without real gain; the Germans, however, grasped it with the originality and freedom of their nature and soon understood how to use it to express that world of ideas which, from the original spiritual direction of the people as well as from Christianity itself, craved external realization. The spirit was now fully victorious over mass and material.[71]

While antique works expressed a physical and intramundane reality, Christian architecture gave form to a higher spirit.[72] That was why Luise's funeral chapel had to be in a Gothic style. Only Gothic could represent death, not as an end but as a beginning, giving it the "friendly and bright appearance" it had in Christian theology. "Pagan architecture is in this respect quite meaningless for us," wrote Schinkel.[73]

Schinkel did not copy medieval forms directly. The task required a synthesis of the medieval and the classical, he

thought, recommending that Gothic forms be developed in light of the classical principles of beauty.[74] Racknitz had proposed a similar synthesis, but what for him remained a static hybrid was for Schinkel a dynamic principle. Style was an evolving thing, forever modified and reinvented in response to the task at hand. The funeral chapel bears out this dynamism, combining the solemn atmosphere of a Gothic church with the clear-cut geometry and full-width portico of a classical temple.[75]

Schinkel's essay presents a rich and original understanding of architectural style. Not simply the fingerprint of the zeitgeist, style is seen as a vehicle for a complex process of appropriation and modification. An architectural motif developed at a particular point in time (for instance the Roman vault) might be brought to its spiritual realization somewhere else (for instance in the German Middle Ages) and be subject to further modifications in the present and the future. Such appropriations were necessary, Schinkel thought, to retain recognizability and meaning while at the same time ensuring that higher freedom that architecture was due. Slavish imitation of historical styles was not the solution—on the contrary, Schinkel considered it a duty to "find the new form."[76] He treated historical style as an almost alchemical phenomenon by which the new age could be brought to completion via the heart and mind of each feeling individual:

> Art does not manage to represent the infinite and eternal
> directly. Apart from size, sublimity, and beauty... it is really
> the deep, inner coherence of a work of art that hints at what
> cannot be represented; for this coherence reveals itself solely
> to the sentient mind as it grasps the represented forms
> and creations through its own activity. Only for those who
> already carry eternity within themselves... can art represent
> the eternal.[77]

For Schinkel, observes Erik Forssman, the perfection of architecture parallels the perfection of the observer, a process which in both instances is triggered by the deft use of style.[78]

Schinkel's little chapel would not have looked out of place in Grohmann's *Ideenmagazin*. In many ways, as Forssman notes, it resembles a folly.[79] Schinkel's intensely emotive eclecticism, with its explicit ambition to move the spectator—he spoke literally about an *Ortsversetzung*—had much in common with contemporaneous

Karl Friedrich Schinkel, project for a Befreiungsdom, 1815. bpk/Kupferstichkabinett, SMB.
Photo: Jörg P. Anders.

garden architecture.[80] Compared to the light-hearted association-
ism of the eighteenth-century garden, however, Schinkel's stylistic
synthesis had weightier aspirations—national, metaphysical, and
moral. Beyond splendid effects and delightful shudders, Schinkel
sought redemption through style.

The idea of the Gothic cathedral as the ultimate symbol of
Germanness came to a climax around 1813 with the German
wars of liberation and Napoleon's defeat at Leipzig. This brief
period was also the peak of Schinkel's first Gothic phase. In
1811, he drew a neo-Gothic proposal for the reconstruction of
St. Petri church in Berlin and completed a Gothic memorial to
Queen Luise at Gransee. His most significant experiments in
Gothic style were made, however, on paper, canvas, and in print
over the next two to three years. When the king in 1814 commis-
sioned a Gothic cathedral of liberation to celebrate the victory
over Napoleon, Schinkel replied that he had been preparing for
the job for years.[81] The fruit of that preparation is summed up in
two short texts he wrote on the *Befreiungsdom*.

The royal commission of 1814 was for a "splendid cathedral,
a thanksgiving memorial for Prussia, to be erected in Berlin."[82]
Schinkel proposed to place the monument on Leipziger Platz,
recently renamed in memory of the 1813 battle. He enthused over

the prospect of a "large and beautiful square with the building in a national style in the middle," arguing that the ensemble would form a lovely contrast to the Viereck (now Pariser Platz) further north, with Carl Gotthard Langhans's sumptuously neoclassical Brandenburger Tor.[83]

Schinkel's cathedral is a very strange building. Not yet codified into the polite neo-Gothic we know from later in the century, it seems alien, voluptuous, out of control. In a text on religious buildings from around this time Schinkel wrote of architecture as a living being, and this building is certainly alive, hovering over Berlin like some prehistoric creature.[84] Yet he accounted for the choice of style succinctly and logically. A monument like this must be understood in three senses, he argued. It is a religious monument, made for worship and celebration, hence it calls for a Christian, not a classical style. It is a historical monument, made to "make visible the entire history of the fatherland," hence its architecture and sculpture should follow the old German style.[85] The third aspect was of particular concern to Schinkel. The cathedral should be a didactic monument, he wrote, "a living monument for the people, which directly, through its construction, will establish something in the people that will live on and bear fruit."[86] Just as the centuries-long construction of medieval cathedrals had formed centers of craft and culture, the new building project was to reawaken the German spirit. The church's style, then, was not simply a matter of form and ornament, but intimately related to the act of building it. Only a prolonged, collective effort would—as with the medieval cathedral projects—bring forth a true German style corresponding to a true German spirit. The cathedral was to be a century-long enterprise, a *Bauhütte* for the modern nation.[87] Schinkel summed up what was at stake in a second memorandum on the Befreiungsdom:

> [T]o erect a large and holy monument to this most
> confounding time... a church in the soul-stirring style of old
> German architecture, an architecture whose full completion
> has been saved for the time yet to come. A wonderful and
> beneficial return to antiquity interrupted the development
> of this architecture in its prime, whereby the world, it seems,
> was fated to complete this art, merging it with the elements
> still missing.[88]

119

Karl Friedrich Schinkel. *Gotischer Dom am Wasser*, 1813. bpk/Kupferstichkabinett, SMB. Photo: Jörg P. Anders.

This is Schinkel's theory of style in condensed form. Adding a twist to Winckelmann's notion of the birth, growth, and decay of style, Schinkel considered style not simply as a product of historically specific circumstances, but as having a life of its own, the span of which it is somehow destined to complete. Modern cultures can thus legitimately reach back in time, find what is theirs, and continue to develop it. With this way of thinking, Schinkel escaped the epochal determinism latent in Winckelmann's system, allowing historical style to acquire a new availability for the present and the future. At once authentically old and genuinely new, style bridges past, present, and future.

One last cathedral—this time in painting. Now almost hard to look at for its glossy, historicist pathos, *Gotischer Dom am Wasser* is actually an eloquent pictorial essay on changing notions of history, nationhood, and style. Schinkel started it in 1812, as the first in a series of cathedral paintings, exhibiting it for the first time at the Academy exhibition in 1814.[89] It shows a great Gothic cathedral by a river or a bay, situated on a steep promontory and flanked by a city. Or perhaps one should say cities, for there are very different urban conglomerations popping up on either side of the water. On the cathedral side is what seems to be a medieval northern European town, roughly contemporary with the cathedral. But look closer: among the steep gabled houses appear a French medieval tower, an Italian Gothic church, and a castle-like building with battlements in the Ghibelline swallow-tail pattern—an unmistakable reference to northern Italy and the Holy Roman Empire. The lantern-like belvedere on top of one of the vernacular buildings turns one's thoughts to Rome, while the ornate gables in the foreground indicate northern European Renaissance. Rather than an exclusively German achievement, Schinkel's cathedral emerges out of a rich pan-European culture.

On the other side of the river the plot thickens even more. If the left bank has many places gathered into one time, the right has many times gathered into one place. Crossing the magnificent Roman bridge (not unlike the aqueduct in Spoleto that had enthused so many German travelers[90]) we have to our right a northern European late medieval town, and to the left a Palladian vision with temple fronts and rotunda, gleaming in white stone. Below the medieval city, all the way down on the shore, sits a small classical temple, not dissimilar to Luise's Doric mausoleum. Unlike the teeming left bank, where boisterous boatsmen and strolling gentry populate the scene, the eerily lit right bank is entirely devoid of people, appearing more like an ideal vision than a real place.

Schinkel's emotional eclecticism left critics confused. What was this—a Gothic reverie or part of a historical argument—science or Stimmung? An anonymous reviewer in the *Vossische Zeitung* dug in:

> Mr. Schinkel has painted his Old-German cathedral with the unmistakable intention of creating a character painting. In this he has failed, however, in that he shows it from the back

and surrounded by the most assorted styles from all ages. Has he perhaps intended to show the Old-German cathedral as victor in a competition between different styles? If so, the task belongs more to reason than to the emotions and would require a geometric juxtaposition of these buildings drawn to scale, as in the Parallèle d'architecture by Durau [sic].[91]

Disliking Schinkel's unsystematic Stimmungsarchitektur, the reviewer missed the point completely. Far from a competition, Schinkel established a conversation between pasts and presents, allowing them to coexist as equals across time and place. The past, here, is not a foreign country but an extended homeland, constituting a cosmopolitan totality that belongs to many epochs simultaneously. In that sense, the cathedral painting goes beyond the national chauvinism so often read into it. Style is an expression of the nation, sure, but even more it is a way to link the nation to a larger world.

Schinkel never got to build his cathedral. The enthusiasm for the Befreiungsdom abated and was rechanneled into the completion of Cologne cathedral, initiated by Josef Görres and Sulpiz Boisserée, among others, and seen through with great resolve by the crown prince, later king Friedrich Wilhelm IV.[92] The great cathedral in Berlin was reduced to the Prussian National Monument for the Liberation Wars, a small Gothic cast iron monument erected in 1821 on the Tempelhofer Berg, today known as the Viktoriapark in Kreuzberg. Schinkel's first Gothic phase ended where it began; in the garden.

4 *Style and the Ideal*

In December 1795, Friedrich Schiller and Johann Wolfgang von Goethe were busy plotting the *Xenien*—a collection of short, satirical verses, rebuffing critics and mocking whoever they thought deserving. One of the couplets went like this: "Once we had a taste. Now we have tastes. / But tell me, where sits this taste for tastes?"[1]

Jervis identifies the target of the quip as Joseph von Racknitz, whose prospectus for the *Presentation and History of Taste* had just been published.[2] Finding Racknitz's stylistic pluralism distasteful, Goethe and Schiller ridiculed his lack of standards and his penchant for barbarian art. In another verse addressed to "German building enthusiasts" they asked acerbically (and with clear reference to Racknitz) whether the promoters of Kamchatkan style home decoration were not, perhaps, "Kamchatkadalian enough" themselves.[3]

The previous two chapters may have given the impression that the concept of style evolved in an orderly and unequivocal fashion from Winckelmann's comparative taxonomy to the young Schinkel's emotive eclecticism. It did not. As Goethe and Schiller's mockery suggests, style, together with its sibling concepts, taste, manner, character, and Bauart, were contested and multivalent, called upon to defend the most adverse stances. This chapter examines one such position.

Imitation, Manner, Style

Goethe's distaste for the proliferation of *Geschmäcke* had developed over some time. As a young man he had mocked classicists and universalists, but by the late 1780s he had become something of a universalist himself. Style was key to that conversion. Goethe discussed the concept thoroughly in the essay "Einfache Nachahmung der Natur, Manier, Styl" (On simple imitation of nature, manner, style), published anonymously in the literary magazine *Der Teutsche Merkur* in February 1789. This is a very different thinker than the one encountered outside Strasbourg cathedral some seventeen years earlier. If the young Goethe conceived architectural style as an emotive trigger, the mature Goethe had a different take.

Having said that: rather than style, "Einfache Nachahmung" is mainly about imitation, or more specifically how art imitates nature. There are three modes of imitation, Goethe stated. The first is simple imitation, by which the artist copies forms directly from nature. The second is manner, by which the artist's personality and soul are brought into the work. Neither of these modes realizes the potential of art, however. That only happens on the third level of imitation, which Goethe labelled style:

> Through imitation of nature, through the effort of creating
> a general language, through painstaking and thorough
> study... the artist finally reaches the point where he
> becomes increasingly familiar with the characteristic and
> essential features of things.... Then, art will have reached
> its highest possible level, which is style and equal to the
> highest achievement of mankind. While simple imitation
> therefore depends on a tranquil and affectionate view of
> life, manner is a reflection of the ease and competence with
> which the subject is treated. Style, however, rests on the

Der Teutsche Merkur, February
1789, with Goethe's essay
"Einfache Nachahmung der
Natur, Manier, Styl." Bayerische
Staatsbibliothek.

most fundamental principle of cognition, on the essence of
things—to the extent that it is granted us to perceive this
essence in visible and tangible form.[4]

Simple imitation works in the forecourt of style, Goethe said; it
is a necessary step toward true art, but far from sufficient. Per-
sonal manner, too, may be a stepping-stone to style, yet must
be distinguished from style proper.[5] Only when the artwork is
purged of everything incidental and reaches a level of universal
significance may one talk about style, understood as art's "high-
est possible level."

Goethe's mimetic hierarchy represented both a continuation
and a critique of the neoclassical idea of imitation as the principle
of fine art. Enlightenment writers had often argued that the artist
must imitate nature not in its outward appearance but in its inner
essence.[6] Goethe agreed, but changed the nomenclature. Where
Enlightenment theorists had spoken of the artist's capacity to

penetrate the essence of things as ideal imitation, Goethe called it style. Winckelmann was a decisive influence on this move. Construing golden-age Greece as ideal nature and a universally valid paradigm for emulation, Winckelmann had insisted that "[t]he only way for us to become great—indeed, to become inimitable—is to imitate the ancients."[7] Goethe recalibrated Winckelmann's position. Imitation is necessary, but so is innovation, he argued, using his 1789 essay to figure out the balance between the two. Goethe scholar Hilmar Frank points out the dialectical buildup of Goethe's argument by which straightforward copying of nature (simple imitation), combined with the artist's particular way of working (manner), results in a higher synthesis of nature and art; in other words, style. Style, here, represents an ascent from appearance to essence in which the subject (the artist genius) and the object (ideal nature) merge in the ultimate work of art.[8] This syncretic style concept can be found in much idealist art theory, where noble style is often construed as the combined product of ideal imitation and the genius's dignified soul.[9]

Just how well established the distinction between style and manner had become by the 1790s can be gaged from another contribution to the *Teutsche Merkur*, the 1795 essay "Ueber den Stil in den bildenden Künsten" by Carl Ludwig Fernow. Closely allied to the Weimar classicists, the art historian Fernow upheld Goethe's distinctions and added a few of his own. Style pertains exclusively to fine art, he held, defining the latter with Kant as art which has its purpose within itself.[10] The mechanical arts are not in possession of style, for they are not representational (*darstellende*) but "merely making."[11] Fernow admitted that architecture, works of prose, and even science may—despite their usefulness—potentially have style, but insisted that style in these art forms was an incidental property, as opposed to the essential style of the fine arts.

Having made these preliminary distinctions, Fernow set out to define style itself. Like Goethe, he did so in contrast to manner. If the mannerist copies external things, the true artist communes with his subject matter and grasps its inner idea. "Manner is merely the body that makes the artist's style visible for us," he wrote; "The style itself is the artwork's characteristic spirit."[12] To have a manner is not a fault, but it is also not enough, for it lacks the spiritual truth of real art, expressed through style. In a cunning analogy, Fernow compared manner to an author's handwriting and style to his written expression.[13] The mannerist is more

like a craftsman than an artist, not yet emancipated from the demands of the material, he held. The artist who creates in style, on the other hand, puts his materials and his means at the service of a higher idea. "Style, insofar as we consider it in an artwork and with respect to art, is the relationship between the beautiful artwork's represented parts, insofar as they are represented, and the purpose of the whole," was Fernow's somewhat convoluted definition.[14] Art's overriding purpose is to instill in the viewer a sense of ideal beauty and truth, and to do so, material constraints and individual manners must be overcome.

The ultimate example of the idealist notion of style has to be Schiller's short text, "Das Schöne der Kunst," enclosed in a letter to Gottfried Körner in the winter of 1793. Unlike Goethe, who considered imitation and manner necessary steps toward style, Schiller went one step further, presenting them as opposites. Not only must the material and the artistic technique be put at the service of the idea, he insisted; they must be entirely sublimated and overcome—*vertilgt* (annihilated) was the term he used in the *Aesthetic Letters*.[15] If a single trait reveals the marble as marble, the sculpture is ruined; if the etching bears the faintest trace of the copper's resistance to the burin, it is ugly. Only when both matter and manner are fully conquered does style emerge:

> The opposite of manner is style, which is none other than the representation's full independence from all subjective and all objective-incidental conditions.... Style is a complete sublimation of the incidental into the universal and necessary.[16]

By distinguishing style and manner, using the latter to absorb all the relative aspects of art, the term style could be reserved exclusively for art's ideal potential.

To the idealists, style is a liminal concept that can be approximated but hardly reached, writes Hilmar Frank.[17] It is a state—much like Winckelmann's ideal antiquity—in which the historical transcends into the universal. It is logical, therefore, that ideal style exists primarily in the singular. Style is a representation of the ideal "which in pure terms is but One," wrote Fernow in his *Römische Studien*, declaring that "style can and must always be the same."[18] No wonder that Goethe and Schiller (and undoubtedly Fernow, too) found Racknitz's plural Geschmäcke so distasteful.

Schlegel's Doubt

As is becoming painfully clear, many different, even contradictory, ideas of style were in circulation around 1800. The rhetorical notion of style as a mode of expression chosen by a speaker or an artist was still in use; in fact, judging from dictionaries and encyclopedias, this remained the most common sense of the term. But style had also come to mean the expression of an epoch, making it an index to historical and geographical change as well as a potential trigger of atmosphere and association. And as if that wasn't enough, the idealists promoted yet another sense of the term: style as an ideal correlation between form and idea. To align these conflicting interpretations and turn style into an operative aesthetic concept was one of the challenges for theorists of art and architecture at the beginning of the nineteenth century.

A poignant response to this challenge was August Wilhelm Schlegel's essay, "Über das Verhältniss der schönen Kunst zur Natur; über Täuschung und Wahrscheinlichkeit; über Styl und Manier" (On the relationship between fine art and nature; on illusion and truthfulness; on style and manner), presented as a lecture in Berlin in 1802 and published in the Viennese magazine *Prometheus* in 1808. Like Goethe, Schlegel defined style not as an individual mode of expression (that would be manner) but rather as an ideal correlation between the human spirit and objective reality:

> There is, then, necessarily something in the middle between art and nature that keeps them apart. This is called *manner*, when it is an obscure or confused medium that gives a false appearance to all the represented things; *style*, when it respects the rights of both art and nature. This is possible only through the work itself, with its own, as it were, imprinted elucidation.[19]

Schlegel linked the distinction between manner and style to their respective etymologies. Manner derives via *maniera* from *manus*, hand, and is linked to a purely personal expression, he told his readers. The stilus, for its part, is detached from the user's hand as an independent tool, lending a certain objectivity to its creations.[20] The stilus does not belong to the artist but to the work, and is thus a suitable metaphor for the objective principle that Schlegel sought. Style is individuality sublimated

into universality: "a transformation of the inevitable limitation of the individual into a voluntary limitation, in accordance with an artistic principle."[21]

At first glance, Schlegel promoted an absolute notion of style and repeated Goethe's distinction between style and manner. Yet toward the end of the essay, a doubt creeps into Schlegel's text. It is possible, he asked, to speak about several styles without lapsing into mannerism? If there is only one truth, and style is the manifestation of truth, can we speak of style in the plural? His answer, somewhat unexpectedly, is yes. Because art is a complex phenomenon that can be approached from many angles, there is room for more than one style. Not only does every art form and genre have a different style; the individual artist may also develop his or her own version of the artistic principle, "which develops with freedom and awareness into a practical system; into style."[22]

Having fused Goethe's absolute notion of style with a far more relativized understanding of the term, Schlegel went one step further, into fully-fledged historicization:

> [A]rt develops... gradually in time: this happens indisputably according to certain laws, even if we cannot always comprehend them within a limited period of time. Yet if we view an art corpus as a whole, and perceive the lawfulness of its development, then we are entitled to use the term style to characterize its different epochs. Style is then a necessary step in the development of art.[23]

The statement takes the reader by surprise. Goethe had defined style as the highest stage attainable by art, a position Schlegel seemed to share. And yet here he was, calling style simply a necessary step in the historical development of art. He even admitted the possibility of imperfect style; another blunt contradiction of the Weimar classicists' stylistic idealism.[24] Yet Schlegel's reasoning was consistent. The different stages that art goes through are not random, he argued, but necessary steps in its lawful development. While certain periods (such as the contemporary one) may seem lost in mannerism, they are actually undergoing a necessary development toward fulfillment. By seeing art as an organic phenomenon, Schlegel could construe the history of art as a developmental continuum in which each stage was necessary and therefore, at least potentially, in possession of style.

Schlegel's aesthetic organicism captures a key feature of historicism. History, here, is understood as an organism (a tree, Herder famously proposed) complete at every stage yet evolving according to strict laws.[25] The individuality of expression found at different times and places is not random mannerism but the manifestation of a lawful development. It is this historicist credo that allowed Schlegel to combine Goethe's absolute notion of style with a historicist idea of style as epochal expression. By introducing historical development rather than aesthetic perfection as the yardstick of art, Schlegel coined a concept of style that was at the same time relative and universal. Recognizing that artists at different times, in different places, and of different temperaments do not necessarily strive toward the same ideal, Schlegel nonetheless insisted that their striving followed the same laws. Style, then, denotes the lawful correlation between historical conditions and artistic output, referring not to a particular expression but to a relationship with presumed universal validity.

Schlegel is a good example of the persistent polarity built into the modern understanding of style, anticipating the century-long tug of war between style and the styles. I will get to that in a moment, but first, one last example of the idealist notion of style and its impending undoing: the *Kunstblatt* controversy of the early 1820s.

The Editor's Footnote: Schorn vs. Rumohr

In the spring and summer of 1820, the art magazine *Das Kunstblatt*—a supplement to the influential journal *Morgenblatt für gebildete Stände*—printed a series of communications by the connoisseur, collector, cookbook author, and self-taught art historian Carl Friedrich von Rumohr.[26] Starting as a travel letter from Florence, Rumohr's "Mittheilungen über Kunstgegenstände" meandered through a rich material from medieval Florentine churches to contemporary painting. Rumohr presented his cases in lively close-ups, paying careful attention to detail. But he was not averse to theoretical speculation. In the third installment he turned to "The Principle of Beauty," giving a startlingly iconoclastic analysis of, among other things, style.

Again, the question was about imitation: how is it that the artist appropriates his or her model, be it from nature or antiquity. While the classicists considered antiquity an eternally valid model, Rumohr argued that only those ancient motifs that can

134

be appropriated *enthusiastically* by the modern artist should be considered worthy of imitation. He criticized the blanket imitation of antiquity as a "sterile enterprise" lacking the necessary connection to modern life. "It is unimaginable," he wrote, "that mere taste, without enthusiasm (*Begeisterung*) for the represented ideas... can bring out life in a work of art."[27] Antiquity could and should be imitated, but the imitation had to be fueled by contemporary passions, similar to the way Raphael and his school took themes from classical mythology and made them their own.

With his preference for living passions over theoretical principles, it is no surprise that Rumohr loathed the idealists' abstractions. The problem with the "so-called principles of beauty," he wrote, was that their promoters tended to confuse their own limited taste with absolute truth.[28] In art, as in life, one had to allow for the "incidental, the timely, and the individual," and only people who had no idea about art expected ideal beauty to emerge fully and purely in any individual artwork.[29] Yet there were ways for the artist to reach beauty and truth:

> The artist can create beautifully in a twofold sense. Firstly, by penetrating his object with his spirit, so that it imperceptibly communicates the beauty of the idea that fills him; secondly, by sensitively fulfilling the conditions for a pleasing appearance, which exist singly for each art form, and generally for all [the arts]. The fulfillment of these conditions, which cannot be exhaustively spelled out, I consider to be the essence of style—a concept that cannot be delimited carefully enough, and that must be held apart from anything extraneous. It is very common to confuse the particularities of individual oeuvres, even entire schools and epochs, with style*), which is, however, something far more general.[30]

At this point, the *Kunstblatt*'s editor Ludwig Schorn—himself very much part of the aesthetic establishment that Rumohr was attacking—felt compelled to intervene. Inserting his own footnote into Rumohr's text, Schorn objected that the use of style to denote individual character was so well established as to be unavoidable, and that what Rumohr called style was better subsumed under the label "das Kunstschöne"—as Schorn himself had done in his *Über die Studien der griechischen Künstler* (1818).[31]

Schorn obviously did not think his interjection had done the trick, for he returned to the matter five years later. Under the heading "Ueber Styl und Motive in der bildenden Kunst. An Herrn Baron C. F. v. Rumohr," Schorn presented an expanded theory of style. Courteously admitting that he had revised his own position after the encounter with Rumohr, he now defined style as a joint offspring of nature and spirit: "I saw that it must be something founded in nature as well as in the human spirit, and at the same time an essential part of artistic activity. This is nothing other than the application of the fundamental laws of form, of the mathematics inherent in man and nature."[32] For style to become ideal, laws and passions must unite. Addressing his adversary in polite, almost deferential terms, Schorn made a point of adopting Rumohr's notion of enthusiasm, obviously intended as a conciliatory move. But he did not accept all of Rumohr's propositions, for where the baron separated representation from execution and reserved style for the latter, Schorn insisted on their union. The artwork forms an inseparable whole based on the "basic elements of beauty," and style has to do with the way these elements are brought together: "[B]eauty is the basic precondition of artistic representation; style is the mode of representation."[33]

Schorn's concept of style was packed with meaning. He used it as a relative, historical term denoting the particular expression of different times and places, speaking of Egyptian, Greek, and Gothic style. He wrote of the style of various artists, for although he did distinguish style and manner, he nonetheless granted that there was such a thing as individual style. In its highest sense, however, Schorn saw style as an ideal union of idea and form:

> So what is style in the highest artistic meaning of the word? Obviously that inner regularity of artistic representation that results from the enthusiastic application of the basic forms of beauty to the appearances of nature.... In this way form is transfigured into the ideal, insofar as the pure, the meaningful, and the useful emerge in the radiance of beauty, while the inessential disappears. Once present, this mode of representation—the pure style—becomes the norm for all artistic creation, without in any way restricting the individuality of the creative genius.[34]

Rumohr was not swayed by Schorn's idealist proclamations. "Spare me any hairsplitting verbosity [*Wortlauberey*]," he retorted with characteristic ruthlessness, declaring himself largely indifferent to whether the term style was used "in this way or that."[35] His own reasoning on the subject was practical through and through. In order to speak about art in a clear and meaningful way, one had to distinguish between its different aspects. Rumohr did not deny that there was an idea—or indeed an ideal—at stake in art, but he did not think it should be referred to as style. To disentangle what he saw as an unfortunate conflation of meaning, Rumohr reserved the term style for the artist's treatment of the material, paraphrasing his earlier definition of style as the "distribution and arrangement of raw matter in a comprehensible and sensually pleasing way. This, and only this, is what I call style."[36]

Rumohr's reply to Schorn is a study in understatement, ostensibly polite, but relentlessly mocking the highfalutin art theorist. He could not understand, he wrote, how a modest little tool such as the *stile* could end up as the repository of so many grandiose conceptions of art. His own understanding of style was more in keeping with its lowly origin, for he used it strictly to refer to the "low technical sphere" of art.[37] Art developed just as much in response to material and natural causes as it did to the ideal and the spiritual, he argued, stressing that he spoke of nature in its most concrete and real sense.

Though Rumohr defined style as a kind of skill, it was in no way synonymous with manner. On this point he was quite aligned with Goethe, dismissing manner as "thoughtless dexterity"—a kind of necessary evil, but not essential to art.[38] The style skill he was after had nothing to do with individual mannerisms. Rather, it was a shared sense, developed through a millennia-long engagement with materials; their hardness, weight, brittleness, or malleability—in short, all the resistances and affordances of the material world. As he explained with respect to Greek sculpture:

A good deal of the tiny modifications and changes in design that Winckelmann noticed in ancient sculpture did not, as he believed, arise from conventional... ways of representing particular ideal purposes, but far more from a sense of what the raw artistic material allowed or barred. The vertical posture of the statue was not always, as Winckelmann

assumed, a result of the ideas it represented, but simply a result of style. This same law of style toned down all hints of lightness and softness in ancient sculpture, because these qualities, represented in stone and metal, appear neither light nor soft but heavy and hard. It was therefore farfetched of Winckelmann to look for the reason for such temperance in representational conventions... when, in fact, it was the result of the utmost naturalness.[39]

Rumohr may come across as something of a materialist, but as Michael Podro points out, one should not be fooled.[40] The reduction of style from an idealist to a technical term goes together with an expansion of what the technical realm might imply. If Schiller had defined style as the spirit's annihilation of matter, Rumohr was interested in the interplay between the two—in the way the artist's mind (idea) and the artist's hand and material (style) affect each other. This entailed a radical reconsideration of the role of the artist. If ideal style requires an artist genius with a godlike spiritual awareness, Rumohr's "reduced" style calls for a more down-to-earth competence—a kind of wisdom of the hand or measure of the eye. By heeding or challenging the material according to artistic tradition, the artist can transcend his or her personal limitations, tapping into a larger continuum of forms and techniques. In that sense, style is a shared practice: "For the artist is always... reliant on the forms of nature that are available in his field; and even in the happiest cases—in the busy, active, lively periods of art—he is never alone in his endeavor."[41]

I am going on a bit, I know, but for good reasons. The Schorn/ Rumohr debate has hardly been touched on in English-language architectural scholarship (with Wolfgang Herrmann's short but incisive mention of it in the introduction to his style anthology as a rare exception), and has been pretty much ignored at home, too, despite Rumohr's somewhat cult-like following.[42] One reason for that, perhaps, is that it was never really concluded. While Rumohr's 1825 reply was labelled with the numeral I, indicating there was more to come, he did not pursue the debate in the *Kunstblatt*, returning to it only in the first volume of *Italienische Forschungen* two years later. Instead it was Schorn who authored "Ueber den Styl in der bildenden Kunst II," giving himself, for the time being at least, the last word.

Rumohr's reply had left the editor stunned. "I was so surprised," he wrote, "that I resolved not to reply until I had fully comprehended your position and compared it to mine in a completely impartial way."[43] Going through Rumohr's arguments one by one, Schorn did his best to pick them apart. If style is "the comprehensible, sensually pleasing distribution and arrangement of the raw material," then what exactly is this material? Rumohr had admittedly been vague about this, mentioning only "solid bodies for the sculptor; color and light/darkness for the painter."[44] Schorn was not satisfied. Not only was the material ill defined, so were the criteria for its "comprehensible and pleasing" distribution. Did wood, metal, and stone dictate the rules for their own shaping? Perhaps in architecture, Schorn admitted, the dumb forces of gravity or hardness could be seen to affect the final result—but in painting? "It is impossible to deduce the laws of style from the demands of the materials," he concluded, for there were necessarily other considerations (ideas, for instance) that conditioned the artist's endeavor.[45] Surely Herr Baron von Rumohr had to see that? The baron did see that. He never claimed that style encompassed all aspects of art. His misgivings about the idealist style concept derived precisely from the fact that it was too full; too laden with significance to be useful. Loathing the abstract and pretentious language of idealist aesthetics, Rumohr wanted to get back to concrete reality. A reduced concept of style seemed like a step in the right direction.

Rumohr returned to the question of style a few years later in *Italienische Forschungen*, where he continued the dispute with Schorn, and even paid a sarcastic visit to Fernow. Yet his first line of attack was Winckelmann, whom he saw as the origin of style's unfortunate expansion from the domain of technical execution to that of spiritual ideals.[46] Rumohr considered this an aberration and insisted that his own reduced understanding of style connected to the word's original tool-related meaning. "We are therefore not far removed from the real sense of the term... when we declare style to be a submission, turned into a habit, to the intrinsic demands of the material from which the sculptor actually builds his figures and from which the painter makes [his figures] appear."[47] Accepting neither the idealist use of style as a spiritual ideal, nor its customary significance as epochal or individual characteristics (a sense he ascribed to Vasari and other Italian writers), Rumohr rephrased his own concept of style:

Style, or what for me signifies style, derives neither, as for Winckelmann, from a particular direction or elevation of the spirit, nor, as for the Italians, from the particular habits of individual schools or masters, but simply from a correct, but necessarily modest and down-to-earth feeling for the outer limitations of art, set by the raw and... formless material.[48]

Rumohr did not develop his ideas on style further. They remained a springboard for thought that would be fully tested only by Gottfried Semper some two and a half decades later, writes art historian Alexander Auf der Heyde.[49] The baron himself seemed more interested in nettling the idealists than in imposing rigorous conceptual constraints on his own thinking, for he continued unapologetically to use style in many of the senses he had himself dismissed. Yet his critique of the idealist style concept struck a chord that would continue to reverberate in the writings of Heinrich Hübsch, Semper, and many others. It could even be seen as an unwitting anticipation of George Kubler's "reductive theory of visual style" a century and a half later, a project triggered—just like Rumohr's—by a mounting irritation over the ill-defined and all-encompassing use of the term.[50] Yet Rumohr's most important insight was perhaps that style, as a kind of shared practice, presupposes an artist who is neither a slavish copyist nor a solitary genius but a creative participant in a millennium-long tradition, negotiating the resistances and affordances (agency, we would perhaps say today) of the material world. The artist "is never alone in his endeavor," wrote Rumohr.[51] Style, then, is an antidote to the solitude of genius.

Style and the Styles (II)

"There is *style*, then there are the *styles*," wrote Eugène-Emmanuel Viollet-le-Duc in his 1854 *Dictionnaire raisonné de l'architecture*. The styles are epochal characteristics that allow the sorting of monuments according to their time and place; style, on the other hand, is "the manifestation of an ideal based on a principle" and as such only exists in the singular.[52] The last chapters' dive into the early nineteenth-century's conflicting notions of style shows this dichotomy in the making. An assorted vocabulary was mobilized to construct it. There was absolute versus relative style; essential versus incidental style; ideal style versus manner. Or as the 1817 edition of *Brockhaus Enzyklopädie* had it:

Style (stylos), originally the tool with which the ancients inscribed their writing onto hard materials; then the peculiar manner of expression in language or image (hence style in painting, sculpture, and architecture), *subjective style*; finally the most fitting manner of thought-expression in general, *objective style*.[53]

Subjective style refers to artistic expression as it changes with artist, period, art form, or genre; objective style denotes an ideal correlation between idea and form. The pair comes pretty close to the distinction made four decades later by Viollet-le-Duc and repeated by everyone from Le Corbusier to Rem Koolhaas. But architects and architectural historians of the early nineteenth century also pondered the relationship between style and the styles, and after this long excursion into art theory and aesthetics, it is time to turn to them.

Winckelmann's period style had been eagerly adopted to order the history of architecture into neat epochal units. From the 1820s onward, such style-based histories were becoming well established.[54] But Goethe's ideal style (which to some extent he shared with Winckelmann himself) had an equally strong hold, especially on those who shared the reverence for ancient Greece as an eternally valid model for art. The question was how to reconcile the two. "If it is a virtue to apprehend the purity of each style, it is an even greater [virtue] to reflect on pure style in general," wrote Schinkel, as usual speaking in aphorisms when his readers could have done with an exposition.[55] But the task was admittedly tricky. Struggling to unite the belief in universal style with an increasing recognition of the integrity of the historical styles, architects and architectural historians were forced to perform some intriguing intellectual somersaults.

It was Aloys Hirt who confronted the dilemma most explicitly. As mentioned in chapter 2, Hirt used the term style frequently (spelling it, unlike most of his contemporaries, with an i), mainly as an epochal characteristic. In keeping with the Vitruvian tradition, he considered the classical orders a key example of stylistic differentiation, but he did not reserve the term for classical architecture. Recognizing the plurality of styles, Hirt wrote about Egyptian, Byzantine, and Gothic style alongside Greek and Roman. The plurality did not, however, contradict the existence of ideal style. He set out this seeming paradox in the preface to

Die Baukunst nach den Grundsätzen der Alten (1809), a passage worth quoting at length:

> The architecture of the Egyptians and other oriental peoples, the Phoenicians, Israelites, Babylonians, and Persians; the architecture of the Greeks and Romans; the Byzantine-Italic, Arabic and Gothic styles of the Middle Ages; the architecture of the modern age, all became objects of my research. I lined up the monuments of these peoples before me; I scrutinized their age; I noticed the transitions from one to another, the emergence, the progression, the maturity, the decline, the decay. From this study of history and of monuments sprang observations and insights into the nature and essence of architecture itself. No object, however large or small, however important or insignificant it might seem, remained unexamined. This is how rules, laws, principles emerged; this is how a system, a theory, a structure came about—or, if you like, an ideal for architecture itself. This architecture is indeed none other than the Greco-Roman. Yet it is not because it is Greco-Roman that we hold it as the ideal for architecture but because these favored peoples exhaustively explored everything that belongs to the perfection of this art.[56]

Hirt was trying to resolve a problem that Winckelmann himself had fudged. If style is the result of historical circumstance, how can one particular style be considered a universal ideal? Winckelmann's solution had been to present golden-age Greece as a consummate moment in history, in which perfection in everything from climate and food to politics and morals resulted in ideal style. And while other historical civilizations were not as fortunate as the Greeks, Greek style represented perfection even for them. Hirt adopted a similar reasoning, arguing from the point of view of the architectural historian. If you study all the world's monuments, you will discover rules and laws governing their composition. In most cases, these laws are not perfectly realized, but merely point toward the possibility of perfection. Only in the architecture of Greece and Rome is perfection achieved, something that will become clear if you compare it to other epochs. To study the historical styles leads to an understanding of ideal style, which is nothing other than the fully realized potential of architecture.

Hirt's merging of the historical and the universal is ingenious. If idealist aestheticians like Fernow and Schorn had deduced ideal style in the general (and been scorned for their abstraction), Hirt insisted on its historical induction. "Can architecture be considered a thing in itself, outside history?" he asked, and answered with a firm no. Ideal style exists above and beyond history, that is true, but it must nonetheless be approached historically, for only in comparison with lesser expressions can it be recognized as ideal. "There surely exists an idea of architectural reason prior to all experience," Hirt argued, "but this idea is like the zero amongst the digits, it only counts when experience enters in. Only through experience can architectural reason, or what we may call the ideal of architecture, be awakened, developed, and recognized."[57] It is an elegant solution to a notoriously difficult problem. Proposing that the ideal is graspable only through historical experience, Hirt—a bit like Schlegel—could acknowledge style both as a relative historical expression and an eternal ideal. The road to style, it seems, goes via the styles.

The idealist attempt to reconcile style and the styles can be summed up by a building: Leo von Klenze's Glyptothek in Munich, built between 1816 and 1830. In white marble and with an elegant Ionic portico, the Glyptothek was Klenze's response to Crown Prince Ludwig's demand for a museum in the "purest antique style" to house his collection of Greek and Roman sculpture.[58] It was situated at Munich's new Königsplatz, where it would be joined some years later by Georg Ziebland's exhibition building (now Staatliche Antikensammlung, 1848) and Klenze's own Propyläen (1862).

That Leo von Klenze would become the chief proponent of German philhellenism was in no way a given. Trained in Berlin and Paris under the influence of Durand's rationalism, the start of his career was marked, as Winfried Nerdinger points out, by a somewhat naive eclecticism.[59] For the Glyptothek competition in 1814–1815 he submitted proposals in three different styles—Greek, Roman, and Renaissance—based on more or less the same plan. "Greek, Roman, and presumably modern artworks will be exhibited there, and one is all the more indecisive as to which of these types to comply with, as the preferable among them, the Greek, offers no examples of similar monuments," he explained candidly.[60] But during the Glyptothek's long planning process Klenze had a change of heart—Nerdinger likens it to a religious conversion.[61]

143

Overleaf: Leo von Klenze, Glyptothek in Munich, ca. 1855. Photographer unknown. Staatliche Antikensammlungen und Glyptothek, Munich.

Leo von Klenze,
plan of the
Glyptothek, 1830.
Architekturmuseum
TU München.

Abandoning his earlier typological eclecticism, he gradually became convinced that the Greek style was "for all times the most fit and beautiful," not invented by man but given by God.[62] Ludwig's museum was meant to embody that ideal to perfection.

The Glyptothek is well known and expertly documented, so I can get straight to the point.[63] This hinges on the building and its collection, but particularly on its catalog, prepared jointly by Klenze and Ludwig Schorn for the opening in 1830. The authors started by presenting the order of the exhibition. They rejected the so-called "Götterideale," by which sculpture collections were ordered according to iconographical reference, opting instead for a chronological system where the visitor's route would retrace the historical development of art.[64] Twelve exhibition rooms around an atrium led the visitor in a circle from ancient history to the modern age, introducing the major historical styles along the way. The journey started in the Egyptian room to the left of the south entrance. The aim here was not to show as many works as possible, Klenze explained, but to show the development of Egyptian art and its links to other cultures. The room therefore also contained non-Egyptian works, for instance a Buddha from Java and an Indian Brahma figure. Klenze inserted a door relief of the Egyptian goddess Isis finding her brother Osiris trapped

inside a wooden column at the Babylonian court—a fitting tale, he thought, to illustrate the dissemination of the Egyptian style among other peoples. Yet the most important connection was to Greece, a fact reflected in the hall's ornaments in old Greek style.[65]

The tight fit between architecture and exhibits continued throughout the museum. The circular Incunabeln-Saal in the southeast corner acted as a hinge—architecturally and narratively—between Egypt and Greece, showing examples of Etruscan and early Greek style.[66] From here, the visitor could see along the entire west wing with its three enfilade rooms dedicated to classical Greece: the Aegineten-Saal, with the pediment sculptures from the temple of Aphaia, controversially restored by Bertel Thorvaldsen; the Apollo-Saal, with the nine-foot-tall Apollo Citharoedus, praised by Winckelmann as a paradigmatic example of Greek high style; and the Bacchus-Saal, with the sleeping Barberini Faun in the center.[67] The rooms were decorated with stucco marble in strong colors, and though the vaults overhead were Roman, the decorative program of the entire sequence was inspired by Greek precedents.

In addition to the exhibition rooms, Ludwig's brief had asked for two large representational spaces. The request had caused

View from the Aegineten-Saal along the Greek wing of the Glyptothek. Bildarchiv Foto Marburg.

147

Entwurf zu den Bildern an der Pinakothek. Bild an der Südseite. W. Kaulbach. München.

Klenze some headaches, as these rooms inevitably interrupted the historical sequence.[68] He chose to make a virtue of necessity, however, placing the reception rooms symmetrically around the museum's north entrance, separated by a small vestibule. In this way, Ludwig's halls lay right between Greece and Rome, inserting the Bavarian monarchy into classical history while at the same time marking the transition between the apogee of art and its subsequent decay.[69] The reception rooms were decorated with a

Wilhelm Kaulbach, *König Ludwig I., umgeben von Künstlern und Gelehrten, steigt vom Thron, um die ihm dargebotenen Werke der Plastik und Malerei zu betrachten*, 1848. bpk/Bayerische Staatsgemäldesammlungen.

cycle of frescoes by Peter von Cornelius: Hesiod's creation myth in the small vestibule; Homeric epics in the adjacent Götter-Saal and Trojaner-Saal. With a fine sense of historical dramaturgy, Cornelius had the panel over the eastern door in the Trojan hall show Aeneas fleeing a burning Troy for Rome—a fitting accompaniment for the visitor on her way into the Roman section.

The Roman hall was undoubtedly the Glyptothek's grandest space, filling the entire length of the east wing. One hundred and thirty feet by forty-two feet and vaulted by three cupolas, it seemed of an entirely different scale than the rest of the museum. The walls were decorated with violet stucco marble and medallions of Roman commanders and emperors, while the coffers in the ceiling were bright red at the base and adorned with gilded rosettes. The three vaults corresponded to the three main epochs of Roman art, Klenze explained, describing in detail how the architectural iconography underscored the historical narrative of the collection.[70] The visitor now found herself at the end of the circumambulation. The round room in the southeast corner contained polychrome works from several epochs. Mirroring the Egyptian hall across the main entrance, it too functioned as a kind of hinge, this time between the Romans and the moderns. Klenze used the figure of the phoenix arising from the ashes to describe how artists from Michelangelo to Thorvaldsen had put "art back on the only right track, the one leading back to antiquity."[71]

The Glyptothek in its original form allowed the visitor to follow the rise and fall of classical art from its crude beginnings to its contemporary resurrection. The different epochs were laid out in strict chronology and accompanied by matching architectural iconography, offering a didactic display of historical styles. Yet the museum was first and foremost a demonstration of Style—in singular and with a capital S. Displaying real classical art inside an idealized classical building, Klenze curated the styles by means of style. The Glyptothek took its cue from "the very highest purpose," he wrote; it was to transcend the historical styles and become an image of the ideal.[72] Precisely what his friend Schorn had called style.

5 *The Principle of Correspondence*

J ust as Munich was preparing for the opening of the Glyptothek (the first public preview was on a summer's night in 1828, when the Aeginetan sculptures were displayed by candlelight in their new hall), an essay was published that challenged the entire theoretical basis of the new museum. Written by the thirty-three-year-old Karlsruhe architect Heinrich Hübsch, it would become one of the nineteenth century's most famous architectural texts. At the time of its publication, however, the crudely printed pamphlet must have seemed an unlikely threat. Barely fifty pages long and with only two pages of rudimentary illustrations, the only hint of the commotion it would cause lay in its provocative title: *In welchem Style sollen wir bauen?*

In What Style Should We Build?
Hübsch's agenda was ambitious: to abolish the mindless imitation of antiquity and define an appropriate style for the present

Title page of Heinrich Hübsch's *In welchem Style sollen wir bauen?*, 1828. Universitätsbibliothek Heidelberg.

day. The targets for his attack were classicists and idealists (Hirt in particular, but Klenze got a beating, too); all those who "really believe that the beauty of architectural form is something absolute, which can remain unchanged for all times and under all circumstances."[1] Hübsch, for his part, did not. While the basic elements of architecture—wall, ceiling, column, door—occurred in all ages, different habits, needs, climates, and building materials caused the elements to be shaped in very different ways. Style was the product of these particular "formative factors" and was consequently an attribute exclusive to the time and the place that had produced it.[2] In that lay the key not only to understanding historical style, but also to creating a new one:

> If we wish, therefore, to attain a style that has the same qualities as the buildings of other nations... then this cannot arise from the past but only from the present state of natural formative factors—that is: first, from our usual building material; second, from the present level of technostatic experience; third, from the kind of protection that buildings need in our climate in order to last; and fourth, from the more general nature of our needs based on climate and perhaps in part on culture.[3]

156

The way to rise to the same level as the ancients, Hübsch argued, was not to imitate their buildings but rather to emulate their way of building—to build according to our needs and conditions just as they had built according to theirs. There is an inescapable correspondence between an epoch and its style, and only those who heed that correspondence will build in truth.

Like Winckelmann, Hübsch sorted the factors influencing architectural style into two main classes. First, there were natural factors such as climate, building material, and structural system; second, conventional factors such as taste and cultural conditions. And although Hübsch recognized both as important, he found the former easier to deal with. Tracing the correspondence between natural factors and resulting style in ancient Greece and modern Germany respectively, he set out to demonstrate the futility of imitating antiquity. There was a difference in materials: while the Greeks built in hard, durable marble, producing architraves capable of taking large spans, the soft, rubbly sandstone of northern Europe required an entirely different structural system.[4] There was a difference in climate: Greece's temperate clime permitted gently sloping roofs, while colder and wetter regions required steep gables for the rain and the snow to drain. And there were different spatial needs: ancient Greek buildings were small

Heinrich Hübsch, the two original style systems, trabeated and arched. *In welchem Style sollen wir bauen?*, 1828. Universitätsbibliothek Heidelberg.

157

with simple programs, and to apply the Greek style to complex modern building programs was bound to violate the very principle one sought to emulate.[5] In short, modern northern Europe required a completely different style than the classical, one that matched its particular conditions and needs.

To find such a style, Hübsch turned to the arch. Invented by the Romans and adopted into medieval Christian building practice, the arch constituted, alongside the trabeated system of the Greeks, one of the two great structural systems in architecture, he thought. These were the two original styles from which all later styles had evolved.[6] Examining the development of arched and vaulted architecture from early Christian to Gothic, Hübsch weighed its various iterations against contemporary needs. And after careful consideration of everything from cost and durability to weather protection and spatial requirements, he announced with some satisfaction that he had established "the principles according to which the architectural elements of the new style must be formed":[7]

> We have now reached the goal that we tried to attain and have established a strictly objective skeleton for the new style, sufficiently articulated, I believe, for the artist to enliven with his own individuality. Everyone will realize at once that the new style must come closest to the *Rundbogenstil*—that it is, essentially the *Rundbogenstil* as it would have evolved had it developed freely and spontaneously, unimpeded by all harmful reminiscences of the ancient style. This resemblance arises from the nature of things and was not brought about by authoritarian influence or individual preference.... The influence of reality in all its complexity has consistently been upheld.[8]

Systematically tracing the correspondence between style and epoch, Hübsch was convinced he could deduce the true style for the present. Only by grasping the formative factors of contemporary society could a new style emerge—a style that would be so perfectly in tune with its time that it would be recognized and felt by everyone. "The buildings of the new style will no longer have a historical and conventional character, so that emotional response is impossible without prior instruction in archaeology,"

he boasted; "they will have a truly natural character, and the layman will feel what the educated artist feels."[9]

Hübsch's 1828 manifesto was a "plea for contemporaneity in art," writes Barry Bergdoll, pointing out the radical historicization going on in Hübsch's thinking.[10] Along with that historicization, another shift took place as well. If style in the late eighteenth-century garden had to do with rhetorical variation, and style for the turn-of-the-century idealists had to do with ideal beauty, for Hübsch and his generation it had to do with truth. Not the eternal truth of the idealists, that is, but the truth of epochal correspondence. If style is the outcome of historically relative factors, then imitation of another epoch's style is by definition untrue; out of sync with its own time. The art historian Rudolf Zeidler calls it "the thesis of correspondence" and sees it as a particular invention of the nineteenth century.[11] It was a logic that would condition the style debate profoundly, opening an imaginative range of solutions for what might count as a true style for the present.

Hübsch's pamphlet caused an immediate stir. Critics were puzzled that he had chosen to adopt yet another historical style for the present, after insisting so vehemently on the correlation between style and epoch. To swap classicism for Rundbogenstil was "exchanging one set of fetters for another," wrote the architect Rudolf Wiegmann in a staunchly critical review published in Schorn's *Kunstblatt*.[12] Turning Hübsch's own reasoning against him, Wiegmann argued that if architecture was a reflection of its time—as they both agreed—then *no* historical style could adequately match the present. "We must create something new that fits our time, just as in the preceding centuries something new was created that fitted their time," wrote Wiegmann, endorsing Hübsch's logic while rejecting his solution.[13]

Hübsch and Wiegmann both believed in the principle of correspondence, seeking a perfect match between architectural style and the formative factors of the epoch. How these factors were to be defined was a trickier question. Wiegmann found Hübsch's material and technical focus reductive, accusing him of missing the essential point of style: "[H]e attaches to the term 'style' a meaning that relates to material and construction, while in everyday language it is used in a spiritual sense only," Wiegmann complained.[14] As far as he was concerned, style had two meanings. First, it denoted "the signal character of a nation and

an epoch," marking every cultural expression from fashion to poetry. This is Winckelmann's period style, thoroughly assimilated by the Göttingen-trained Wiegmann. The second was a rhetorical sense of style, defined by Wiegmann as "a distinctive mode of expression or specific quality," such as for instance high or sublime style.[15] In the first sense, a nation had only one style; in the second, it had all styles at its simultaneous disposal. And while Wiegmann did not quite succeed in reconciling these two meanings (yet another variation of the style/styles conundrum), he was adamant that neither could be reduced to construction. "Style is not a definite and unalterable system of construction and decoration; even less does it exclusively signify two different approaches to spanning—the arch and the straight architrave."[16] Rather than a structural principle, style was an expression of the zeitgeist, and could neither be reduced to material factors, nor constructed at will. Style had always "crystallized organically out of the time and the circumstances," Wiegmann held, optimistic that the new style would emerge from the womb of time, just as it had done in previous epochs.[17]

Title page of Friedrich Eisenlohr's *Rede über den Baustyl der neueren Zeit und seine Stellung im Leben der gegenwärtigen Menschheit*, 1833. Sächsische Landesbibliothek— Staats- und Universitätsbibliothek Dresden.

Another rebuke came from Hübsch's own assistant and later colleague at the Polytechnikum in Karlsruhe, Friedrich Eisenlohr, in his 1832 lecture "Rede über den Baustyl der neueren Zeit und seine Stellung im Leben der gegenwärtigen Menschheit" (On the architectural style of the modern age and its place in the life of contemporary humanity), later published as a small book. Already in the title he took issue with his older colleague. If Hübsch had concentrated on the "technostatic" aspects of style, Eisenlohr probed its cultural significance. Architecture did not emerge from physical needs, he argued, but sprang from the human desire to "externally represent and express, in sensually perceptible works, that feeling of the divine which the intuition of nature had aroused in him." Architecture, it follows, "has more freedom in its shaping of natural matter than mere physical need dictates."[18]

This idealist manifesto in miniature must have appeared as a direct criticism of Hübsch, who was probably in the lecture audience. Not only did Eisenlohr adopt a radically different definition of style than his colleague; he also returned to an idealist aesthetics that Hübsch himself had dismissed. Eisenlohr sounded in fact more like Schlegel (or indeed Hegel, albeit five years before the lectures on aesthetics were published) than he did Hübsch, presenting art and architecture as sensuous representations of the ideal.[19] Like Schlegel and Hegel, Eisenlohr understood the ideal not as unchanging but as an evolving historical entity. Architectural history is an expression of the human spirit in its historical development, he stated, and because the human spirit changes with the times, so must architecture: "Given the difference in spirit between different times and peoples, the works of architecture must also be different, insofar as they appear to be animated by that spirit."[20] The particular way in which architecture expressed the zeitgeist was what he called style.

Though Eisenlohr distanced himself from Hübsch's materialist approach, their conclusions were in the end surprisingly similar. Not only did both promote the Middle Ages as a source for a new style; they also shared a belief in the nineteenth century's most dominant imperative: if style signifies the correlation between a time and its art, then the task now is to find a new style for the present. That did not, paradoxically, imply breaking with the past, but rather appropriating whatever was still relevant in it. Eisenlohr framed it as a matter of homeliness versus estrangement: "If a style does not evolve from the inner and outer life and needs of a people

and a time, it will remain a remote copy, forever foreign to life and spirit," he stated.[21] Hübsch would probably have agreed.

Wolfgang Herrmann has analyzed the German style debate carefully, looking not least at the critical reactions to Hübsch. The differences were many and the disagreements profound, yet most of the participants—whichever side they took—held onto the principle of correspondence. A string of almost indistinguishable statements expresses the point: "Our art must represent our time, just as past art represented its time" (Wiegmann, 1829); "Architectural works will... express the character of the nation, of the period, and of the country" (Carl Albert Rosenthal, 1844); "The contemporary architectural style must give a true image of the spirituality that nurtures the time in which it is made" (F.W. Horn, 1845).[22] And most forceful of all: "Every epoch has left behind an architectural style—why should we not try to see if it is possible to devise a style for our own time?" (Schinkel, 1829).[23] The logic is clear. If every historical epoch has produced its own distinctive style based on its own needs and means, then the present must do the same. Or put differently: once style has become the style of the time, the demand for a style of *our* time becomes inescapable.

The Stuff of Style

The style debate of the 1830s and 1840s has often been likened to a battle, yet its German version was less a confrontation between clearly defined fronts than a drawn-out guerrilla war between highly fluid factions, marked by ambushes, renegades, and general mayhem. Much of the combat took place in journals and magazines such as *Kunstblatt* (Stuttgart 1816–1849); *Museum— Blätter für bildende Künste* (Berlin 1833–1837); *Allgemeine Bauzeitung* (Vienna 1836–1860); *Journal für die Baukunst* (Berlin 1829–1851); *Zeitschrift für praktische Baukunst* (Leipzig 1841–1868) and many more—publications that were fostering a new architectural debate culture across the German-speaking world. The positions were complex. Most agreed that a new style had to match a new time, but what exactly was it meant to correspond to? What was the stuff of style? As the Hübsch/Wiegmann/Eisenlohr exchanges show, the possibilities were many. If Hübsch defined the correspondence mainly in technical terms, Wiegmann and Eisenlohr saw it as a spiritual quest to give form to the contemporary zeitgeist. From the 1840s on many architects abandoned this kind of historicized idealism, however, turning instead to materials to

Kunstblatt (Stuttgart 1816–1849); *Museum—Blätter für bildende Künste* (Berlin 1833–1837);
Allgemeine Bauzeitung (Vienna 1836–1860); *Journal für die Baukunst* (Berlin 1829–1851).
Universitätsbibliothek Heidelberg, Eblaska Biblioteka Cyfrova, and Bayerische
Staatsbibliothek.

find the key to style. A new style would not emerge until a new
material was invented, it was argued, eliciting a heated debate
over what that new material might be.[24] The century's many
new building tasks—railway stations, exhibition buildings, new
civic institutions—also triggered reflections on the relationship
between purpose and style, paving the way for the typological
eclecticism of the midcentury.

Another bone of contention was the question of whether the new style was to be an innovation, a revival, or some kind of synthesis. The revivalists—be they classicists, medievalists, or promoters of some other period style—argued that historical styles were relevant for the present because they somehow corresponded with the contemporary ethos and harbored an as yet unfulfilled potential for development. That was Hübsch's argument for Rundbogenstil, and it would subsequently be mobilized on behalf of at least half a dozen historical styles throughout the nineteenth century. Rosenthal, for instance, while insisting that architecture had to represent its time, considered Gothic (or Germanic, as he called it) the obvious style for the present, as it represented a living Christian spirit. The Germanic style was to be adopted "not as it developed historically but as it would have developed and would still be developing under more favorable circumstances."[25] Based on such hopeful, if counterfactual, logic, the evolutionary revivalists framed period style as a continuously evolving thing and saw a style's "developability" (*Entwicklungsfähigkeit*) as a key criterion for stylistic choice.[26] By the 1830s, this argument had become something of a topos in architectural discourse, lurking, as we shall see, in both Schinkel and Semper.

There were other positions, too, facilitated by the principle of correspondence. One, rather surprisingly, was pluralism. To be sure, to denounce stylistic pluralism and strive for an organic unity of style and epoch was the default position of most participants in the early nineteenth-century style debate, and laments over "Babylonian confusion"; "false masquerade"; "borrowed feathers"; and buildings "dressed up in the rags of every nation and period" were common.[27] Yet if pluralism could be construed as integral to the modern condition, it might also be considered a legitimate stylistic response. Typological eclecticism—that is, the idea that different building types require different styles to express their purpose—was perhaps the most straightforward response to this. A rapidly expanding pattern book industry, propelled by cheap printing and new image techniques, catered to an increasingly diverse taste culture. "The main benefit of combining ornaments of different styles in one work, is that the comparison... will prevent one-sided bias and foster an unprejudiced mind from which free self-invention may develop," wrote the young Hübsch in the introduction to a pattern book for craftsmen and architects, confirming the genre as a key vehicle for

Stilpluralismus.[28] The style-based architectural history handbooks emerging from the early 1840s also contributed to an increasingly omnivorous stylistic appetite, offering examples and motifs from across history and from all over the world. Franz Kugler's *Handbuch der Kunstgeschichte* (1842), Carl Schnaase's *Geschichte der bildenden Künste* (1843), and Wilhelm Lübke's *Geschichte der Architektur* (1855) were influential examples, providing, as Petra Brouwer and Henrik Karge both show, a crash course in stylistic pluralism.[29]

For if architectural practice was profoundly affected by the principle of correspondence, so was architectural history writing. In fact, the idea of a necessary accord between culture and style would underpin the great historiographical systems of the late nineteenth century, from Burckhardt to Wölfflin and beyond, for whom, as Alina Payne recalls, "culture was the other side of the style coin."[30] The idea would become a vehicle for nationalist and even racist deductions, for if style captures the essence of a culture, it may also serve as a tool to compare and judge the developmental level of peoples and nations.[31] In the early to mid-nineteenth century these grand comparative schemes were not yet fully in place, yet style's potential as an instrument for cultural diagnosis was clearly understood. By judging a people's cultural level by its stylistic expression, the history of civilization could be presented as a tidy chain of epochs and styles.

As soon as one turned from diagnosing the past to pondering the here and now, however, the tidiness collapsed. Past epochs might have been fueled by a distinct spirit and expressed by a distinct style, but the present displayed no such coherence, lacking the organic unity of earlier times. Pluralism offered a paradoxical solution to that dilemma. If the present could be thought of as a synthesis of multiple pasts, absorbing several historical and spiritual modes, as it were, one could argue that several styles were required to craft its self-expression. Even conservatives like Ludwig Schorn would occasionally pander to this idea, for after having been exposed to the stylistic cacophony of the Munich art exhibition in 1829), he wrote that "[t]he multifaceted spirit expressed in these old epochs should be united and renewed in you, you contemporaries, and emerge from you as a new and distinct beauty."[32] Not only could stylistic plurality fulfill the modern desire for variation (an argument frequently encountered in turn-of-the-century garden literature); one might also argue that the modern spirit is itself so complex, multifaceted,

Karl Friedrich Schinkel, proposal in classical style for the Friedrichswerdersche Kirche in Berlin, 1821. bpk/Kupferstichkabinett, SMB. Photo: Wolfram Büttner.

and shifting that it is incapable of being represented by one, fixed style. This is incidentally a similar argument to the one Adolf Loos would use some hundred years later, when he argued there was no adequate style for the modern personality.[33] And although Loos's solution (to retreat into a discrete stylelessness) was pretty much the opposite of nineteenth-century pluralism, the idea that this out-of-syncness constituted the very essence of modernity united *Stilloskeit* and *Stilpluralismus* in a wonderfully paradoxical way.[34] The emancipation of the modern spirit from epochal constraints, eloquently theorized by Hegel in the *Phenomenology of Spirit*, could legitimize not only spiritual liberation but stylistic diversity as well.

Several authors tried to get an overview of this contradictory landscape of opinions. Their attempts were mostly made in the spirit of profound pessimism, for the present inevitably seemed

a mess when seen against the period style's ideal of a perfect unity between style and epoch.[35] "We have no church—no distinct architectural style—no distinct architecture," Kugler mournfully observed in an 1834 essay in his journal *Museum*, diagnosing an unprecedented lack of coherence between spirit and style.[36] Neither revivalists like Klenze nor style inventors like Hübsch had managed to remedy this flaw, Kugler thought; the former because they underestimated the creative power of the present; the latter because they tried to reduce architecture to a material issue, entirely missing its higher purpose. Only Schinkel had united continuity and innovation, spirit and matter, in a way that hinted at the possibility of a contemporary style, but at times even he had succumbed to fruitless revivalism. True style could only emerge when everything incidental was shed, Kugler wrote, seeing it as an ideal manifestation of the spirit that the present hardly seemed capable of.[37]

A more upbeat diagnosis came from Kugler's old Bauakademie teacher Wilhelm Stier in 1843. Stier divided the contemporary scene into six factions, his list reading a bit like Borges's Chinese encyclopedia: (1) Critics of the imitation of antiquity; (2) Medievalists, striving to resurrect a patriotic German architecture; (3) Critics of the medievalists, promoting a modern national style instead; (4) Those who demanded a style based exclusively on the needs and forces of the present, be they material or spiritual (this group was further divided into two depending on how they weighted that particular balance); (5) Classicists who despite everything held onto antiquity as an ideal; and (6) Francophile rascals promoting a faux "style de la Renaissance."[38] The positions were not fixed, but intermingled and influenced each other mutually, creating a fluid and kaleidoscopic scene. Unlike Kugler, however, Stier viewed the chaos not as a crisis but as an opportunity to study the inner workings of style. Not convinced by the idea of a seamless match between style and epoch, he encouraged his peers to analyze the actual preconditions out of which the historical styles had emerged, and to pay particular attention to the role of originality.[39]

Stier was not alone in his reluctance to embrace the principle of correspondence, for although it formed a prevailing figure of thought in the early 1840s, it did have its detractors. One formidable opponent was Schinkel, who challenged the epochal determinism of his time not so much in writing as in his architecture.

In case it needs restating: the style debate of the 1830s and 1840s was not just an academic affair, but took place on drawing boards and building sites across the German states. And while the theoretical exchange may make it seem as if architects considered one thing at a time (purpose *or* material, say; construction *or* iconography), the making of buildings inevitably involves the simultaneous consideration of a number of contradictory factors. Schinkel's careful negotiation of political, material, and historical aspects in his design of the Friedrichswerdersche Kirche in Berlin is a case in point.

Schinkel on the Friedrichswerder

Built to replace a seventeenth-century chapel housed in an old riding hall, the Friedrichswerder church was a so-called *Simultankirche*, accommodating the German and the French Protestant congregations at either end. By 1820, the "Langer Stall" was in such bad shape that it needed either renovation or replacement. Notable architects such as Johann Gottlieb Schlaetzer and Aloys Hirt submitted proposals, both in vaguely Italianate styles.[40] Schinkel, by now *Geheimer Oberbaurat*, did not like either of them. Criticizing the projects for their "impure style," Schinkel argued that both the brief and the site required a "simple arrangement patterned after antique buildings."[41]

To demonstrate his point, Schinkel made a proposal of his own: a classical temple with engaged columns on three sides and a portico of freestanding Corinthian columns. Schinkel called it a *pseudoperipteros*, "like the Maison Carré in Nimes."[42] Since the desired belltower did not fit well with the Greek style, Schinkel suggested placing a freestanding tower next to the building. Nothing came of it, and in 1822 he returned with a very different proposal. As the church was surrounded by narrow streets on three sides, making it impossible to see the long façades properly, it should have a plain and unadorned exterior, he argued. Only the front lent itself to monumental gestures, in this case a colossal arched niche by which the "inner vaults are indicated in their full scale."[43] The solution would lend importance and dignity to the building, Schinkel thought, and would also go well with Heinrich Gentz's Mint building across the square—an innovative structure, boldly reinterpreting classicism to express its civic purpose.[44] This version, too, failed to get the crown prince's approval, but Schinkel himself was clearly

PERSPECTIVISCHE ANSICHT DES INNEREN DER PROJECTIRTEN KIRCHE AUF DEM WERDERSCHEN MARKT ZU BERLIN.

Karl Friedrich Schinkel, second classical proposal for the Friedrichswerdersche Kirche in Berlin, 1822. *Sammlung architektonischer Entwürfe*, vol. 8, 1826. Oslo School of Architecture and Design.

Karl Friedrich Schinkel, Gothic proposal for the new Friedrichswerdersche Kirche in Berlin, 1824. bpk/Kupferstichkabinett, SMB. Photo: Wolfram Büttner.

pleased with it, including it in the eighth volume of the *Sammlung architektonischer Entwürfe* a few years later.

During 1823 and the spring of 1824, Schinkel submitted several new proposals. Again, he used the urban context and the brief to determine the style, and again, he reached a different conclusion:

> In this somewhat dense part of town, which due to the
> irregularity of its streets seems close to the ancient times, a
> church in the medieval style would be in place. As the site
> is not very big, it would be inadvisable to follow plans for a
> great medieval cathedral; rather, I found it fitting to give the
> building the character of an English chapel, in which only a
> few proportions are at work, drawing the building together as
> a tight-knit whole.[45]

The first of these projects showed a plain neo-Gothic building with stump towers in all four corners, pronounced stringcourse tiers and large pointed arch windows in an even rhythm along

the façade. The proposal was meant only for the German congregation (the French were to remain in the old building), but Schinkel envisioned a future lengthening of the nave into a six-tower structure, making it an imposing figure on the square. The church was to be built in brick with details in cast iron, all executed in a simple yet careful manner.[46]

Schinkel's interlocutor had so far been Crown Prince Friedrich Wilhelm, whose stylistic preferences he had had to navigate carefully.[47] Now the king himself intervened, asking to see the latest plans. Schinkel—eyeing an opportunity to promote one of his earlier schemes, perhaps—prepared a drawing of four proposals in different styles that was presented to the king in March 1824. Top and bottom left was his pseudoperipteros in Doric and Corinthian order respectively, now equipped with a rotunda over the apsis. To the right were two Gothic proposals, one with a central front tower, the other with twin towers flanking the entrance. It was this last project that finally secured royal approval; construction started that same year.

Friedrichswerdersche Kirche was inaugurated in April 1831. It counts as Prussia's first neo-Gothic church and as one of Germany's first modern monumental buildings in exposed brick. The horizontality created by the near flat roof and the stringcourse tiers has had historians label it as a classicizing Gothic.[48] Schinkel himself described it as stripped-down medieval, "working only through its proportions."[49] The interior is dominated by a tall, rib-vaulted main nave defined by two rows of slender piers drawn in from the walls. The originally star-studded vaults echoed the chapel in Marienburg—one of the first "rediscovered" Gothic monuments in Prussia—while the long galleries between the piers have been seen as a reference to Luther's Schlosskirche in Wittenberg, a forceful link, if so, to the Protestant tradition.[50] As in his first Gothic proposal, Schinkel emphasized craftsmanship, insisting that the construction be made legible through a careful detailing of the brickwork.[51]

Despite all the care taken in its execution, Friedrichswerdersche Kirche has often been viewed as something of an embarrassment in Schinkel's oeuvre.[52] Not medieval enough for the medievalists and far from classical enough for the classicists, the church seemed to muddle stylistic categories. Kugler—otherwise a great admirer of Schinkel—found its squat silhouette out of keeping with the Gothic style, and Heinrich Heine mocked

Overleaf: Karl Friedrich Schinkel, four alternative proposals for the new Friedrichswerdersche Kirche in Berlin, 1824. bpk/Kupferstichkabinett, SMB. Photo: Wolfram Büttner.

II.

II.

I'.

its odd proportions and untimely appearance.[53] Twentieth-century art historians such as Hans Sedlmayr have construed it as the beginning of the nineteenth century's unprincipled eclecticism and a symptom of the loss of authentic culture—a *Verlust der Mitte*, as Sedlmayr ominously put it.[54] Yet the church was entirely in keeping with Schinkel's ideas on style. For although he recognized style as a product of the epoch, his ideas on what constituted a new style went far beyond the principle of correspondence. As he wrote in 1829, just as the Friedrichswerdersche Kirche was nearing completion:

> The new style will not... depart from everything past and present, so that, like a phantasm, it is hard to recognize and understand. On the contrary: many will hardly notice the new therein, the greatest merit of which lies in the methodical use of a series of historical inventions that have not previously been brought artfully together.[55]

The new style does not exclude historical styles but appropriates them, subtly transforming historical motifs into a new totality. The church on the Werdersche Markt was the product of such an appropriation. What Kugler and Heine saw as clumsy revivalism and Sedlmayr as willful eclecticism, may equally well be seen as a conscious effort at transforming a historical style into a contemporary expression. Schinkel did not focus exclusively on technology and materials like Hübsch, nor on abstract ideals like the idealists, but sought to integrate technology, history, and the artist's free imagination—"the poetical," as he called it—into an expression of the building's higher purpose. The balance between these factors had to be judged anew in each situation, just as Schinkel weighed and reweighed context, purpose, historical associations, and contemporary desires in his designs for the Friedrichswerdersche Kirche, each time coming to a different solution. If you only consider construction and function, the result will be lifeless abstraction, he wrote; if you rely too much on historical motifs you will end in pure randomness. Schinkel found the balancing act challenging, famously comparing it to a labyrinth: "I found myself trapped in a great labyrinth, where I had to weigh on the one hand the need for a rational principle and on the other, the higher influence of historical and artistic poetic purpose... It was

FAÇADE DER THÜRME.

GRUNDRISS.

KIRCHE AUF DEM WERDERSCHEN MARKT IN BERLIN.

Karl Friedrich Schinkel, final proposal for the Friedrichswerdersche Kirche in Berlin, 1830.
Sammlung architektonischer Entwürfe, vol. 13, 1829. Oslo School of Architecture and Design.

82

PERSPECTIVISCHE ANSICHT DES INNEREN DER KIRCHE AUF DEM WERDERSCEN MARKT IN BERLIN.

not difficult to realize that the relationship between these highly diverse principles had to be different in each case."[56]

What are the preconditions for an authentic architectural style, Stier asked. That depends, was Schinkel's answer. Schinkel's eclecticism was a situational and contextual one, operating, as Cicero instructed, according to occasion. In that sense, his notion of style had more in common with the decorum-based tradition from classical rhetoric than with Hübsch's or Winckelmann's epochal determinism. For while Schinkel on the face of it repeated the "new time equals new style" formula, he did not believe that architecture had to limit its means to the contemporary, nor that there was a single style fit for all contemporary tasks. If the architect's duty was to express a building's higher purpose, then history, technology, and artistic imagination were the "places"—topoi in the rhetorical tradition—from which the motifs for such expressions could be gleaned. Style was a matter of a situational judgment, not dogmatic revivalism, for historical associations that were appropriate for one building might be out of place in another. The fact that Schinkel completed the Friedrichswerdersche Kirche within a year of the Museum in Lustgarten (and the same year as starting the Bauakademie) testifies to this way of thinking. A public museum, charged with conveying the very idea of beauty, could best express its purpose through an updated classicism. A Protestant church, on the other hand, was most appropriately represented by northern European forms, sprung from a Christian belief and a northern building tradition. Yet neither the museum nor the church copied historical style. A mere glance at how the museum's Ionic colonnade meets a modern multi-story façade around the corner, or at the church's bold brick face with its distinctly un-Gothic ornamentation, makes it clear that the architect's aim was innovation as much as imitation. "To act historically is to bring about the new, by which history continues," wrote Schinkel.[57] His church on the Friedrichswerder represents that kind of continuity.

Alone in the Void
The German style debate of the 1830s and 1840s is extensive, but I will curb encyclopedic inclinations and end this chapter with the reading of a single text. It is a lecture given by the Berlin architect and archaeologist Karl Bötticher, titled "Das Prinzip

177

Karl Friedrich Schinkel, final proposal for the Friedrichswerdersche Kirche in Berlin, 1830. *Sammlung architektonischer Entwürfe*, vol. 13, 1829. Oslo School of Architecture and Design.

der hellenischen und germanischen Bauweise hinsichtlich der Übertragung in die Bauweise unserer Tage" (The principles of the Hellenic and Germanic ways of building with regard to their application to our present way of building), given at the Berlin Architects Association's Schinkelfest in 1846. Bötticher had just published the first part of *Die Tektonik der Hellenen*, where he presented his later so famous theory of architecture's "core form" and "art form," arguing that style was essentially an expression of the inner, structural workings of the architectural elements.[58] The insight lay at the heart of his lecture as well. Structure is the stuff of style, he proclaimed, and unless that is recognized, it makes no sense to speak of style at all. Unsurprisingly, Bötticher had little time for the contemporary style debate, which he found to be all over the place. In fact, his savage attacks on adversaries were notorious, compelling the editor of *Allgemeine Bauzeitung* to plead for reconciliation after a particularly heated exchange between Bötticher and Stier in the journal in the early 1840s.[59] Bötticher was unrepentant, spending a good part of his 1846 lecture admonishing those who failed to grasp the "true essentials" of style, namely "the structural principle and material conditions on which each [style] is based."[60] He was particularly irked by the revivalists' naive insistence that "their" style was right and the others' wrong:

By presenting one style as uniquely true and valid while negating the other, each side has abolished one-half of the history of art, thus clearly revealing a failure to understand either the style that was favored or the style that was dismissed. What was overlooked was that these two styles, even though we see them as opposites, are not opposites in the sense of being conceived or created in order to cancel or destroy each other, but opposites that are complementary and, within the vast framework of the history of art, are therefore always conceived together. They signify two stages of development that have had to run their prescribed course before a third style can see the light of day, one that will reject neither of the two preceding ones but will base itself on the achievements of both in order to occupy a third stage in the development, a higher stage than either: a third style that is destined to be produced as a matter of historical

inevitability, by the age that will follow us, and for which we have already begun to prepare the ground.[61]

The third stage would not be a patchwork of old forms but a new expression, developing logically from a new way of building, Bötticher argued. Like all true styles, it had to emerge from "a new structural principle derived from the material," for only such a principle could generate new and authentic art forms.[62] And since stone construction had long since exhausted its structural possibilities, the new style called for an entirely new material, the most promising of which was iron. Bötticher presented an elaborate analysis of how the absolute strength of iron complemented the relative strength of the trabeated system and the reactive strength of the arch, completing the stylistic-structural schema of architecture, so to speak.[63] The three systems were complementary rather than competing, he thought, forming a logical historical sequence.

Having defined his third principle, Bötticher turned to the question of originality. "[W]hy do we still cling to tradition instead of striving for an original and completely independent style?" he asked polemically.[64] Surely, a new structural principle

Karl Bötticher, Corinthian column. *Die Tektonik der Hellen*, 1844–1852. Universitätsbibliothek Heidelberg.

would logically engender a completely novel art form—an unprecedented new style? Not so, according to Bötticher. Because the art forms draw on conventional motifs to express the mute workings of the architectural members (think of the gently bending acanthus expressing the weight of the entablature on a Corinthian capital), they are inevitably part of a tradition, their motifs saturated with history.[65] Even a new structural system based on an entirely new material would have to use such conventional forms to express itself. To throw tradition overboard would therefore not only be impossible (as most of the time this historicity is not even consciously recognized), it would also be detrimental, leaving the modern human disconnected from a vast cultural continuum. "[W]e would find ourselves alone in an immense void," wrote Bötticher, "having lost all the historical ground that the past has provided for us and for the future as the only basis on which further development is possible."[66]

The nineteenth-century architect was stuck between the Scylla of false appropriation and the Charybdis of cultural isolation—an awkward place to be. What was the solution? For Bötticher, it lay in what he called "true eclecticism"—an attitude that heeded the historicity of architectural form while at the same time transforming that form in response to modern conditions. The stuff of style may well be the architectural structure, but its means of expression is history—an insight that gives a new complexity to the principle of correspondence. Bötticher agreed with Hübsch that style had to reflect the contemporary formative factors, but unlike Hübsch, he included tradition among those factors. And while the Karlsruhe architect—in theory at least—sought to rid architecture of conventional ornaments and motifs, Bötticher considered such motifs vital to the legibility of architecture. In that sense he was more akin to Schinkel than to Hübsch, though he arrived at his conclusions by a very different route. Both Schinkel and Bötticher resisted what might be described as the "epochal solitude" imposed by the principle of correspondence, whereby each era was fundamentally on its own. Insisting on architecture as a transhistorical rather than an epochal product, they defied the logic of the period style.

Toward the end of his long and aggressive harangue Bötticher turned unexpectedly lyrical, using a fresco in the Vatican, Raphael's *The Cardinal and Theological Virtues*, to illustrate the paradoxes of style. What had caught his imagination was the

Raphael, allegory of Prudence. Detail of the fresco *Cardinal and Theological Virtues* on the south wall of the Stanza della Segnatura in the Apostolic Palace of the Vatican, 1511.

depiction of Truth, or Prudence, as the figure is usually identified. Young and beautiful, Truth turns her face toward the mirror of present reality. Yet at the back of her head is another face; an old man gazing into the past, which is at the same time "the source of all that exists" and "a foreboding of a future state."[67] For Bötticher, the image was an allegory of architectural style. Architecture, he hinted, is inhabited by history, mirroring not only the present but all times past. For all its innovations, architecture inevitably remains tied to tradition, lest it become illegible and alone in the void.

6 *My Kingdom for a Style*

A highpoint (or lowpoint, depending on one's disposition) in the German style debate came in the early 1850s, in what must be one of the more surreal episodes in modern architectural history. In it, the historian Eberhard Drüeke writes, all aspects of nineteenth-century style thinking came together "as in a kaleidoscope."[1] And just like the kaleidoscope tends to distort its shapes and forms, this event amalgamated philosophical speculation, political aspiration, and the will to style in a dazzling but confusing mix.

The episode in question is King Maximilian II of Bavaria's competition for a new architectural style, announced in 1850. For later generations of architectural historians, the king's competition became a byword for "bad" eclecticism; proof of the inauthenticity ("Lügenstil" was a favorite label) of nineteenth-century architecture. Yet Maximilian's attempt to "find a path by which our architecture might attain the characteristic stamp of our

time," as his biographer put it, was not only a bold and in a certain sense heroic endeavor, it also constituted a fraught, fascinating, and eminently revealing moment in the history of architectural style.[2] —My kingdom for a style!, Berlage would write in 1905.[3] Here we have an actual king putting his royal authority on the line for the sake of style.

Maximilian II, son and successor of the great patron king Ludwig I, had long nurtured an interest in architecture. As a young prince he refashioned the medieval castle Hohenschwangau into something of a Gothic fantasy, and persuaded his otherwise classically minded father to build him a Gothic palace in the middle of Munich. It was no surprise, then, that Maximilian displayed considerable architectural ambition on succeeding Ludwig I in 1848. He came well prepared. Since the early 1830s he had corresponded with authorities in the field, seeking guidance on understanding architecture past and present. "Must one—in order to create something appropriate in architecture—always exclusively follow a pure style, or is it permitted for a creative soul to choose from the best of various [styles] in order to create something original?" he asked Ludwig Schorn in February 1833.[4] Schorn, unsurprisingly,

August Voit, *Vedute eines Platzes im Maximilianstil*, 1850. Architekturmuseum TU München.

 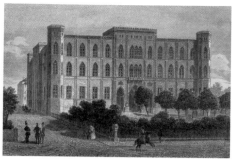

Schloss Hohenschwangau, rebuilt by Domenico Quaglio for Prince Maximilian, 1833–1837. Johann Poppel after Domenico Quaglio, 1842. bpk/Bayerische Staatsbibliothek.

Friedrich Gärtner, the Wittelsbacher palace in Munich, built as the crown prince's residence, 1843–1848. Engraving K. Gunkel, private collection.

hated the idea of creative selection, declaring that different stylistic elements could not be combined at will but could only be united organically by the hand of the genius.[5] Obviously not satisfied with this response, the prince turned to Schinkel, who was at the time busy designing a royal palace on the Acropolis for Maximilian's brother Otto, recently crowned king of Greece. Is there a true ideal for architecture, Maximilian asked, and did such an ideal exist for the ancient Greeks?[6] Schinkel's answer was polite but hesitant— the art historian Hermann Bauer calls it a Solomonic but unoriginal answer to an un-Solomonic but original question:[7]

> The two questions... can only generally be answered thus, that the ideal in architecture is only fully achieved when a building perfectly corresponds to its purpose, in all its parts and as a whole, and in a spiritual as well as in a physical respect. From this it follows that the striving for the ideal will at any time be modified according to the new demands that arise. The beautiful material which the different epochs have prepared for art lies partly close to, partly further away from the demands of the present, and its application must consequently be modified in various ways. Entirely new inventions may be required in order to achieve the goal, for in order to produce a truly historical work, the historically completed cannot be repeated, for no history is produced in that way. It is necessary to create something new which has the capacity to allow a real continuation of history.[8]

Solomonic or not, Schinkel's historicist mini-manifesto was a decisive departure from idealist universalism, embracing the relativity of historical expression and the possibility for change and innovation. Maximilian listened carefully. But where the architect searched for the new through creative practice, the prince took a more theoretical approach. The difference became particularly apparent in the winter of 1839, when the prince wrote to ask how Schinkel viewed "the possibilities for a new style." Again, the architect hesitated. Any work of art worthy of its name must contain something new, Schinkel held, yet exactly what this newness consists in "cannot be put into words" but must be explored through practice. "It remains the safest way to look out for a talent, who through unremitting practical work may achieve some degree of perfection, while at the same time leaving an opportunity for the style to achieve its perfection in the future," Schinkel recommended.[9] It was advice Maximilian did his best to heed.

Short, sharp questions directed at select experts became Maximilian's *modus operandi*. He flung them out with great urgency. —Must one build in a pure style or is it possible to mix and match?[10]—Are the basic forms of architectural construction given once and for all?[11]—Were ordinary houses in the Middle Ages built in the Gothic style?[12] And most important of all—Is it possible to achieve a new style, and if so, how?[13] The questions were posed to Munich architects such as August Voit, Georg Friedrich Ziebland, and Leo von Klenze, as well as historians like Schorn, Friedrich Thiersch, Wilhelm Heinrich Riehl, and Leopold Ranke—the latter two exercising a particularly strong influence on Maximilian. The prince's queries were not confined to local circles. He wrote to Theophil Hansen in Vienna, Heinrich Hübsch in Karlsruhe, Carl Schnaase in Düsseldorf, and Friedrich Hitzig as well as Schinkel in Berlin. And if the answers he got were rarely as succinct as his questions, Maximilian turned the question of architectural style into an urgent political, philosophical, and historical problem.

For although Maximilian was interested in architecture, he was even more passionate about history, a discipline he pursued through serious academic studies. At the university of Göttingen he studied with Arnold Heeren, whose Winckelmann-inspired take on style was touched on in chapter 2. In Berlin, he attended the lectures of Leopold Ranke, who became a close friend—a relationship that would fundamentally shape the prince's thoughts

188

on epoch and style. For Maximilian, as for Ranke, history was a philosophical and a political issue, pertaining to the future as much as to the past. Not least, the prince considered history a means to heighten the Bavarian national consciousness, a crucial part of his effort to make Bavaria a cultural and political center on a par with Prussia and Austria. The fact that he had been brought to the throne by an uprising (the conservative Ludwig was forced to abdicate in 1848) undoubtedly intensified Maximilian's resolve to defuse revolutionary tendencies by cultivating a new nationalist sentiment.[14] History was essential to this project, as was architecture, for in the king's mind, the new strong and stable Bavaria was to be consolidated by means of national history and manifested by means of style.[15] The "Invitation for a Prize Competition for the Plan of a Building Destined for an Institution of Higher Culture and Instruction," issued by Munich's Royal Academy of Fine Art in the autumn of 1850, bore out all those ambitions.

Agent of Time

While the king's stylistic interests may have been more philosophical than practical, the competition brief did heed Schinkel's warning that a new style must emerge through practice. The brief was for a very real building; an institution for higher education, complete with lecture halls and laboratories, chapel and library, dormitories, instruction rooms, kitchen facilities, and accommodation for staff; even a swimming pool. It was to be situated on the east bank of the Isar and be connected to the city by a new bridge. The competition brief is worth quoting in full:

> In no field of the visual arts has the striving for a new
> development—answering to nature as well as the time
> and characteristic of people as well as place—asserted
> itself in such a decisive and noticeable way as in the field
> of architecture. However, our architects have taken very
> different directions and paths in order to achieve their goal.
> While some seek salvation in an unconditional surrender to
> the classical forms of the Greeks and Romans; in the cheerful
> and ornate façade style of the Renaissance, or even the
> baroque clumsiness of Rococo, others insist on a pure revival
> of Romanesque or Gothic architectural style as the sole
> precondition for a national architectural rebirth. Still others

try to create a new style, merging elements and peculiarities from the various styles so as to create the foundations for a hitherto unseen design.

Whether the latter is at all possible—whether the aspect characterizing our time, which struggles for an organically fulfilled form uniting all the life conditions and vital forces of the nation, will also benefit architecture—will only become apparent with the passage of time.

However, in order to give contemporary architects a new cause and opportunity to participate in the present struggle for a national reshaping of architecture, according to their inclinations and talents, a free competition will be held under the auspices of His Majesty the reigning King Maximilian of Bavaria for the preparation of a plan for a higher education and teaching institution according to the program and provisions specified in the following.

The undertaking is based on the conviction that the purpose in question can only be achieved through a practical task of appropriate worthiness and size This is because the construction of a building, in which the full appearance of the character of the time attains its understandable and unmistakable expression, may bring forth the ideas and aspirations of the present. It may at the same time embody the experience of past architecture, the astonishing advances in technology, the entire historical accumulation of constructive and ornamental models, the extraordinarily expanded field of material—use them with unlimited freedom, appropriate to both the purpose and the character of the building and with the greatest possible economy of means—an effort that should undoubtedly have the most beneficial consequences for the future of architecture.

If the architect is completely filled and absorbed by the full content of his task—by the idea of the building and its intended purpose—and if he understands how to bring architecture's basic technical conditions—that is, purpose... plan, situation, climate, and building material; the elements and ornamental effect with respect to the construction—into living harmony with the higher ideas and to combine practical purposefulness and cheerful comfort with simplicity and beauty, then he cannot fail to create a building that forms a complete, expressive, and beautiful whole.

However, while there are no constraints imposed on the competing artists, and while it is particularly desirable that they use the most diverse architectural styles and their ornamentation in full freedom to solve the task at hand so that the chosen style does not belong exclusively and specifically to any known architectural style, it should not go unremarked that, since this is about a building in Germany, in line with German sensibilities and interests, it might seem expedient to apply the principle of the old German, so-called Gothic, architecture and not entirely overlook the possibility of using German animal and plant forms in the ornamentation.

In addition, it should be noted that the sister arts of painting and sculpture ought to be thoroughly incorporated into the architectural sphere, so that with their help a monument of art and education is created—significant in all its parts and characteristic of the present—in which—in accordance with its purpose and the spirit of our time, with its spatial arrangement as well as its material-formal implementation—everything frosty, heavy, gloomy, and strict is avoided, while the light and cheerful sway of forms is given ample opportunity to develop.[16]

The brief was, as the historian August Hahn notes with a touch of understatement, "unusual."[17] The new style, it seemed, should be new yet old; original yet tradition-bound; free yet adhering to medieval precedents. No wonder architects did not quite know what to make of it. The call was printed in German, French, and English and distributed internationally to architects in France, England, Switzerland, and Denmark, as well as across Germany.[18] It was received with bewilderment. *The Builder*, for instance, wondered whether the call was entirely sure of what it called for, given its contradictory oscillation between innovation and revivalism.[19] To alleviate the confusion, the Munich Academy found it necessary to issue an explanatory note shortly after the competition launch. "Erläuternde Bemerkungen in Bezug auf das architektonische Preisprogramm" did not actually clarify much, but added some notable points of its own, including an astonishingly progressive philosophy of architectural style. The human spirit strives for innovation, the reader was told, and the task of contemporary architecture is to create

a new style. But it was on the question of how such a new style might come about that the Bemerkungen were most revealing:

> We no longer live in the time of unconscious, natural creation in which the earlier forms of building emerged. Rather, we live in an era of thinking, of research, of self-conscious reflection. To aid the solution of the set task, it may be appropriate here to hint at certain aspects that have influenced the architecture of various countries, and continue to do so.[20]

Rather than the intuitive approach of previous epochs, the present had to create style in a strictly scientific way. To that end, the Bemerkungen provided a list of aspects influencing style. It started inconspicuously enough. Climate and materials, the physiognomy of the landscape (Riehl's favorite topic), the technological state of the art. But above all the Bemerkungen emphasized the contemporary zeitgeist, which it found characterized by "the yearning for liberty, free development, and the unrestricted exercising of all physical and moral powers."[21] This free spirit has all previous epochs and styles at its disposal yet must first and foremost respond to the demands of the present. Today's political and social conditions are different from previous eras, the text argued, and given that architecture is rooted in such conditions, the modern era "allows for the emergence of quite different buildings than before."[22] The author added that lively ornamentation (preferably inspired by German flora and fauna), as well as experiments with colored glass and iron, were encouraged as long as they were not too costly, for the new style required the "greatest possible economy of means."[23]

The combination of zeitgeist hyperbole and cost-saving advice makes the Bemerkungen an amusing read. But the intention was serious enough. Insisting that the new building had to give "a comprehensible expression of the characteristic totality of the time"; that it had to embody all the ideas and desires of the present and utilize all the possibilities granted by modern progress, the competition call outlined a historicist utopia marked by a perfect correspondence between the epoch and its style. Using catchphrases from 1848 (freedom, development, *Zwangslosigkeit*), it framed architecture as the representation of an ongoing process of spiritual and historical liberation by

192

which the modern epoch would be fully realized. The king—momentarily represented by his architect—had become a true agent of the zeitgeist.

The Zeitgeist and Its Quirks

The competition call triggered debate and criticism both in the press and in intellectual circles. Even Maximilian's own advisors were skeptical. When the king wrote an enthusiastic letter to his favorite philosopher Friedrich Schelling in April 1852, raving about the competition and enclosing a copy of the call, he received a surprisingly forthright reply.[24] Schelling had a hard time imagining what such a new style might be, he wrote. Given that the Greek and the Gothic were antithetical, the new must lie somewhere between them, rather than beyond. Besides, the call was so confusedly written that the philosopher could make neither head nor tail of its "vacuous phrases." In particular, he was bewildered by the claim that the new building was to represent and embody the zeitgeist:

> He [the author of the call] demands, among other things, an architectural work "in which the full appearance of the character of the time (by which is understood the present) attains its understandable and unmistakable expression." Assuming that our time really had a character, and one that would be worthy of being expressed architecturally, this would express itself by itself and be consciously manifested in contemporary buildings, requiring no invitation or preconception. However, if the character of our time consists in having *no* character, the building corresponding to it, if it is true to its time, could only provide an image of perfect spiritual and moral disunity. This would certainly be a new architectural style, but one of which I have no concept.[25]

Apologizing for his negative response, Schelling tried to make up by wholeheartedly supporting the competition's practical purpose, the educational institution. This was an undertaking that would no doubt give honor to both king and country, he thought, but it was far too noble a cause to be sullied by the "random and inappropriate" brief.[26]

If the king was rattled by Schelling's criticism he must have been equally upset by the reception in the press. Influential

journals such as *Deutsches Kunstblatt* acknowledged that the competition raised important questions but remained far from convinced about the suggested answers.[27] The Augsburg-based *Allgemeine Zeitung* published a series of critical articles on the matter, questioning both the possibility of a new style and the proposed method for achieving one. The brief proposed nothing new, only a new mix, claimed an anonymous author in March 1851, mocking the fancy talk of amalgamation (*Verschmelzung*) when all that was proffered was an unprincipled jumble of styles.[28] A new style cannot be made but must emerge organically, the writer maintained, urging architects to take a more concrete and structural approach to the question of style.[29] An even more ferocious diatribe appeared in the same newspaper the following year, in a commentary that questioned the very logic of Maximilian's zeitgeist thinking. The competition program had got it all wrong, argued the author. Style cannot be made overnight and to order as the brief suggested. Rather than a representation of the zeitgeist, style is simply the result of centuries of lived life. And as such, it cannot be invented:

> For the architectural style of a nation is not its image, its imitation, and also not an allegory, but its child, its fruit, one of its deeds.... In short: a building is not made in this or that way *in order to* reflect the time of its creation and the nature of its people—rather, one recognizes both from it *because* it is made in that way! Harmony with time and people is not an aim, but a consequence![30]

The competition's quest to represent the zeitgeist is a fundamental misunderstanding, the author argued—like putting the cart before the horse. Figure out the needs of the present and style will follow—not as a manifestation of an elusive zeitgeist but as the very real and concrete outcome of a particular way of life. Besides, he added with a twinkle in his eye, the zeitgeist does not make itself readily available for representation: "it has its quirks, it does not yield to just any architect, and it can go for a long time without doing a single thing."[31]

This sharp and witty analysis of historicist zeitgeist thinking is pretty unique in the nineteenth-century style debate, and I would give much to know who wrote it. Presumably Maximilian's

Munich circle felt the same, as they struck back against the anonymous critic in two long articles in the *Allgemeine Zeitung*.[32] Denouncing the criticism as "unfruitful" and reciting long passages from the competition brief to prove its consistency, the Academy secretary Rudolf Marggraff managed neither to clarify the brief's position nor to tackle the logical challenge posed by the anonymous article. But he did expand interestingly on the notion—proposed in the Bemerkungen—that the contemporary architect could no longer create intuitively, but only by means of research and reflection:

> The basis of any such unconscious and natural style creation has been pulled from under our feet, due to the extremely entangled nature of our public conditions, reduced to cold reflection or freebooting arbitrariness. Today the individual forms, as it were, a world unto himself; he no longer recognizes himself as a necessary... part of a larger community, and is no longer so unconsciously and irresistibly penetrated by the spirit that animates and drives perceptions, inclinations, and activities.[33]

Marggraff put this apt diagnosis of the modern experience—which anticipated Ferdinand Tönnies's *Gemeinschaft und Gesellschaft* by more than three decades—to immediate architectural use.[34] The modern architect no longer acted in accordance with his time but in accordance with himself, the Academy secretary lamented; a disconnect that had to be rectified by a scientific analysis of the present conditions. The competition would provide the opportunity for such an analysis to take place, and its result would hopefully amount to that "sum total of the entire life of our time and our people" that the anonymous critic had called for.[35] If the contemporary era was suffering from fragmentation and isolation, a new style was to put the modern *Gemeinschaft* back together again.

Maximilianstil
In a certain sense, Maximilian's competition resembles the "parallel action" in Robert Musil's *The Man without Qualities*: a wildly ambitious cultural effort that bore very little fruit. After several postponements, the deadline for the final submission was set for June 1, 1852. A full overview of projects and authors no longer

Wilhelm Stier, competition project for the parliament in Pest (1846–1847).
Architekturmuseum TU Berlin.

exists, but Hahn presents a list of seventeen projects (some identi-
fied by name, others just with a motto) and mentions several other
contributors, among them Friedrich Wilhelm IV of Prussia.[36] Given
its ambitious reach and the fact that the more or less contemporary
competition for the Great Exhibition in London had attracted two
hundred and forty-five proposals from all over the world, the scant
participation must have been a disappointment. The jury (Klenze,
Voit, and Ziebland from Munich; Hübsch, Friedrich Stüler, Carl
Heideloff, and Ernst Zwirner from elsewhere in Germany, as well as
Franz Christian Gau and Jakob Ignaz Hittorff from Paris, and Edu-
ard van der Nüll from Vienna) did not shy away from submitting
projects or even distributing prizes among themselves; Voit and
Ziebland both got purchased.[37] The results were not announced
until spring 1854, when the jury awarded the first prize to the stylis-
tically liberal Wilhelm Stier. The winning project, submitted under
the motto "Labor quoque voluptas est" (work is also pleasure), is
lost, but if Stier's other competition projects from the same period
are anything to go by, it provided precisely that "cheerful sway of
forms" that the program had asked for.

Contemporaries described Stier's proposal as a rich neo-
Gothic building, "striving for the unusual" but displaying consid-
erable talent.[38] Leo von Klenze praised Stier's accomplished plans
but criticized his eclectic use of style, jumbling together elements
from different epochs.[39] The winning entry constituted neither

196

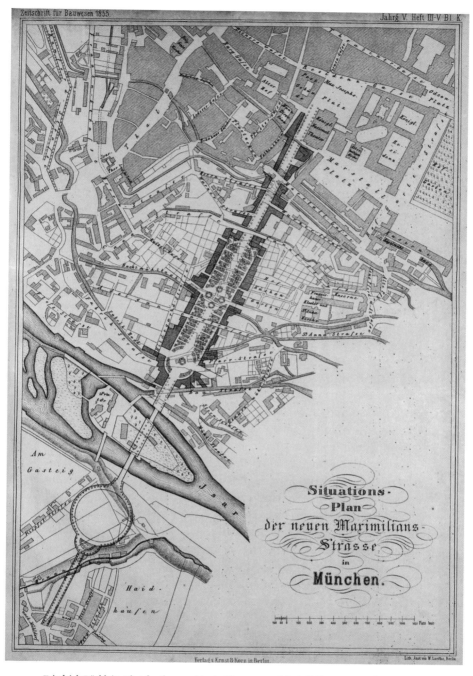

Situations-
Plan
der neuen Maximilians-
Strasse
in
München.

Verlag v. Ernst & Korn in Berlin.

Lith. Anst von W. Loeillot, Berlin.

Friedrich Bürklein, plan for the new Maximilianstrasse. *Zeitschrift für Bauwesen*, 1855.
Bayerische Staatsbibliothek

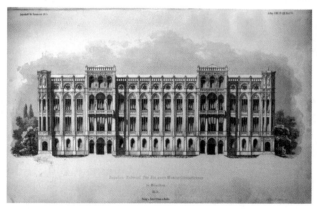

Friedrich Bürklein (top two) and Rudolf Gottgetreu, façade proposals for Maximilianstrasse, *Zeitschrift für Bauwesen*, 1855 (Atlas). Zentral- und Landesbibliothek Berlin.

a new style nor a credible building, Klenze held, for its excessive embellishment made it both too costly and too cumbersome to build. He was right: Stier's project remained unrealized. It was probably never even intended to be built, for while the competition dragged on, Maximilian was making quite different arrangements for his "great national building on the Isar Heights."

From the early 1830s on, Prince Maximilian had dreamt of creating a monumental avenue rivaling his father's Ludwigstrasse.[40] As the competition for a new style was being launched in the autumn of 1850, he revived the idea, inviting Friedrich Bürklein— architect of Munich's recently completed main station—to prepare plans for the new street. Bürklein submitted plans "Regarding the Beautification of Munich" on March 4, 1851, showing a grand new avenue running east from the royal residence to a new "Acropolis" across the Isar—the institution for which the competition had just been announced.[41] In the middle of this 1.3-kilometer stretch was a grand forum with parks, fountains, and important public buildings. The project was revised several times, but urban works commenced in July 1853, and construction of the street's first building began the following year.[42] Maximilian had prepared detailed instructions for the architecture of the new street, inviting five Munich architects (Bürklein, Voit, and Ziebland as well as Rudolf Gottgetreu and Eduard Riedel) to develop model façades. The guidelines borrowed freely from the 1850 competition brief:

> The highest aspiration when establishing a timely and
> artistic architecture is that the new buildings will have a
> contemporary character marked by practical functionality,
> comfort, simplicity, beauty, and nationhood. Consequently,
> the proposed model façades must avoid everything that is
> frosty, heavy, and strict.... It follows that the new buildings
> cannot be derived from any of the existing architectural styles
> or from actual buildings, but must be built independently,
> in accordance with local climatic conditions and existing
> building materials, using advanced technology such as the
> processing and application of colored and enameled glass,
> porcelain enamel, terracotta, cast iron, et cetera.[43]

Though the king encouraged innovation, the five contestants based their proposals on neo-Gothic forms. Bürklein's ornate yet economical proposals won the king's favor and became the

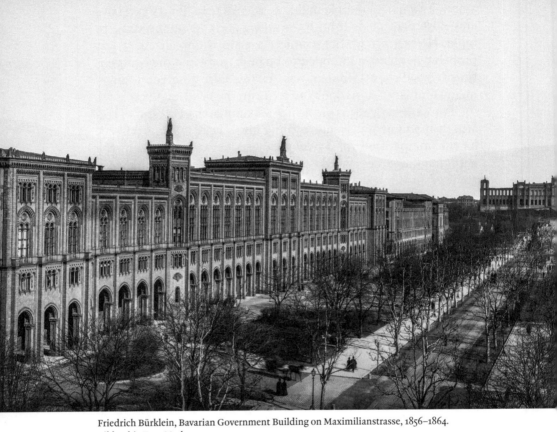

Friedrich Bürklein, Bavarian Government Building on Maximilianstrasse, 1856–1864.
Bildarchiv Foto Marburg.

stylistic prototype for the new street.[44] Private buildings were regulated by the "Grundbestimmungen für die Ausführung von Privatbauten in der Maximilianstrasse und deren neuen Seiten-strassen" (1854), while the public buildings were designed by the king's own circle of architects and kept under close royal control. Maximilian had high hopes for the public institutions on the forum, seeing them as a potential realization of the new style. In November 1856, the foundation stone for the Bavarian govern-ment building was laid, a 175-meter-long neo-Gothic façade on the north side of the forum, this too designed by Bürklein. Despite its clear historical references, the modularity, slenderness, and scale of the main façade gave it a repetitive, almost industrial character that looked surprisingly modern. Facing the government build-ing across the forum was the Bavarian National Museum (today

200

Museum Fünf Kontinente), a central ingredient in Maximilian's attempt to consolidate the nation through humanist *Bildung*. A somewhat clumsy building with a dash of Tudor, the museum was designed by Eduard Riedel. Maximilian dedicated it to "Meinem Volk zu Ehr und Vorbild," hoping its form as well as its content would imbue a new sense of Bavarianness.

The grandest of the public projects on the Maximilianstrasse was the Isar Heights monument, to which the 1850 competition had been dedicated. During its protracted gestation it took many names—the Athenaeum; the Acropolis; later the Maximilianeum—but its purpose remained the same: to crown the new street and act as a symbolic focal point for Maximilian's national efforts. Despite the competition, the king seems to have had no intention of building Stier's winning project. Instead, he once again commissioned Bürklein, who in 1857 started the construction of a grand neo-Gothic structure. It was a tricky task. "Extraordinarily difficult to conceive of a building form that signifies what is new and characteristic of its time!" Bürklein sighed in 1858, battling an indecisive king, a critical public, galloping costs, and major difficulties with the foundations.[45] Shortly before his death in 1864, the king made things even more complicated by insisting that the main façade be altered to a round-arch Renaissance style—a change that added to the already considerable delays. Only in 1874 was the Maximilianeum finally finished, housing, in addition to the king's educational facility, a historical gallery, open to the public.[46] With its wildly monumental 150-meter-long façade, consisting in large part of arcaded screens, the Maximilianeum has become a symbol of historicist vacuousness. Jacob Burckhardt called it a "cardboard concoction" (*Kartonmachwerk*) and generally lamented the Maximilianstrasse's "miserable Gothic."[47] Gottfried Semper—who had his own troubled encounter with the Bavarian royal house when he was commissioned (or so he thought) to design an opera house for Ludwig II a few years later—considered the whole thing an embarrassment.[48] Maximilian's early demise saved him from being exposed to the harshest of these verdicts, but even during his lifetime the attempt to invent a new style came in for serious criticism. Yet the king did not budge; he pursued his dream of a new style right up to his death. What made him so determined?

At least part of the answer may be found in a series of lectures given at the behest of the king in the autumn of 1854, just a few

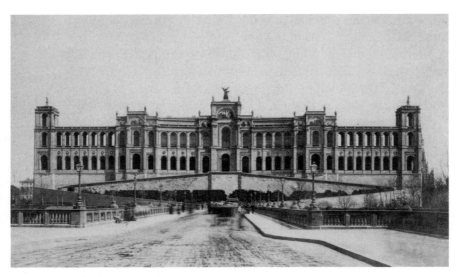

Friedrich Bürklein, Maximilianeum, Munich, 1855–1874. Bridgeman Images.

months after the competition for a new style was finally concluded. Maximilian invited his old friend Leopold Ranke (who had not yet acquired his noble "von") for an extended stay in Munich. Ranke's lectures—nineteen in total—were given at Maximilian's legendary evening symposia and later published as the collection *Über die Epochen der neueren Geschichte.*[49] The topic went right to the heart of Maximilian's grand plans. His obsession with style was all about the epoch: a dream to transform a fragmented modernity into an organic and coherent age manifested by an organic and coherent style. Ranke gave him the philosophical apparatus to defend it.

A world history in miniature, Ranke's lectures revolved specifically around the autonomy of the epoch. Dismissing the idea of progress as a historical principle, Ranke held that each epoch forms an inviolable whole, marked by its own particular character and in principle incommensurable to any other. As he famously put it:

> [E]very epoch is immediate to God, and its worth is not at all based on what derives from it but rests in its own existence, in its own self. In this way the contemplation of history, that is to say of individual life in history, acquires its own particular attraction, since now every epoch must be seen as something valid in itself and appears highly worthy of consideration.[50]

Engelbert Seibertz, *Die imaginäre Einführung Alexander von Humboldts in einen Kreis berühmter Männer aus Kunst und Wissenschaft*, 1857. Fresco in the Academy Room of the Maximilianeum. Bayerischer Landtag.

Each epoch is governed by a "certain great tendency" which allows distinctive cultural expressions to emerge, Ranke held.[51] It is a spiritual unity, tied together by a common bond that unites every event, object, and action. Architectural style is an expression of this epochal character; Ranke spoke for instance about Gothic style as a symbol of medieval religiosity and hierarchy.[52] Yet the historian was no determinist on behalf of the zeitgeist. Human nature is so complex and diverse that each epoch harbors an infinite number of possible developments, he said.[53] Innovation is possible, and no time is confined to repeating past epochs' achievements.

Ranke's notion of epochal integrity and the possibility of innovation became the basis for Maximilian's thinking on style. Perhaps one could say that he took Ranke's concept of the epoch and put it into operation as a political and aesthetic project. In the so-called Academy Room of the Maximilianeum is an image that sums up his ambition. Engelbert Seibertz's 1857 fresco, a kind of Bavarian *School of Athens*, portrays "The imaginary introduction of Alexander von Humboldt into a circle of famous men from the arts and sciences," or more specifically the recipients—actual and imaginary—of the Maximilianorden, the king's highest order for academic and artistic merit. Ranke, Schelling, and Thiersch feature prominently; Klenze and Kaulbach (who painted Ludwig I's legendary style battle in front of the Glyptothek), too,

are given central positions, as are chemists, geologists, composers, and representatives of numerous other fields. But where is the king? Given Maximilian's love of academic company you would think he would be centerstage. Yet he is nowhere to be seen, at least not in person. The king's presence is unmistakable, however, represented not by a human figure but by a building. Looming over and beyond the proceedings is the Maximilianeum—still in its neo-Gothic version—its arcaded wings embracing the scholarly community.[54] Monument to a reborn nation, the Maximilianeum was to forge the intellectual and artistic forces of not only Bavaria but the whole of Germany into a new spiritual unity, embodied by means of style. "When one has the desire, the will, and the ability to do something significant in one's own time, must one not first understand the time—clarify the task itself and comprehend the particular direction of the period—in order to realize the task at hand?" Maximilian asked with poorly disguised ambition after Ranke's final lecture on the French revolution.[55] He spoke for himself. In his own personal parallel action, Maximilian was determined to do something significant and timely—he just wasn't quite sure what style it would take.

7 *Style in the Making*

"**S**tyle theory is not art history," stated Gottfried Semper in the first volume of *Der Stil in den technischen und tektonischen Künsten, oder Praktische Aesthetik* from 1860.[1] If style since Winckelmann had been understood as the fingerprint of the epoch and a key to art historical periodization, Semper understood it as a far more complex phenomenon, deeply ingrained in the creative process. Dismissing the epochal determinism latent in so much nineteenth-century thinking on architectural style, he located style in the acts and processes of making, seeing it as a principle of continuity and transformation that linked a work, not to one time and place, but to many. Organizing *Der Stil* by ways of making rather than by chronology and epoch was a logical consequence of that dismissal. Semper never completed his grand theory of style, leaving future readers with a convoluted and at times contradictory body of work. But in the midst of his wild conjectures, his prickly critique, and his obsessively detailed analyses of everything from rubber technology to the finer techniques of crochet, lie clues for a radical rethinking of architectural style.

"Roman silk fabric from Sion, Switzerland." Gottfried Semper, *Der Stil in den technischen und tektonischen Künsten*, 1860.

Semper came to maturity as an architect and scholar in parallel with the German style debate of the 1830s and 1840s, and followed it closely. He loathed it. German architects had obsessed more over style than anyone else, he acknowledged, yet the result was nothing but Babylonian confusion, both in theory and in practice.[2] And although Semper—just like Maximilian II—had studied history in Göttingen with Arnold Heeren, he did not embrace the historian's style concept. On the contrary, Semper distrusted epochal style as a historiographical principle, lamenting the style historians' pedantic separation of architectural history into isolated epochal units.[3] "Would it not be better and more useful to stress the ascending and descending integration of a work of art into its surroundings and with its accessories, rather than always to distinguish and divide?" he asked.[4] When it came to architectural practice, Semper was even harsher. He mocked the "chorus of private style inventors, who shine their cheap inventive spirit on every large and small residence," and despised "tourist architects" cramming their notebooks full of copied details in the hope of recreating a "Walhalla à la Parthenon, a basilica à la Monreale, a boudoir à la Pompeii."[5] Semper himself believed neither in style invention nor in style revival but rather in style as an

ongoing reinterpretation of inherited modes of making. "Style is the accord of an art object with its genesis, and with all the preconditions and circumstances of its becoming," he stated in a late lecture.[6] Much of his scholarly life was spent trying to understand those preconditions.

Despite dedicating large parts of his scholarship to the question of style, Semper rarely defined it explicitly. One of his first attempts to do so reads as follows:

Among the notions that the theory of taste has taken pains to formulate, one of the most important is the idea of style in art. This term, as everyone knows, is one for which many interpretations have been offered, so many that skeptics have wanted to deny it any clear conceptual basis. Yet every artist and true connoisseur feels its whole meaning, however difficult it may be to express in words. Perhaps we can say:

Style means giving emphasis and artistic significance to the basic idea and to all intrinsic and extrinsic coefficients that modify the embodiment of the theme in a work of art.

Title page of the first volume of Gottfried Semper's *Der Stil in den technischen und tektonischen Künsten*, 1860. Private collection.

Textile techniques. Gottfried Semper, *Der Stil in den technischen und tektonischen Künsten*, 1860.

According to this definition, absence of style signifies the shortcomings of a work caused by the artist's disregard of the underlying theme and his ineptitude in exploiting aesthetically the means available for perfecting the work.[7]

The quote gives a condensed introduction to Semper's style theory. Revolving around the notion of the basic idea (he referred to it also as Urtype; theme; motif; and—closely related—the "basic element(s) of architecture"), Semper outlined a process by which certain primordial motifs run through the history of art and architecture, constantly modified according to new conditions, yet always present.[8] These were not conventional architectural elements, but rather material and formal constellations gleaned from the applied arts: the woven enclosure, the ceramic bowl, the wooden frame, etc. It was a way of thinking that demoted architecture from its traditional position as mother of the arts to their bastard offspring, but that was just one of its radical

212

Lycian tomb. Gottfried Semper, *Der Stil in den technischen und tektonischen Künsten*, 1860.

implications. Even more interesting is the way Semper's motifs anchor any work of architecture in (pre)history via a long process of transformation. "The primordial motif in a work of art, however removed it may be from its point of origin, pervades the composition like a musical theme," he wrote, setting out to study precisely that modulation.[9]

An example. The first enclosure was the woven wickerwork fence, Semper famously asserted, and the technique of weaving echoes in all later enclosures. At first, the woven enclosure was present directly, as in the wickerwork hut or in the ancient custom of covering loadbearing walls with carpets. Later, the textile motif of enclosure metamorphosed into wood, stone, or metal panels; was recreated in mosaic and stucco or reinterpreted in wall paintings. "The history of wall Decoration in all its phases begins and is based upon this fundamental motif of carpet making," he concluded firmly in one of his London lectures.[10] *Der Stil* is full of detailed analyses of such metamorphosis. When for

instance the ancient Lycians in what is today southern Anatolia built their tombs as tent-like structures on rectangular plinths, they imitated and transformed a previous custom of erecting carpet-covered funeral pyres in wood. The pyres, in turn, echoed the primordial motif of enclosure, which in turn again sprang from the ritual act of defining and protecting a sacred interior. The Lycian tombs were the "funeral pyre monumentally reconceived," as Semper put it; they were products of an age-old metamorphic process in which not only the carpet-covered pyre was transmuted into stone, but where the entire sequence from ritual, via ephemera, to building was given a monumental articulation.[11] To Semper, the Lycian tomb was *Stoffwechsel* caught in the act, capturing a decisive moment in the evolution of the artistic motif. The inner logic of that process was what he called style.

According to Semper's definition, style was the articulation of a basic idea, but also an expression of "all intrinsic and extrinsic coefficients that modify the embodiment of the theme in a work of art." This may sound familiar: Winckelmann, too, operated with style's inner and outer factors, which by the 1850s was a well-established binary. Semper gave it a twist, however, for his intrinsic coefficients encompassed not natural factors such as climate but rather the work's purpose or idea, its materiality, as well as the tools and techniques that had produced it.[12] In the case of the Lycian tomb, that meant first and foremost its practical and symbolic function as a burial place and the formal and technical possibilities granted by the material sequence from textile and wood to limestone. The intrinsic factors also included what Semper called *Gestaltungsmomente*: formal laws such as symmetry, directionality, and proportion that govern all physical phenomena, including works of art.[13] The tomb's symmetrical gables and tapered base conformed to such laws, Semper thought, making it a manifestation not only of a particular purpose and materiality, but also of fundamental aesthetic principles. The extrinsic coefficients encompassed more historically contingent aspects; religious and political system, for instance, but also climate, topography, traditions, and customs; the skill and imagination of the artist, or the patron's particular position.[14] In Semper's theory of Stoffwechsel, the petrification of ephemera is a "gesture of localization," writes Ákos Moravánszky in his book on metamorphism in architecture.[15] The Lycian tomb is a good example of that. Modifying and

reinterpreting ancient motifs according to local circumstance, the Lycians made them their own.

The Lycian tomb turned out the way it did because of the subtle interplay between all these factors. Its purpose as a tomb tied it to ancient burial traditions—ephemeral ritual practices that had been translated into a succession of different materials in accordance with the inherent laws of form. It bore marks of weaving and joinery—the tools and techniques used in the original carpet and wood pyre—but was also shaped by the stone tools that had translated these motifs into their present petrified form. In addition, the tomb responded to the climate, topography, political system, and religious practice of fourth-century BCE Anatolia, reflecting local and regional beliefs and customs. To understand style one must study all these factors, Semper insisted, and spent much time devising a system for doing so. His conceptual apparatus would change over time. In "Science, Industry and Art" from the early 1850s, the "doctrine of style" was divided into three: the basic motifs and their historical development; their technical and material execution, and finally "local, temporal, and personal influences on form extrinsic to the work of art."[16] In *Der Stil*, less than ten years later, this had evolved into a two-part structure where each of the four material-technical "families"—textile, ceramics, tectonics, and stereotomy (with metallurgy added as an afterthought)—were discussed first in terms of their "formal-aesthetic" and then their "technical-historical" properties. That meant starting each section with an analysis of the formal laws and purposes pertaining to each group (how the string's capacity for binding things together allows it to create unity in multiplicity, for instance, and how string motifs such as the wreath consequently are structured radially), then turning to execution and historical development. Semper struggled to stick to his own structure, and as *Der Stil*'s many digressions, aberrations, and repetitions testify, he was not terribly successful.[17] The third volume that was meant to study how all these different aspects came together in architecture was never even written. Nonetheless, Semper always held on to the idea that any work of art or architecture was a product of many different kinds of factors, and he never gave up trying to understand their interaction. "Every work of art is a *result*, or, using a Mathematical Term, it is a *Function* of an indefi[ni]te number of quantities or powers, which are the variable coefficients of the embodiment of it."[18]

Semper presented his mathematical analogy in a lecture given in London in May 1853, in an attempt to explain to his audience exactly what he meant by the term style. To get his point across, he drew up the mathematical function U = φ x, y, z, t, v, w, stating that "[a]s soon as one or some of these coefficients vary, the Result must vary likewise, and must show in its features and general appearance a certain distinct c[h]aracter;—if this is not the case, then it fails for want of Style."[19] Critics—this author included—have found the "formula for style" reductive, seeing it an attempt to turn the artwork into a calculable product of a finite set of factors.[20] But Semper's intention was actually quite different. Always insisting that the coefficients were innumerable and that their interaction could never be fully known, he used the equation simply to demonstrate the complexity of artistic creation and show that a work could not be explained by means of a simple correlation between epoch and style. It was a recognition that set Semper apart from the principle of correspondence in its naive form. The difference came across in his historical analyses, but even more markedly in his ideas on contemporary architecture. Like Hübsch and his fellow "correspondence thinkers," Semper dreamt of using "*our* social needs as factors in the style of *our* architecture."[21] But unlike those who envisioned a brand new style for the new age, Semper recognized that the contemporary has a historicity of its own and that architecture can never relate to the present except via the past. Rather than confirming the principle of correspondence, Semper's formula for style actually smuggled an epoch-defying sense of history into the equation.

The Mystery of Transfiguration
With its petrified carpets and joints, the Lycian tomb was doing precisely what Semper's first style definition called for, namely "giving emphasis and artistic significance to the basic idea and all intrinsic and extrinsic coefficients that modify [its] embodiment." That was not a single-step process. Style denoted not only how ancient motifs metamorphosed into new materials, but also the way they changed when they did so—how the carpet ornaments transformed when they were imitated in painted stone relief, say, or the way the geometry of the wooden joints was altered when translated into masonry.[22] Other cases displayed even more complex chains of transformation. Semper considered

60. Gopura, Combaconum. From a Sketch by the Author.

Hindu temple at Kumbakonam. From James Fergusson, *Illustrated Handbook of Architecture*, 1855. Universitätsbibliothek Heidelberg.

Hindu temples—commonly seen as direct translations of wood into stone—examples of a multi-stage translation, from textile, via wood, stucco, and paint, before reaching their monumental appearance in stone.[23] Rejecting the Vitruvian wood-to-stone hypothesis as a gross simplification, he replaced it with a far more intricate story:

> A particular method of artistic representation is inherent in each material because each has properties that distinguish it from other materials, and each demands its own treatment or technique. When an artistic motif undergoes any kind of

Left: "Sculptured Pavement (Kouyunjik)," Austen Henry Layard, *Monuments of Nineveh II*, 1853. Universitätsbibliothek Heidelberg. Right: "Assyrian carpet pattern engraved in stone (British Museum)," Gottfried Semper, *Der Stil in den technischen und tektonischen Künsten*, 1860.

material treatment, its original type will be modified; it will receive, so to speak, a specific coloring. The type is no longer in its primary stage of development but has undergone a more or less pronounced metamorphosis. If the motif undergoes a new change of material (Stoffwechsel) as a result of this secondary or even multiple transformation, the resulting new form will be composite, one that expresses the primeval type and all the stages preceding the latest form.[24]

The Hindu temple bore out this "multiple transformation" in an exemplary manner, Semper thought, its stone form displaying all the stages of its metamorphosis. In doing so, it testified not only to material but also to spiritual and cultural practices, for the technical motifs making up its iconography (band, seam, wreath, and so on) were laden with cosmological and religious meaning. The motif's material metamorphosis retained and even actualized that meaning, allowing the work to transcend material necessity and be sublimated into a symbol. It was this Semper alluded to in his famous footnote in *Der Stil*, when he wrote about the "destruction of reality" and the need for symbolic masking.[25] Transformation, here, happens along several axes. On the one hand, motifs metamorphose from one material to another; on the other, their significance moves back and forth between the material and the symbolic, absorbing ever new layers of meaning as

218

time goes by. Semper called this process "the mystery of transfiguration," seeing it as a key to understanding the enigmatic relationship between meaning, matter, and form.[26]

One last example. In 1848, the British archaeologist Austen Henry Layard excavated the Palace of Sennacherib from seventh-century BCE Nineveh, present-day Iraq. Among the many treasures brought to the British Museum was a bas relief in alabaster thought to have been a doorsill.[27] It has stylized lotus calyxes along the edge and lotus flowers inscribed into evenly spaced squares toward the center. Semper must have known the piece both from Layard's publications and from the museum, and he examined it in minute detail. The geometricized flowers imitated the underlying order of the natural world, he thought; they may have originated in the Egyptian lotus, yet their figurative associations had long been shed. Rather than local origin, the slab spoke of basic human principles of ordering. Semper described the stylized hem as a primordial motif of completion, and the central squares' zigzag border as variants of the earliest human attempts at imitating the cosmos through rhythmic movement.[28] But what fascinated him most of all was the way the alabaster slab echoed, not just visual motifs but ways of making; techniques stemming from other times, places, and materials. The most obvious example was the way the stone relief translated textile techniques into monumental form.

"Assyrian vegetable entanglement." Gottfried Semper, *Der Stil in den technischen und tektonischen Künsten*, 1860.

Schlangengewirr an der Aspis der Athene; Museum zu Dresden. (S. Seite 83.)

"Entangled snakes on the aegis of Athena. Dresden Museum." Gottfried Semper, *Der Stil in den technischen und tektonischen Künsten*, 1860.

Snake ornaments from different cultures. Gottfried Semper, *Der Stil in den technischen und tektonischen Künsten*, 1860.

Semper described it as a "stone embroidery" and a carpet in petrified form.[29] Yet the slab echoed not only textiles but also a series of other techniques. Like the Indian craftsmen, the Assyrians did not move directly from textile to stone, but via other forms of dressing such as gilded wooden paneling and painted stucco.[30] The "Assyrian carpet" bore traces of all these stages, Semper thought, from the geometricized imitation of natural form, via embroidery and

weaving, wood carving and gilding, stucco and paint, to the final result in stone. And while this ancient lineage may not have been consciously understood by the stone carver, millennia of inherited craft traditions and motifs had given him or her an innate sense of how things were to be done.[31] A sense, that is, of style.

Perhaps it is worth spelling out explicitly: while Semper described architectural history as Stoffwechsel—material metamorphosis—he did not for a moment believe that it was driven by material concerns alone. Though often accused of it, Semper was no materialist.[32] As the previous examples demonstrate, the metamorphic process was driven by numerous factors simultaneously, ranging from metaphysical ideas to natural laws. The earliest motifs of art were at the same time cosmic symbols and material techniques, for example, the seam that signified the union of parts, or the hem that symbolized completion. Sometimes a motif might seem to lose contact with its material basis altogether, such as when the knot and other textile motifs were allegorized into fantastical beasts in ancient Asian architecture. "Thus arose basilisks and chimera, tragelaphs and hippocampi, griffins and echidnas, sirens and nereids, sphinxes and centaurs," Semper wrote, reveling in the richness of symbolic form.[33] Yet even at their most "tendentious," these hybrid monsters continued to reverberate with the memory of their original motif, much as the serpents on Norwegian stave church portals invoked both religious ideas and textile techniques, or the Assyrian sacred tree represented both a technical skill and a cosmic symbol.[34] Adopted across cultures and translated into ever new materials, the textile origins of such symbolism remained a constant, if at times faint, reference, establishing the visual and technical logic according to which such motifs could and should be treated. This treatment was not static, and certainly not a matter of copying. On the contrary: Semper insisted that each epoch had to modify the inherited motifs, put its own mark on them and make them "its own flesh and blood."[35] At certain points in history the motifs might even disintegrate altogether, such as when the ancient Greeks took the "tendentious" iconography of Egyptian and Middle Eastern architecture and abstracted it into an autonomous aesthetic system.[36] For Semper, architectural history constituted an endless cycle of imitation, appropriation, and disintegration, and neither servile copying nor *ex nihilo* invention could ever give a meaningful result.

A work of architecture, according to Semper, carries all the memories of its previous stages with it at any point of its development. The Lycian tomb, the Hindu temple, the Assyrian slab, or the knotted monsters of the Celts and the Vikings demonstrate the complexity of that endurance. The gradual modification of the basic motifs into ever new materials and techniques renders them at the same time recognizable and new. On the one hand, the motif guarantees continuity and legibility, tying the work to the past and establishing criteria for how to understand and execute it. On the other hand, the "mystery of transfiguration" detaches the motif from any one particular context, allowing objects, ornaments, and monuments to transcend their material, geographical, and epochal origin and belong to more than one time and place at once. Artworks "resist anchoring in time," write Alexander Nagel and Christopher S. Wood in their book *Anachronic Renaissance*, arguing that art harbors a multiple temporality that allows it to transcend the particular circumstances of its creation.[37] "No device more efficiently generates the effect of a doubling or bending of time than the work of art, a strange kind of event whose relation to time is plural," they write.[38] Semper's style theory captures that plurality.

Material Agency

Semper's notion of style as a metamorphic historical product posed a formidable challenge to Winckelmann's period style. Prising open the tight fit between style and epoch (the very core of the principle of correspondence), Semper saw style as a multi-temporal phenomenon that allowed art and architecture to transcend geographical and epochal confines. It did so—and this is important—not simply through the survival of visual motifs over time, but even more through persistent ways of making that had been inherited, modified, and transformed by generations of craftsmen and artists. Semper elaborated this point in another of his rare attempts at defining style, this one from the late 1850s. Returning to style's etymological root in the stylus, he mused on the relationship between the tool and the hand:

> The word "style" originally signified a stylus with which one impressed letters on wax tablets; later the term was used to convey the quality of the manner of writing in general. We have adopted the word together with its meaning... I see in

the word "style" the quintessence of those qualities of a work that come to the fore when the artist knows and observes the limitations imposed on his hand by the particular character of all contributing coefficients and, at the same time, takes into account and gives artistic emphasis to everything that, within these limitations, these contributory coefficients offer, provided this will serve the purpose of the task.[39]

Der Stil set out these limitations and affordances in great detail. Every material has its own "domain of forms" that springs from its basic technical properties.[40] Pliable fibers lend themselves to knotting, tying, and weaving, and the logic and look of these techniques govern the treatment of pliable materials at all times. Wood lends itself to constructing light, loadbearing frames, a technique that is appropriate for all similar materials. Joseph Rykwert calls the four material-technical categories in *Der Stil* "four root ways of the willing hand's working of inert material"—an apt if idiosyncratic way of describing Semper's anthropologically informed approach to materials.[41] For again: while *Der Stil* is structured around materials, it does not mean that Semper promoted some kind of material honesty or *Materialgerechtigkeit*. As the famous footnote on masking reminds us, he insisted that the artwork "should make us forget the means and the materials by which and through which it appears."[42] Like Schiller in the *Aesthetic Letters*, Semper saw the annihilation of the material as the highest aim of art. But unlike the idealists, who thought that aim could be achieved via the artistic idea alone, Semper aimed to get there through an intense engagement with the material itself. If, for Schiller, any trace of the chisel destroyed the sculpture, for Semper, those traces were key to its style.

The creative logic inherent in every task and material—today we might call it agency—had a direct impact on design as Semper understood it. The motif's materiality placed certain restrictions and obligations on the artist, prompting him or her to deal with the given task in particular ways. Craftsmen and artists had to learn to recognize and heed this logic, even when they would ultimately transform or even "annihilate" the material. Perhaps it was the wish to aid that process that led Semper to call *Der Stil* a handbook for craftsmen and artists, and describe it as a "practical aesthetics," despite being anything but practical. He crammed it full of recommendations and reprimands to the practitioner, many

of them rather puzzling. Lace should be treated as an ornamental hem or seam, not as a surface, for the technique originates in plaiting, which is by definition linear.[43] To treat leather with hard lacquer or gilding is inherently wrong, for such practice follows "a principle of surface decoration that is useful and applicable only to stiff surfaces," and fails to take advantage of the leather's inherent pliability. Simple boot polish is a more correct treatment of leather than even the most sumptuous gilded ornament, Semper declared.[44] And on a more architectural scale: intercolumnar drapery in a Gothic church is an abomination, for Gothic tectonics is alien to the classical motif of *Bekleidung*.[45] Et cetera, et cetera.

The most pressing problem with contemporary design was that the modern means of production no longer matched the inherent logic of the artistic motifs, a situation Semper found fatal for both art and architecture.[46] Industrial production methods severed the tie to millennia-long artistic traditions, leaving the modern artist without criteria for correct design. Wandering among the exhibits at the Great Exhibition in London in 1851, Semper lamented how "the hardest porphyry and granite are cut like chalk and polished like wax. Ivory is softened and pressed into forms. Rubber and gutta-percha are vulcanized and utilized in a thousand imitations of wood, metal, and stone carvings, exceeding by far the natural limitations of the material they purport to represent."[47] The problem was not that one material imitated another—that was after all a key point in Semper's own style theory. The problem occurred when the adaptation no longer heeded the creative logic inherent in the original motif—the enclosing order of the textile hem, say, or the articulation of the tectonic frame. If you lose that connection you end up in utter randomness, a state Semper thought nineteenth-century European architecture had reached long ago.

Semper's focus on fabrication makes his theory of style very different from the abstract zeitgeist thinking of his contemporaries. If architectural thinkers from Hübsch to Maximilian II dreamed of an architecture that mirrored the present, Semper envisioned an architecture that tied the present to the past through constantly evolving ways of making. His style theory did have precedents, however. When Bötticher lamented the curious solitude characterizing attempts at a new style, commenting that the modern style inventor finds himself "alone in the void," he no doubt spoke for Semper, too.[48] And when Schinkel described new

style as consisting of "a series of historical inventions" interpreted anew, Semper must have empathized.[49] Like the Berlin Nestor, Semper was convinced that innovation required tradition, and that acting historically "is to bring about the new, by which history continues."[50] Yet Semper was not satisfied with scattered aphorisms. He wanted to map the labyrinth, finding out exactly how style worked. He found his Ariadne's thread not in Schinkel, but in Carl Friedrich von Rumohr, whose concept of style was very close to Semper's own:

> The importance of the material in the question of Style is so great, that some of the best Writers on art have considered it the very thing which constitutes for itself alone what we call style in Art. So for instance Baron Rumohr, one of our best German writers on art, who gives in his Researches on Italian Art the following definition of this notion. *Style is the accom[m]odation of the Artist to the intimate demands of the material in which the sculptor really forms his objects, and the painter represents them.*[51]

Chapter 4 showed how Rumohr related style to material practice. Rebelling against the disembodied style concept of the idealists, the baron reserved the term for the shared know-how of artists and craftsmen, developed through a millennia-long engagement with materials. The style of Egyptian sculpture was as much a product of the hardness of the local stone and the various artistic strategies developed to deal with that hardness, as of an artistic "idea," he argued.[52] Semper listened carefully. The hardness of stone; the pliability of fibers; the slender strength of wood, were indeed factors in his development history, as were the various ways artists had learned to utilize such qualities. In fact, Rumohr's definition of style as "a sense of what the... artistic material allowed or barred"[53] is almost identical to Semper's own, invoking the limitations and affordances of materials as a main factor in the historical development of art. Yet even Semper felt the need to modify Rumohr's most provocative assertions:

> It was Rumohr who... was the first to trace the notion of style to its true empirical root; but he took into account only the "crude material."... I believe that the "crude

225

material" is only one of several factors the inner exicencies [*sic*] of which the artist has to submit to and which it is his task to emphasize.[54]

Semper's critical remark was actually more a clarification than a rejection, for he knew perfectly well that Rumohr was no materialist. I argued earlier that Rumohr's seeming reduction of style to a technical term went together with an expansion of what the technical realm might imply. Semper continued that expansion. He adopted Rumohr's notion of material agency as a key factor in the development of style, but put the baron's scattered remarks into an all-encompassing theoretical system.[55] If the correspondence theory framed style as a form of representation, Semper and Rumohr treated it more as a generative principle governing culturally informed and historically conditioned material practices.[56] Architectural style theory in the nineteenth century was "a search to understand the profound nature of the creative act itself, . . . it sought to grapple with humanity's very 'shaping power,'" writes architectural historian Martin Bressani.[57] No style theory fits that description better than Semper's.

Toward a Generative Style Theory

Semper's final attempt to define style occurred in a public lecture given at the Zurich city hall in spring 1869. It bore the title "On Architectural Styles," and was later published as a little book. The talk, apparently intended as a pilot for the long-awaited third volume of *Der Stil*, would in fact become Semper's last published text.[58] He chose his words carefully:

> Permit me to set forth in a short definition what I wish to be understood by the term style. Style is the accord of an art object with its genesis, and with all the preconditions and circumstances of its becoming. When we consider the object from a stylistic point of view, we see it not as an absolute, but as a result. Style is the stylus, the instrument with which the ancients used to write and draw; therefore it is a very suggestive word for that relation of form to the history of its origin.

In contrast to his previous writings on style, Semper did not address the basic motifs or their metamorphosis. He even took

226

Title page of Gottfried Semper's *Über Baustyle: Ein Vortrag*, 1869. ETH Bibliothek, Zurich.

issue with those who wanted to explain architectural style according to "the laws of natural selection, heredity, and adaptation from a few primitive types"—a position deceptively similar to the one he himself had proposed in his London lectures.[59] Architecture could in a certain sense be described as "fossilized receptacles of extinct social organizations," he admitted, but that did not mean it sprang from blind natural processes like the shell on a snail's back. Declaring that "the free will of the creative human

spirit is the first and most important factor in the question of the origin of architectural styles," Semper spent most of the lecture outlining how this human factor—individually and collectively—shapes architectural style.[60]

The examples are mostly familiar. Starting from the "primitive" individual who uses adornment to create order and differentiation, Semper discussed the hierarchical social structures of ancient Egypt, China, and the Middle East, before turning to the new emphasis on individuality and freedom emerging in classical Greece and Rome. "Every religious system has its own cosmogonic basis, every form of government is, as it were, the embodiment of a certain predominant way of looking at the normal conditions of society and their origin," he argued, trying to tease out the architectural implications of those "ways of looking."[61] Because architecture not only reflects society but also shapes it (Semper described buildings as "the most effective instruments for the clear development, stabilization, and expansion of [social, political, and religious] systems"[62]), architectural style has always had an important sociopolitical role. It was a role that was well beyond the control of the architect, for the cultural ideas embodied in the various historical styles had emanated "not from architects, but from the great reformers of society when the time had been ripe."[63] It was consequently not architects who were to blame for the contemporary crisis, but culture at large. Just as the architects of Hagia Sophia had depended on the new theological outlook of Constantin and Justinian to create their Byzantine masterpiece, the contemporary architect awaited "a new concept of universal historical importance."[64] Such a concept would not come in the guise of a new material or construction system, for architectural innovation did not spring from matter alone. As he elaborated in the prospectus to the third volume of *Der Stil*:

> A vast field of inventiveness will be revealed to us once we try to make artistic use of *our* social needs as factors in the style of *our* architecture, in the same way as has been done in the past; whereas it would hardly ever be possible only through new materials and their use in new methods of construction to bring about a decisive and lasting change in architecture, and even less so through the simple power of a genius who has dreamed up his so-called new style.[65]

228

Against those who dreamed that a new style would emerge from material innovation, Semper emphasized the need for new ideas.

"On Architectural Styles" is a puzzling text, often seemingly at odds with Semper's earlier writings. If *Der Stil* and the London lectures had emphasized the material and technical aspects of style, the Zurich lecture ignored these altogether, presenting what at first seems to be a far more conventional story of architecture as the representation of an epochal idea. Yet if the lecture is thought of as a mini-version of the third volume of *Der Stil*, it sort of falls into place. In his prospectus, Semper had promised that this last volume was to study "the social structure of society and the conditions of the times, which to express artistically and in a monumental way has always been the most eminent task of architecture."[66] It was to deal, in other words, with the last aspect of Semper's tripartite doctrine of style, namely the "local, temporal, and personal influences on form."[67] These factors do not exclude, but rather complement, materiality and motif as drivers of artistic practice, all part of those "preconditions and circumstances" to which the work of art responds. The subject matter of all artistic endeavor is "man in all his relations and connection to the world," Semper stated, demonstrating once and for all that his alleged materialism was actually a sustained reflection on the cultural significance of style.[68]

Another seeming mismatch between the Zurich lecture and Semper's previous writings has to do with the question of representation. I have spent much time in this chapter arguing that Semper's style theory was not primarily about representation but about creation; that is, he thought of style not as the fingerprint of the zeitgeist but as a product of historically evolving ways of making. And yet here he was in Zurich city hall, describing architecture as kind of cultural fossil—a zeitgeist formula if ever there was one. Perhaps this really is an unresolved tension in Semper's work—if so, it would not be the first.[69] But it is tempting to think it through a bit further. Semper thought of Stoffwechsel as a process whereby certain inherited motifs are modified in response to particular cultural and material conditions. An epoch or a nation does not invent its own style but taps into a collective reservoir of form-making, modifying it according to its own desires and needs. To speak of a national architectural style made little sense for Semper, because for him, architecture was a shared, global

endeavor. And yet there *was* a link between time, place, and style, allowing one legitimately to speak about Chinese style, Egyptian style, and so on.[70] The link consisted, not in the stylistic representation of a zeit- or volksgeist, but in the particular modulation—"coloring," as Semper called it—that artists of a particular time and place gave to the basic motifs of art. To Semper, architectural style is not a "mirror of its time," as naive historicism would have it, but a result of enduring yet constantly evolving ways of making.

"Thus, Ladies and Gentlemen, we have come to the end of our very summary panorama of the field of style," Semper announced to his Zurich audience.[71] I am almost at the end, too. Like Semper, I have left many things unresolved. But one thing that has hopefully become clear is the distinction between style theory and art history invoked at the start of this chapter. Insisting on style as a practice-related rather than an art historical concept, Semper anticipated the very different roles style would play in modern architecture and art history respectively. If style in art history has been first and foremost the sorting tool of the historian, in architecture it went to the heart of architectural practice, becoming a vehicle for furious debates over truth, meaning, and morals. The architectural "battle of style" was a battle over what to do and how to do it, not just over how to categorize it once it had been done. This is the reason, perhaps, that the question of style became so much more contentious in architecture than in any other field. For Semper and many of his fellow architects, style existed first and foremost in the making.

Coda

"**A**nyone who (still) deals with the concept of style today, quickly enters into a peculiar state of suspension," writes the cultural theorist Karl Ludwig Pfeiffer.[1] Indeed. Style is puzzling and confusing, constituting, as Macmillan's *Dictionary of Art* points out, one of the discipline's "most difficult concepts."[2] This book will not solve that, but by highlighting the contradictory ways in which style has impacted modern architecture, it has hopefully shown that those contradictions have a history, and an interesting one at that. The transition from rhetorical style to period style formed an important moment in that story, as did the different uses to which the period style lent itself, from taxonomic tool to emotional trigger. Architecture was more profoundly affected by that transition than any other discipline, construed, as it was, as a privileged (or cursed, depending on how one sees it) embodiment of the zeitgeist.

The belief in a quasi-organic relationship between the epoch and its architecture—the "principle of correspondence," as it was

235

termed in chapter 5—affected both architectural practice and architectural history writing. Through this particular optic, past epochs appeared to display a seamless match between style and zeitgeist, while the present inevitably seemed a mess, lacking the organic coherence of previous times. It sent architects and their patrons on a wild goose chase for a "style of one's own"— the "great, lost happiness," as Berlage put it—prompting endless debates over what a timely architecture might be.[3] It allowed architectural historians to turn style into a tool for often dubious forms of cultural classification, opening for the nationalist and racist perspectives that Gombrich, Sauerländer, and many after them rightly described as fateful.[4] Unlike style in the rhetorical tradition, the period style no longer implied a choice between a range of cultural possibilities, but a destiny—an involuntary manifestation of a zeit- or volksgeist whose will the historian had to divine and the architect obey. Far more scholarship is needed to unravel the effects those perspectives have had on architectural history and historiography, but a critical analysis of the epoch/style conflation is certainly a place to start.

But again: however fateful the period style might have been, it is not the only strand in the history of architectural style. To me, the most interesting and surprising bit of the tale has been to discover architects and architectural historians who thought *against* the principle of correspondence, resisting the particular kind of determinism built into it. By reading and rereading Schinkel, Rumohr, Stier, Bötticher, Semper, and many others, I have tried to show that there were alternatives to that determinism that may still be interesting and relevant today. Schinkel's decorum-based use of historical motifs and Semper's finely tuned analyses of architectural making point toward other understandings of style—not as a representation of the zeitgeist, but as ongoing negotiations of the historicity and agency of architecture's materials and motifs. The growing interest in materiality, memory, and the expressive potential of fabrication in contemporary architecture makes an examination of these alternative style concepts worthwhile.

Most of this book was written during the COVID-19 pandemic and edited during the Russian war on Ukraine. I have occasionally been embarrassed to be working on something so esoteric at a time of crisis. But then I have thought of my protagonists. Of Goethe, who wrote his 1789 essay on style while revolution was

brewing in France; Semper, who formulated his most important ideas on style while in political exile; Behrendt, whose publication of *Der Kampf um den Stil* was delayed but in no way stopped by the outbreak of World War I, and Gropius, who published "Der stilbildende Wert industrieller Bauformen" just before entering that same war as an officer on the Western Front. It is as if times of crisis attract thinking on style, not as an ivory tower exercise but as a crucial discussion of how architecture relates to the world. For as the seven chapters have hopefully shown, style is not a matter of superficial frippery but has for centuries been a way to reflect on how meaning travels across time and space in the form of architecture.

This book opened by quoting Georg Simmel, and I want to return to him at the end. The essay cited—"The Problem of Style" from 1908—was actually quite a critical musing on style, framing it as something stale and general in contrast to the uniqueness and vibrancy of the individual work. But Simmel recognized that generality also has its qualities. "What drives modern man so strongly to style," he observed, "is the unburdening and concealment of the personal, which is the essence of style."[5] Harboring an accumulated collective experience that belongs to everyone and no one, style was for Simmel an antidote to the solitude of individual expression. In a time obsessed with individuality, it is a welcome reminder.

Simmel's description of style as a shared store of motifs and practices resonates with many of the style thinkers discussed in this book, from Cicero to Semper. If the period style threatened to turn architecture into a parochial and solitary manifestation of its time and place, these more cosmopolitan ways of thinking emphasized style as common property—a place, as Simmel put it, where "one no longer feels alone."[6]

Notes

Introduction

1. Georg Simmel, "The Problem of Style" (1908), in *Simmel on Culture: Selected Writings*, ed. and trans. David Frisby and Mike Featherstone (London: Sage, 1997), 215.

2. Rem Koolhaas and Bruce Mau, *S,M,L,XL* (New York and Rotterdam: Monacelli Press and 010 Publishers, 1995), 1188; Le Corbusier, *Toward an Architecture* (1923), trans. J. Goodman (Los Angeles: Getty, 2007), 147. Parts of this introduction have been published in a different version in Hvattum, "Mere Style," *Architectural Histories* 6, no. 1 (2018): http://doi.org/10.5334/ah.342.

3. George Kubler, "Toward a Reductive Theory of Visual Style," in *The Concept of Style*, ed. Berel Lang (Ithaca: Cornell University Press, 1979), 163–173.

4. Alina Payne, *From Ornament to Object* (New Haven: Yale University Press, 2012), 157.

5. See e.g. Susan Sontag, "On Style," in *Against Interpretation and Other Essays* (New York: Farrar, Straus and Giroux, 1961); Willibald Sauerländer, "From Stylus to Style: Reflections of the Fate of a Notion," *Art History* 6, no. 3 (September 1983): 253–270; Christopher S. Wood, *A History of Art History* (Princeton: Princeton University Press, 2019); Éric Michaud, *The Barbarian Invasions: A Genealogy of the History of Art* (Cambridge, MA: MIT Press, 2019).

6. Getty's *Texts & Documents* series has been particularly important in documenting French and German style debates, translating and critically editing key nineteenth- and twentieth-century texts. The series of exhibitions on major nineteenth-century architects at the Architecture Museum in Munich in the 1990s and 2000s has likewise generated important scholarship; see e.g. Winfried Nerdinger, ed., *Leo von Klenze: Architekt zwischen Kunst und Hof 1784–1864* (Munich: Prestel, 2000), and Nerdinger, ed., *Friedrich von Gärtner. Ein Architektenleben, 1791–1847* (Munich: Klinkhardt & Biermann, 1992).

7. Wolfgang Herrmann, *In What Style Should We Build? The German Debate on Architectural Style* (Los Angeles: Getty, 1992); Payne, *From Ornament to Object*; Harry Francis Mallgrave, *Gottfried Semper: Architect of the Nineteenth Century* (New Haven: Yale University Press, 1997); Barry Bergdoll, *Leon Vaudoyer: Historicism in the Age of Industry* (Cambridge, MA: MIT Press, 1994).

8. Caroline van Eck, James McAllister, and Renée van de Vall, eds., *The Question of Style in Philosophy and the Arts* (Cambridge: Cambridge University Press, 1995); Klaus Jan Philipp, *Um 1800: Architekturtheorie und Architekturkritik in Deutschland zwischen 1790 und 1810* (Stuttgart: Axel Menges, 1997); Martin Bressani, *Architecture and the Historical Imagination: Eugène-Emmanuel Viollet-le-Duc 1814–1879* (London: Ashgate, 2014); Martin Bressani and Christina Contandriopoulos, eds., *Companion to Architectural History*. Volume III: *Nineteenth-Century Architecture* (New York: Wiley, 2017); Farshid Moussavi, *The Function of Style* (Cambridge, MA: Harvard GSD/Actar, 2014).

9. Some seminal studies of this kind are Georg Germann, *Gothic Revival in Europe and Britain: Sources, Influences, and Ideas* (Cambridge MA: MIT Press, 1973); Michael J. Lewis, *The Politics of the German Gothic Revival: August Reichensperger* (Cambridge, MA: MIT Press, 1993); Kathleen Curran, *The Romanesque Revival: Religion, Politics, and Transnational Exchange* (Philadelphia: Penn State University Press, 2003); Alina Payne and Lina Bolzoni, eds., *The Italian Renaissance in the 19th Century: Revision, Revival,*

and Return (Cambridge, MA: Harvard University Press, 2018); Katherine Wheeler, *Victorian Perceptions of Renaissance Architecture* (London: Routledge, 2017); Dora Wiebenson, *Sources of Greek Revival Architecture* (London: Zwemmer, 1969).

10. Germann, *Gothic Revival*, 11.

11. Hans Ulrich Gumbrecht and Ludwig L. Pfeiffer, eds., *Stil. Geschichten und Funktionen eines kulturwissenschaftlichen Diskurselements* (Frankfurt am Main: Suhrkamp, 1986).

12. Karl Bötticher, "The Principles of the Hellenic and Germanic Ways of Building with Regard to Their Application to Our Present Way of Building" (1846), in Herrmann, *In What Style*, 151.

Chapter 1

1. Bjarke Ingels, "Bjarke Ingels to Cities: Take a Longer View," interview by Andrew Zuckerman, *Time Sensitive* Podcast, episode 4, February 6, 2019. https:// timesensitive .fm/episode/bjarke-ingels-cities-longer-view/.

2. Jacques Herzog, "You can't just leave a city as is. If you do that, it will die," interview by Finn Canonica, *Tages Anzeiger*, April 2015. English translation in https:// www.herzogdemeuron. com/index/projects/ complete-works/426-450/444-expo-milan-2015-conceptual-master-plan/ focus/jacques-herzog-das-magazin-interview. html; Jeffrey Kipnis, "A Conversation with Jacques Herzog," *El Croquis*, no. 84 (1997): 7–21.

3. Winy Maas and Jacob van Rijs, "MVRDV 25," https://www.mvrdv.nl/ news/1173/charismatic-idiosyncratic-data-driven-green-innovative-25-years-of-mvrdv. Posted October 19, 2018.

4. Steven Holl, "Not a signature architect," interview by Andrew Caruso. *ArchDaily* (September 2, 2012) https://www. archdaily.com/269251/ steven-holl-interview-not-a-signature-architect-andrew-caruso.

5. Patrik Schumacher, "A New Global Style for Architecture and Urban Design," *Architectural Design* 79, no. 4 (July/ August 2009); Patrik Schumacher, "On Style," *Architectural Review* 120 (January 19, 2017) https://www. architectural-review. com/essays/ar-120/ar-120-patrik-schumacher-on-style/10016459. article. On the criticism of parametricism, see e.g. *The Politics of Parametricism: Digital Technologies in Architecture*, eds. Matthew Poole and Manuel Shvartzberg (London: Bloomsbury, 2015).

6. Svetlana Alpers, "Style Is What You Make It: The Visual Arts Once Again," in *The Concept of Style*, ed. Berel Lang (Ithaca: Cornell University Press, 1979), 137.

7. Sarah Williams Goldhagen, "Something to Talk About: Modernism, Discourse, Style," *Journal of the Society of Architectural Historians* 64, no. 2 (June 2005): 158.

8. Of the many attempts at defining style, one of the more productive is Rainer Rosenberg and Wolfgang Brückle, "Stil," *Ästhetische Grundbegriffe*, vol. 5, ed. Karlheinz Barck et al. (Stuttgart/Weimar: Metzel, 2003), 641–688.

9. Goldhagen, "Something to Talk About," 146.

10. Goldhagen, "Something to Talk About," 154.

11. Rem Koolhaas, "House with NO STYLE," *Japan Architect* 7, no. 3 (Summer 1992): prelim, not paginated. I am grateful to Hilde Heynen for bringing this competition to my attention, and to Cathelijne Nuijsink for unearthing the competition material. Nuijsink's postdoc project *Architecture as a Cross-Cultural Exchange: The Shinkenchiku Residential Design Competition, 1965–2017* at the ETH, Zurich, deals extensively with this competition series.

12. Rem Koolhaas, "About the Results," in Koolhaas, ed. "Results: House with NO STYLE," *Japan Architect* 9, no. 1 (Spring 1993): 6.

13. Koolhaas, "About the Results," 6.

14. Koolhaas, "About the Results," 6.

15. Henry-Russell Hitchcock, "The International Style Twenty Years Later," *Architectural Record* 110, no. 2 (August 1951): 91.

16. Mitsugu Okagawa and Yutaka Kinjo, "Second Place," in Koolhaas, "Results: House with NO STYLE": 12–13.

17. Yosuku Fujiki, "First Place," in Koolhaas, "Results: House with NO STYLE": 8–9.

18. Koolhaas, "About the Results," 7.

19. Rem Koolhaas and Bruce Mau, *S,M,L,XL* (New York and Rotterdam: Monacelli Press and 010 Publishers, 1995), 284. In his glossary, Koolhaas deals with deconstructivism under the keyword "Decorative," a snub to MoMA's 1988 *Deconstructivism* show and its curator Mark Wigley.

20. Mark Wigley, "Deconstructivist Architecture," in *Deconstructivist Architecture*, eds. Philip Johnson and Mark Wigley (New York: MoMA, 1988), 19.

21. Hermann Muthesius, *Stilarchitektur und Baukunst: Wandlungen der Architektur im XIX. Jahrhundert und ihr heutiger Standpunkt* (Mühlheim a.d. Ruhr: Schimmelpfeng, 1902). Translated into English as *Style Architecture and Building Art: Transformations of Architecture in the Nineteenth Century and its Present Condition* by Stanford Anderson (Los Angeles: Getty, 1994).

22. Muthesius, *Style Architecture and Building Art*, 58–59.

23. Muthesius, *Style Architecture and Building Art*, 76.

24. Muthesius, *Style Architecture and Building Art*, 78.

25. Muthesius, *Style Architecture and Building Art*, 76.

26. Muthesius, *Style Architecture and Building Art*, 79.

27. Muthesius, *Style Architecture and Building Art*, 83.

28. Muthesius, *Style Architecture and Building Art*, 100.

29. Alfred Barr, preface to Hitchcock and Johnson, *The International Style* (1932) (New York: Norton, 1995), 29.

30. Alfred Barr, foreword to Hitchcock and Johnson, *Modern Architecture: International Exhibition* (New York: MoMA, 1932), 13.

31. Hitchcock and Johnson, *The International Style*, 34.

32. Hitchcock and Johnson, *The International Style*, 35.

33. Hitchcock and Johnson, *The International Style*, 35–36.

34. Philip Johnson, letter to J.J.P. Oud, 1930. NAI. J.J.P. Oud Papers OUDJ-B69. Quoted in Reto Geiser, *Giedion and America. Repositioning the History of Modern Architecture* (Zurich: gta Verlag, 2018), 157.

35. Hitchcock and Johnson, *The International Style*, 36.

36. Philip Johnson, "Foreword to the 1995 edition," *The International Style*, 16.

37. Rudolph Schindler, letter to Philip Johnson, March 9, 1932. Quoted in Terence Riley, *The International Style: Exhibition 15 and the Museum of Modern Art* (New York: Rizzoli, 1992), 87.

38. "Form als Ziel ist Formalismus, und den lehnen wir ab. Ebensowenig erstreben wir einen Stil. Auch der Wille zum Stil ist formalistisch." Ludwig Mies van der Rohe, "Bauen," *G. Material zur elementaren Gestaltung*, no. 2 (September 1923), front page. In the following, I give the original quote in German whenever a published translation does not exist.

39. Knud Lønberg-Holm, "Two Shows: A Comment on the Aesthetic Racket," *Shelter* 2, no. 3 (April 1932): 16–17.

40. Philip Johnson, "Style and the International Style" (1955), in Johnson, *Writings* (Oxford: Oxford University Press, 1979), 76. The reception of *The International Style* has been discussed in e.g. Richard Guy Wilson, "International Style: The MOMA Exhibition," *Progressive Architecture* 63 (February 1982): 92–105,

and Riley, *The International Style*, 85–88.

41. Johnson, "Foreword to the 1995 edition," 15.

42. Sigfried Giedion, *Space, Time and Architecture* (1941; Cambridge, MA: Harvard University Press, 1982), xxxiii. Further on Giedion's reaction to the 1932 exhibition, see Geiser, *Giedion and America*, 157–160.

43. Giedion, *Space, Time and Architecture*, 2.

44. See e.g. Joseph Rykwert, "Sigfried Giedion and the Notion of Style," *Burlington Magazine* XCVI (1954): 123–124.

45. Giedion, *Space, Time and Architecture*, xxxiii. Giedion's debt to Wölfflin and his style concept is explored by Alina Payne, "Architecture, Objects and Ornament: Wölfflin and the Problem of *Stilwandlung*," *Journal of Art Historiography* 7 (2012): 1–20.

46. Walter Curt Behrendt, *Der Sieg des neuen Baustils* (Stuttgart: Wedekind, 1927). Translated into English as *The Victory of the New Building Style* by Harry F. Mallgrave (Los Angeles: Getty, 2000).

47. Detlef Mertins, "Introduction," in Behrendt, *The Victory of the New Building Style*, 8. See also Ákos Moravánszky, "Peter Meyer and the Swiss Discourse on Monumentality," *Future Anterior* 8, no. 1 (Summer 2011): 1–20.

48. Mertins, "Introduction," 31.

49. Walter Curt Behrendt, *Der Kampf um den Stil im Kunstgewerbe und in der Architektur* (Stuttgart and Berlin: Deutsche Verlags-Anstalt, 1920), 7.

50. Behrendt, *Der Kampf*, 46–54, "Die Utopie des Neuen Stils."

51. "Erst wenn... ein herrschender Lebensstil herausgebildet hat, sind die Voraussetzungen für die Entstehung eines Kunststils erfüllt." Behrendt, *Der Kampf*, 15.

52. "Mit diesem steigenden Unwillen aber wächst zugleich, unter den gewaltigen Rückwirkungen des zerstörenden Krieges, allenthalben in den unbefriedigten Herzen eine neue, noch unbestimmte, aber darum nicht weniger lebendige Sehnsucht nach Erlösung auf... Erst wenn durch die veränderte Stellung der Religion innerhalb des gesamten Geisteslebens seine neue seelige Grundstimmung geschaffen ist, wird mit einer neuen architektonischen Verbindung der Kunst auch ein neuer Stil, um den wir so lange vergebens kämpfen, von selbst entstehen." Behrendt, *Der Kampf*, 266–267.

53. Behrendt, *The Victory of the New Building Style*, 89. Behrendt seems to be paraphrasing Semper's cosmic allegory in the prolegomenon to *Der Stil in den technischen und tektonischen Künsten, oder Praktische Ästhetik*

(Frankfurt am Main: Verlag für Kunst und Wissenschaft, 1860), v.

54. Behrendt, *The Victory of the New Building Style*, 89 and 97.

55. Behrendt, *The Victory of the New Building Style*, 97 and 102.

56. Behrendt, *The Victory of the New Building Style*, 126 and 142.

57. Muthesius, *Style Architecture and Building Art*, 76.

58. "Wie nennen unsere Zeitschrift 'Die Form.' Damit erwächst uns Gleich zum Eingang die Pflicht, einem Missverständnis zu begegnen, das sich bei allen denen einstellen muss, die die 'Form' als ein irgendwie Äusseres, ja Äusserliches dem 'Gehalt' gegenüberzustellen gewohnt sind. Mit jenem Formbegriff, der den Inhalt einer formalistischen Ästhetik ausmacht, haben wir nichts zu tun. Für uns bezeichnet 'Form' nichts das Äussere der Kunst... 'Form' ist nicht Hülle, sondern ebensosehr Kern, nicht der Gegensatz von Ausdruck, sondern selber Ausdruck inneren Lebens. Ja, sie ist das Leben selbst." Walter Riezler, "Zum Geleit," *Die Form* 1, no. 1 (1922): 1.

59. "Am Ziele des Weges steht der neue Stil." Riezler, "Zum Geleit," 4.

60. Deborah Asher Barnstone, "Style Debates in Early 20th-Century German Architectural Discourse," *Architectural Histories* 6, no. 1 (2018):

http://doi.org/10.5334/ah.300.

61. Behrens, "Stil?" *Die Form* 1, no. 1 (1922): 5.

62. Riemerschmid, "Zur Frage des Zeitstiles," *Die Form* 1, no. 1 (1922): 8.

63. Muthesius, *Style Architecture and Building Art*, 79. Wassily Kandinsky, similarly, warned against the pursuit of style in *On the Spiritual in Art* (1911; New York: Guggenheim, 1946), 57.

64. Riezler, "Zur Geleit," 4.

65. Cf. Muthesius, "Previously there were no styles, but rather only a straightforwardly prevailing artistic direction to which everything was subordinated as self-evident truth. In the nineteenth century, mankind was for the first time expelled from this artistic paradise, having plucked from the tree of historical knowledge." *Style Architecture and Building Art*, 78. The same idea was proposed by Hitchcock, seemingly in jest, when he stated that "there were no 'styles' in the Garden of Eden." "The International Style Twenty Years Later," 245.

66. Behrendt, *Der Kampf*, 50. He does not indicate a source for the inserted quote.

67. Behrendt, *Der Kampf*, 46–54.

68. Walter Gropius, "Der stilbildende Wert industrieller Bauformen," *Jahrbuch des Deutschen Werkbundes 1914* (Jena:

Eugen Diederichs, 1914): 29–32.

69. Bruno Taut, *Die neue Wohnung: Die Frau als Schöpferin* (Leipzig: Klinkhardt & Biermann, 1926), addendum to fourth edition, 122; Adolf Behne, *Der moderne Zweckbau* (Munich: Masken, 1926). English edition: *The Modern Functional Building* (Los Angeles: Getty, 1996), trans. Michael Robinson, 119.

70. Adolf Behne, "Holländische Baukunst in der Gegenwart," *Wasmuths Monatshefte für Baukunst* 6, no. 1–2 (1921–1922), 4. Quoted in Frederic J. Schwartz, "Form Follows Fetish: Adolf Behne and the Problem of 'Sachlichkeit,'" *Oxford Art Journal* 21, no. 2 (1998): 49.

71. Giedion, *Space, Time and Architecture*, xxxiii; Muthesius, *Style Architecture and Building Art*, 76.

72. Hendrik Petrus Berlage, "Some Reflections on Classical Architecture" (1908), in Berlage, *Thoughts on Style, 1886–1909*, ed. and trans. Iain Boyd-Whyte and Wim de Wit (Los Angeles: Getty, 1996), 273.

73. Iain Boyd-Whyte, "Introduction," in Berlage, *Thoughts on Style*, 71. See also Pieter Singelenberg, *H.P. Berlage: Idea and Style* (Utrecht: Haentjens Dekker & Gumbert, 1972), 178–185.

74. Berlage, "Modern Architecture," *Western Architect* 18 (January 1912),

quoted in Boyd-Whyte, "Introduction," in *Thoughts on Style*, 57.

75. Berlage, "On the Likely Development of Architecture" (1905), in *Thoughts on Style*, 157 and 181.

76. Berlage, *Thoughts on Style*, 136.

77. Berlage, *Gedanken über Stil in der Baukunst* (Leipzig: Zeitler, 1905). English trans. "Thoughts on Style in Architecture," in *Thoughts on Style*, 132 and 151.

78. On the close connections between Berlage and *De Stijl*, see Robert P. Welsh, "De Stijl. A Reintroduction," in *De Stijl 1917–1931: Visions of Utopia*, ed. Mildred Friedman (Oxford: Phaidon, 1982), 23.

79. Theo van Doesburg, "Ter Inleiding," *De Stijl* 1, no. 1 (October 1917): 1–2, quoted in Singelenberg, *H.P. Berlage*, 198.

80. "Die Aufhebung dieses Kampfes, der Ausgleich dieser Extreme, die Aufhebung der Polarität ist Inhalt des Lebens, ist elementarer Gegenstand der Kunst. In diesem Ausgleich, welcher sich in der Kunst als Harmonie oder vitale Ruhe kund gibt, liegt das Kriterium für die wesentliche Bedeutung jedes Kunstwerks. Nicht zwar für das Kunstwerk als Sonderausdruck, sondern für die Kunst als Gesamtausdruck eines Volkes, für einen Stil." Doesburg, "Der Wille zum Stil. Neugestaltung von Leben, Kunst und

Technik" part 1, *De Stijl* 5, no. 2 (February 1922): 25.

81. Doesburg, "Der Wille zum Stil," part 1: 26.

82. "Die Physiognomie jeder Kunstperiode zeigt am deutlichsten, inwieweit es den Menschen gelungen ist, einen Ausdruck zu schaffen, einen Stil, ein Gleichgewicht zwischen obengenannten Gegensätzen." Doesburg, "Der Wille zum Stil," part 1: 25.

83. "Obschon bei diesen experimentellen Ausdrucksformen das Bedürfnis nach einer Aufhebung des in der Tradition üblichen Gleichnisses vorherrschte, gelang es ihnen nicht, eine universale kollektivistische Ausdrucksform, einen Stil zu erobern." Doesburg, "Der Wille zum Stil," part 1: 29.

84. Doesburg, "Der Wille zum Stil," part 2, *De Stijl* 5, no. 3 (March 1922): 33.

85. Doesburg, "Der Wille zum Stil," part 2: 35.

86. Arthur Schopenhauer, "Ueber Schriftstellerei und Stil," in *Parerga und Paralipomena II* (Berlin: A.W. Hayn, 1851), §282.

87. Berlage, "Thoughts on Style," 32.

88. Berlage, "On the Likely Development of Architecture," 181.

89. Berlage, "Thoughts on Style," 136.

90. Behrendt, *Der Kampf*, 23.

91. Behrendt, *Der Kampf*, 29.

92. Muthesius, *Style Architecture and Building Art*, 69.

93. Muthesius, *Style Architecture and Building Art*, 77.

94. Mertins, "Introduction," 33.

95. Walter Gropius, *Programm des staatlichen Bauhauses in Weimar* (Weimar: Bauhaus, 1919), 3.

96. Behne, *The Modern Functional Building*, 100 and 119.

97. Hitchcock and Johnson, *The International Style*, 34.

98. Barr, "Foreword," in Hitchcock and Johnson, *Modern Architecture: International Exhibition*, 13.

99. Johnson and Hitchcock commented on Barr's capitalization on several occasions, see e.g. Johnson, "Foreword to the 1995 Edition," 14, and Hitchcock, "Foreword to the 1966 Edition," in Hitchcock and Johnson, *The International Style*, 20.

100. Johnson, "Style and the International Style," 74.

101. Le Corbusier, *Vers une architecture* (Paris: Éditions Crès, 1923). English translation, *Toward an Architecture*, by John Goodman (Los Angeles: Getty, 2007) 87.

102. Le Corbusier, *Oeuvre complète: 1910–1929* (1936; Paris: Les Editions d'Architecture, 1965), 6.

103. Koolhaas, *S,M,L,XL*, 1188.

104. Goldhagen, "Something to Talk About," 159.

105. Gumbrecht and Pfeiffer, *Stil*.

106. Goldhagen, "Something to Talk About," 159.

107. Ernst Gombrich, "Style," in *International Encyclopedia of the Social Sciences*, vol. 15 (New York: The Free Press, 1968), 352–361, reprinted in *The Art of Art History. A Critical Anthology*, ed. Donald Preziosi (Oxford: Oxford University Press. 1998), 150–163, 159–161. See also Gombrich, *The Sense of Order* (Oxford: Phaidon, 1979), chap. 8: "The Psychology of Styles," 195–216.

108. Jan Bialostocki, "Das Modusproblem in den bildenden Künsten," *Zeitschrift für Kunstgeschichte* 24, no. 2 (1961): 128–141; Meyer Schapiro, "Style," in *Anthropology Today*, ed. Alfred. L. Kroeber (Chicago: University of Chicago Press, 1953), 287–312, reprinted in Preziosi, ed., *The Art of Art History*, 143–149, 145.

109. Kubler, "Toward a Reductive Theory of Visual Style," 167. See also Josef Adolf Schmoll genannt Eisenwerth, "Stilpluralismus statt Einheitszwang—Zur Kritik der Stilepoche-Kunstgeschichte," in *Beiträge zum Problem des Stilpluralismus*, eds. Werner Hager and Norbert Knopp (Munich: Prestel, 1977), 9–19.

110. Alpers, "Style Is What You Make It," 137. Willibald Sauerländer, "From Stylus to Style: Reflections on the Fate

of a Notion," *Art History* 6 (1983): 254.

111. Éric Michaud, *The Barbarian Invasions: A Genealogy of the History of Art* (Cambridge, MA: MIT Press, 2015).

112. Gombrich, "Style," 150.

113. Vincent Scully, "Toward a Redefinition of Style," *Perspecta* 4 (1957): 5.

114. Nelson Goodman, "The Status of Style," *Critical Inquiry* 1, no. 4 (June 1975): 802.

115. On the "dangerous essentialism" of style, see David Summers, "'Form,' Nineteenth-Century Metaphysics, and the Problem of Art Historical Description" (1989), in Preziosi, ed., *The Art of Art History*, 136.

116. Alois Riegl, *Der moderne Denkmalkultus, sein Wesen und seine Entstehung* (Vienna: Braumüller / K.K. Zentralkommission für Kunst- und Historische Denkmale, 1903). See also Riegl, *Stilfragen: Grundlegungen zu einer Geschichte der Ornamentik* (Berlin: Siemens, 1893).

117. Wilhelm Worringer, *Abstraction and Empathy: A Contribution to the Psychology of Style* (1908) (Chicago: Dee, 1997), 11.

118. James S. Ackerman, "A Theory of Style," *Journal of Aesthetics and Art Criticism* 20, no. 3 (Spring 1962): 227–237. Published in revised form in James S. Ackerman and Rhys Carpenter, *Art and Archaeology* (New Jersey: Prentice-Hall, 1963), 164–186, and again in James

S. Ackerman, *Distance Points* (Cambridge, MA: MIT Press, 1994), 3–22, where it is equipped with a postscript by Ackerman himself. See also Ackerman, "On Rereading 'Style,'" *Social Research* 45, no. 1 (Spring 1978): 153–163, 227.

119. Ackerman, "A Theory of Style," 228.

120. Ackerman, "A Theory of Style," 227.

Chapter 2

1. Hendrik Petrus Berlage, "On the Likely Development of Architecture" (1905), in *Thoughts on Style, 1886–1909*, ed. and trans. Iain Boyd-Whyte and Wim de Wit (Los Angeles: Getty, 1996), 157.

2. Alina Payne, "Vasari, Architecture, and the Origins of Historicizing Art," *RES: Anthropology and Aesthetics*, no. 40 (Autumn 2001): 54.

3. Parts of this chapter have been published in a different form in Hvattum, "Style: Notes on the Transformation of a Concept," *Architectural Histories* 7, no. 1 (2019): http://doi.org/10.5334/ah.367 and in Hvattum, "*Zeitgeist*, Style and *Stimmung*: Notes on architectural historiography in the late eighteenth century," in *The Companion to Eighteenth-Century Architecture*, eds. Caroline van Eck and Sigrid de Jong (London: Wiley, 2017), 691–714.

4. Antoine-Chrysostome Quatremère

de Quincy, "Style," in *Encyclopédie méthodique: Architecture*, vol. 3 (Paris: Agasse, 1825), 410–414; English translation in *The Historical Dictionary of Architecture* (1832), trans. and ed. Samir Younés (London: Papadakis, 2000), 238. Ernst Gombrich, "Style," in *International Encyclopedia of the Social Sciences*, vol. 15 (New York: The Free Press, 1968), 352–361.

5. "Stilus," in *A Dictionary of Greek and Roman Antiquities*, eds. William Smith, William Wayte, and G. E. Marindin (London: John Murray, 1890).

6. "Die bis Anfang des 19. Jhs. geltende Schreibung Styl beruht (wie bei frz. engl. style) auf einer orthographischen Variante, entstanden aus einer irrtümlichen Verbindung des Wortes mit griech. stýlos (στῦλος) 'Säule, Pfeiler.'" *Digitales Wörterbuch der deutschen Sprache*, https://www.dwds.de/wb/Stil, consulted March 25, 2020.

7. Kubler gave new life to this dual etymology when he used it to argue that style (from stylos) was a spatial and synchronic concept, unsuitable for understanding temporality and durability (Kubler, "Toward a Reductive Theory of Visual Style," 166–168), a theory Ackerman dismissed as "nice, but... too orderly." "Postscript to the essay

'Style,'" in Ackermann, *Distance Points*, 21.

8. Quatremère de Quincy, "Style," 238.

9. Vitruvius, *Ten Books on Architecture*, book 1, chap. 2, trans. Ingrid Rowland (Cambridge: Cambridge University Press, 1999), 24–26.

10. Vitruvius, *Ten Books on Architecture*, book 4, chap. 1, 54–56.

11. Cicero, *Brutus*, trans. G.L. Hendrickson (Loeb Classical Library. Cambridge, MA: Harvard University Press, 1939), §100, 90.

12. Cicero, *De Oratore*, trans. E.W. Sutton and H. Rackham (Loeb Classical Library. Cambridge, MA: Harvard University Press, 1942), book I, xxxiii, §150, 102.

13. "Stilus," in *A Latin Dictionary*, ed. C. T. Lewis and C. Short (Oxford: Clarendon, 1879). http://www.perseus.tufts.edu/hopper/text?doc=Perseus:text:1999.04.0059.

14. Cicero, *De Inventione*, trans. H. M. Hubbell (Loeb Classical Library. Cambridge, MA: Harvard University Press, 1949), book I, chap. 7. See also Quintilian, *Institutio Oratoria*, vol. III, book 8, where elocutio is translated as style by H.E. Butler (Loeb Classical Library. Cambridge, MA: Harvard University Press, 1921), 195–196.

15. Further on the rhetorical concept of style, see Bernhard Sowinski, "Stil," in *Historisches Wörterbuch der Rhetorik*, vol. 8, ed. Gert Ueding (Tübingen: Max Niemeyer Verlag, 2007), 1393–1419; G.L. Hendrickson, "The Origin and Meaning of the Ancient Characters of Style," *American Journal of Philology* 26, no. 3 (1905): 249–290; Marie Lund, *An Argument on Rhetorical Style* (Aarhus: Aarhus University Press, 2017), and Brian Vickers, *In Defence of Rhetoric* (Oxford: Clarendon / Oxford University Press, 1988).

16. Cicero, *De Oratore*, trans. H. Rackham (Cambridge, MA: Harvard University Press, 1942), book III, lv, §210–212, 167–169.

17. Cicero, *De Oratore*, book III, xlvi, §180, 143.

18. Vitruvius' reliance on the rhetorical tradition is critically discussed in Caroline van Eck, "The Structure of 'De re aedificatoria' Reconsidered," *Journal of the Society of Architectural Historians* 57, no. 3 (1998): 280–297.

19. Vitruvius, *Ten Books on Architecture*, book I, chap. 2, 25.

20. Vitruvius, *Ten Books on Architecture*, book V, chap. 6, 70.

21. Vitruvius refers to Cicero as an authority in the introduction to book IX, 109.

22. Caroline van Eck, *Classical Rhetoric and the Visual Arts in Early Modern Europe* (Cambridge: Cambridge University Press, 2007).

23. Caroline van Eck, "Enduring Principles of Architecture in Alberti's *On the Art of Building*," *Journal of Architecture* 4, no. 2 (1999).

24. Van Eck, *Classical Rhetoric and the Visual Arts*, 33.

25. Payne "Vasari, Architecture," 62. See also Marco Treves, "Maniera. The History of a Word," *Marsyas. A Publication by the Students of the Institute of Fine Arts, New York University*, 1 (1941), 69–88.

26. Payne, "Vasari, Architecture," 61–62.

27. Vasari, *Lives of the Artists*, quoted in Payne, "Vasari, Architecture," 62.

28. Payne, "Vasari, Architecture," 64. Giovanni Pietro Bellori also used maniere to denote individual artistic styles, see e.g. *The Lives of the Modern Painters, Sculptors, and Architects* (1672), trans. Alice Sedgwick Wohl (Cambridge: Cambridge University Press, 2005), 339.

29. Germann, *Gothic Revival*, 12.

30. "Stylus," in Johann Heinrich Zedler, *Grosses vollständiges Universal-Lexicon aller Wissenschafften und Künste* (Leipzig: Zedler, 1731–1754), vol. XL, 1469. The same is the case in Johann Christoph Gottsched's *Handlexicon oder kurzgefasstes Wörterbuch der schönen Wissenschaften und freyen Künste* (Leipzig: Fritsch, 1760), where under "Stylus" he consistently refers to "Schreibart."

31. *Encyclopédie*, 1751–1772: vol. XV, 551.

32. *Encyclopaedia Britannica*, 1771: vol. III, 637.

33. Zedler, *Universal-Lexicon*, vol. XL, 1469–1471.

34. "Styl," *Conversations-Lexicon oder encyclopädisches Handwörterbuch für gebildete Stände* (Altenburg & Leipzig: Brockhaus, 1817), vol. IX, 547.

35. "Styl der Kunst," *Allgemeine deutsche Real-Encyklopädie für die gebildeten Stände* vol. X (Altenburg & Leipzig: Brockhaus, 1827), 790–791.

36. Caroline van Eck, ed., *Germain Boffrand, Book of Architecture: Containing the General Principles of the Art* (Aldershot: Ashgate, 2002), XXII. On Jacques-François Blondel's concept of style, see also Werner Oechslin, "In Search of the 'True Style': The Rigorists' Distinction between 'Right' and 'Wrong,'" *Daidalos* 8 (1983): 21–37.

37. Van Eck, *Germain Boffrand, Book of Architecture*, XXV.

38. Stieglitz did use the term style both in the *Encyklopädie* and in other works, however, cf. *Archaeologie der Baukunst der Griechen und Römer* (Weimar: Verlag des Industrie-Comptoirs, 1801).

39. "Der eigene Geschmack in den Verzierungen und alles dessen, was zur Schönheit gehöret, wodurch die Gebäude verschiedener Völker von

einander unterschieden werden." "Bauart," in Stieglitz, *Encyklopädie der bürgerlichen Baukunst*, vol. 1 (Leipzig: Caspar Fritsch, 1792), 148.

40. "Die Mahlerey nimmt, wie die Redekunst, bald den hohen begeisterten Ton an, bald den Ton des gemeinen täglichen Lebens, oder sie bleibet in der Mitte zwischen dem heroischen und dem ganz gemeinen. Daher entsteht in der Mahlerey, so wie in der Rede, der dreyfache Stil." Johann Georg Sulzer, *Allgemeine Theorie der Schönen Künste* (Leipzig: Weidmann, 1771–1774), vol. 1, 451.

41. "Das besondere Gepräg, das dem Werk von dem Charakter und der... Gemüthsfassung des Künstlers eingedrükt worden, scheinet das zu seyn, was man zur Schreibart, oder zum Styl rechnet." Sulzer, *Allgemeine Theorie der Schönen Künste*, vol. 2, 1047.

42. Winckelmann's architectural thinking is being reassessed, however, see e.g. Michele Cometa, "Der pelasgische Kanon. Deutsch-römische Architekturtheorie zwischen Klassik und Romantik," in *Rom—Europa: Treffpunkt der Kulturen 1780–1820*, eds. Paolo Chiarini and Walter Hinderer (Würzburg: Königshausen & Neumann, 2006), and Jens Bisky, *Poesie der Baukunst: Architekturästhetik von Winckelmann bis Boisserée*

(Weimar: Hermann Böhlaus Nachfolger, 2000).

43. Johann Joachim Winckelmann, *Geschichte der Kunst des Alterthums* (1764), translated into English as *History of the Art of Antiquity* by Harry F. Mallgrave (Los Angeles: Getty, 2006), 71.

44. Winckelmann, *History*, 117–118.

45. Winckelmann, *History*, 118–119.

46. Winckelmann, *History*, 186.

47. Winckelmann, *History*, 120.

48. Winckelmann, *History*, 146 and 175.

49. Winckelmann, *History*, 120–121.

50. Winckelmann, *History*, 187.

51. Winckelmann, *History*, 186.

52. Winckelmann, *History*, 118.

53. Winckelmann, *History*, 159.

54. Winckelmann, *History*, 131.

55. Gombrich, "Style."

56. Winckelmann, *History*, 111.

57. Winckelmann, *History*, 227 onward.

58. Winckelmann, *History*, 239.

59. See Peter C. Bol, ed., *Forschungen zur Villa Albani: Katalog der antiken Bildwerke. 1. Bildwerke im Treppenaufgang und im piano nobile des Casino* (Berlin: Gebr. Mann, 1989), no. 124, 380–388. Thanks to Eirik Bøhn for alerting me to this source. See also Adolf H. Borbein et al., eds., *Johann Joachim Winckelmann:*

Schriften und Nachlass, vol. 4, 2: *Geschichte der Kunst des Alterthums: Katalog der antiken Denkmäler* (Mainz: Philipp von Zabern, 2006), 365–366.

60. See Alex Potts, *Flesh and the Ideal: Winckelmann and the Invention of Art History* (New Haven: Yale University Press, 2000), 33–46. Further on the cyclical notion of history, see e.g. Isaiah Berlin, *Three Critics of the Enlightenment* (London: Pimlico, 2000), 21–121 and Arthur O. Lovejoy, *The Great Chain of Being* (Cambridge, MA: Harvard University Press, 1936), chap. 9.

61. Caylus, *Recueil*, 1752, vol. I, vi, quoted in Katherine Harloe, *Winckelmann and the Invention of Antiquity: History and Aesthetics in the Age of Altertumswissenschaft* (Oxford: Oxford University Press, 2013), 110–111.

62. Harloe, *Winckelmann*, 126.

63. Willibald Sauerländer, "From Stylus to Style: Reflections of the Fate of a Notion," *Art History* 6 (1983), 261. See also Lorenz Dittmann, "Zur Entwicklung des Stilbegriffs bis Winckelmann," in *Kunst und Kunsttheorie 1400–1900*, eds. Peter Ganz and Martin Gosebruch (Wiesbaden: Harrassowitz, 1991), 189–218.

64. Winckelmann, *History*, 82. I am grateful to Daniel Orrells at King's College London as well as to my AHO colleagues for help in interpreting this image. Some of the elements in the image are discussed in Borbein et al., eds., *Katalog der antiken Denkmäler*, 52 (no. 45); 106 (no. 201a); and 527 (no. 1285).

65. In his *Description des pierres gravées du feu Baron de Stosch*, Winckelmann identifies this sphinx as follows: "Touchant les Sphinx barbus N. 7. & suivans, j'aurois pû parler avec plus de décision, si j'avois alors remarqué un tel Sphinx sur un bas-relief parmi les desseins de Mr. le Card. Alex. Albani. Vis à vis de ce Sphinx est couché un autre avec la tête de femme, & au milieu d'eux il y a une figure Egyptienne. Cet Ouvrage est du tems [*sic*] des Empereurs." (Florence: Bonducci, 1760), xvii.

66. Winckelmann, *History* 76.

67. The draftsman for the vignette is unknown, though Canova has been suggested by e.g. Martin Disselkamp and Fausto Testa, eds., *Winckelmann-Handbuch: Leben–Werk–Wirkung* (Stuttgart: Metzler, 2017), 234. The engraver was Michael Keyl (1722–1798), a Dresden-based *Kupferstecher* known for his engravings in Lauritz de Thurah's *Den Danske Vitruvius* (1746–1749), a two-volume folio work inspired by Colen Campbell's *Vitruvius Britannicus* (1715–1725).

68. "Ich aber behaupte: jede Epoche ist unmittelbar zu Gott, und ihr Wert beruht gar nicht auf dem, was aus ihr hervorgeht, sondern in ihrer Existenz selbst, in ihrem Eigenen selbst." The statement was made in a lecture held for King Maxmilian II of Bavaria in 1854. Leopold Ranke, *Über die Epochen der neueren Geschichte: Historisch kritische Ausgabe. Werk und Nachlass II*, ed. Theodor Schieder and Helmut Berding (Munich: Oldenbourg, 1971), 60.

69. Potts, *Flesh and the Ideal*, 8. See also Potts, "Introduction" to Winckelmann, *History*, 1.

70. Sauerländer, "From Stylus to Style," 259.

71. Further on this turn, see e.g. Friedrich Piel, "Der historische Stilbegriff," in Herman Bauer, ed., *Kunstgeschichte und Kunsttheorie im 19. Jahrhundert* (Berlin: De Gruyter, 1963), 19.

72. Johann Gottfried Herder, *Über die neuere Literatur: Fragmente* (1766–1768), quoted in Harloe, *Winckelmann*, 208. Hegel, Introduction to the *Lectures on Aesthetics*, trans. T.M. Knox (Oxford: Clarendon, 1988), 63.

73. Quatremère de Quincy, *Éloge historique de M. Visconti* (1820), quoted in Potts, *Flesh and the Ideal*, 14.

74. "Der Stil aller Künste, ja selbst der Depeschen und Liebesbriefe eines Herzogs von Richelieu, steht gegen einander in einigem Verhältniss." Möser, "Deutsche

Geschichte," in *Von Deutscher Art und Kunst*, ed. Johann Gottfried Herder (Hamburg: Bode, 1773), 181. Chris Wood observes how Möser "understands 'style' as a formative dynamic pervading all creative production." *A History of Art History* (New Jersey: Princeton University Press, 2019), 175.

75. Herder, "Further Reflections on the Philosophy of the History of Humankind" (1784–1791), in *On World History. Johann Gottfried Herder*, ed. and trans. Hans Adler and Ernest A. Menze (Abingdon: Routledge, 1997), 270.

76. "Nicht alles aber, was man hat und haben kann, will oder darf man gebrauchen; also bezirkte sich die persische Kunstgeschichte nach dem Klima und der Verfassung des Reichs, nach Religion, Sitten und äussern Umständen: dadurch gewann sie sowohl in Gegenständen als im Styl der Kunst ihren eigenen Umriss." Herder, "Persepolitanische Briefe an Herrn Hofrath Heyne" (1798), in *J.G. von Herders Sämmtliche Werke: Zur Philosophie und Geschichte* (Karlsruhe: Bureau der deutschen Classiker, 1820), vol. 1, 132.

77. Herder, "On the Monuments of the Distant Past" (1792), in *On World History*, 69.

78. Herder: "On the Monuments of the Distant Past," 63–80.

79. Herder, "On the Monuments of the Distant Past," 72.

80. Herder, "Further Reflections on the Philosophy of the History," 272.

81. Harloe, *Winckelmann*, 165, 168–169, 187–188.

82. Arnold Heeren, *Ideen über die Politik, den Verkehr, und den Handel der vornehmsten Völker der alten Welt* (Göttingen: Vandenhoeck & Ruprecht, 1793–1796), vol. 1, 37.

83. "Die Säulen von Persepolis streben schlank und doch fest empor, und zeigen noch das Bild der Palme, von dem sie wahrscheinlich hergenommen waren. So wie bey den Ägyptern alles bedeckt und oft niedergedrückt erscheint, so ist hier alles offen und frey; in schöner Harmonie mit dem Charakter des Volkes, das die Sonne, die Elemente, und das offene Gewölbe des Himmels zu den Gegenständen seiner Verehrung machte!" Heeren, *Ideen*, vol. 1, 224–225.

84. Christian Ludwig Stieglitz, *Archaeologie der Baukunst der Griechen und Römer*, 7; Semper, *Style*, 201. Semper actually studied under Heeren in Göttingen in 1823–1825, see Sonja Hildebrand, *Gottfried Semper: Architekt und Revolutionär* (Darmstadt: Wissenschaftliche Buchgesellschaft wbg/Theiss, 2020), 12–20.

85. Hirt on Heeren, see e.g. *Die Geschichte der Baukunst bei den Alten*, vol. 1 (Berlin: Reimer, 1821), 176.

86. "Alles trägt dasselbe Gepräge, denselben Geist," Hirt, *Geschichte*, vol. 1, 104–105 and 251.

87. For examples on how Hirt used style as a dating device, see e.g. *Die Baukunst nach den Grundsätzen der Alten* (Berlin: Realschulbuchhandlung, 1809), 38 and 51.

88. "In der *Baukunst* habe ich die Grundsätze aufgestellt, nach welchen Griechen und Römer in den glänzendsten Perioden ihre Baue führten. Zehn Jahre darauf folgte die *Geschichte der Baukunst bei den Alten*, worin ich die Anfänge, die Fortschritte, die Höhe, das allmählige Sinken und den Verfall dieser Kunst enwickelte.... Rücksicht auf die Erfordernisse, Rücksicht auf die Formen, welche den Erfordernissen in einem gegebenen Falle am vollkommensten entsprechen, Rücksicht auf die Verhältnisse und den Charakter jeder Art von Anlagen sind hier die allgemeinen und ersten Bedingungen. Das Clima, das Oertliche, das Gebräuchliche und Herkömmliche, so wie religiöse und bürgerliche Einrichtungen, Erziehung, Lebensweise, Spiele und Erholungen, Vermögensumstände und selbst das Material, üben hierauf entschiedenen Einfluss, und bewirken mehr oder

weniger bedeutende Abänderungen; und ein Gleiches thut die Zeit. Was man für zweckmässig und bequem zu einer Zeit hielt, ist es nicht mehr für eine andere. Was für die Väter anständig und selbst prachtvoll galt, ist es nicht mehr für die Söhne und Enkel." Hirt, *Geschichte*, vol. 3, v.

89. "Wer möchte eine gothische Kirche im griechischen Stile ergänzen?" Hirt, *Geschichte*, vol. 1, 5.

90. Sauerländer, "From Stylus to Style," 254–255.

91. Quatremère de Quincy, "Style," 238.

Chapter 3

1. "Man geht von hier nach der Burg. Dies ist ein alter halb verfallener gothischer Thurm, in einem wahren täuschenden Styl, nach der Zeichnung des Prinzen vortrefflich gebauet. Die rohen Feldsteine, die kühnen Massen, die seltsame gothische Gestalt, die scheinbaren Merkmale von den Zerstörungen der Zeit, das Eckige sowohl, als das Abgestumpfte, die Oeffnungen, die Fenster, das ganze äussere Ansehen kündigt ein Werk vergangener Jahrhunderte an; und seine Lage zwischen ehrwürdigen Eichen, die ihren Nachbar zu befragen scheinen, ob er nicht mit ihnen von gleichem Alter ist, trägt nicht wenig zu der guten Wirkung seiner Aussenseite bey."

Christian Hirschfeld, *Theorie der Gartenkunst*, vol. 5 (Leipzig: Weidmanns Erben und Reich, 1785), 105.

2. Further on the notion of caractère in French architectural theory, see Werner Szambien, *Symétrie. Goût. Caractère. Théorie et terminologie de l'architecture à l'âge Classique, 1500–1800* (Paris: Picard, 1986), and Van Eck, *Boffrand*, Introduction. For the German adaptation of the French notion of caractère, see Klaus Jan Philipp, *Um 1800: Architekturtheorie und Architekturkritik in Deutschland zwischen 1790 und 1810* (Stuttgart: Axel Menges, 1997), 80–83.

3. *Allgemeines Magazin für die bürgerliche Baukunst* 1, no. 1 (1789): 97–172; no. 2 (1789): 66–169. The definition of character appeared in the anonymous *Untersuchungen über den Charakter der Gebäude, über die Verbindung der Baukunst mit den schönen Künsten, und die Wirkungen, welche durch dieselbe hervorgebracht werden sollen* (Leipzig: Joh. Philipp Haugs Wittwe, 1788), 11. Sulzer did not include an entry on character in the *Allgemeine Theorie der schönen Künste*, but used the concept frequently throughout the work. Stieglitz's encyclopedia included an entry on architectural character where he emphasized emotional effect. *Encyklopädie der bürgerlichen Baukunst*,

vol. 1, "Charakter der Gebäude."

4. The section on Hirschfeld has been published in an earlier version in Hvattum, "*Zeitgeist*, Style and *Stimmung*. Notes on architectural historiography in the late eighteenth century," in The Companion to Eighteenth-Century Architecture, eds. Caroline van Eck and Sigrid de Jong (London: Wiley, 2017), 691–714.

5. Christian Hirschfeld, *Theory of Garden Art*, abridged translation by Linda Parshall (Philadelphia: University of Pennsylvania Press, 2001), 154.

6. Hirschfeld, *Theory*, 196.

7. On Hirschfeld's associationism, see Wolfgang Schepers, *Hirschfelds Theorie der Gartenkunst* (Worms: Werner'sche Verlagsgesellschaft, 1980), 129–135.

8. Hirschfeld, *Theory*, 286.

9. Hirschfeld, *Theory*, 293.

10. Hirschfeld, *Theory*, 298 and 302.

11. See Monique Mosser, "Paradox in the Garden: A Brief Account of Fabriques," in The History of Garden Design, eds. Monique Mosser and Georges Teyssot (London: Thames & Hudson, 1991), 262–279. For the landscape garden in German architectural thinking, see Philipp, *Um 1800*, 183–190.

12. Thomas Whately, *Observations on Modern Gardening, illustrated by descriptions* (1770); Claude-Henri Watelet, *Essai sur les jardins* (1774); Jean-Marie Morel, *La théorie des jardins* (1776).

13. Hirschfeld, *Theory*, 281.

14. Hirschfeld, *Theory*, 303.

15. Hirschfeld, *Theory*, 287.

16. Hirschfeld, *Theory*, 302.

17. Further on Wilhelmsbad, see Elke Conert, *Wilhelmsbad: Garten der Empfindsamkeit* (Hanau: CoCon Verlag, 1997). For an eighteenth-century account, see Adolph von Knigge, *Briefe eines Schweizers über das Wilhelmsbad bei Hanau* (1780) (Hanau: CoCon Verlag, 2009).

18. Johann Wolfgang von Goethe, "On German Architecture" (1772), in *The Essential Goethe*, ed. Michael Bell (Princeton: Princeton University Press, 2016), 869.

19. Johann Gottfried Herder, *This Too a Philosophy of History* (1774), in *Herder: Philosophical Writings*, trans. and ed. Michael N. Forster (Cambridge: Cambridge University Press, 2002), 306–312.

20. Herder, *This Too a Philosophy of History*, 292.

21. Georg Forster, *Ansichten vom Niederrhein* (Berlin: Voss, 1791), vol. 1, 70–89; Gilly, "On the Views of Marienburg" (1796), in *Friedrich Gilly: Essays on Architecture 1796–1799*, ed. and trans. Fritz Neumeyer and David Britt (Los Angeles: Getty, 1994), 105–111; Schlegel, "Grundzüge der gotischen Baukunst" (1803), in *Kritische Schriften*, ed. Wolfdietrich Rasch (Munich: Carl Hanser, 1958), 358ff. On the national significance of Gothic in Prussia, see Ulrich Reinisch, "Schinkels Entwürfe für den 'Befreiungsdom' und die 'Neue Wache,'" in *Klassizismus–Gotik: Karl Friedrich Schinkel und die patriotische Baukunst*, eds. Anette Dorgerloh, Michael Niedermeier, and Horst Bredekamp (Berlin: Deutscher Kunstverlag, 2007), 147–164. On the emergence of modern heritage culture in Germany, see Norbert Huse, ed., *Denkmalpflege: Deutsche Texte aus drei Jahrhunderten* (Munich: Beck, 2006).

22. The authorship is debated. Alfred Neumeyer attributes the building to the Wörlitzer building director Georg Christoph Hesekiel ("Die Erweckung der Gotik in der deutschen Kunst des späten 18. Jahrhunderts: ein Beitrag zur Vorgeschichte der Romantik," in *Repertorium für Kunstwissenschaft*, vol. 49, ed. Wilhelm Waetzoldt [Berlin: De Gruyter, 1928]), while eighteenth-century sources tended to ascribe the design to the prince himself and his architect Erdmannsdorff.

23. The western part was constructed 1773–1774, the eastern 1785–1790. Kilian Heck, "Wörlitz als Gartenreich," *Kunsthistorische Arbeitsblätter*, no. 6 (2001): 17–26.

24. Ludwig Trauzettel, "Wörlitz: England in Germany," *Garden History* 24, no. 2 (Winter 1996): 221–236.

25. "Er erbaute das gothische Haus und versammelte darin um sich alles, was dazu dienen konnte, seinen Geist in die Vorwelt zu versetzen." August von Rode, *Das gotisches Haus zu Wörlitz* (1818), quoted in Neumeyer, "Die Erweckung der Gotik," 104.

26. "[D]ie Gebäude *an sich*, d.h. nach Grundriss und als Raumgebilde, so gut wie nichts bedeuten... Ihre Existenz ist lediglich als Erscheinungswert in der Landschaft und als Stimmungswert in der Empfindung gesetzt." Neumeyer, "Die Erweckung der Gotik," 82.

27. Philipp, *Um 1800*.

28. "Wir werden daher in unsern Heften die ausgesuchtesten Entwürfe von Gartenhäusern, Pavillons, Tempeln, Hütten, Meierhöfen, Einsiedeleien, Grotten, Promenaden, Pflanzungen, Ruinen, Denk- und Grabmählern, Ruhesitzen, Brücken, Inseln, Cascaden u.s.f. liefern, und ihnen Stoffs genug zur beliebigen Wahl geben." *Ideenmagazin*

1, no. 1 (1796): Introduction.

29. "... um Gärten und ländliche Gegenden, sowohl mit geringem als auch grossem Geldaufwand nach den originellsten Englischen, Gothischen, Sinesischen Geschmacksmanieren zu verschönern und zu veredeln." *Ideenmagazin* 1, no. 1 (1796): title.

30. See Philipp, *Um 1800*, 106–120.

31. "Es kann Stimmungen der Seele geben, und giebt ihrer zuverlässig, welche vermöge der sonderbaren Laune, die darin herrscht, in einer gewissen unbeschreiblichen Analogie mit dem Zimmer stehen, das wir auf diesem Blatte darstellen. Und wenn es erwiesen ist, dass die Stimmung und Rührung unsrer Seele sehr oft von den Gegenständen, die uns umgeben, abhängt, so könnte man sich durch die Anlage und Verzierung eines Zimmers in diesem Geschmack, den ich den phantastisch-arabesken nennen möchte, eine Quelle von launigen, sonderbaren Spielen des Gefühls eröffnen." *Ideenmagazin* 3, no. 19 (1798): Tab. I.

32. Klinsky's illustrations are identified and discussed in Philipp, *Um 1800*, 107.

33. Philipp, *Um 1800*, 106.

34. *Ideenmagazin* 1, no. 1 (1796): Tab. VI.

35. "Eine Zimmerverzierung in Aegyptischen Styl: wir sagen wohlbedächtig nicht, im Aegyptischen Geschmack, denn die Aegyptier hatten, wie von ihnen übrig gebliebene Werke der bildenden Kunst beweisen, keinen Kunstgeschmack. Man werfe daher diesem Blatte Geschmacklosigkeit nicht vor: es würde aufhören, im Aegyptischen Style zu sein, wenn man ihm diese Eigenschaft, das Krause und Bunte in jeglicher Beziehung, nähme." *Ideenmagazin* 1, no. 9 (1796): Tab. I.

36. "Dieses Blatt enthält in der ersten Figur eine Gartennische in einem guten Styl, für eine Scene von ernsthaftem, feierlichem Charakter." *Ideenmagazin* 1, no. 8 (1796): Tab. I.

37. Hendrik Bärnigshausen and Margitta Çoban-Hensel, "Joseph Friedrich Freiherr von Racknitz (1744–1818), seine 'Darstellung und Geschichte des Geschmacks der vorzüglichsten Völker' und ein Ausstattungsprojekt für Schloss Moritzburg (1792/1793)," *Staatliche Schlösser, Burgen und Gärten Sachsen* 11 (2003): 40–71. Simon Swynfen Jervis, *A Rare Treatise on Interior Decoration and Architecture: Joseph Friedrich zu Racknitz's Presentation and History of the Taste of the Leading Nations* (Los Angeles: Getty, 2019).

38. Racknitz, "Design for the Arrangement and Furnishing of Schloss Moritzburg" (1793), quoted in Jervis, *A Rare Treatise*, 17–18.

39. "... wie jeder Geschmack zu einer reissenden Auszierung der Zimmer benutzt werden kann." Georg Joachim Göschen, "Darstellung und Geschichte des Geschmacks der vorzüglichsten Völker," *Intelligenz-Blatt des Journals des Luxus und der Moden* 10, no. 11 (November 1795): CXCV. See also Jervis, *A Rare Treatise*, 23–24.

40. Jervis, *A Rare Treatise*, 23.

41. Racknitz's liberal use of the term taste drew criticism from contemporaries such as Carl August Böttiger (otherwise a great supporter of the project), who thought "manner" would be more appropriate when talking about non-Western civilizations such as the Egyptian. Jervis, *A Rare Treatise*, 27.

42. Racknitz, "Presentation and History," in Jervis, *A Rare Treatise*, 71; 201; and 242–243.

43. Racknitz, "Presentation and History," 255–256.

44. Racknitz, "Presentation and History," 59.

45. Racknitz, "Presentation and History," 122–125. Discussed in Philipp, *Um 1800*, 123–127.

46. Racknitz, "Presentation and History," 124.

47. Racknitz, "Presentation and History," 126.

48. Racknitz, "Presentation and History," 126.

49. Racknitz, "Presentation and History," 68.

50. Racknitz, "Presentation and History," 244.

51. Racknitz, "Presentation and History," 245. Racknitz cited the rebuilding of St. Nicholas in Leipzig as a potential precedent. The medieval church was rebuilt with a neoclassical interior in 1784–1797 by Johann Dauthe. Discussed in Philipp, *Um 1800*, 60–61.

52. "Versuch, die lieblich sehnsuchtsvolle Wehmuth auszudrücken welche das Herz beim Klange des Gottesdienstes aus der Kirche herschallend erfüllt, auf Stein gezeichnet von Schinkel." For an introduction to the print, see Heinrich Schulze Altcappenberg, "Kirche im gotischen Stil hinter Bäumen," in *Das Erbe Schinkels*. Online catalog, http://schinkel.smb.museum/index.php?object_id=1534525.

53. On Schinkel's print and its relation to Friedrich, see e.g. Helmut Börsch-Supan, *Bild-Erfindungen: Karl Friedrich Schinkel Lebenswerk*, vol. 20 (Berlin: Deutscher Kunstverlag, 2007), 551–554, and Andreas Haus, *Karl Friedrich Schinkel als Künstler* (Berlin: Deutscher Kunstverlag, 2001), 119.

54. Schinkel, "Entwurf zu einer Begräbniskapelle für Ihre Majestät die hochselige Königin Luise von Preussen" (1810), in *Aus Schinkel's Nachlass*, vol. 3, ed. Alfred von Wolzogen (Berlin: Verlag der königlichen Geheimen Ober-Hofbuchdruckerei, 1863), 161.

55. On the German reappraisal of the Gothic around 1800, see Philipp, *Um 1800*, 60–80.

56. Nationalist agendas in the Prussian style debate are thoroughly discussed in Dorgerloh et al., *Klassizismus—Gotik*, and Lewis, *The Politics of the German Gothic Revival*.

57. Rudolf Speth, "Königin Luise von Preußen—deutscher Nationalmythos im 19. Jahrhundert," in Sabine Berghahn and Sigrid Koch-Baumgarten, eds., *Mythos Diana—von der Princess of Wales zur Queen of Hearts* (Giessen: Psychosozial-Verlag, 1999), 265–285.

58. Philipp Demandt, *Luisenkult. Die Unsterblichkeit der Königin von Preussen* (Cologne: Böhlau, 2003), 24–25.

59. "Sie ist todt! Todt die erste der Frauen der Welt, unsere erhabene, unsere angebetete Königin!" Quoted in *Zum Angedenken der Königin Luise von Preussen, Sammlung der vollständigsten und zuverlässigsten Nachrichten von allen das Absterben und die Trauerfeierlichkeiten dieser unvergesslichen Fürstin betreffenden Umständen* (Berlin: Haude und Spenerschen Zeitungsexpedition, 1810), 30.

60. Eva Börsch-Supan, *Arbeiten für König Friedrich Wilhelm III. von Preußen und Kronprinz Friedrich Wilhelm (IV.), Karl Friedrich Schinkel Lebenswerk*, vol. 21 (Berlin: Deutscher Kunstverlag, 2011), 133–193.

61. See e.g. Erik Forssman, *Karl Friedrich Schinkel. Bauwerke und Baugedanken* (Munich: Schnell & Steiner, 1981), 64, and Haus, *Schinkel als Künstler*, 115.

62. Eva Börsch-Supan, *Arbeiten für König Friedrich Wilhelm III*, 134–141.

63. "Ein mannigfach gewölbter Raum… so angeordnet, dass die Empfindung eines schönen Palmenhains erregt wird, umschliesst das auf Stufen mit vielen sprossenden Blättern, Lilien- und Rosenkelchen sich erhebende Ruhelager…. Das Licht fällt durch die Fenster von dreien Nischen, die das Ruhelager von drei Seiten umgeben; das Glas ist von rosenrother Farbe, wodurch über die ganze Architektur, welche in weissem Marmor ausgeführt ist, ein sanft rothes Dämmerlicht verbreitet wird. Vor dieser Halle ist eine Vorhalle, die von den dunkelsten Bäumen beschattet wird; man steigt Stufen hinan und tritt mit einem sanften

Schauer in ihr Dunkel ein, blickt dann durch drei hohe Oeffnungen in die liebliche Palmenhalle, wo in hellem morgenrothen Lichte die Ruhende, umringt von himmlischen Genien, liegt." Schinkel, "Entwurf zu einer Begräbnisskapelle," 161. The various versions of this text, including their reception history, are discussed and analyzed in Eva Börsch-Supan, *Arbeiten für König Friedrich Wilhelm III*, 141–162.

64. "Ein jeder sollte darin gestimmt werden, sich Bilder der Zukunft zu schaffen, durch welche sein Wesen erhöht, und er zum Streben nach Vollendung genöthigt würde." Schinkel, "Entwurf zu einer Begräbnisskapelle," 161.

65. Philipp Otto Runge famously described red as "der Mittler zwischen Erde und Himmel." Letter of November 11, 1802, quoted in Forssman, *Schinkel*, 64–65. Further on light metaphors in Schinkel, see Jan Werquet, "Künstlerisches Ideal und historischer Aussagewert. Schinkel und die rheinischen Bauprojekte Kronprinz Friedrich Wilhelms (IV.) von Preußen," in Altcappenberg and Johannsen, *Das Studienbuch*, 261–271.

66. Ludwig Achim von Arnim, "Nachfeier nach der Einholung der Hohen Leiche Ihrer Majestät der Königin," in *Ausgewählte Gedichte von Achim von Arnim* (Musaicum Books,

2017), unpaginated. See also Friedrich Duncker's poem in *Zum Angedenken*, 31.

67. Haus expands on the links between Arnim and Schinkel in *Schinkel als Künstler*, 119. Eva Börsch-Supan argues convincingly that Arnim's cantata could not have influenced Schinkel's project, as it was made before the cantata was written (*Arbeiten für König Friedrich Wilhelm III*, 145.) However, it seems plausible that Arnim and Schinkel shared a common understanding of the monument and may have exchanged ideas.

68. Schinkel, "Entwurf zu einer Begräbnisskapelle," 161.

69. Demandt, *Luisenkult*, 117.

70. Schinkel, "Entwurf zu einer Begräbnisskapelle," 154. On Schinkel's organicism with an incisive reading of this text, see Caroline van Eck, *Organicism in Nineteenth-Century Architecture* (Amsterdam: Architectura & Natura Press, 1994), 146–162.

71. "[D]ie durchaus Neues schaffende und die gesammte Menschheit auf eine ganz andere Stufe setzende Idee des Christenthums... bemächtigte sich endlich eines wahren Urvolks, der Deutschen, welches fern davon, sich unbedingt dem Einflusse des Alterthums hinzugeben, aus dem eigenen Freiheitssinne

heraus allerdings unter Aufnahme früherer Formen eine eigen geartete Welt des Geistes und Lebens entstehen liess. In der Architektur hatte man bisher, wie wir gesehen, die Kunst des Gewölbebaues schon lange, jedoch einseitig und ohne eigentliche Frucht betrieben; die Deutschen ergriffen dieselbe aber mit der Ursprünglichkeit und Freiheit ihrer Natur und verstanden es bald, sie zum Ausdruck derjenigen Ideenwelt zu verwenden, die ebenso aus der ursprünglichen Geistesrichtung des Volkes, wie aus den Anschauungen des Christenthums nach einer äusseren Verwirklichung drängte. Jetzt ward der Geist völlig Sieger über die Masse oder Materie." Schinkel, "Entwurf zu einer Begräbnisskapelle," 157.

72. Schinkel, "Entwurf zu einer Begräbnisskapelle," 158. This point is discussed in light of e.g. Fichte and the Schlegel brothers by Forssman, *Schinkel*, 58–83; van Eck, *Organicism*, 151–152; and Reinisch, "Schinkels Entwürfe," in Dorgerloh et al., *Klassizismus–Gotik*, 156–157.

73. "Die Architektur des Heidenthums ist daher in dieser Hinsicht ganz bedeutungslos für uns." Schinkel, "Entwurf zu einer Begräbnisskapelle," 160.

74. Schinkel, "Entwurf zu einer Begräbniskapelle," 161.

75. Forssman, *Schinkel*, 68.

76. "aber jedem Menschen wird es Pflicht, die neue Gestaltung zu finden." Schinkel, "Entwurf zu einer Begräbniskapelle," 155.

77. "Das Unendliche und Ewige darzustellen, vermag die Kunst nicht geradezu. Ausser Grösse, Erhabenheit und Schönheit, welche über das Gemeine fortheben und in empfänglichen Gemüthern eine Ahnung des Ewigen erzeugen, ist es eigentlich der tiefe innere Zusammenhang eines Kunstwerkes, welcher hindeutet auf das nicht Darstellbare; denn dieser Zusammenhang wird selbst nicht anders klar, als indem jedes fühlende Gemüth ihn in den dargestellten Formen und Gestalten durch eigene Thätigkeit ergreift. Nur für den, der das Ewige schon in sich trägt, nicht aber für den bloss sinnlichen Menschen kann vermittelst der Kunst das Ewige und Göttliche dargestellt werden." Schinkel, "Entwurf zu einer Begräbniskapelle," 160.

78. Forssman, *Schinkel*, 68.

79. Forssman, *Schinkel*, 63. Eva Börsch-Supan even mentions Martin Friedrich Rabe's Abbey in Buchwald Park as a possible precedent.

Arbeiten für König Friedrich Wilhelm III, 145.

80. Cf. Schinkel, letter to August Wilhelm Iffland, December 11, 1813, in Paul Ortwin Rave, *Karl Friedrich Schinkel, Lebenswerk: Berlin I–Bauten für die Kunst, Kirchen und Denkmalpflege* (Berlin: Deutscher Kunstverlag, 1981), 84. Kurt Forster discusses Schinkel's emotive "dislocation" strategies in relation to his stage architecture in "Only Things that Stir the Imagination: Schinkel as a Scenographer," in *Karl Friedrich Schinkel: The Drama of Architecture*, edited by John Zukowsky (Tübingen: Wasmuth, 1994), 18–35. I am grateful to Emma Jones for bringing the notion of *Ortsversetzung* to my attention.

81. Schinkel, "Ueber das Projekt des Baus einer Cathedrale auf dem Leipziger Platz zu Berlin, als Denkmals für die Befreiungskriege. A. Schinkel's Bericht hierüber an den Geheimen Kabinetsrath Albrecht," in Wolzogen, *Aus Schinkel's Nachlass*, vol. 3, 189.

82. Quoted in Gottfried Riemann, "Sketch design for a Cathedral as a Memorial to the Wars of Liberation," in *Karl Friedrich Schinkel: A Universal Man*, ed. Michael Snodin (New Haven: Yale University Press, 1991), 103.

83. "der hieraus formirte grosse und schöne Platz mit

dem in seiner Mitte errichteten Gebäude im vaterländischen Styl." Schinkel, "Ueber das Projekt," 191.

84. Schinkel, "Religiöse Gebäude," in *Das architektonische Lehrbuch*, ed. Goerd Peschken (Berlin: Deutscher Kunstverlag, 1979), 31–34.

85. Schinkel, "Ueber das Projekt," 193.

86. "ein lebendiges Monument in dem Volke, indem unmittelbar durch die Art der Errichtung desselben etwas in dem Volke begründet werden soll, welches fortlebt und Früchte trägt." Schinkel, "Ueber das Projekt," 193.

87. Haus, *Schinkel als Künstler*, 130–131. See also Reinisch, "Schinkels Entwürfe," in Dorgerloh et al., *Klassizismus–Gotik*, 156–159.

88. "dieser ewig merkwürdigen Zeit ein grosses und heiliges Denkmal zu errichten, . . . eine Kirche in dem ergreifenden Styl altdeutscher Bauart, einer Bauart, deren völlige Vollendung der kommende Zeit aufgespart ist, nachdem ihre Entwicklung in der Blüte durch einen wunderbaren und wohlthätigen Rückblick auf die Antike für Jahrhunderte unterbrochen ward, wodurch, wie es scheint, die Welt geschickt werden sollte, ein dieser Kunst zur Vollendung noch fehlendes Element in ihr zu verschmelzen." Schinkel, "Ein zweiter

Auffass Schinkel's, denselben Gegenstand betreffend und sicher auch aus derselben Zeit," in Wolzogen, *Aus Schinkel's Nachlass*, vol. 3, 198–207, 198–199.

89. Schinkel painted several other large cathedral paintings, e.g. *Mittelalterliche Stadt an einem Fluss* and *Gotische Kirche auf einem Felsen am Meer*, both in 1815. For an introduction to this painting and its numerous copies, see Helmut Börsch-Supan, *Bild-Erfindungen*, 349–356. See also Bernhard Maaz, "Sozialutopische Stadtlandschaften. Schinkels Architekturmalerei—Bedeutung und Folgen," in Dorgerloh et al., *Klassizismus–Gotik*, 113–122.

90. Cf. Goethe, *Italian Journey* (1786–1788), trans. W. H. Auden and Elizabeth Mayer (Harmondsworth: Penguin, 1970), 124.

91. "Mit der unverkenntlichen Absicht ein Charakterbild darzustellen, hat Herr Schinkel seinen altdeutschen Dom gemalt, diesen Zweck aber dadurch verfehlt, dass er ihn mit der Rückseite zeigte, und ihn mit Gebäuden von der verschiedensten Bauart aus allen Zeitaltern umringte. Hat er etwa den Zweck gehabt, den altdeutschen Dom als Sieger im Wettkamp mit den Werken anderer Bauart zu zeigen?

So lag diese Aufgabe mehr im Gebiet des Verstandes als des Gemüths, und bedingte eine geometrische Zusammenstellung dieser Gebäude nach einem Massstabe wie in der Parallèle d'architecture von Durau." Review in *Vossischen Zeitung*, 1814, quoted in Helmut Börsch-Supan, *Bild-Erfindungen*, 350.

92. On the political backdrop for the decision, see Reinisch, "Schinkels Entwürfe," in Dorgerloh et al., *Klassizismus–Gotik*, 160.

Chapter 4

1. "Ehmals hatte man einen Geschmack. Nun gibt es Geschmäcke. / Aber sagt mir wo sitzt dieser Geschmäcke Geschmack?" Schiller and Goethe, "Xenien," in Schiller, *Musen-Almanach für das Jahr 1797* (Tübingen: Cotta, 1797), 205.

2. Jervis, *A Rare Treatise*, 26.

3. "Kamtschadalisch lehrt man euch bald die Zimmer verzieren, / Und doch ist Manches bey euch schon kamtschadalisch genug." Schiller and Goethe, "Xenien," 205.

4. Goethe, "Simple Imitation, Manner, Style" (1789), in *The Essential Goethe*, ed. Matthew Bell (Princeton: Princeton University Press, 2016), 876.

5. On the relationship between style and manner in Vasari, Diderot,

and Goethe, see Ursula Link-Heer, "Maniera. Überlegungen zur Konkurrenz von Manier und Stil," in Gumbrecht and Pfeiffer eds., *Stil*, 93–114.

6. See for instance Charles Batteaux, *Les beaux-arts réduits à un même principe* (Paris: Durand, 1746); Johann Georg Sulzer: "Nachahmung," in *Allgemeine Theorie der Schönen Künste*, vol. 2 (Leipzig: Weidmanns Erben & Reich, 1774), 794–798.

7. Winckelmann, *Gedanken über die Nachahmung der griechischen Werke in der Malerei und Bildhauerkunst* (1755, Stuttgart: Reclam, 1995), 4.

8. Hilmar Frank, "Einfache Nachahmung der Natur, Manier, Styl," in *Goethe Handbuch*, vol. 3: *Prosaschriften*, eds. Bernd Witte and Peter Schmidt (Stuttgart: J. B. Metzler, 1997), 571.

9. See e.g. Karl Philipp Moritz, *Ueber die bildende Nachahmung des Schönen* (Braunschweig: Schul-Buchhandlung, 1788), 8.

10. Carl Ludwig Fernow, "Ueber den Stil in den bildenden Künsten," *Der neue Teutsche Merkur* 1, no. 4 (1795): 404–424, and no. 5 (1795): 3–36.

11. Fernow, "Ueber den Stil I": 405.

12. "Die Manier ist nur der Körper, der den Stil des Künstlers uns versichtbart; der Stil selbst ist der karakteristische Geist des

Kunstwerks." Fernow, "Ueber den Stil I": 409.

13. Fernow, "Ueber den Stil I": 409.

14. "Stil, in wieferne wir ihn an einem Kunstwerke in Rücksicht auf die Kunst betrachten, ist das Verhältniss der dargestellten Theile des schönen Kunstwerks, in wieferne sie dargestellt sind, zum Zwecke des Ganzen." Fernow, "Ueber den Stil I": 412. Kant's theory of purposiveness is developed in *Critique of Judgment*, see for instance "Third Moment of Judgments of Taste," §15.

15. Schiller, *Über die aesthetische Erziehung der Menschen* (1795), 22nd letter. https://www.friedrich-schiller-archiv.de/ueber-die-aesthetische-erziehung-des-menschen/zweiundzwanzigster-brief/.

16. "Das Gegentheil der Manier ist der Stil, der nichts anders ist, als die höchste Unabhängigkeit der Darstellung von allen subjektiven und allen objektivzufälligen Bestimmungen.... Der Stil ist eine völlige Erhebung über das Zufällige zum Allgemeinen und Nothwendigen." Schiller, letter to Gottfried Körner, January 28, 1793. https://www.friedrich-schiller-archiv.de/briefe-schillers/briefwechsel-mit-gottfried-koerner/schiller-an-gottfried-koerner-28-februar-1793/.

17. Frank, "Einfache Nachahmung," *Goethe Handbuch*, vol. 3, 571.

18. "Der Stil der Plastik kann und muss also im Wesentlichen, d.i. in sofern er das Ideal, das, in seiner Reinheit gedacht, nur Eines ist, im Besonderen darstellt, immer nothwendig einer und derselbe seyn." Fernow, *Römische Studien* (Zurich: Gessner, 1806–1808), vol. 1, 42.

19. "Zwischen der Kunst und der Natur steht also nothwendig etwas mitten inne, was sie aus einander hält. Dieses heisst *Manier*, wenn es ein gefärbtes oder trübes Medium ist, welches auf alle dargestellten Gegenstände einen falschen Schein wirft; *Styl*, wenn es den Rechten von beyden, der Kunst und der Natur nicht zu nahe tritt, welches nicht anders möglich ist, als durch die dem Werke selbst gleichsam eingeprägte Erklärung." Schlegel, "Über das Verhältniss der schönen Kunst zur Natur; über Täuschung und Wahrscheinlichkeit; über Styl und Manier" (1802/1808), in *August Wilhelm Schlegel: Kritische Ausgabe der Vorlesungen*, ed. Ernst Behler (Paderborn: Ferdinand Schöningh, 2007), 266.

20. Schlegel, "Über das Verhältniss," 268.

21. "Styl ist eine Verwandlung der individuellen unvermeidlichen Beschränktheit in freywillige Beschränkung nach einem Kunstprinzip." Schlegel, "Über das Verhältniss," 266.

22. "welches sich mit Freyheit und Bewusstseyn entwickelt, zum praktischen Systeme, zum Style bildet." Schlegel, "Über das Verhältniss," 267.

23. "Endlich entwickelt sich die Kunst als etwas von Menschen zu Verwirklichendes nur allmählig in der Zeit: dieses geschieht unstreitig nach gewissen Gesetzen, wenn wir sie schon nicht immer in einem beschränkten Zeitraume nachweisen können. Wo wir aber eine Kunstmasse als geschlossenes Ganzes übersehen; und die Gesetzmässigkeit in ihrem Fortgange wahrnehmen, da sind wir berechtigt, sie auch durch Bezeichnung der verschiedenen Epochen mit der Benennung Styl anzudeuten. Styl heisst alsdann eine nothwendige Stufe in der Entwicklung der Kunst." Schlegel, "Über das Verhältniss," 267.

24. Schlegel, "Über das Verhältniss," 268.

25. Herder, *This Too a Philosophy of History*, 299 and 310. See also Eck, *Organicism*, 114–125.

26. Rumohr, "Mittheilungen über Kunstgegenstände," I–IV, *Kunstblatt* no. 39 (15 May 1820); no. 52 (29 June 1820); no. 54 (6 July 1820); and no. 55 (10 July 1820).

27. Rumohr, "Mittheilungen," III,

Kunstblatt no. 54 (6 July 1820): 213.

28. Rumohr, "Mittheilungen," III: 214.

29. "Indessen muss der Kunst in der Ausübung... das Zufällige, Zeitliche und Individuelle nothwendig zugegeben werden." Rumohr, "Mittheilungen," III: 214.

30. "Nun kann der Künstler in einem gedoppelten Sinne schön bilden. Im ersten, wenn er seinen Gegenstand im Geiste durchdringt, und ihm unmerklich die Schönheit der Idee mittheilt, die ihn erfüllt; im zweyten, wenn er die Bedingungen einer wohlgefälligen Erscheinung, welche einzeln für jede Kunstart und allgemein für alle vorhanden sind, feinsinnig erfüllt. Die Erfüllung jener Bedingungen, welche nicht wohl erschöpfend ausgesprochen werden können, halte ich für das Wesen des Styles. Ein Begriff, der nicht sorgfältig genug umgrenzt, und von allem Fremdartigen geschieden werden kann. Es ist nämlich sehr gewöhnlich, die Eigenheiten, welche einzelne Meisterschaften, oder ganze Schulen und Kunstepochen anzunehmen pflegen, mit dem Styl zu verwechseln*), der doch etwas viel Allgemeineres ist." Rumohr, "Mittheilungen," III: 214–215.

31. "Da der Ausdruck Styl immer die Beziehung auf das Individuelle des Künstlers einschliesst, so ist diese Anwendung kaum zu vermeiden. Was der Hr. Vf. im folgenden als Wesen des Styles andeutet, haben wie anderswo als dem Begriffe des *Kunstschönen* angehörig betrachtet, durch welchen Ausdruck freylich auch etwas Allgemeines nur unvollkommen bezeichnet wird. Anm. der Red." Schorn's footnote to Rumohr, "Mittheilungen," III: 215.

32. "Ich sah, es müsse etwas in der Natur wie im menschlichen Geiste Gegründetes, und zugleich ein wesentlicher Bestandtheil der künstlerischen Thätigkeit seyn. Diess ist nichts andres als die Anwendung der Grundgesetze der Formen, der dem Menschen wie der Natur engeborenen Mathematik." Schorn, "Ueber Styl und Motive in der bildenden Kunst. An Herrn Baron C. F. v. Rumohr," *Kunstblatt*, no. 1 (January 3, 1825): 1.

33. Schorn, "Ueber Styl und Motive": 2.

34. "Was ist demnach Styl in der höchsten künstlerischen Bedeutung des Worts? Offenbar jene innere Gesetzmässigkeit der künstlerischen Darstellung, die sich aus der begeisterten Anwendung der Grundformen der Schönheit auf die mit der tiefsten Kenntniss erfassten Gestalten der Natur ergibt…. So wird die Gestalt zum Idealen verklärt, indem das Reine, Bedeutende und Zweckmässige an ihr im Glanz der Schönheit hervortritt, das Unwesentliche verschwindet. Einmal vorhanden, wird diese Darstellungsweise— der reine Styl—zur Norm für alle künstige Hervorbringungen, ohne desshalb die Eigenthümlichkeit des schaffenden Genies zu beschränken." Schorn, "Ueber Styl und Motive": 2.

35. Rumohr, "Ueber den Styl in der bildenden Kunst. I. Antwort des Freyherrn v. Rumohr auf das Schreiben vom Herausgeber im Kunstbl. Nr. 1. d.J.," *Kunstblatt*, no. 75 (September 19, 1825): 297.

36. "… den derben Stoff auf jene leichterfassliche, dem Sinne wohlgefällige Weise vertheilen und anordnen, welche ich ausschliesslich den Styl nenne." Rumohr, "Ueber den Styl": 297.

37. Rumohr, "Ueber den Styl": 298.

38. Rumohr, "Mittheilungen," III, 215.

39. "Denn ein guter Theil der kleinen Auslassungen und Abänderungen der Gestaltung, welche Winckelmann an alten Bildwerke wahrnahm, entsprang nicht, wie er glaubte, aus irgend einer willkürlichen—nur den ältesten, eigentlich vorkünstlerischen Zeiten beyzumessenden—

Bezeichnungsart von bestimmten ideellen Aufgaben, vielmehr aus dem Gefühle dessen, was der derbe Kunststoff jedesmal zuliess oder ausschloss. Der senkrechte Stand der Statuen ward nicht immer, wie Winckelmann annahm, von den Ideen geboten, welche sie gerade darstellen, sondern im Ganzen eben nur vom Style. Dasselbe Stylgesetz mässigte in den Bildwerken der Alten die Andeutung alles Leichten und Weichen, eben weil solches nach seiner wirklichen Ausdehnung dargestellt in Stein und Erz nicht leicht noch weich, sondern schwer und hart erscheint, und es war daher weit hergeholt, wenn Winckelmann etwa in Bezug auf Sehen und Adern den Grund ihrer Milderung in einer übereinkömmlichen Darstellungsweise bestimmter Kunstideen aussuchte; wenn er anders nicht etwa in dem Wahne befangen war, dass die Naturformen sich wirklich so übertrieben anatomisch darstellen, wie neuere Maler aus Prunk mit einem ärmlichen Wissen sie wohl zu zeigen pflegten, wo dann, was ihm als Auslassung und Milderung auffiel, eben nur höchste Natürlichkeit sey dürfte." Rumohr, "Ueber den Styl": 299–300.

40. Michael Podro, *The Critical Historians of Art* (New Haven: Yale University Press, 1982), 27–30.

41. "Denn der Künstler ist stets—wie der individuelle Charakter aller Localschulen neuer wie alter Kunst ausnahmlos bezeugt— auf solche Formen der Natur angewiesen, als gerade in seinem Bereich liegen; und eben in den glücklichsten Fällen, denen beschäftigter, thätiger, lebenvoller Kunstzeiten, macht er sich seine Aufgabe nie selbst." Rumohr, "Ueber den Styl": 300.

42. Herrmann, *In What Style*, 4–6. See also Wood, *A History of Art History*, 204–205, and Harry Francis Mallgrave, *Modern Architectural Theory* (Cambridge: Cambridge University Press, 2009), 106. For the debate's German reception, see Julius Schlosser's preface to Carl Friedrich von Rumohr, *Italienische Forschungen* (1827–1831) (Frankfurt am Main: Frankfurter Verlags-Anstalt, 1920), xxiv–xxv, and Alexander Auf der Heyde, "Stil/ Stylus: Rumohrs Versuch einer Neuprägung des Stilbegriffs und die Flucht in die Kulturgeschichte," in *L'idée du style dans l'historiographie artistique. Variantes nationales et transmissions*, eds. Sabine Frommel and Antonio Brucculeri (Rome: Campisano Editore, 2012), 21–34.

43. Schorn, "Ueber den Styl in der bildenden Kunst. II. Antwort an Herrn Baron v. Rumohr," *Kunstblatt*, no. 76 (September 22, 1825): 301.

44. "—feste Körper für den Bildner, Farbe und Helldunkel für den Maler." Rumohr, "Ueber den Styl": 297.

45. Schorn, "Ueber den Styl, II": 302.

46. Rumohr, *Italienische Forschungen*, 59.

47. "Also werden wir nicht wesentlich weder vom Wortgebrauch noch von dem eigentlichen Sinne der besten Künstler dieser Zeit abweichen, wenn wir den Styl als ein zur Gewohnheit gediehenes sich Fügen in die inneren Forderungen des Stoffes erklären, in welchem der Bildner seine Gestalten wirklich bildet, der Maler sie erscheinen macht." Rumohr, *Italienische Forschungen*, 60.

48. "Styl, oder solches, was mir Styl heisst, entspringt also auf keine Weise, weder, wie bey Winckelmann… aus einer bestimmten Richtung oder Erhebung des Geistes, noch, wie bey den Italienern, aus den eigenthümlichen Gewöhnungen der einzelnen Schulen und Meister, sondern einzig aus einem richtigen, aber nothwendig bescheidenen und nüchternen Gefühle einer äusseren Beschränkung der Kunst durch den derben, in seinem Verhältniss zum Künstler gestalt-freyen Stoff." Rumohr, *Italienische Forschungen*, 60.

49. Auf der Heyde, "Stil/Stylus," 21.

50. Kubler, "Toward a Reductive Theory of Visual Syle," in Lang, ed., *The Concept of Style*, 163–173. Kubler does not refer to Rumohr's writings, yet frames his own endeavor in strikingly similar terms.

51. Rumohr, "Ueber den Styl, I": 300.

52. Viollet-le-Duc, "Style" (1854), in *The Foundations of Architecture: Selections from the* Dictionnaire raisonné, trans. K. D. Whitehead (New York: Braziller, 1990), 231–232.

53. "Styl (stylos), ursprünglich der Griffel, mit welchem die Alten ihre Schrift in harte Materien eintrugen; dann die eigenthümliche Art des Gedankenausdrucks in Sprache oder Bild (daher Styl in der Malerei, Bildhauer- und Baukunst), *subjectiver* Styl; endlich die zweckmässigste Art des Gedankenausdrucks überhaupt, *objectiver* Styl." *Conversations-Lexicon, oder encyclopädisches Handwörterbuch für gebildete Stände* (Leipzig: Brockhaus, 1817), 546.

54. See for instance Jean-Baptiste Louise Seroux d'Agincourt, *Histoire de l'art par les monuments* (Paris: Treuttel et Würtz, 1823); Aloys Hirt, *Die Geschichte der Baukunst bei den Alten*, vols. 1–3 (Berlin: Reimer, 1821–1827); and Carl Friedrich von Wiebeking, *Theoretisch-praktische bürgerliche Baukunde*, vols. 1–4 (Munich: Lindauer, 1821–1825). A few years later, the illustrated handbook would firmly establish style-based historiography, with Franz Kugler's *Handbuch der Kunstgeschichte* (Stuttgart: Ebner & Seubert, 1842), Carl Schnaase's *Geschichte der bildenden Künste* (Düsseldorf: Buddeus, 1843), and Wilhelm Lübke's *Geschichte der Architektur* (Leipzig: Graul, 1855) as key examples. See Henrik Karge, "Franz Kugler und Karl Schnaase. Zwei Projekte zur Etablierung der allgemeinen Kunstgeschichte," in *Franz Theodor Kugler: Deutscher Kunsthistoriker und Berliner Dichter*, ed. Michel Espagne et al. (Berlin: Akademie Verlag, 2010), 83–104; Henrik Karge, "Stil und Epoche. Karl Schnaases dialektisches Modell der Kunstgeschichte," in *L'idée du style dans l'historiographie artistique: Variantes nationales et transmissions*, eds. Sabine Frommel and Antonio Brucculeri (Rome: Campisano Editore, 2012), 35–48; and Petra Brouwer, "Handbook," in *The Printed and the Built*, eds. Mari Hvattum and Anne Hultzsch (London: Bloomsbury, 2018), 211–217. For an overview of architectural history writing in nineteenth-century Europe, see Matteo Burioni, ed., *Weltgeschichten der Architektur: Ursprünge, Narrative, Bilder 1700–2016* (Passau: Dietmar Klinger, 2016).

55. Schinkel, "—Ist das ein Verdienst die Reinheit jedes Styls aufzufassen—so ist es noch ein grösseres einen reinen Styl im allgemeinen zu erdenken." Undated fragment, *Das architektonische Lehrbuch*, 146.

56. "Die Architektur der Aegypter und anderer orientalischen Völker, der Phönizier, Israeliten, Babylonier und Perser; die Architektur der Griechen und Römer; die byzantinisch-italische, die arabische und gothische Bauart des Mittelalters; die Architektur der Neuern, wurden die Gegenstände meines Forschens. Ich reihete die Monumente dieser Völker vor mich hin; ich fixirte ihr Zeitalter; ich bemerkte die Übergänge, von einem in das andere, das Entstehen, das Fortschreiten, die Reife, die Abnahme, den Verfall. So entstanden durch das Studium der Geschichte und der Monumente Ansichten und Einsichten in die Natur und das Wesen der Baukunst selbst. Kein Gegenstand, so gross oder klein, so wichtig oder unbedeutend er auch scheinen mochte, blieb ungeprüft. So ergaben sich Regeln, Gesetze, Grundsätze; so entstand ein System, eine Theorie, ein Bau,—oder wenn

man es so nennen will, ein Ideal der Baukunst selbst. Diese Baukunst ist zwar keine andere, als die griechisch-römische. Aber nicht, weil sie die griechisch-römische ist, geben wir sie als das Ideal der Baukunst; sondern weil diese begünstigten Völker alles erschöpfen, was zur Vollkommenheit dieser Kunst gehört. Die Griechen und Römer trafen in Beziehung alles dessen, was das Wesen und das Ideal dieser Kunst ausmacht, jene glückliche Mittellinie und jene Gränzen." Hirt, *Grundsätze*, IV.

57. "Zwar existirt die Idee einer architektonischen Vernunft allerdings vor aller Erfahrung. Aber diese Idee ist der Null unter den Ziffern gleich; sie gilt nur, wenn die Erfahrung hinzutritt. Nur durch die Erfahrung kann die architektonische Vernunft, oder dasjenige, was wir das Ideal der Baukunst nennen möchten, geweckt, entwickelt und erkannt werden." Hirt, *Grundsätze*, 5. This is a very similar attitude to that of Friedrich Weinbrenner (who had been Hirt's student in Berlin as well as his compatriot in Rome). See for instance the little-known *Über die wesentlichen Theile der Säulen-Ordnungen und die jetzige Bauart der Italiäner, Franzosen und Deutschen* (Tübingen: Cotta, 1809).

58. "Ganzes wie Teile wird im reinsten

antiken Styl gefordert." Competition program for the Glyptothek, 1814, quoted in Winfried Nerdinger, "'Das Hellenische mit dem Neuen verknüpft'—Der Architekt Leo von Klenze als neuer Palladio" in *Leo von Klenze: Architekt zwischen Kunst und Hof 1784–1864*, ed. Nerdinger (Munich: Prestel, 2000), 16. See also Volker Plagemann, *Das Deutsche Kunstmuseum, 1790–1870* (Munich: Prestel 1967), 43–64.

59. Nerdinger, "'Das Hellenische mit dem Neuen verknüpft,'" 17.

60. "Griechische, römische und wahrscheinlich neue Kunstwerke werden darin gleichmässig Platz finden, und man ist umsomehr unschlüssig nach welchem dieser Typen man sich richten soll, da der vorzüglichste derselben, der griechische, . . . kein Beispiel eines ähnlichen Monumentes darbieten.... so haben wir, um der Sache und uns selbst möglichst genüge zu leisten, drey verschiedene auf alle Fälle berechnete Entwürfe gemacht." Klenze, "Erklärung dreyer Entwurfe eines Gebäudes zur Aufstellung von Statuen bestimmt," Klenziana III/6, quoted in Sonja Hildebrand, "Verksverzeichnis / Glyptothek," in Nerdinger, ed., *Leo von Klenze*, 241.

61. Nerdinger, "'Das Hellenische mit dem Neuen verknüpft,'" 20.

62. "für alle Zeiten die Zweckmässigste und schönste," Klenze, *Memorabilien*, Klenzeana I/2, fol. 111r.

63. English speakers will find a good introduction to the building in Adrian von Buttlar and Bénédicte Savoy, "Glyptothek and Alte Pinakotek, Munich: Museums as Public Monuments," in *The First Modern Museums of Art*, ed. Carole Paul (Los Angeles: Getty, 2012), 305–329.

64. Klenze and Schorn, *Beschreibung der Glyptothek Sr. Majestät des Königs Ludwig I. von Bayern. Architektonischer Theil von Leo von Klenze, Verzeichniss der Bildwerke und Gemälde von Ludwig Schorn* (Munich: Cotta, 1830), VI–VII. On the political context for the museum, see Michael Kamp, *Das Museum als Ort der Politik: Münchner Museen im 19. Jahrhundert*, PhD dissertation, Ludwig-Maximilians-Universität München, 2002, and Plagemann, *Das Deutsche Kunstmuseum*, 43–64.

65. Klenze and Schorn, *Beschreibung*, 2. Klenze reflected further on the relationship between different cultures in the unpublished "Architektonische Erwiederungen und Erörterungen über Griechisches und Nichtgriechisches" (ca. 1860–1864), Klenzeana I/9–11, published in

Nerdinger, *Leo von Klenze*, CD supplement.

66. Klenze and Schorn, *Beschreibung*, 27.

67. Klenze and Schorn, *Beschreibung*, 72. Winckelmann is invoked repeatedly throughout the catalog text.

68. See Sonja Hildebrand, "Glyptothek," in Nerdinger, ed., *Leo von Klenze*, 243.

69. Klenze and Schorn, *Beschreibung*, 127.

70. Klenze and Schorn, *Beschreibung*, 168–171.

71. "Die Bestimmung des Saales ist durch den aus der Asche entstehenden Phönix, und durch die Bildnisse in Medaillons von vier Bildhauern bezeichnet, welche vorzüglich dazu beitrugen, die Kunst wieder auf den einzig richtigen Weg der Antike zurückzuführen." Klenze and Schorn, *Beschreibung*, 217.

72. Klenze and Schorn, *Beschreibung*, VII.

Chapter 5

1. Heinrich Hübsch, *In welchem Style sollen wir bauen?* (Karlsruhe: Müller, 1828). English translation in *In What Style Should We Build? The German Debate on Architectural Style*, in Herrmann *In What Style*, 63. The text was originally Hübsch's address at a meeting of Nazarene artists at the 1828 Dürer festival in Nuremberg. For a good introduction to Hübsch and his context, see Barry Bergdoll, "Archaeology vs. History: Heinrich Hübsch's

Critique of Neoclassicism and the Beginnings of Historicism in German Architectural Theory." *Oxford Art Journal*, 5, no. 2 (1983): 3–12.

2. Hübsch, *In What Style Should We Build*, 67.

3. Hübsch, *In What Style Should We Build*, 71.

4. Hübsch, *In What Style Should We Build*, 71–72.

5. Hübsch, *In What Style Should We Build*, 75.

6. Hübsch, *In What Style Should We Build*, 68.

7. Hübsch, *In What Style Should We Build*, 95.

8. Hübsch, *In What Style Should We Build*, 99.

9. Hübsch, *In What Style Should We Build*, 99.

10. Bergdoll, "Archaeology vs. History," 8.

11. Rudolf Zeidler, *Die Kunst des 19. Jahrhundert* (Berlin: Propyläen-Verlag, 1990), 24. See also Hvattum, "Crisis and Correspondence: Style in the Nineteenth Century," *Architectural Histories* 1, no. 1 (2013), http://doi.org/10.5334/ah.an.

12. Rudolf Wiegmann, "Bemerkungen über die Schrift: *In welchem Style sollen wir bauen?* von H. Hübsch," *Kunstblatt* 10 (1829), no. 44: 173–174, no. 45: 177–179, no. 46: 181–183. Translated by Wolfgang Herrmann as "Remarks on the Treatise," *In What Style Should We Build*, 103–112.

13. Wiegmann, "Remarks," 109.

14. Wiegmann, "Remarks," 105.

15. Wiegmann, "Remarks," 105.

16. Wiegmann, "Remarks," 106.

17. Wiegmann, "Remarks," 106.

18. "Erst dann konnte sie beginnen, als der Menschengeist einen innern Drang, ein Bedürfniss fühlte, jene Empfindung des Göttlichen, welche die Anschauung der Natur in ihm erregt hatte, äusserlich wieder darzustellen und auszusprechen in sinnlich wahrnehmbaren Werken…. Hieraus geht in der Baukunst ein freieres Gestalten und Formen des Naturstoffes hervor, als es das blosse physische Bedürfniss erfordert." Friedrich Eisenlohr, *Rede über den Baustyl der neueren Zeit und seine Stellung im Leben der gegenwärtigen Menschheit* (Karlsruhe: Groos, 1833), unpaginated [5]. The date of the lecture is not certain, but it seems to be Eisenlohr's inaugural lecture, in which case it would probably be from 1832—the year he started teaching at the Polytechnikum.

19. "In der Kunst aber strebt der Geist, das empfundene Göttliche mittelst der eigenen Schöpfungskraft durch ein sinnlich wahrnehmbares Werk darzustellen, sie wird wirksam in dem ästhetischen Eindruck auf das Gemüth.—Aber die Darstellung des Idealen ist ein Bedürfniss des Geistes, und dieses das geistige Moment bei

jeder Kunstschöpfung." Eisenlohr, *Rede über den Baustyl*, [9].

20. "Nach der Verschiedenheit des Geistes der Zeiten und Völker, mussten auch die Bauwerke verschieden werden in ihrer Form, die uns als belebt von jenem Geiste erscheint." Eisenlohr, *Rede über den Baustyl*, [10].

21. "Die Baukunst dient der Menschheit und nicht diese der Baukunst. Entwickelt sich ihr Styl nicht aus dem innern und äussern Leben und den Bedürfnissen einer Volkes und einer Zeit, so wird er, als ein fremdes nachgeahmtes Eigenthum, diesem Leben und dem Geiste ewig fremd bleiben." Eisenlohr, *Rede über den Baustyl*, [22]. I discuss Eisenlohr's lecture in greater depth in "Style. Notes on the Transformation of a Concept," *Architectural Histories* 7, no. 1 (2019): http://doi.org/10.5334/ah.367.

22. Wiegmann, "Remarks," 109; Rosenthal, "In what style should we build? A question addressed to the members of the Deutsche Architekturverein," *In What Style*, 114; Horn ("Der jedesmalige Baustil müsse ein getreues äusseres Bild jener Gedankenwelt darstellen, welche die Zeit bewegt, die ihn hervorbringt"), quoted in Klaus Döhmer, *"In welchem Style sollen wir bauen?" Architekturtheorie zwischen Klassizismus und Jugendstil*

(Munich: Prestel, 1976), 34.

23. "Jede Hauptzeit hat ihren Styl hinterlassen in der Baukunst—warum wollen wir nicht versuchen ob sich nicht auch für die unsrige ein Styl auffinden lässt?" Schinkel, *Das architektonische Lehrbuch*, 146.

24. Prominent "materialists" included, for example, Eduard Metzger, Johann Andreas Romberg, and Anton Hallmann. Discussed in Herrmann, *In What Style*, 6–9.

25. Rosenthal, "In what style," 122.

26. Cf. Döhmer, *"In welchem Style,"* 36.

27. In order of mention: Rudolf Wiegmann, "Gedanken über die Entwicklung eines zeitgemässen nazionalen Baustyls," *Allgemeine Bauzeitung* 6 (1841): 208; Eisenlohr, "Rede über den Baustyl," [19]; C.A. Menzel, *Jahrbuch der Baukunst und Bauwissenschaft in Deutschland*, 2 (1845), 100; Wiegmann "Remarks," 103. More examples in Döhmer, *"In welchem Style,"* 32–35.

28. *Architectonische Verzierungen für Künstler und Handwerker*, vol. 1 (Frankfurt am Main: n.p., 1823), 2. Quoted in Döhmer, *"In welchem Styl,"* 20.

29. Karge, "Franz Kugler und Karl Schnaase"; Brouwer, "Handbook."

30. Payne, *From Ornament to Object*, 157.

31. On style and racism, see Michaud, *The Barbarian Invasions*, and Martin Bressani, "World History, Architecture, and Race in Germany, 1770–1850," in *Narrating the Globe: The Emergence of World Histories of Architecture 1790–1900*, eds. Petra Brouwer, Martin Bressani, and Christopher Drew Armstrong (Cambridge, MA: MIT Press, 2023).

32. "die mannigfaltigen Geister, die aus diesen alten Epochen sprechen, sollen sich in Euch, ihr Zeitgenossen, vereinigen und verjüngen, und als Ein Geist von neuer eigenthümlicher Schönheit aus Euch hervortreten." Schorn, "Betrachtungen über die Kunstausstellung in München im October 1829," *Kunstblatt* 10, no. 100 (14 December 1829): 399. Quoted in Döhmer, *"In welchem Style,"* 18.

33. Loos, "Ornament und Verbrechen" (1910), in *Trotzdem* (Innsbruck: Brenner, 1931). On Loos and stylelessness, see Anders Munch, *Adolf Loos: Der stillose Stil* (Paderborn: Fink, 2005).

34. Further on *Stilpluralismus*, see J. A. Schmoll genannt Eisenwerth, "Stilpluralismus statt Einheitszwang. Zur Kritik der Stilepochen-Kunstgeschichte," and Norbert Knopp, "Schinkels Idee einer Stilsynthese," both in

Hager and Knopp, eds., *Beiträge zur Problem des Stilpluralismus*, 9–19 and 245–254.

35. On the notion of crisis intrinsic to the principle of correspondence, see Hvattum "Crisis and Correspondence," and Schmoll, "Stilpluralismus statt Einheitszwang."

36. Franz Kugler, "Ueber den Kirchenbau und seine Bedeutung für unsere Zeit," *Museum: Blätter für bildende Kunst* 2, no. 1 (January 6, 1834): 1–8. For a thorough introduction to Kugler, see *Franz Theodor Kugler: Deutscher Kunsthistoriker und Berliner Dichter*, eds. Michel Espagne, Bénédicte Savoy, and Céline Trautmann-Waller (Berlin: Akademie Verlag, 2010).

37. Kugler, "Ueber den Kirchenbau," 7.

38. Wilhelm Stier, "Uebersicht bemerkenswerther Bestrebungen und Fragen für die Auffassung der Baukunst in der Gegenwart und jüngsten Vergangenheit," *Allgemeine Bauzeitung* 8 (1843): 296–302.

39. Stier, "Uebersicht," 301.

40. The most comprehensive account of the Friedrichswerdersche Kirche's complicated history is Paul Ortwin Rave, *Karl Friedrich Schinkel: Lebenswerk, Berlin*, vol. 1 (Berlin: Deutscher Kunstverlag, 1981), 254–300. Schlaetzer's name appears with various spellings; Rave calls him Schloetzer. Schinkel's verdict on Schlaetzer's and Hirt's projects (dated February 23, 1821 and May 2, 1822 respectively) are reprinted in Rave, 256–258 and 260–261. Schlaetzer's drawings are lost, while Hirt's drawings are held in the Berlin Kupferstichkabinett.

41. "Im allgemeinen glauben wir übrigens, dass der Charakter des Gebäudes sowohl wie der Ort, wo es steht, die allereinfachste Anordnung nach dem Muster antiken Gebäude verlangt und bei dieser Anordnung unstreitig die grösste Wirkung tun wird." Schinkel, "Gutachten der Oberbaudeputation," February 23, 1821, in Rave, *Schinkel/Berlin 1*, 257.

42. Schinkel, "Gutachten der Oberbaudeputation," February 23, 1821, in Rave, *Schinkel/Berlin 1*, 258.

43. "Die Lage des Bauplatzes, wie der höheren Ortes bestimmt wurde, gab die Veranlassung zu der vorliegenden Anordnung des Gebäudes. An drei Seiten von engen Strassen umschlossen, in denen ein reiche Architektur ungeniessbar sein würde, ist dem Gebäude ein ganz einfaches Äusseres gegeben worden, wozu auch der nur sehr mässige Umfang des Ganzen noch mehr aufforderte. Die vierte Seite des Giebels mit der grossen Eingangspforte ist dem Markt zugekehrt und um dieser Front mehr Wichtigkeit zu geben, ist das Innere Gewölbe des Gebäudes hier äusserlich in seinem ganzen Verhältnis durch eine tiefe Nische angedeutet, in deren Hintergrund die grosse Eingangspforte, in ihren Flügeln reich geschmückt, in Bronze gegossen, von Marmortäfelungen umgeben, eingefugt." Schinkel, *Sammlung architektonischer Entwürfe*, vol. 8 (Berlin: Wittich, 1826), n.p. Forssman argues that Schinkel might have been influenced by examples from Klenze's *Anweisung zur Architectur des christlichen Cultus* (1822). Forssman, *Schinkel*, 130.

44. On Gentz's notion of purpose, see Bergdoll, *Schinkel*, 87–90.

45. "In dieser etwas engeren Gegend der Stadt, die durch die Unregelmässigkeit ihrer Strassenanlagen sich dem Altertümlichen nähert, dürfte eine Kirche im Mittelalterstil wohl an ihrem Platze sein. Da jedoch die Baustelle nicht sehr gross ist, würde es nicht geraten sein, dem Plan grosser Dome aus dem Mittelalter zu folgen; deshalb hielt ich es zweckmässig, dem Gebäude mehr den Charakter englischer Chapels zu geben, worin einige grosse Verhältnisse wirken und das Ganze sich eng zusammenschliesst." Schinkel, letter of March

2, 1824, in Rave *Schinkel/ Berlin 1*, 269.

46. "Die Säulen der schmalen Emporen in der Kirche, sowie das Fenstersprossenwerk und die Dachgeländer könnten aus Gusseisen sein; das ganze übrige Gebäude würde aus Backstein erbaut und bliebe in sorgsamer Mauerarbeit ohne Abputz, wie die Kirchen des Mittelalters unserer Gegenden." Schinkel, letter of March 2, 1824, in Rave *Schinkel/Berlin 1*, 269.

47. Rave argues that Schinkel was coaxed into submitting a medieval project by the crown prince. Later historians have been less convinced of this, arguing that the stylistic diversity was Schinkel's own. See e.g. Andreas Haus, "Gedanken über K. F. Schinkels Einstellung zur Gotik." In *Marburger Jahrbuch für Kunstwissenschaft*, 1989, 22 (1989), 215–231, and Forssman, *Schinkel*, 130–131.

48. Bergdoll, *Schinkel*, 92; Forssman, *Schinkel*, 131–132.

49. "Da bei dem Entwurf die Sparsamkeit zur Pflicht gemacht ward, so ging ich davon aus, den angenommenen Mittelalterstil in grösster Einfachheit durchzuführen und allein durch die Verhältnisse zu wirken." Schinkel, *Sammlung architektonischer Entwürfe*, vol. 13 (Berlin: Wittich, 1829).

50. Hans-Joachim Kunst, "Bemerkungen zu Schinkels Entwürfen für die Friedrich Werdersche Kirche in Berlin," *Marburger Jahrbuch für Kunstwissenschaft* 19 (1974): 241–258. See also Snodin, *Schinkel*, 169. There was originally a partition wall in the middle of the nave, dividing the German from the French part. Schinkel considered this a temporary arrangement and did not show it in his published drawings.

51. "dass die Konstruktion überall in einem sorgfältig und für jeden Bauteil eigens zweckmässig behandelten Backsteinmaterial sichtbar gelassen wurde." Schinkel, *Sammlung architektonischer Entwürfe*, vol. 13.

Haus points out that Schinkel was increasingly concerned with the building process, seeing it as a key part of a building's significance. Haus, "Gedanken," 217.

52. See for instance Johannes Krätschell, "Schinkels gotisches Schmerzenskind. Das Werdersche Kirche in Berlin," *Blätter für Architektur und Kunsthandwerk* 1, no. 12 (October 16, 1888): 114–117.

53. Franz Kugler, *Karl Friedrich Schinkel. Eine Charakteristik seiner künstlerischen Wirksamkeit* (Berlin: Gropius, 1842), 64–65. Heine, *Reisebilder*, vol. 3 (1830), chap. 2: https://www.projekt-gutenberg.org/heine/reisebld/reise312.html.

54. Hans Sedlmayr, *Verlust der Mitte: Die bildende Kunst des 19. und 20. Jahrhunderts als Symptom und Symbol der Zeit* (Salzburg: Müller, 1965), chap. 2: "Auf dem Suche nach dem verlorenen Stil," 60–78.

55. "Dieser neue Styl wird desshalb nicht so aus allem Vorhandenen und Früheren heraustreten dass er [wie] ein Phantasma ist, welches sich schwer allen aufdringen und verständlich werden würde, im Gegentheil, mancher wird kaum das neue darin bemerken, dessen grösstes Verdiens mehr in der consequenten Anwendung einer Menge im Zeitlaufe gemachter Erfindungen werden wird, die früherin nicht kunstgemäss vereinigt werden konnten." Schinkel, text fragment, 1829, in *Das architektonische Lehrbuch*, 146. In Peschken's transcription, the "schwer" is omitted, making the sentence hard to make sense of. I follow here the transcription in Hans Mackowsky, ed., *Karl Friedrich Schinkel: Briefe, Tagebücher, Gedanken* (Berlin: Propyläen-Verlag, 1922), 194.

56. "je tiefer ich den Gegenstand durchdrang je grösser sah ich die Schwierigkeiten die sich meinem Bestreben entgegenstellten. Sehr bald gerieth ich in der Fehler der rein radicaler Abstraction, wo ich

die ganze Conception
für ein bestimmtes
Werk der Baukunst
aus seinem nächsten
trivialen Zweck allein
und aus der Konstruction
entwickelte, in diesem
Falle entstand etwas
Trockenes, starres das
der Freiheit ermangelte
und zwei wesentliche
Elemente: das Historische
und das Poetische ganz
ausschloss. Ich forschte
weiter, sah mich aber sehr
bald in einem grossen
Labirinth gefangen: wo
ich abwägen musste
wie weit das rationelle
Princip wirksam seyn
müsse, um den Trivial-
Begriff des Gegenstandes
festzustellen, und wie
weit anderseits jenen
höheren Einwirkungen
von Geschichtlichen und
artistischen poetischen
Zwecken der Eintritt
dabei gestattet werden
dürfe um das Werk zur
Kunst zu erheben. Es
war nicht schwer hierbei
zu erkennen, dass dies
Verhältniss des Einflusses
so verschiedener
Principien in jedem
concreten Fall ein anderes
werden würde." Schinkel,
text fragment 1835,
in *Das architektonische
Lehrbuch*, 150. For
interesting readings of
this passage, see e.g.
Alex Potts, "Schinkel's
Architectural Theory," in
Snodin, *Schinkel*, 47–56,
and Emma L. Jones,
*Schinkel in Perspective: The
Architect as Illusionist in
Nineteenth-Century Prussia*
(Cambridge, MA: MIT
Press, 2024).

57. "Historisches is
nicht, das alte allein
festzuhalten oder zu
wiederholen, dadurch
würde die Historie zu
Grunde gehen. Historisch
handeln ist das welches
das Neue herbei führt
und wodurch die
Geschichte fortgesetzt
wird." Schinkel,
undated fragment, *Das
architektonische Lehrbuch*,
71.
58. Karl Bötticher, *Die
Tektonik der Hellenen*, 2
vols. + atlas (Potsdam:
Riegel, 1844–1852). In
the first edition of the
Tektonik, Bötticher used
the term "Kernform" but
changed it to "Werkform"
in the second edition
from 1874.
59. Wilhelm Stier,
"Beiträge zur Feststellung
des Principes der
Baukunst für das
vaterländische Bauwesen
in der Gegegenwart,"
Allgemeine Bauzeitung 8
(1843): 309–339. Bötticher,
"Polemisch-Kritisches,"
*Literatur- und Anzeigeblatt
für das Baufach. Beilage zur
Allgemeinen Bauzeitung*
2, no. 18 (1845): 281–
320. Note the editor's
conciliatory remark after
Bötticher's essay. The
hefty debate between
Bötticher and Stier is
discussed by Herrmann,
In What Style, 40–41.
60. Karl Bötticher, "The
Principles of the Hellenic
and Germanic Ways of
Building with Regard to
Their Application to our
Present Way of Building"
(1846), in Herrmann,
In What Style, 150. The
speech is discussed in

Kenneth Frampton,
Studies in Tectonic Culture
(Cambridge, MA: MIT
Press, 1995), 83–84.
61. Bötticher,
"Principles," 150–151.
62. Bötticher,
"Principles," 153.
63. Bötticher,
"Principles," 158.
64. Bötticher,
"Principles," 159.
65. Bötticher's tectonic
theory is discussed
in Werner Oechslin,
*Stilhülse und Kern. Otto
Wagner, Adolf Loos und
der evolutionäre Weg zur
modernen Architektur*
(Zurich: gta Verlag, 1994).
66. Bötticher,
"Principles," 151.
67. Bötticher,
"Principles," 160.

Chapter 6
1. Eberhard Drüeke,
*Maximilianstil: Zum
Stilbegriff der Architektur
im 19. Jahrhundert*
(Mittenwald: Mäander,
1981), 75.
2. "er strebte bald dahin
einen Weg zu finden,
der unserer Architektur
den charakteristischen
Stempel unserer Zeit
aufprägen könnte."
Ludwig Hauff, *Leben und
Wirken Maximilian II.,
Königs von Bayern* (Munich:
Fleischmann, 1864), 331.
3. "Not only a kingdom,
but all of heaven itself for
a Style!" Berlage, *Thoughts
on Style*, 136.
4. "Muss man in der
Baukunst, um etwas
Treffliches zu schaffen,
immer aussliesslich
einem reinen Style
folgen, oder ist es
einem schöpferischen

Geiste erlaubt, aus dem Verschiedenen das Beste wählend, etwas Originelles zu bilden?" Maximilian II to Ludwig Schorn, February 24, 1833, quoted in Drüeke, *Maximilianstil*, 15.

5. Schorn to Maximilian II, February 24, 1833, quoted in August Hahn, *Der Maximilianstil in München: Programm und Verwirklichung* (1932) (Munich: Heinz Moos, 1982), 12.

6. "1). ob es überhaupt ein Ideal der Baukunst gäbe oder nicht? 2). ob es für Griechenland eins gäbe, und welches es sei?" The prince's questions were reiterated by Schinkel in his 1834 reply, published as "Ein Schreiben Schinkel's an Seine Königliche Hoheit, den Kronprinzen, jetzigen König Maximilian II. von Baiern, den Bau eines Königpalastes in Athen betreffend." In *Aus Schinkel's Nachlass*, ed. Wolzogen, vol. III, 333–335.

7. Hermann Bauer, "Architektur als Kunst. Von der Grösse der idealistischen Architektur-Ästhetik und ihrem Verfall." In Hermann Bauer and Lorenz Dittman, eds., *Kunstgeschichte und Kunsttheorie der 19. Jahrhundert* (Berlin: De Gruyter, 1963), 133.

8. "Die beiden Fragen ad 1. und 2. werden sich allgemein nur dahin beantworten lassen, dass das Ideal in der Baukunst nur dann völlig erreicht ist, wenn ein Gebäude seinem Zwecke in allen Theilen und im Ganzen in geistiger und physischer Rücksicht vollkommen entspricht. Es folgt hieraus schon von selbst, dass das Streben nach dem Ideal in jeder Zeit sich nach den neu eintretenden Anforderungen modificiren wird, dass das schöne Material, welches die verschiedenen Zeiten für die Kunst bereits niedergelegt haben, den neuesten Anforderungen theils näher, theils ferner liegt und deshalb in der Anwendung für diese mannigfach modificirt werden muss, dass auch ganz neue Erfindungen nothwendig werden, um zum Ziele zu gelangen, und dass, um ein wahrhaft historisches Werk hervorzubringen, nicht abgeschlossenes Historisches zu wiederholen ist, wodurch keine Geschichte erzeugt wird, sondern ein solches Neue geschaffen werden muss, welches im Stande ist, eine wirkliche Fortsetzung der Geschichte zuzulassen." Schinkel to Maximilian II, 1834. In *Aus Schinkel's Nachlass*, vol. III, 333–334. Also in *Schinkel Briefe*, ed. Mackowsky, 180–181.

9. "Jedes Kunstwerk muss ein neues Element bei sich haben; ohne ein solches, wenn es auch in einem bekannten, schönen Stil gearbeitet ist, kann es kein wahres Interesse erzeugen. Was aber zu diesem neuen Element an Erfindung, Verschmelzung, Anknüpfungspunkten der verschiedensten Art gehört, ist mit Worten nicht auszusprechen, und es bleibt immer das sicherste Mittel, sich nach einem Talent umzusehen, das durch fortwährende praktische Arbeit die Versuche zu einem Grad der Vollendung emporwachsen lässt, zugleich aber die Aussicht eröffnet, dass der Stil von der Art sei, eine fernere Vollendung zuzulassen. Euerer Königlichen Hoheit bin ich so frei zu bekennen, dass dies das Höchste sein würde, worauf ich rechnen würde." Schinkel to Maxmilian II, December 17, 1839. The original letter is lost, but is quoted extensively in Hahn, *Maximilianstil in München*, 12. A different version of the same letter is reprinted in *Schinkel Briefe*, ed. Mackowsky, 189–191. Further on this correspondence, see e.g. Norbert Knopp. "Schinkels Idee einer Stilsynthese."

10. Maximilian II to Schorn, February 24, 1833, quoted in Drüeke, *Maximilianstil*, 19.

11. "ob überhaupt die Grundformen der baulichen Konstruktion ein für allemal erschöpft seien und die Architektur von nun an auf einen völlig subjektiven Eklektizismus angewiesen sey, oder ob wir nur etwa in einer

Übergangsepoche stehen, aus deren Gärung sich über kurz oder lang neue Stylweisen entwickeln und Herrschaft und Geltung in weiteren Kreisen gewinnen würden?" Maximilian II, "Neue Verhandlungen über den Ausgangspunkt eines neuen Baustyls (1858–1861)," quoted in Drüeke, *Maximilianstil*, 35.

12. "ob im Mittelalter die gewöhnlichen Wohnhäuser der Massen auch gothisch gebaut wurden?" Maximilian II, "Neue Verhandlungen," quoted in Drüeke, *Maximilianstil*, 82, note 105.

13. "ob und in welcher Weise überhaupt ein neuer Baustyl zu erreichen sei?" Maximilian II, "Neue Verhandlungen," quoted in Drüeke, *Maximilianstil*, 32.

14. See Manfred Hanisch, "Maximilian II. und die Geschichte. Bayerisches Nationalgefühl durch Geschichtsbewusstsein," in *Zwischen Glaspalast und Maximilianeum. Architektur in Bayern zur Zeit Maximilians II. 1848–1864*, ed. Winfried Nerdinger (Munich: Edition Minerva, 1997), 16–27.

15. Bavaria as a state dates back to the sixth century, but in the aftermath of the Napoleonic wars it was thoroughly reconfigured, losing Northern Tyrol and Vorarlberg to Austria while gaining Würzburg and the Palatinate region, as well as parts of Hesse-Darmstadt. The population that Maximilian tried to coax into one Bavarian "Volk," then, was not necessarily homogenous. See Hanisch, "Maximilian II. und die Geschichte."

16. "In keinem Gebiete der bildenden Kunst hat sich das Streben nach einer neuen, natur- und zeitgemässen, volks- und ortseigenthümlichen Entwicklung seither auf eine so entschiedene und augenfällige Weise geltend zu machen gesucht als in dem [Gebiete] der Baukunst. Doch sind die Richtungen und Wege, auf welchen unsere Architekten dabei zum Ziele zu gelangen hoffen, sehr verschieden, und während die Einen das Heil ihrer Kunst von dem unbedingten Anschluss an die klassischen Bauformen der Griechen und Römer, von dem heitern und schmuckreichen Façaden-Styl der Renaissance, ja von der barocken Schwerfälligkeit des Rococco erwarten, Andere dagegen die reine Wiederaufnahme des romanischen oder gothischen Baustyls als einzige Bedingung einer nationalen Wiedergeburt für unsere Architectur fordern, sehen wir noch Andere bemüht, mittels einer Verschmelzung der Elemente und Eigentümlichkeiten dieser verschiedenen Stylgattungen eine neue, bis dahin noch nicht dagewesene Bauart zu begründen.

Ob letzteres überhaupt möglich, ob das in unserer Zeit liegende, nach einer organisch vollendeten Gestaltung aller Lebensverhältnisse und Lebenskräfte im nationalen Sinne ringende Element auch der Baukunst zugut kommen wird, darüber kann allerdings nur die Erfahrung späterer Zeiten entscheiden.

Um aber den lebenden Architecten neuen Anlass und Gelegenheit zu bieten, bei diesem Ringen der Gegenwart nach einer nationalen Neugestaltung der Architectur, ihren Neigungen und Kräften gemäss, sich zu betheiligen, wird, mit Ermächtigung Seiner Majestät des regierenden Königs Maximilian von Bayern, eine freie Preis-Bewerbung zur Anfertigung eines Bauplanes für eine höhere Bildungs- und Unterrichtsanstalt nach dem beifolgenden Programme und den weiter dort angegebenen Bestimmungen hiermit eröffnet.

Man geht dabei von der Ueberzeugung aus, dass der fragliche Zweck nur in unmittelbaren Anschluss an eine bestimmte practische Aufgabe von entsprechender Würdigkeit und Grösse sich werde erreichen lassen, indem die Herstellung eines Bauwerkes, in dessen gesammter Erscheinung

der Character der Zeit so recht unverkennbar seinen verständlichen Ausdruck fände, in welchem die Ideen und Bestrebungen der Gegenwart sich verkörpert sähen und bei dem zugleich die seitherigen Erfahrungen der Architectur, die nach allen Seiten hin ausgreifenden, staunenswerthen Fortschritte der Technik, die gesamte Errungenschaft der Vergangenheit an constructiven und ornamentalen Vorbildern, das ausserordentlich erweiterte Feld des Materials in unbeschränkter Freiheit und sowohl dem Zwe[c]ke wie dem Charakter des Gebäudes selbst angemessen und mit dem möglichsten Haushalte in den Mitteln benützt wäre, unstreitig von den wirksamsten Folgen auch für die entferntere Zukunft der Baukunst seyn müsste. Ist der Architekt von dem vollen Inhalt seiner Aufgabe, von der Idee des Bauwerks, das er zu schaffen hat, und dessen Zweckbestimmung ganz erfüllt und durchdrungen, und versteht er es, die technischen Grundbedingungen alles architektonischen Schaffens, nämlich den von dem Baubedürfnis abhängigen und die gesammte Raumanlage bestimmenden Grundplan und die von der Oertlichkeit, dem

Klima und Baumaterial bedingte, auf die Gesammt-Gliederung und die ornamentale Einzelgestaltung des Bauwerkes rückwirkende Konstruction mit den höheren Anforderungen jener Ideen in lebendigen Einklang zu bringen, weiss er den Charakter praktischer Zweckmässigkeit und heiterer Behaglichkeit mit dem der Einfachheit und Schönheit zu verbinden, so kann es nicht fehlen, dass das Gebäude ein in sich vollendetes, ausdrucksvolles und schönes Ganze in dem angedeuteten Sinne bilden werde. Wenn nun aber auch den concurrirenden Künstlern keinerlei Zwang aufzuerlegen ist, und es namentlich wünschenswert erscheint, dass sie sich in voller Freiheit der verschiedenen Baustyle und ihrer Ornamentik zur zweckmässigen Lösung der vorliegenden Aufgabe bedienen, damit die zu erwählende Bauart keinem der bekannten Baustyle ausschliesslich und speziell angehöre, so soll doch auch nicht verschwiegen bleiben, da es sich hier um die Herstellung eines Gebäudes in Deutschland und im deutschen Sinne und Interesse handelt, dass es vielleicht zweckdienlich erscheinen dürfte, bei dem Enwurf dazu das Formenprinzip der altdeutschen, sogenannten gothischen

Architectur, und beim Ornament die Anwendung deutscher Thier- und Pflanzenformen wo möglich nicht ganz aus den Augen zu lassen.

Ueberdiess glaubt man bemerken zu müssen: dass in den Bereich dieses Bauwerkes auch die Schwesterkünste der Malerei und Bildhauerei in grösserer Ausdehnung zugezogen werden sollen, um mit ihrer Hülfe ein nach allen seinen Teilen bedeutsames, für die Gegenwart charakteristisch-schönes Denkmal der Kunst und Bildung ins Leben zu rufen, bei welchem, seiner Bestimmung und dem Geiste unserer Zeit gemäss, nach räumlicher Anlage wie nach seiner materiell-formellen Durchführung alles Frostige, Schwerfällige, Düstere und Strenge vermieden, dem leichten und heiteren Schwunge der Formen und Verhältnisse dagegen ein weites Feld der Entwicklung dargeboten seyn möge." Royal Academy of Fine Art, Munich, "Einladung zu einer Preisbewerbung die Anfertigung eines Bauplanes zu einer höheren Bildungs- und Unterrichts-Anstalt betreffend," 1850, 3–6. Bayerisches Hauptstaatsarchiv, Abt. III Geheimes Hausarchiv, Kabinettsakten König Maximilians II. Nr. 90a.

17. Hahn, *Maximilianstil in München*, 22.

18. On the distribution and reception of the call, see Hahn, *Maximilianstil in München*, 18–22, and Drüeke, *Maximilianstil*, 19–29.

19. "Attempt for a New Style of Architecture: Prize Programme of the Munich Academy of Arts," *The Builder* 9, no. 426 (1851): 223.

20. "Wir leben nicht mehr in der Zeit des unbewussten, naturnothwendigen Schaffens, durch welches früher die Bauordnungen entstanden, sondern in einer Epoche des Denkens, des Forschens und der selbstbewussten Reflexion. Zur Lösung der besprochenen Aufgabe wird es vielleicht hier am Orte seyn, auf die Momente hinzudeuten, welche auf die Architektur der verschiedenen Länder eingewirkt und noch einwirken." Royal Academy of Fine Art, Munich, "Erläuternde Bemerkungen in Bezug auf das architectonische Preisprogramm," 1850, 2. Bayerisches Hauptstaatsarchiv, Abt. III Geheimes Hausarchiv, Kabinettsakten König Maximilians II. Nr. 90a.

21. "Als rein geistiges Moment, das auf die Architektur Einfluss hat, steht obenan der Geist der Zeit, in welcher die Bauwerke entstehen. Als die Grundideen unserer Epoche kann man theilweise bezeichnen: das Streben nach Freiheit, freier Entwicklung und zwangloser Uebung

aller physischen und moralischen Kräfte, Ideen, welche auch in der Architektur ihren Ausdruck zu finden verlangen." "Erläuternde Bemerkungen," 2.

22. "Die politischen und sozialen Verhältnisse, welche ganz besonders den Unterschied der Bauwerke der Zeit nach begründen, sind andere geworden, und lassen ganz andere Bauwerke, als früher, entstehen." "Erläuternde Bemerkungen," 2.

23. "Dem möglichste Haushalte in den Mitteln." "Erläuternde Bemerkungen," 3.

24. Maximilian II to Schelling, April 14, 1852. In *König Maximilian II. von Bayern und Schelling: Briefwechsel*, eds. Ludwig Trost and Friedrich Leist (Stuttgart: Cotta, 1890), 219–221.

25. "Er verlangt unter andern ein architektonischen Werk, 'in dessen gesammter Erscheinung der Charakter der Zeit (versteht sich der gegenwärtigen) so recht unverkennbar seinen verständlichen Ausdrück finde.' Angenommen, unsere Zeit hätte wirklich einen Charakter und einen, der würdig wäre, architektonisch ausgedrückt zu werden, so würde dieser sich von selbst und ihr bewusst in ihren Bauwerken ausdrücken, dann aber würde es keiner Aufforderung und keines Vorsatzes dazu

bedürfen. Gesetzt aber der Charakter unserer Zeit bestünde eben darin, *keinen* Charakter zu haben, so könnte das ihm entsprechende Gebäude und zwar je treuer es denselben ausdrücke, desto mehr nur ein Bild der vollkommenen geistigen und moralischen Zerfahrenheit gewähren. Diess wäre allerdings ein neuer Baustyl, aber von dem ich keinen Begriff habe." Schelling to Maximilian II, April 22, 1852, "Zu dem Programm, die architektonische Preisaufgabe betreffend." In Trost and Leist, *König Maximilian II. und Schelling*, 281–283.

26. "Der Gedanke einer eignen, der Erziehung höherer Staatsdiener gewidmeten Anstalt ist zu schön, zu folgenreich für Bayern wäre seine Verwirklichung, als dass man durch das zufällig-Ungeschickte der ersten Veröffentlichung die Ausführung selbst gefährdet glauben könnte." Schelling to Maximilian II, April 22, 1852.

27. *Deutsches Kunstblatt* 2, no. 14 and 19 (1851), and 5, no. 5 (1854).

28. "Neue Bewegungen auf dem Gebiete der Baukunst. Versuche zur Gewinnung eines neuen Baustyls," *Allgemeine Zeitung*, March 20, 1851.

29. The author referred to Metzger in this respect, particularly the idea that a new style would emerge from new materials and

constructive principles. "Ueber die neue Bewegungen auf dem Gebiete der Baukunst," *Allgemeine Zeitung*, April 30, 1851.

30. "Denn der Baustyl einer Nation ist nicht ihr Bild, ihr Abklatsch, auch keine Allegorie, sondern ihr Kind, ihre Frucht, eine ihrer Thaten... Kurz gesagt: ein Bauwerk is nicht so und so gemacht damit man die Zeit seiner Entstehung und die Art seines Volkes daraus erkenne, sondern man erkennt beides daraus weil es so gemacht ist! Die Harmonie mit Zeit und Volk ist nicht Zweck, sondern Folge!" N.N., "Der Bauplan zu einer höhern Bildungs- und Unterrichts-Anstalt in München." *Allgemeine Zeitung*, March 16, 1852 (supplement).

31. "Der Zeitgeist hat aber seine Mucken, er gibt sich nicht mit jedem Architekten ab, und manchmal macht er eine Zeitlang gar keine Bestellungen!" N.N., "Der Bauplan zu einer höhern Bildungs- und Unterrichts-Anstalt."

32. Rudolf Marggraff (attr.), "Die architektonische Preisaufgabe bezüglich einer höhern Bildungs- und Unterrichtsanstalt in München," *Allgemeine Zeitung*, April 16, 1852 (supplement). I follow Drüeke in attributing this article to Marggraff.

33. "Durch die Natur unserer äusserst verwickelten, kalter Reflexion oder freibeuterischer Willkür verfallenen öffentlichen Verhältnisse ist ihnen der Boden solch' unbewussten, naturwüchsigen Stylschaffens unter den Füssen hinweggezogen. Der Einzelne bildet jetzt mehr eine Welt für sich; er fühlt, er erkennt sich nicht in dem Masse wie früher als ein nothwendiges Glied, als einen ergänzenden Bestandtheil einer auch ihn umfassenden grösseren Gemeinschaft, nicht mehr auch sich so unbewusst und unwiderstehlich von dem Geiste welcher diese belebt durchdrungen und in der entsprechenden Richtung seiner Anschauungen, Neigungen und Thätigkeiten vorwärts getrieben." Marggraff, "Die architektonische Preisaufgabe."

34. Ferdinand Tönnies, *Gemeinschaft und Gesellschaft* (Leipzig: Fues, 1887).

35. "Summe des Gesammtlebens unserer Zeit und unseres Volkes." Marggraff, quoting the anonymous critic, "Die architektonische Preisaufgabe."

36. The Prussian king submitted his proposal privately and outside the competition, according to Hahn, *Maximilianstil*, 25.

37. There are different accounts of the composition of the jury, here I follow Hahn. See also Heidrun Laudel, "Auf der Suche nach Stil. Maximilian II. und Gottfried Semper," in Nerdinger, ed., *Zwischen Glaspalast und Maximilianeum*, 66.

38. "ein Streben nach Ungewöhnlichem." August Voit, report of December 1852, quoted in Hahn, 25.

39. "Den architektonischen Stil desselben kann man aber nur insofern neu nennen, als dabei von allen existierenden Baustilen und Arten Teile und Einzelheiten verwendet werden: eine unendliche, ganz willkürliche Anzahl von Fenster- und Thürüberdachungen, Halbzirkeln, Korbbögen und Zirkelsegmenten, Spitzbögen, Hufeisen- und venetianischen Bogenformen stehen nebeneinander, und in der Ornamentierung ist rein Griechisches neben der Renaissance, dem Byzantinischen, Florentinischen und Maurischen angewendet." Klenze, quoted in Hahn, *Maximilianstil*, 26.

40. Cf. Gerhard Hojer, "München—Maximilianstrasse und Maximilianstil," in *Die Deutsche Stadt im 19. Jahrhundert*, ed. Ludwig Grote (Munich: Prestel, 1974), 33.

41. Friedrich Bürklein, "Die Verschönerung Münchens betreffend," report of March 4, 1851. Quoted in Hahn, *Maximilianstil*, 29–30.

42. On the planning of the Maximilanstrasse,

see Florian Koch "Maximilianstrasse," in Nerdinger, ed., *Zwischen Glaspalast und Maximilianeum*, 276–301, and Gerhard Hojer, "München—Maximilianstrasse und Maximilianstil," 33–65. On Voit's role in the process, see Henrik Karge, "Projecting the future in German art historiography of the nineteenth century: Franz Kugler, Karl Schnaase, and Gottfried Semper," *Journal of Art Historiography*, no. 9 (December 2013): 1–26.

43. "Das allerhöchste Anstreben bei der Begründung einer zeit- und kunstgemässen Bauform ist, dass die neu zu errichtenden Bauwerke den Charakter einer zeitgemässen Architektur, praktische Zweckmässigkeit, Komfort des Lebens, Einfachheit, Schönheit und Nationalität an sich tragen, folglich alles Frostige, Schwerfällige und Strenge bei den aufzustellenden Musterfassaden zu vermeiden ist... Hieraus geht folgerecht hervor, dass die neuen Bauwerke keinem der vorhandenen Baustile oder bestehenden Bauwerke zu entnehmen, sondern selbstständig zu bilden sind, nach den örtlichen klimatischen Verhältnissen und dem vorhandenen Baumaterial, in der vorgeschrittenen Technik bezüglich

der Bearbeitung und Anwendung von farbigem Glas und Glaspasten, Porzellanpasten, Terrakotta, Gusseisen et cetera." Royal instructions of 1852 for the architecture of the new street. Quoted in Hahn, *Maximilianstil*, 39.

44. "Grundbestimmungen für die Ausführung von Privatbauten in der Maximilianstrasse und deren neuen Seitenstrassen," March 1854, quoted in Hahn, *Maximilianstil*, 59.

45. "Riesenhaft schwer aber ist die Aufgabe einer Bauweise zu bedenken, die neu und charakteristisch ihre Zeit kennzeichnet!" Quoted in Wolfgang Fruth, *Die Maximilianstrasse und ihr Architekt Friedrich Bürklein* (Munich: Bayerische Landtag und Regierung von Oberbayern, 2015), 25.

46. On the Maximilianeum, see Florian Koch, "Maximilianeum," in Nerdinger, ed., *Zwischen Glaspalast und Maximilianeum*, 297–298; Peter Kock, *Das Maximilianeum—Biografie eines Gebäudes* (Munich: Allitera, 2008). There have been speculations that Gottfried Semper was responsible for the sudden shift in style; he has even been said to have taken over the completion of the building. This is not correct, however, as documented by e.g. Heinrich Habel,

"Gottfried Semper und der Stilwechsel am Maximilianeum," *Jahrbuch der bayerischen Denkmalspflege*, 28, Munich (1973): 284–302.

47. Burckhardt, *Briefe an einen Architekten 1870–1889* (Munich: Müller & Rentsch, 1913), 37.

48. Semper's "Munich episode" is described in Harry Francis Mallgrave, *Gottfried Semper, Architect of the Nineteenth Century* (New Haven: Yale University Press, 1997), 251–266.

49. On Maximilian's legendary symposia, see Michael Dirrigl, *Maximilian II. König von Bayern 1848–1864*, vol. 1 (Munich: Hugendubel, 1984), 539–544.

50. Leopold von Ranke, *Über die Epochen der neueren Geschichte: Historisch kritische Ausgabe. Werk und Nachlass II*, ed. Theodor Schieder and Helmut Berding (Munich: Oldenbourg, 1971), 60. The first lecture is translated as "On Progress in History" in *The Theory and Practice of History: Leopold von Ranke*, ed. Georg Iggers (London: Routledge, 2011), 20–23. Peter Gay describes this passage as "the single most important pronouncement in the historical school." Gay, *Style in History* (London: Cape, 1975), 85.

51. Ranke, "On Progress in History," 21. See also Iggers' introduction, *The Theory and Practice of History*, xxvii.

52. "In der Baukunst hatte sich der gotische Stil geltend gemacht, in welchem die Idee der Christenheit symbolisiert wurde, und der, da er keinem Lande besonders angehört, in Wahrheit der Stil der Hierarchie genannt werden kann." Ranke, *Über die Epochen*, lecture 13.

53. Ranke, "On Progress in History," 22.

54. Bayerischer Landtag, *Kunst im Maximilianeum: Das Konferenzzimmer* (Munich: Bayerischer Landtag, 2011).

55. "Wenn man in seiner Zeit etwas Bedeutendes wirken will, soll und kann, so muss man also seine Zeit verstehen, die Aufgabe derselben sich klarmachen und eine gewisse Zeitrichtung ergreifen, um die besondere Aufgabe, die man sich hiernach gestellt hat, zu realisieren?" Maximilian II, comment to Ranke, *Über die Epochen*, lecture 19.

Chapter 7

1. Published in English as Gottfried Semper, *Style in the Technical and Tectonic Arts, or Practical Aesthetics*, trans. Harry Francis Mallgrave and Michael Robinson (Los Angeles: Getty, 2004), 277.

2. Gottfried Semper, *Ueber Baustyle: Ein Vortrag gehalten auf den Rathhaus in Zürich am 4. März 1869* (Zurich: Friedrich Schulthess, 1869). Published in English as

"On Architectural Styles," in *Gottfried Semper: The Four Elements of Architecture and Other Writings*, ed. and trans. Harry Francis Mallgrave and Wolfgang Herrmann (Cambridge: Cambridge University Press, 1989), 267.

3. Semper studied mathematics and history in Göttingen 1823–1825. See Sonja Hildebrand, *Gottfried Semper: Architekt und Revolutionär*, 12–20.

4. Gottfried Semper, *Vorläufige Bemerkungen über bemalte Architektur und Plastik bei den Alten* (Altona: Hammerich, 1834). Published in English as "Preliminary Remarks on the Polychrome Architecture and Sculpture in Antiquity," in Mallgrave and Herrmann, *The Four Elements*, 89.

5. Semper, "Preliminary Remarks," 46–47.

6. Semper, "On Architectural Styles," 269.

7. Gottfried Semper, *Wissenschaft, Industrie und Kunst: Vorschläge zur Anregung nationalen Kunstgefühles bei dem Schlusse der Londoner Industrie-Ausstellung* (Brunswick: Vieweg & Sohn, 1852). Published in English as "Science, Industry, and Art: Proposals for the Development of a National Taste in Art at the Closing of the London Industrial Exhibition," in Mallgrave and Herrmann, eds., *The Four Elements*, 136.

8. On Semper's inconsistent terminology with regards to the

"motifs," see Heidrun Laudel, *Gottfried Semper: Architektur und Stil* (Dresden: Verlag der Kunst, 1991), 37–55. Unlike Mallgrave, I use the English term motif rather than motive for the German term *Motiv*.

9. Semper, "Science, Industry, and Art," 137.

10. Semper, "On the Relations of the Different Branches of Industrial Art to each other and to Architecture," London lecture of May 20, 1853, second version. In *Gottfried Semper: London Writings 1850–1855*, eds. Michael Gnehm, Sonja Hildebrand, and Dieter Weidmann (Zurich: gta Verlag, 2021), 102. This critical edition fundamentally reorders, retranscribes, and renames Semper's London lectures, departing significantly from previous attributions and classifications. Further references to Semper's London lectures follow Gnehm et al. throughout.

11. Semper, *Style*, 249. He discusses the Lycian tombs also in "On Timber Construction, and its Influence on Architectural Form," London lecture of November 25, 1853, in Gnehm, Hildebrand, and Weidmann, *London Writings*, 168. On the Lycian tomb as example of material metamorphosis, see Ákos Moravánszky, *Metamorphism: Material Change in Architecture* (Basel: Birkhäuser, 2018), 193–194.

12. Semper, "Science, Industry, and Art," 136. See also "The Attributes of Formal Beauty" (1856/1859), in *Gottfried Semper: In Search of Architecture*, ed. and trans. Wolfgang Herrmann (Cambridge, MA: MIT Press, 1984), 242.

13. Semper's clearest presentation of his theory of formal beauty is found in his Zurich lecture, "Über die formelle Gesetzmässigkeit des Schmuckes" (1856), in *Gottfried Semper: Kleine Schriften*, eds. Hans and Manfred Semper (Mittenwald: Mäander Kunstverlag, 1979), 304–343. For interpretations, see e.g. Ernst Stockmeyer, *Gottfried Sempers Kunsttheorie* (Zurich: Rascher, 1939), 20–24; Spyros Papapetros, "World Ornament: The Legacy of Gottfried Semper's 1856 Lecture on Adornment," *RES: Anthropology and Aesthetics*, nos. 57/58 (Spring/ Autumn 2010): 309–329; and Hvattum; *Gottfried Semper and the Problem of Historicism*, 88–102.

14. Semper, "Science, Industry, and Art," 137.

15. Moravánszky, *Metamorphism*, 100.

16. Semper, "Science, Industry, and Art," 137–139.

17. On the discrepancies in Semper's classification system, see e.g. Andreas Hauser, "Der 'Cuvier der Kunstwissenschaft.' Klassifizierungsprobleme in Gottfried Sempers 'Vergleichende Baulehre.'"

In *Grenzbereiche der Architektur: Festschrift Adolf Reinle*, ed. Thomas Bolt et al. (Basel: Birkhauser, 1985), 97–114.

18. Semper, "On the Relations of the Different Branches of Industrial Art to each other and to Architecture," London lecture of May 20, 1853, third version, in Gnehm, Hildebrand, and Weidmann, *London Writings*, 108. Different versions of this lecture manuscript have been published as "Outline for a System of Comparative Style Theory" (thought to be a lecture manuscript for November 11, 1853) in *RES: Anthropology and Aesthetics*, no. 6 (Autumn 1983): 5–22, and as "Entwurf eines Systems der vergleichende Stillehre," in *Kleine Schriften*, 259–291. For a discussion of the different versions and the confusion surrounding them, see Mallgrave, "A Commentary on Semper's November Lecture," *RES: Anthropology and Aesthetics*, no. 6 (Autumn 1983): 23–31, and Gnehm, Hildebrand, and Weidmann, *London Writings*, 410.

19. Semper, "On the Relations of the Different Branches of Industrial Art," third version, 108. The formula for style was written in different ways in Semper's various manuscripts, see e.g. "General Remarks on the Different Styles in Art," London lecture of November 11, 1853,

in Gnehm, Hildebrand, and Weidmann, *London Writings*, 119. The discrepancy is discussed by e.g. Ute Porschke, "Architecture as a Mathematical Function: Reflections on Gottfried Semper," *Nexus Network Journal* 14, no. 1 (2012): 119–134.

20. See Hvattum, *Gottfried Semper and the Problem of Historicism*, 107–113.

21. Semper, "Prospectus. Style in the Technical and Tectonic Arts or Practical Aesthetics (1859)," in Mallgrave and Herrmann, eds., *The Four Elements*, 179.

22. Semper, *Style*, 249.

23. Semper, *Style*, 266.

24. Semper, *Style*, 250.

25. Semper, *Style*, 438–439, note 85.

26. Semper, *Style*, 248.

27. Austen Henry Layard, *A Second Series of the Monuments of Nineveh: Including Bas-Reliefs from the Palace of Sennacherib and Bronzes from the Ruins of Nimroud* (London: John Murray, 1853), plate 56. Semper frequently referred to Layard and seems to have based his own image on Layard's engraving, a practice that was not unusual at the time. See Hvattum, "Heteronomic Historicism," *Architectural Histories*, 5, no. 1 (2017): http://doi.org/10.5334/ ah.216.

28. Semper, *Style*, 138–146. Semper returned to the Assyrian slab several times, see e.g. *Style*, 260,

276, and 324. Alois Riegl discussed the same slab, and while he rejected Semper's carpet theory, he shared Semper's interest in the way artistic motifs travel through time and space. *Stilfragen* (1893), translated into English as *Problems of Style: Foundations for a History of Ornament* by Evelyn Kain (New Jersey: Princeton University Press, 1992).

29. Semper, *Style*, 276, 324.

30. Semper, *Style*, 324.

31. See e.g. Semper, *Style*, 828: "These types were retained by art and applied everywhere in keeping with their original spirit, in part unconsciously."

32. Semper repeatedly refuted the materialist position: "Thus a certain subordination of the material question is appropriate both to the true principles of practical aesthetics and to the general tenor of this book (whose author is fundamentally opposed to modern materialism in art.)" *Style*, 651. On the academic context for Semper's anti-materialism, see Werner Oechslin, "'. . . bei furchtloser Konsequenz (die nicht jedermanns Sache ist)...' Prolegomenon zu einem verbesserten Verständnis des Semper'schen Kosmos," in *Gottfried Semper 1803–1879: Architektur und Wissenschaft*, eds.

Winfried Nerdinger and Werner Oechslin (Munich: Prestel / Zurich: gta Verlag, 2003), 52–90.

33. Semper, *Style*, 276.

34. Semper divided symbols into natural, technical, and mystical or "tendentious" [tendenziös], see for instance "On Architectural Symbols," London lecture of November 22, 1854, in Gnehm, Hildebrand, and Weidmann, *London Writings*, 177–188.

35. Semper, "Science, Industry, and Art," 144.

36. Semper, *Style*, 756, 761–766.

37. Alexander Nagel and Christopher S. Wood, *Anachronic Renaissance* (New York: Zone Books, 2010), 7.

38. Nagel and Wood, *Anachronic Renaissance*, 9.

39. Semper, "The Attributes of Formal Beauty," 243.

40. Semper, *Style*, 109.

41. Joseph Rykwert, "Semper and the Conception of Style," in Rykwert, *The Necessity of Artifice* (New York: Rizzoli, 1982), 123–130: 130.

42. Semper, *Style*, 438–439, note 85. Semper's position on *Materialgerechtigkeit* is discussed in Moravánszky, *Metamorphism*, 158–159, as well as in Elena Chestnova, "Substantial differences. Semper's Stoffwechsel and truth to materials," in *Architecture and Knowledge*, eds. Sonja Hildebrand, Daniela Mondini, and Roberto Grognola (Mendrisio:

Mendrisio Academy Press, 2018), 113–126.

43. Semper, *Style*, 221–223.

44. Semper, *Style*, 180.

45. Semper, *Style*, 302, see also 416–419.

46. Semper, "Science, Industry, and Art," 135.

47. Semper, "Science, Industry, and Art," 134.

48. Bötticher, "Principles," 151.

49. Schinkel, *Das architektonische Lehrbuch*, 146.

50. Schinkel, *Das architektonische Lehrbuch*, 71.

51. Semper, "On the Relations of the Different Branches of Industrial Art," in Gnehm, Hildebrand, and Wiegmann, *London Writings*, 115. Original emphasis. Semper does not give an exact reference, but is clearly paraphrasing and translating the following passage: "Also werden wir nicht wesentlich weder vom Wortgebrauch, noch von dem eigentlichen Sinne der besten Künstler dieser Zeit abweichen, wenn wir den Styl als ein zur Gewohnheit gediehenes sich Fügen in die inneren Forderungen des Stoffes erklären, in welchem der Bildner seine Gestalten wirklich bildet, der Maler sie erscheinen macht." Rumohr, *Italienische Forschungen*, 60.

52. Rumohr, "Ueber den Styl": 299–300.

53. Rumohr, "Ueber den Styl": 299–300.

54. Semper, "The Attributes of Formal Beauty," 243–244.

55. Semper's admiration for Rumohr found other expressions, too, as he designed a tombstone for the baron at the Innerer Neustädter Friedhof in Dresden.

56. Further on the parallels between Rumohr and Semper, see Harry Francis Mallgrave, *Gottfried Semper: Architect of the Nineteenth Century* (New Haven: Yale University Press, 1996), 150–155. See also Alexander Auf den Heyde, "Stil/Stylus," 21: "Denn die von Julius von Schlosser gern betonte revolutionäre Wende in Rumohrs Stilreflexion bleibt in letzter Instanz einer an Italien orientierten, klassizistischen Denktradition treu und kann erst mit Gottfried Sempers 'praktischer Aesthetik,' anhand von vollkommen anders gearteten Anschauungsobjekten zu Ende gedacht werden."

57. Martin Bressani, "The Performative Character of Style," *Architectural Histories* 6, no. 1 (2018): http://doi.org/10.5334/ah.322.

58. On the origin of the lecture, see Wolfgang Herrmann, "The Genesis of *Der Stil*," in Herrmann, *Gottfried Semper: In Search of Architecture*, 88–117, and Mallgrave, *Gottfried Semper*, 303–308.

59. Semper, "On Architectural Styles,"

268. On the Darwinian language of this paragraph, see e.g. Mallgrave, *Gottfried Semper*, 305, and Winfried Nerdinger, "Der Architekt Gottfried Semper," in Nerdinger and Oechslin, eds., *Gottfried Semper 1803–1879*, 9–10.

60. Semper, "On Architectural Styles," 268.

61. Semper, "On Architectural Styles," 265.

62. Semper, "On Architectural Styles," 265–266.

63. Semper, "On Architectural Styles," 269.

64. "No Anthemios of Tralles nor Isidorus of Miletus would have invented it unless the ground had been broken by a new concept of universal historical importance, of which this church was only its architectural expression." Semper, "On Architectural Styles," 282.

65. Semper, Prospectus to *Style*, 179. Original emphasis.

66. Semper, Prospectus to *Style*, 179. Hans Semper confirmed that Semper thought of the lecture as a condensed version of *Der Stil* volume III. Hans Semper, *Gottfried Semper: Ein Bild seines Lebens und Wirkens*, 30. See also Herrmann, "The Genesis of *Der Stil*," 107, and Mallgrave, *Gottfried Semper*, 304.

67. Semper, "Science, Industry, and Art," 137.

68. Semper, "On Architectural Styles," 269.

69. I have spent an entire book tracking such

tensions in Semper's work: Hvattum, *Gottfried Semper and the Problem of Historicism*.

70. "[I]t is equally correct to say: Chinese style, style of the age of Louis XIV, style of Raphael, ecclesiastic style rural style, timber style, metal style, heavy style, light style, grand style, etc." Semper, "Attributes of Formal Beauty," 244.

71. Semper, "On Architectural Styles," 283.

Coda

1. "Wer sich heute (noch) mit dem Stilbegriff beschäftigt, gerät schnell in einen eigenthümlichen Schwebzustand." Pfeiffer, "Produktive Labilität. Funktion des Stilbegriffs," in Gumbrecht and Pfeiffer, *Stil*, 685.

2. "Style," in *The Dictionary of Art*, ed. Jane Turner et al. (London: Macmillan, 1996), 876–883: 876.

3. Berlage, "Thoughts on Style," 136.

4. See Gombrich on the physiognomic fallacy in "Style," 159–161; Sauerländer, "From Stylus to Style," 254–255; Michaud, *The Barbarian Invasions*, and Bressani, "World History, Architecture, and Race in Germany, 1770–1850."

5. Simmel, "Problem of Style," 216.

6. Simmel, "Problem of Style," 214.

Bibliography

Ackerman, James S. "On Rereading 'Style.'" *Social Research* 45, no. 1 (Spring 1978): 153–163.

Ackerman, James S. "A Theory of Style." *Journal of Aesthetics and Art Criticism* 20, no. 3 (Spring 1962): 227–237.

Allgemeine deutsche Real-Encyklopädie für die gebildeten Stände. Altenburg and Leipzig: Brockhaus, 1827.

Altcappenberg, Hein-Th. Schulze, and Rolf H. Johannsen, eds. *Karl Friedrich Schinkel: Geschichte und Poesie—Das Studienbuch*. Berlin: Deutscher Kunstverlag, 2012.

Altcappenberg, Hein-Th. Schulze. "Kirche im gotischen Stil hinter Bäumen." In *Das Erbe Schinkels*. http://schinkel.smb.museum/index.php?object_id=1534525.

Arnim, Ludwig Achim von. "Nachfeier nach der Einholung der hohen Leiche Ihrer Majestät der Königin" (1810). In *Ausgewählte Gedichte von Achim von Arnim*, unpaginated. Musaicum Books, 2017.

Auf der Heyde, Alexander. "Stil/Stylus: Rumohrs Versuch einer Neuprägung des Stilbegriffs und die Flucht in die Kulturgeschichte." In *L'idée du style dans l'historiographie artistique: Variantes nationales et transmissions*, edited by Sabine Frommel and Antonio Brucculeri, 21–34. Rome: Campisano Editore, 2012.

Bärnigshausen, Hendrik, and Margitta Çoban-Hensel. "Joseph Friedrich Freiherr von Racknitz (1744–1818), seine 'Darstellung und Geschichte des Geschmacks der vorzüglichsten Völker' und ein Ausstattungsprojekt für Schloss Moritzburg (1792/1793)." *Staatliche Schlösser, Burgen und Gärten Sachsen* 11 (2003), 40–71.

Barnstone, Deborah Asher. "Style Debates in Early 20th-Century German Architectural Discourse." *Architectural Histories* 6, no. 1 (2018). http://doi.org/10.5334/ah.300.

Batteaux, Charles. *Les beaux-arts réduits à un même principe*. Paris: Durand, 1746.

Bauer, Hermann. "Architektur als Kunst: Von der Grösse der idealistischen Architektur-Ästhetik und ihrem Verfall." In *Kunstgeschichte und Kunsttheorie der 19. Jahrhundert*, edited by Hermann Bauer and Lorenz Dittman, 133–171. Berlin: De Gruyter, 1963.

Bayerischer Landtag. *Kunst im Maximilianeum: Das Konferenzzimmer*. Munich: Bayerischer Landtag, 2011.

Behne, Adolf. "Holländische Baukunst in der Gegenwart." *Wasmuths Monatshefte für Baukunst* 6, nos. 1–2 (1921–1922): 1–38.

Behne, Adolf. *The Modern Functional Building* (1926). Translated by Michael Robinson. Los Angeles: Getty, 1996.

Behrendt, Walter Curt. *Der Kampf um den Stil im Kunstgewerbe und in der Architektur.* Stuttgart and Berlin: Deutsche Verlags-Anstalt, 1920.

Behrendt, Walter Curt. *The Victory of the New Building Style* (1927). Translated by Harry Francis Mallgrave. Los Angeles: Getty, 2000.

Behrens, Peter. "Stil?" *Die Form* 1, no. 1 (1922): 5–8.

Bellori, Giovanni Pietro. *The Lives of the Modern Painters, Sculptors, and Architects* (1672). Translated by Alice Sedgwick Wohl. Cambridge: Cambridge University Press, 2005.

Bergdoll, Barry. "Archaeology vs. History: Heinrich Hübsch's Critique of Neoclassicism and the Beginnings of Historicism in German Architectural Theory." *Oxford Art Journal* 5, no. 2 (1983): 3–12.

Bergdoll, Barry. *Leon Vaudoyer: Historicism in the Age of Industry.* Cambridge, MA: MIT Press, 1994.

Berlage, Hendrik Petrus. *Thoughts on Style, 1886–1909.* Edited and translated by Iain Boyd-Whyte and Wim de Wit. Los Angeles: Getty, 1996.

Berlin, Isaiah. *Three Critics of the Enlightenment.* London: Pimlico, 2000.

Bialostocki, Jan. "Das Modusproblem in den bildenden Künsten." *Zeitschrift für Kunstgeschichte* 24, no. 2 (1961): 128–141.

Bisky, Jens. *Poesie der Baukunst: Architekturästhetik von Winckelmann bis Boisseree.* Weimar: Hermann Böhlaus Nachfolger, 2000.

Bol, Peter C., ed. *Forschungen zur Villa Albani: Katalog der antiken Bildwerke. 1. Bildwerke im Treppenaufgang und im piano nobile des Casino.* Berlin: Gebr. Mann, 1989.

Borbein, Adolf H., and Thomas W. Gaethgens, eds. *Johann Joachim Winckelmann: Schriften und Nachlass,* vol. 4.2: *Geschichte der Kunst des Alterthums: Katalog der antiken Denkmäler.* Mainz: Philipp von Zabern, 2006.

Börsch-Supan, Eva. *Karl Friedrich Schinkel Lebenswerk,* vol. 21. *Arbeiten für König Friedrich Wilhelm III. von Preußen und Kronprinz Friedrich Wilhelm (IV.).* Berlin: Deutscher Kunstverlag, 2011.

Börsch-Supan, Helmut. *Karl Friedrich Schinkel Lebenswerk,* vol. 20. *Bild-Erfindungen.* Berlin: Deutscher Kunstverlag, 2007.

Bötticher, Karl. "Polemisch-Kritisches." *Literatur- und Anzeigeblatt für das Baufach. Beilage zur Allgemeinen Bauzeitung* 2, no. 18 (1845): 281–320.

Bötticher, Karl. "The Principles of Hellenic and Germanic Ways of Building with Regard to Their Application to Our Present Way of Building." (1846). In *In What Style Should We Build: The German Debate on Architectural Style,* edited by Wolfgang Herrmann, 147–167. Los Angeles: Getty, 1992.

Bötticher, Karl. *Die Tektonik der Hellenen.* 2 vols. and atlas. Potsdam: Riegel, 1844–1852.

Bressani, Martin. *Architecture and the Historical Imagination: Eugène-Emmanuel Viollet-le-Duc 1814–1879.* London: Ashgate, 2014.

Bressani, Martin. "The Performative Character of Style." *Architectural Histories* 6, no.1 (2018): http://doi.org/10.5334/ah.322.

Bressani, Martin, and Christina Contandriopoulos, eds. *Companion to Architectural History*, vol. III. *Nineteenth-Century Architecture*. New York: Wiley, 2017.

Brevern, Jan von, and Joseph Imorde, eds. "Stil/Style." *Kritische Berichte* 42, no. 1 (2014): 3–163.

Brouwer, Petra. "Handbook." In *The Printed and the Built*, edited by Mari Hvattum and Anne Hultzsch, 211–217. London: Bloomsbury, 2018.

Brouwer, Petra, Christopher Drew Armstrong, and Martin Bressani, eds. *Narrating the Globe: The Emergence of World Histories of Architecture 1790–1900*. Cambridge, MA: MIT Press, 2023.

Brownlee, David B., ed. *Friedrich Weinbrenner: Architect of Karlsruhe*. Philadelphia: University of Pennsylvania Press, 1986.

Burckhardt, Jacob. *Briefe an einen Architekten 1870–1889*. Munich: Müller & Rentsch, 1913.

Burioni, Matteo, ed. *Weltgeschichten der Architektur: Ursprünge, Narrative, Bilder 1700–2016*. Passau: Dietmar Klinger, 2016.

Buttlar, Adrian von, and Bénédicte Savoy. "Glyptothek and Alte Pinakotek, Munich: Museums as Public Monuments." In *The First Modern Museums of Art*, edited by Carole Paul, 305–329. Los Angeles: Getty, 2012.

Chestnova, Elena. "Substantial Differences. Semper's *Stoffwechsel* and Truth to Materials." In *Architecture and Knowledge*, edited by Sonja Hildebrand, Daniela Mondini, and Roberto Grognola, 113–126. Mendrisio: Mendrisio Academy Press, 2018.

Cicero, Marcus Tullius. *Brutus, Orator*. Translated by G. L. Hendrickson and H. M. Hubbell. Loeb Classical Library. Cambridge, MA: Harvard University Press, 1939.

Cicero, Marcus Tullius. *De Inventione*. In Cicero, *Rhetorical Treatises*. Translated by H. M. Hubbell. Loeb Classical Library. Cambridge, MA: Harvard University Press, 1949.

Cicero, Marcus Tullius. *De Oratore, Books I–II*. Translated by E. W. Sutton and H. Rackham. Loeb Classical Library. Cambridge, MA: Harvard University Press, 1942.

Cicero, Marcus Tullius. *De Oratore, Book III*. Translated by H. Rackham. Loeb Classical Library. Cambridge, MA: Harvard University Press, 1942.

Clark, Donald Lemen. *Rhetoric in Greco-Roman Education*. New York: Columbia University Press, 1957.

Cometa, Michele. "Der pelasgische Kanon. Deutsch-römische Architekturtheorie zwischen Klassik und Romantik." In *Rom—Europa: Treffpunkt der Kulturen 1780–1820*, edited by Paolo Chiarini

and Walter Hinderer, 235–256. Würzburg: Königshausen & Neumann, 2006.

Conert, Elke. *Wilhelmsbad: Garten der Empfindsamkeit*. Hanau: CoCon Verlag, 1997.

Conversations-Lexicon oder encyclopädisches Handwörterbuch für gebildete Stände. Leipzig: Brockhaus, 1817.

Curran, Kathleen. *The Romanesque Revival: Religion, Politics, and Transnational Exchange*. Philadelphia: Penn State University Press, 2003.

Demandt, Philipp. *Luisenkult: Die Unsterblichkeit der Königin von Preussen*. Cologne: Böhlau, 2003.

Dirrigl, Michael. *Maximilian II: König von Bayern 1848–1864*, vols. 1–2. Munich: Hugendubel, 1984.

Disselkamp, Martin, and Fausto Testa, eds. *Winckelmann-Handbuch: Leben–Werk–Wirkung*. Stuttgart: Metzler, 2017.

Doesburg, Theo van. "Der Wille zum Stil: Neugestaltung von Leben, Kunst und Technik," parts 1 and 2. *De Stijl* 5, no. 2 (February 1922): 23–32, and no. 3 (March 1922): 33–41.

Doesburg, Theo van. "Ter Inleiding." *De Stijl* 1, no. 1 (October 1917): 1–2.

Döhmer, Klaus. "In welchem Style sollen wir bauen?" In *Architekturtheorie zwischen Klassizismus und Jugendstil*. Munich: Prestel, 1976.

Dorgerloh, Anette, Michael Niedermeier, and Horst Bredekamp, eds. *Klassizismus—Gotik: Karl Friedrich Schinkel und die patriotische Baukunst*. Berlin: Deutscher Kunstverlag, 2007.

Drüeke, Eberhard. *Maximilianstil: Zum Stilbegriff der Architektur im 19. Jahrhundert*. Mittenwald: Mäander, 1981.

Eck, Caroline van. *Classical Rhetoric and the Visual Arts in Early Modern Europe*. Cambridge: Cambridge University Press, 2007.

Eck, Caroline van. "Enduring Principles of Architecture in Alberti's *On the Art of Building*." *Journal of Architecture* 4, no. 2 (1999): 119–127.

Eck, Caroline van, ed. *Germain Boffrand, Book of Architecture: Containing the General Principles of the Art*. Aldershot: Ashgate, 2002.

Eck, Caroline van. *Organicism in Nineteenth-Century Architecture*. Amsterdam: Architectura & Natura Press, 1994.

Eck, Caroline van. "The Structure of 'De re aedificatoria' Reconsidered." *Journal of the Society of Architectural Historians* 57, no. 3 (September 1998): 280–297.

Eck, Caroline van, James McAllister, and Renée van de Vall, eds. *The Question of Style in Philosophy and the Arts*. Cambridge: Cambridge University Press, 1995.

Eisenlohr, Friedrich. *Rede über den Baustyl der neueren Zeit und seine Stellung im Leben der gegenwärtigen Menschheit*. Karlsruhe: Groos, 1833.

Encyclopaedia Britannica, or a Dictionary of Arts and Sciences Compiled Upon a New Plan, vols. 1–3. Edinburgh: Bell & Macfarquhar, 1771.

Espagne, Michel, Bénédicte Savoy, and Céline Trautmann-Waller, eds. *Franz Theodor Kugler: Deutscher Kunsthistoriker und Berliner Dichter.* Berlin: Akademie Verlag, 2010.

Fernow, Carl Ludwig. *Römische Studien* vol. 1–3. Zurich: Gessner, 1806–1808.

Fernow, Carl Ludwig. "Ueber den Stil in den bildenden Künsten." *Der neue Teutsche Merkur* 1, no. 4 (1795): 404–424 and no. 5 (1795): 3–36.

Forssman, Erik. *Karl Friedrich Schinkel: Bauwerke und Baugedanken.* Munich: Schnell & Steiner, 1981.

Forster, Georg. *Ansichten vom Niederrhein.* Berlin: Voss, 1791.

Forster, Kurt. "Only Things That Stir the Imagination: Schinkel as a Scenographer." In *Karl Friedrich Schinkel: The Drama of Architecture*, edited by John Zukowsky, 18–35. Tübingen: Wasmuth, 1994.

Forster, Kurt. *Schinkel: A Meander Through his Life and Work.* Basel: Birkhäuser, 2018.

Frampton, Kenneth. *Studies in Tectonic Culture.* Cambridge, MA: MIT Press, 1995.

Frank, Hilmar. "Einfache Nachahmung der Natur, Manier, Styl." In *Goethe Handbuch*, vol. 3, *Prosaschriften*, edited by Bernd Witte and Peter Schmidt. Stuttgart: J. B. Metzler, 1997.

Frank, Josef. "Vom neuen Stil." *Die Baukunst* (September 1927): 233–250.

Frommel, Sabine and Antonio Brucculeri, eds. *L'idée du style dans l'historiographie artistique: Variantes nationales et transmissions.* Rome: Campisano Editore, 2012.

Fruth, Wolfgang. *Die Maximilianstrasse und ihr Architekt Friedrich Bürklein.* Munich: Bayerische Landtag und Regierung von Oberbayern, 2015.

Gay, Peter. *Style in History.* London: Cape, 1975.

Geiser, Reto. *Giedion and America: Repositioning the History of Modern Architecture.* Zurich: gta Verlag, 2018.

Germann, Georg. *Gothic Revival in Europe and Britain: Sources, Influences and Ideas.* Cambridge, MA: MIT Press, 1973.

Giedion, Sigfried. *Space, Time and Architecture* (1941). Cambridge, MA: Harvard University Press, 1982.

Gilly, Friedrich. *Essays on Architecture 1796–1799.* Edited and translated by Fritz Neumeyer and David Britt. Los Angeles: Getty, 1994.

Ginsburg, Moisei. *Style and Epoch* (1924). Translated by Anatole Senkevitch. Cambridge, MA: MIT Press, 1983.

Gnehm, Michael. *Stumme Poesie: Architektur und Sprache bei Gottfried Semper.* Zurich: gta Verlag, 2004.

Gnehm, Michael, and Sonja Hildebrand, eds. *Architectural History and Globalized Knowledge: Gottfried Semper in London*. Mendrisio and Zurich: gta Verlag/Mendrisio Academy Press, 2021.

Goethe, Johann Wolfgang von. "On German Architecture" (1772). In *The Essential Goethe*, edited by Michael Bell, 867–872. Princeton: Princeton University Press, 2016.

Goethe, Johann Wolfgang von. *Italian Journey* (1786–1788). Translated by W. H. Auden and Elizabeth Mayer. Harmondsworth: Penguin, 1970.

Goethe, Johann Wolfgang von. "Simple Imitation, Manner, Style" (1789). In *The Essential Goethe*, edited by Michael Bell, 875–878. Princeton: Princeton University Press, 2016.

Goldhagen, Sarah Williams. "Something to Talk About: Modernism, Discourse, Style." *Journal of the Society of Architectural Historians* 64, no. 2 (June 2005): 144–167.

Gollwitzer, Heinz, ed. *100 Jahre Maximilianeum 1852–1952*. Munich: Pflaum, 1953.

Gombrich, Ernst. *The Sense of Order*. Oxford: Phaidon, 1979.

Gombrich, Ernst. "Style." In *International Encyclopedia of the Social Sciences*, vol. 15, 352–361. New York: The Free Press, 1968.

Goodman, Nelson. "The Status of Style." *Critical Inquiry* 1, no. 4 (June 1975): 799–811.

Göschen, Georg Joachim. "Darstellung und Geschichte des Geschmacks der vorzüglichsten Völker: In Beziehung auf die innere Auszierung der Zimmer und auf die Baukunst." *Intelligenz-Blatt des Journals des Luxus und der Moden* 10, no. 11 (November 1795): cxcv–cxcviii.

Gottsched, Johann Christoph. *Handlexicon oder Kurzgefasstes Wörterbuch der schönen Wissenschaften und freyen Künste*. Leipzig: Fritsch, 1760.

Grohmann, Johann Gottfried, ed. *Ideenmagazin für Liebhaber von Gärten, englischen Anlagen und für Besitzer von Landgütern*. Leipzig: Grohmann, 1796–1802.

Gropius, Walter. "Der stilbildende Wert industrieller Bauformen." In *Jahrbuch des Deutschen Werkbundes 1914*, 29–32. Jena: Eugen Diederichs, 1914.

Gropius, Walter. *Programm des Staatlichen Bauhauses Weimar*. Dessau: Bauhaus, 1919.

Gumbrecht, Hans Ulrich, and Karl Ludwig Pfeiffer, eds. *Stil: Geschichten und Funktionen eines kulturwissenschaftlichen Diskurselements*. Frankfurt am Main: Suhrkamp, 1986.

Habel, Heinrich. "Gottfried Semper und der Stilwechsel am Maximilianeum." *Jahrbuch der bayerischen Denkmalspflege*, 28 (1973): 284–302.

Hager, Werner, and Norbert Knopp, eds. *Beiträge zum Problem des Stilpluralismus*. Munich: Prestel, 1977.

Hahn, August. *Der Maximilianstil in München: Programm und Verwirklichung* (1932). Munich: Heinz Moos, 1982.

Harloe, Katherine. *Winckelmann and the Invention of Antiquity: History and Aesthetics in the Age of Altertumswissenschaft*. Oxford: Oxford University Press, 2013.

Hauff, Ludwig. *Leben und Wirken Maximilian II., Königs von Bayern*. Munich: Fleischmann, 1864.

Haus, Andreas. "Gedanken über K. F. Schinkels Einstellung zur Gotik." *Marburger Jahrbuch für Kunstwissenschaft* 22 (1989): 215–231.

Haus, Andreas. *Karl Friedrich Schinkel als Künstler*. Berlin: Deutscher Kunstverlag, 2001.

Hauser, Andreas. "Der 'Cuvier der Kunstwissenschaft': Klassifizierungsprobleme in Gottfried Sempers 'Vergleichende Baulehre.'" In *Grenzbereiche der Architektur: Festschrift Adolf Reinle*, edited by Thomas Bolt et al., 97–114. Basel: Birkhäuser, 1985.

Heck, Kilian. "Wörlitz als Gartenreich." *Kunsthistorische Arbeitsblätter*, no. 6 (2001): 17–26.

Heeren, Arnold Herrmann. *Ideen über Politik, den Verkehr, und den Handel der vornehmsten Völker der alten Welt*. Göttingen: Vandenhoeck & Ruprecht, 1793–1796.

Heine, Heinrich. *Reisebilder*, vol. 3 (1830). In *Heinrich Heine, Sämtliche Werke*, vol. 2. Munich: Artemis & Winkler, 1969. https://www.projekt-gutenberg.org/heine/reisebld/reise312.html.

Hendrickson, G.L. "The Origin and Meaning of the Ancient Characters of Style." *The American Journal of Philology* 26, no. 3 (1905): 249–290.

Herder, Johann Gottfried. *On World History. An Anthology*, edited and translated by Hans Adler and Ernest A. Menze. Abingdon: Routledge, 1997.

Herder, Johann Gottfried. *Philosophical Writings*, edited and translated by Michael N. Forster. Cambridge: Cambridge University Press, 2002.

Herder, Johann Gottfried. *Sämmtliche Werke: Zur Philosophie und Geschichte*, vol. 1. Karlsruhe: Bureau der deutschen Classiker, 1820.

Herrmann, Wolfgang, ed. *Gottfried Semper: In Search of Architecture*. Cambridge, MA: MIT Press, 1984.

Herrmann, Wolfgang, ed. *In What Style Should We Build? The German Debate on Architectural Style*. Los Angeles: Getty, 1992.

Herzog, Jacques. "You can't just leave a city as is. If you do that, it will die." Interview by Finn Canonica. April 2015. https://www.herzogdemeuron.com/index/projects/complete-works/426-450/444-expo-milan-2015-conceptual-master-plan/focus/jacques-herzog-das-magazin-interview.html.

Hildebrand, Sonja. "Concepts of Creation: Historiography and Design in Gottfried Semper." *Journal of Art Historiography* 11 (December 2014): 1–13.

Hildebrand, Sonja. *Gottfried Semper: Architekt und Revolutionär*. Darmstadt: Wissenschaftliche Buchgesellschaft wbg/Theiss, 2020.

Hirschfeld, Christian Cay Lorenz. *Theorie der Gartenkunst*, vols. 1–5. Leipzig: Weidmanns Erben und Reich, 1779–1785.

Hirschfeld, Christian Cay Lorenz. *Theory of Garden Art*. Abridged translation by Linda Parshall. Philadelphia: University of Pennsylvania Press, 2001.

Hirt, Aloys. *Die Baukunst nach den Grundsätzen der Alten*. Berlin: Realschulbuchhandlung, 1809.

Hirt, Aloys. *Die Geschichte der Baukunst bei den Alten*, vols. 1–3. Berlin: Reimer, 1821–1827.

Hitchcock, Henry-Russell. "The International Style Twenty Years Later." *Architectural Record* 110, no. 2 (August 1951): 89–97.

Hitchcock, Henry-Russell, and Philip Johnson. *The International Style* (1932). New York: Norton, 1995.

Hojer, Gerhard. "München—Maximilianstrasse und Maximilianstil." In *Die Deutsche Stadt im 19. Jahrhundert*, edited by Ludwig Grote, 33–65. Munich: Prestel, 1974.

Holl, Steven. "Not a signature architect." Interview by Andrew Caruso. *ArchDaily* (September 2, 2012). https://www.archdaily.com/269251/ steven-holl-interview-not-a-signature-architect-andrew-caruso.

Hübsch, Heinrich. *In welchem Style sollen wir bauen*. Karlsruhe: Müller, 1828.

Hübsch, Heinrich. *In What Style Should We Build* (1828). In *In What Style Should We Build: The German Debate on Architectural Style*, edited by Wolfgang Herrmann, 63–101. Los Angeles: Getty, 1992.

Huse, Norbert, ed. *Denkmalpflege: Deutsche Texte aus drei Jahrhunderten*. Munich: Beck, 2006.

Huth, Gottfried, ed. *Allgemeines Magazin für die bürgerliche Baukunst*. Weimar: Hoffmanns Wittwe und Erben, 1789–1796.

Hvattum, Mari. "Crisis and Correspondence: Style in the Nineteenth Century." *Architectural Histories* 1, no. 1 (2013). http://doi.org/10.5334/ ah.an.

Hvattum, Mari. *Gottfried Semper and the Problem of Historicism*. Cambridge: Cambridge University Press, 2003.

Hvattum, Mari. "Heteronomic Historicism." *Architectural Histories* 5, no. 1 (2017): http://doi.org/10.5334/ah.216.

Hvattum, Mari. "Mere Style?" *Architectural Histories* 6, no. 1 (2018), http:// doi.org/10.5334/ah.342.

Hvattum, Mari. "Style: Notes on the Transformation of a Concept." *Architectural Histories* 7, no. 1 (2019): http://doi.org/10.5334/ah.367.

Hvattum, Mari. "*Zeitgeist*, Style and *Stimmung*: Notes on Architectural Historiography in the Late Eighteenth Century." In *Companions to Architectural History*, vol. II: *The Companion to Eighteenth-Century*

Architecture, edited by Caroline van Eck and Sigrid de Jong, 691–714. London: Wiley, 2017.

Ingels, Bjarke. "Bjarke Ingels to Cities: Take a Longer View." Interview by Andrew Zuckerman. *Time Sensitive Podcast*, episode 4, February 6, 2019. https://timesensitive.fm/episode/bjarke-ingels-cities-longer-view/.

Jervis, Simon Swynfen, ed. *A Rare Treatise on Interior Decoration and Architecture: Joseph Friedrich zu Racknitz's Presentation and History of the Taste of the Leading Nations*. Los Angeles: Getty, 2019.

Johnson, Philip. "Style and the International Style" (1955). In Philip Johnson, *Writings*, 72–79. Oxford: Oxford University Press, 1979.

Jones, Emma L. *Schinkel in Perspective: The Architect as Illusionist in Nineteenth-Century Prussia*. Cambridge, MA: MIT Press, 2024.

Kamp, Michael. "Das Museum als Ort der Politik: Münchner Museen im 19. Jahrhundert." PhD diss., Ludwig-Maximilians-Universität München, 2002.

Kandinsky, Wassily. *On the Spiritual in Art* (1911). New York: Guggenheim, 1946.

Karge, Henrik. "Franz Kugler und Karl Schnaase: Zwei Projekte zur Etablierung der allgemeinen Kunstgeschichte." In *Franz Theodor Kugler: Deutscher Kunsthistoriker und Berliner Dichter*, edited by Michel Espagne et al., 83–104. Berlin: Akademie Verlag, 2010.

Karge, Henrik. "Projecting the Future in German Art Historiography of the Nineteenth Century: Franz Kugler, Karl Schnaase, and Gottfried Semper," *Journal of Art Historiography*, no. 9 (December 2013): 1–26.

Karge, Henrik. "Stil und Epoche: Karl Schnaases dialektisches Modell der Kunstgeschichte." In *L'idée du style dans l'historiographie artistique: Variantes nationales et transmissions*, edited by Sabine Frommel and Antonio Brucculeri, 35–48. Rome: Campisano Editore, 2012.

Karlholm, Dan. *Art of Illusion: The Representation of Art History in Nineteenth-century Germany and Beyond*. Pieterlen: Peter Lang, 2006.

Kipnis, Jeffrey. "A Conversation with Jacques Herzog." *El Croquis*, no. 84 (1997): 7–21.

Klenze, Leo von. *Anweisung zur Architektur des christlichen Cultus*. Munich: n.p., 1822.

Klenze, Leo von, and Ludwig Schorn. *Beschreibung der Glyptothek Sr. Majestät des Königs Ludwig I. von Bayern*. Munich: Cotta, 1830.

Knigge, Adolph von. *Briefe eines Schweizers über das Wilhelmsbad bei Hanau* (1780). Hanau: CoCon Verlag, 2009.

Kock, Peter. *Das Maximilianeum—Biografie eines Gebäudes*. Munich: Allitera, 2008.

Koolhaas, Rem. "House with NO STYLE." *Japan Architect* 7, no. 3 (Summer 1992): prelim, not paginated.

Koolhaas, Rem, ed. "Results: House with NO STYLE." *Japan Architect* 9, no. 1 (Spring 1993): 5–43.

Koolhaas, Rem, and Bruce Mau. *S,M,L,XL*. New York and Rotterdam: Monacelli Press and 010 Publishers, 1995.

Krätschell, Johannes. "Schinkels gotisches Schmerzenskind: Das Werdersche Kirche in Berlin." *Blätter für Architektur und Kunsthandwerk* 1, no. 12 (October 16, 1888): 114–117.

Kubler, George. "Toward a Reductive Theory of Visual Style." In *The Concept of Style*, edited by Berel Lang, 163–173. Ithaca: Cornell University Press, 1979.

Kugler, Franz. *Handbuch der Kunstgeschichte*. Stuttgart: Ebner & Seubert, 1842.

Kugler, Franz. *Karl Friedrich Schinkel: Eine Charakteristik seiner künstlerischen Wirksamkeit*. Berlin: Gropius, 1842.

Kugler, Franz. "Ueber den Kirchenbau und seine Bedeutung für unsere Zeit." *Museum: Blätter für bildende Kunst* 2, no. 1 (January 6, 1834): 1–8.

Kunst, Hans-Joachim. "Bemerkungen zu Schinkels Entwürfen für die Friedrich Werdersche Kirche in Berlin." *Marburger Jahrbuch für Kunstwissenschaft* 19 (1974): 241–258.

Lang, Berel, ed. *The Concept of Style*. Ithaca: Cornell University Press, 1979.

Laudel, Heidrun. *Gottfried Semper: Architektur und Stil*. Dresden: Verlag der Kunst, 1991.

Layard, Austen Henry. *A Second Series of the Monuments of Nineveh: Including Bas-Reliefs from the Palace of Sennacherib and Bronzes from the Ruins of Nimroud*. London: John Murray, 1853.

Le Corbusier. *Oeuvre complète: 1910–1929*. Paris: Les Editions d'Architecture, 1936.

Le Corbusier. *Toward an Architecture* (1923). Translated by John Goodman. Los Angeles: Getty, 2007.

Lewis, C. T., and C. Short, eds. *A Latin Dictionary*. Oxford: Clarendon, 1879. http://www.perseus.tufts.edu/hopper/text?doc=Perseus:text:1999.04.0059.

Lewis, Michael J. *The Politics of the German Gothic Revival: August Reichensperger*. Cambridge, MA: MIT Press, 1993.

Lønberg-Holm, Knud. "Two Shows: A Comment on the Aesthetic Racket." *Shelter* 2, no. 3 (April 1932): 16–17.

Loos, Adolf. *Trotzdem*. Innsbruck: Brenner, 1931.

Lovejoy, Arthur O. *The Great Chain of Being*. Cambridge, MA: Harvard University Press, 1936.

Lübke, Wilhelm. *Geschichte der Architektur*. Leipzig: Graul, 1855.

Lund, Marie. *An Argument on Rhetorical Style*. Aarhus: Aarhus University Press, 2017.

Maas, Winy, and Jacob van Rijs. "MVRDV 25." Posted October 19, 2018. https://www.mvrdv.nl/news/1173/charismatic-idiosyncratic-data-driven-green-innovative-25-years-of-mvrdv.

Mallgrave, Harry Francis. "A Commentary on Semper's November Lecture." *RES: Anthropology and Aesthetics*, no. 6 (Autumn 1983): 23–31.

Mallgrave, Harry Francis. *Gottfried Semper: Architect of the Nineteenth Century*. New Haven: Yale University Press, 1997.

Mallgrave, Harry Francis. *Modern Architectural Theory*. Cambridge: Cambridge University Press, 2009.

Marggraff, Rudolf (attributed). "Die architektonische Preisaufgabe bezüglich einer höhern Bildungs- und Unterrichtsanstalt in München." *Allgemeine Zeitung*, April 16, 1852 (supplement).

Michaud, Éric. *The Barbarian Invasions: A Genealogy of the History of Art*. Cambridge, MA: MIT Press, 2019.

Mies van der Rohe, Ludwig. "Bauen." *G. Material zur elementaren Gestaltung*, no. 2 (September 1923): 1.

Mittlmeier, Werner. *Die Neue Pinakothek in München 1843–1854*. Munich: Prestel, 1977.

Moravánszky, Ákos. *Metamorphism: Material Change in Architecture*. Basel: Birkhäuser, 2018.

Moravánszky, Ákos. "Peter Meyer and the Swiss Discourse on Monumentality." *Future Anterior* 8, no. 1 (Summer 2011): 1–20.

Moritz, Karl Philipp. *Ueber die bildende Nachahmung des Schönen*. Braunschweig: Schul-Buchhandlung, 1788.

Möser, Justus. "Deutsche Geschichte." In *Von Deutscher Art und Kunst*, edited by Johann Gottfried Herder, 165–182. Hamburg: Bode, 1773.

Mosser, Monique. "Paradox in the Garden: A Brief Account of Fabriques." In *The History of Garden Design*, edited by Monique Mosser and Georges Teyssot, 262–279. London: Thames & Hudson, 1991.

Moussavi, Farshid. *The Function of Style*. Cambridge, MA: Harvard GSD/ Actar, 2014.

Munch, Anders. *Adolf Loos: Der stillose Stil*. Paderborn: Fink, 2005.

Muthesius, Hermann. *Style Architecture and Building Art: Transformations of Architecture in the Nineteenth Century and its Present Condition* (1902). Translated by Stanford Anderson. Los Angeles: Getty, 1994.

N.N. "Attempt for a New Style of Architecture: Prize Programme of the Munich Academy of Arts." *The Builder* 9, no. 426 (1851): 223.

N.N. "Der Bauplan zu einer höhern Bildungs- und Unterrichts-Anstalt in München," *Allgemeine Zeitung*, March 16, 1852 (supplement).

N.N. "Neue Bewegungen auf dem Gebiete der Baukunst: Versuche zur Gewinnung eines neuen Baustyls" I. *Allgemeine Zeitung*, March 20, 1851.

N.N. "Ueber die neue Bewegungen auf dem Gebiete der Baukunst" II. *Allgemeine Zeitung*, April 30, 1851.

N.N. *Untersuchungen über den Charakter der Gebäude, über die Verbindung der Baukunst mit den schönen Künsten, und die Wirkungen, welche durch dieselbe hervorgebracht werden sollen.* Leipzig: Joh. Philipp Haugs Wittwe, 1788.

N.N. *Zum angedenken der Königin Luise vom Preussen, Sammlung der vollständigsten und zuverlässligsten Nachrichten von allen das Absterben und die Trauerfeierlichkeiten dieser unvergesslichen Fürstin betreffenden Umständen.* Berlin: Haude und Spenerschen Zeitungsexpedition, 1810.

Nagel, Alexander, and Christopher S. Wood. *Anachronic Renaissance.* New York: Zone Books, 2010.

Nerdinger, Winfried, ed. *Friedrich von Gärtner: Ein Architektenleben, 1791– 1847.* Munich: Klinkhardt & Biermann, 1992.

Nerdinger, Winfried, ed. *Leo von Klenze: Architekt zwischen Kunst und Hof 1784–1864.* Munich: Prestel, 2000.

Nerdinger, Winfried, ed. *Zwischen Glaspalast und Maximilianeum: Architektur in Bayern zur Zeit Maximilans II. 1848–1864.* Munich: Edition Minerva, 1997.

Nerdinger, Winfried, and Werner Oechslin, eds. *Gottfried Semper 1803– 1879: Architektur und Wissenschaft.* Munich: Prestel/Zurich: gta Verlag, 2003.

Neumeyer, Alfred. "Die Erweckung der Gotik in der deutschen Kunst des späten 18. Jahrhunderts: Ein Beitrag zur Vorgeschichte der Romantik." In *Repertorium für Kunstwissenschaft*, vol. 49, edited by Wilhelm Waetzoldt, 75–123, 159–185. Berlin: De Gruyter, 1928.

Oechslin, Werner. "In Search of the 'True Style': The Rigorists' Distinction between 'Right' and 'Wrong.'" *Daidalos* 8 (1983): 21–37.

Oechslin, Werner. *Stilhülse und Kern: Otto Wagner, Adolf Loos und der evolutionäre Weg zur modernen Architektur.* Zurich: gta Verlag, 1994.

Papapetros, Spyros. "World Ornament. The Legacy of Gottfried Semper's 1856 Lecture on Adornment." *RES: Anthropology and Aesthetics*, nos. 57/58 (Spring/Autumn 2010): 309–329.

Payne, Alina. "Architecture, Objects and Ornament: Wölfflin and the Problem of *Stilwandlung.*" *Journal of Art Historiography* 7 (2012): 1–20.

Payne, Alina. *From Ornament to Object.* New Haven: Yale University Press, 2012.

Payne, Alina. "Vasari, Architecture, and the Origins of Historicizing Art." *RES: Anthropology and Aesthetics*, no. 40 (Autumn 2001): 51–76.

Payne, Alina, and Lina Bolzoni, eds. *The Italian Renaissance in the 19th Century: Revision, Revival, and Return.* Cambridge, MA: Harvard University Press, 2018.

Philipp, Klaus Jan. *Gänsemarsch der Stile: Skizzen zur Geschichte der Architekturgeschichtsschreibung.* Stuttgart: Deutsche Verlags-Anstalt, 1998.

Philipp, Klaus Jan. *Um 1800: Architekturtheorie und Architekturkritik in Deutschland zwischen 1790 und 1810.* Stuttgart: Axel Menges, 1997.

Piel, Friedrich. "Der historische Stilbegriff und die Geschichtlichkeit der Kunst." In *Kunstgeschichte und Kunsttheorie im 19. Jahrhundert,* edited by Hermann Bauer, 18–37. Berlin: De Gruyter, 1963.

Plagemann, Volker. *Das Deutsche Kunstmuseum 1790–1870.* Munich: Prestel, 1967.

Podro, Michael. *The Critical Historians of Art.* New Haven: Yale University Press, 1982.

Poole, Matthew, and Manuel Shvartzberg, eds. *The Politics of Parametricism: Digital Technologies in Architecture.* London: Bloomsbury, 2015.

Porschke, Ute. "Architecture as a Mathematical Function: Reflections on Gottfried Semper." *Nexus Network Journal* 14, no. 1 (2012): 119–134.

Potts, Alex. *Flesh and the Ideal: Winckelmann and the Invention of Art History.* New Haven: Yale University Press, 2000.

Quatremère de Quincy, Antoine-Chrysostome. "Style." In *Encyclopédie Méthodique. Architecture,* vol. 3. Paris: Agasse, 1825, 410–414.

Quatremère de Quincy, Antoine-Chrysostome. "Style." In *Historical Dictionary of Architecture* (1832). Edited and translated by Samir Younés, 238–241. London: Papadakis, 2000.

Quintilian. *Institutio Oratoria.* Translated by H.E. Butler. Loeb Classical Library. Cambridge, MA: Harvard University Press, 1921.

Racknitz, Joseph Friedrich zu. *Darstellung und Geschichte des Geschmacks der vorzüglichsten Völker in Beziehung auf die innere Auszierung der Zimmer und auf die Baukunst,* vols. 1–5. Leipzig: Göschen, 1796–1799.

Racknitz, Joseph Friedrich zu. "Presentation and History of the Taste of the Leading Nations (1796–1799)." In *A Rare Treatise on Interior Decoration and Architecture: Joseph Friedrich zu Racknitz's* Presentation and History of the Taste of the Leading Nations, edited and translated by Simon Swynfen Jervis. Los Angeles: Getty, 2019.

Ranke, Leopold von. *The Theory and Practice of History: Leopold von Ranke.* Edited by Georg Iggers. London: Routledge, 2011.

Ranke, Leopold von. *Über die Epochen der neueren Geschichte: Historisch-kritische Ausgabe. Werk und Nachlass II.* Edited by Theodor Schieder and Helmut Berding. Munich: Oldenbourg, 1971.

Rave, Paul Ortwin. *Karl Friedrich Schinkel: Lebenswerk. Berlin I—Bauten für die Kunst, Kirchen und Denkmalpflege.* Berlin: Deutscher Kunstverlag, 1981.

Riegl, Alois. *Problems of Style: Foundations for a History of Ornament* (1893). Translated by Evelyn Kain. New Jersey: Princeton University Press, 1992.

Riemerschmid, Richard. "Zur Frage des Zeitstiles." *Die Form* 1, no. 1 (1922): 8–12.

Riezler, Walter. "Zum Geleit." *Die Form* 1, no. 1 (1922): 1–4.

Riley, Terence. *The International Style: Exhibition 15 and the Museum of Modern Art.* New York: Rizzoli, 1992.

Rosenberg, Rainer, and Wolfgang Brückle. "Stil." In *Ästhetische Grundbegriffe*, vol. 5, edited by Karlheinz Barck et al., 641–688. Stuttgart/Weimar: Metzel, 2003.

Royal Academy of Art, Munich. *Einladung zu einer Preisbewerbung die Anfertigung eines Bauplanes zu einer höheren Bildungs- und Unterrichts-Anstalt betreffend.* Munich: Royal Academy of Art, 1850. Bayerisches Hauptstaatsarchiv, Abt. III Geheimes Hausarchiv, Kabinettsakten König Maximilians II. Nr. 90a.

Royal Academy of Art, Munich. *Erläuternde Bemerkungen in Bezug auf das architektonische Preisprogramm.* Munich: Royal Academy of Art, 1850. Bayerisches Hauptstaatsarchiv, Abt. III Geheimes Hausarchiv, Kabinettsakten König Maximilians II. Nr. 90a.

Rumohr, Carl Friedrich von. *Italienische Forschungen* (1827–1831). Edited by Julius Schlosser. Frankfurt am Main: Frankfurter Verlags-Anstalt, 1920.

Rumohr, Carl Friedrich von. "Mittheilungen über Kunstgegenstände," I–IV. *Kunstblatt*, no. 39 (May 15, 1820): 153–156; no. 52 (June 29, 1820): 205–207; no. 54 (July 6, 1820): 213–216; and no. 55 (July 10, 1820): 217–219.

Rumohr, Carl Friedrich von. "Ueber den Styl in der bildenden Kunst: I. Antwort des Freyherrn v. Rumohr auf das Schreiben vom Herausgeber im Kunstbl. Nr. 1. d.J." *Kunstblatt* no. 75 (September 19, 1825): 297–300.

Rykwert, Joseph. "Semper and the Conception of Style." In *The Necessity of Artifice.* New York: Rizzoli, 1982.

Rykwert, Joseph. "Sigfried Giedion and the Notion of Style." *Burlington Magazine* 96 (1954): 123–124.

Sauerländer, Willibald. "From Stylus to Style: Reflections of the Fate of a Notion." *Art History* 6, no. 3 (September 1983): 253–270.

Schapiro, Meyer. "Style." In *Anthropology Today*, edited by Alfred. L. Kroeber, 287–312. Chicago: University of Chicago Press, 1953.

Schepers, Wolfgang. *Hirschfelds Theorie der Gartenkunst.* Worms: Werner'sche Verlagsgesellschaft, 1980.

Schiller, Friedrich. Letter to Gottfried Körner, January 28, 1793. https://www.friedrich-schiller-archiv.de/briefe-schillers/briefwechsel-mit-gottfried-koerner/schiller-an-gottfried-koerner-28-februar-1793/.

Schiller, Friedrich. *Musen-Almanach für das Jahr 1797*. Tübingen: Cotta, 1797.

Schiller, Friedrich. *Über die aesthetische Erziehung der Menschen* (1795). In *Schillers sämmtliche Werke*, vol. 12. Stuttgart: Cotta, 1860. https://www.friedrich-schiller-archiv.de/ueber-die-aesthetische-erziehung-des-menschen/.

Schinkel, Karl Friedrich. *Aus Schinkel's Nachlass*, vols. 1–3. Edited by Alfred von Wolzogen. Berlin: Verlag der Königlichen Geheimen Ober-Hofbuchdruckerei, 1862–1864.

Schinkel, Karl Friedrich. *Das architektonische Lehrbuch*. Edited by Goerd Peschken. Berlin: Deutscher Kunstverlag, 1979.

Schinkel, Karl Friedrich. *Karl Friedrich Schinkel: Briefe, Tagebücher, Gedanken*. Edited by Hans Mackowsky. Berlin: Propyläen-Verlag, 1922.

Schinkel, Karl Friedrich. *Sammlung architektonischer Entwürfe: Enthaltend theils Werke welche ausgeführt sind theils Gegenstände deren Ausführung beabsichtigt wurde*, vols. 1–29. Berlin: Wittich/Duncker & Humblot/Gropius, 1819–1840.

Schlegel, August Wilhelm. "Über das Verhältniss der schönen Kunst zur Natur; über Täuschung und Wahrscheinlichkeit; über Styl und Manier" (1802/1808). In *August Wilhelm Schlegel: Kritische Ausgabe der Vorlesungen*, edited by Ernst Behler, 256–270. Paderborn: Ferdinand Schöningh, 2007.

Schlegel, Friedrich. "Grundzüge der gotischen Baukunst" (1803). In *Friedrich Schlegel: Kritische Schriften*, edited by Wolfdietrich Rasch, 543–583. Munich: Carl Hanser, 1958.

Schmoll genannt Eisenwerth, Josef Adolf. "Stilpluralismus statt Einheitszwang—Zur Kritik der Stilepoche-Kunstgeschichte." In *Beiträge zum Problem des Stilpluralismus*, edited by Werner Hager and Norbert Knopp, 9–19. Munich: Prestel, 1977.

Schnaase, Carl. *Geschichte der bildenden Künste*. Düsseldorf: Buddeus, 1843.

Schopenhauer, Arthur. "Ueber Schriftstellerei und Stil." In *Parerga und Paralipomena*, vol. 2, 546–612. Berlin: A. W. Hayn, 1851.

Schorn, Ludwig. "Betrachtungen über die Kunstausstellung in München im October 1829," *Kunstblatt* 10, no. 100 (December 14, 1829): 397–399.

Schorn, Ludwig. "Ueber den Styl in der bildenden Kunst: II. Antwort an Herrn Baron v. Rumohr." *Kunstblatt*, no. 76 (September 22, 1825): 301–304.

Schorn, Ludwig. "Ueber Styl und Motive in der bildenden Kunst. An Herrn Baron C. F. v. Rumohr," *Kunstblatt*, no. 1 (January 3, 1825): 1–4.

Schumacher, Patrik. "A New Global Style for Architecture and Urban Design." *Architectural Design* 79, no. 4 (July/August 2009): 14–23.

Schumacher, Patrik. "On Style." *Architectural Review* 120 (January 19, 2017). https://www.architectural-review.com/archive/ar-120/ar-120-patrik-schumacher-on-style.

Schwartz, Frederic J. "Form Follows Fetish: Adolf Behne and the Problem of 'Sachlichkeit.'" *Oxford Art Journal* 21, no. 2 (1998): 45–77.

Scully, Vincent. "Toward a Redefinition of Style." *Perspecta* 4 (1957): 4–11.

Sedlmayr, Hans. *Verlust der Mitte: die bildende Kunst des 19. und 20. Jahrhunderts des Symptom und Symbol der Zeit.* Salzburg: Müller, 1965.

Semper, Gottfried. *The Four Elements of Architecture and Other Writings.* Edited and translated by Harry Francis Mallgrave and Wolfgang Herrmann. Cambridge: Cambridge University Press, 1989.

Semper, Gottfried. *Kleine Schriften.* Edited by Hans and Manfred Semper. Mittenwald: Mäander Kunstverlag, 1979.

Semper, Gottfried. *London Writings 1850–1855.* Edited by Michael Gnehm, Sonja Hildebrand, and Dieter Weidmann. Zurich: gta Verlag, 2021.

Semper, Gottfried. *Style in the Technical and Tectonic Arts, or Practical Aesthetics* (1860–1863). Translated by Harry Francis Mallgrave and Michael Robinson. Los Angeles: Getty, 2004.

Simmel, Georg. "The Problem of Style" (1908). In *Simmel on Culture: Selected Writings,* edited and translated by David Frisby and Mike Featherstone, 211–217. London: Sage, 1997.

Singelenberg, Pieter. *H.P. Berlage. Idea and Style.* Utrecht: Haentjens Dekker & Gumbert, 1972.

Smith, William, William Wayte, and G. E. Marindin, eds. *A Dictionary of Greek and Roman Antiquities.* London. John Murray, 1890.

Snodin, Michael, ed. *Karl Friedrich Schinkel: A Universal Man.* New Haven: Yale University Press, 1991.

Sontag, Susan. "On Style." In Susan Sontag, *Against Interpretation and Other Essays.* New York: Farrar, Straus and Giroux, 1961.

Sowinski, Bernhard. "Stil." In *Historisches Wörterbuch der Rhetorik,* vol. 8, edited by Gert Ueding, 1393–1419. Tübingen: Max Niemeyer Verlag, 2007.

Speth, Rudolf. "Königin Luise von Preußen—deutscher Nationalmythos im 19. Jahrhundert." In *Mythos Diana—von der Princess of Wales zur Queen of Hearts,* edited by Sabine Berghahn and Sigrid Koch-Baumgarten, 265–285. Giessen: Psychosozial-Verlag, 1999.

Stieglitz, Christian Ludwig. *Archaeologie der Baukunst der Griechen und Römer.* Weimar: Verlag des Industrie-Comptoirs, 1801.

Stieglitz, Christian Ludwig. *Encyklopädie der bürgerlichen Baukunst,* vols. 1–2. Leipzig: Caspar Fritsch, 1792–1794.

Stier, Wilhelm. "Beiträge zur Feststellung des Principes der Baukunst für das vaterländische Bauwesen in der Gegegenwart." *Allgemeine Bauzeitung* 8 (1843): 309–339.

Stier, Wilhelm. "Uebersicht bemerkenswerther Bestrebungen und Fragen für die Auffassung der Baukunst in der Gegenwart und jüngsten Vergangenheit." *Allgemeine Bauzeitung* 8 (1843): 296–302.

Stockmeyer, Ernst. *Gottfried Sempers Kunsttheorie.* Zurich: Rascher, 1939.

Sulzer, Johann Georg. *Allgemeine Theorie der Schönen Künste*, vols. 1–2. Leipzig: Weidmann, 1771–1774.

Summers, David. "'Form,' Nineteenth-Century Metaphysics, and the Problem of Art Historical Description" (1989). In *The Art of Art History: A Critical Anthology*, edited by Donald Preziosi, 141–144. Oxford: Oxford University Press, 1998.

Szambien, Werner. *Symétrie. Goût. Caractère: Théorie et terminologie de l'architecture à l'âge classique, 1500–1800.* Paris: Picard, 1986.

Taut, Bruno. *Die neue Wohnung: Die Frau als Schöpferin.* Leipzig: Klinkhardt & Biermann, 1926.

Tönnies, Ferdinand. *Gemeinschaft und Gesellschaft.* Leipzig: Fues, 1887.

Trauzettel, Ludwig. "Wörlitz: England in Germany." *Garden History* 24, no. 2 (Winter 1996): 221–236.

Treves, Marco. "Maniera: The History of a Word." *Marsyas: A Publication by the Students of the Institute of Fine Arts, New York University* 1 (1941): 69–88.

Trost, Ludwig, and Friedrich Leist, eds. *König Maximilian II. von Bayern und Schelling: Briefwechsel.* Stuttgart: Cotta, 1890.

Vickers, Brian. *In Defence of Rhetoric.* Oxford: Clarendon/Oxford University Press, 1988.

Viollet-le-Duc, Eugène Emmanuel. "Style" (1854). In *The Foundations of Architecture. Selections from the Dictionnaire raisonné.* Translated by K.D. Whitehead, 231–232. New York: Braziller, 1990.

Vitruvius, Marcus Pollio. *Ten Books on Architecture.* Translated by Ingrid Rowland. Cambridge: Cambridge University Press, 1999.

Weissert, Caecilie, ed. *Stil in der Kunstgeschichte.* Darmstadt: WBG, 2009.

Welsh, Robert P. "De Stijl: A Reintroduction." In *De Stijl 1917–1931. Visions of Utopia*, edited by Mildred Friedman. Oxford: Phaidon, 1982.

Wheeler, Katherine. *Victorian Perceptions of Renaissance Architecture.* London: Routledge, 2017.

Wiebeking, Carl Friedrich von. *Theoretisch-praktische bürgerliche Baukunde, durch Geschichte und Beschreibung der merkwürdigsten antiken Baudenkmahle, und ihrer genauen Abbildungen bereichert*, vols. 1–4. Munich: Lindauer, 1821–1825.

Wiebeking, Carl Friedrich von. *Von der Einfluss der Bauwissenschaften oder der Baukunst auf das allgemeine Wohl und die Civilisation*, vols. 1–3. Nuremberg: Riegel & Wiesner in Kommission, 1816–1818.

Wiebenson, Dora. *Sources of Greek Revival Architecture*. London: Zwemmer, 1969.

Wiegmann, Rudolf. "Gedanken über die Entwicklung eines zeitgemässen nazionalen Baustyls." *Allgemeine Bauzeitung* 6 (1841): 207–214.

Wiegmann, Rudolf. "Remarks on the Treatise *In What Style Should We Build*" (1829). In *In What Style Should We Build: The German Debate on Architectural Style*, edited by Wolfgang Herrmann, 103–112. Los Angeles: Getty, 1992.

Wigley, Mark. "Deconstructivist Architecture." In *Deconstructivist Architecture*, edited by Philip Johnson and Mark Wigley, 10–20. New York: MoMA, 1988.

Wilson, Richard Guy. "International Style: The MoMA Exhibition." *Progressive Architecture* 63 (February 1982): 92–105.

Winckelmann, Johann Joachim. *Description des pierres gravées du feu Baron de Stosch*. Florence: Bonducci, 1760.

Winckelmann, Johann Joachim. *Gedanken über die Nachahmung der griechischen Werke in der Malerei und Bildhauerkunst* (1755). Stuttgart: Reclam, 1995.

Winckelmann, Johann Joachim. *History of the Art of Antiquity* (1764). Translated by Harry Francis Mallgrave. Los Angeles: Getty, 2006.

Wood, Christopher S. *A History of Art History*. Princeton: Princeton University Press, 2019.

Worringer, Wilhelm. *Abstraction and Empathy: A Contribution to the Psychology of Style* (1908). Translated by Michael Bullock. Chicago: Dee, 1997.

Zedler, Johann Heinrich. *Grosses vollständiges Universal-Lexicon aller Wissenshafften und Künste*. Leipzig: Zedler, 1731–1754.

Zeitler, Rudolf. *Die Kunst des 19. Jahrhunderts*. Berlin: Propyläen-Verlag, 1990.

Illustration Credits

Note: Illustrations are identified by page number

COVER Karl Friedrich Schinkel's Friedrichswerdersche Kirche and the DDR Ministry of Foreign Affairs by Josef Kaiser, Heinz Aust, Gerhard Lehmann, and Lothar Kwasnitza, Berlin. Photo: Gerd Danigel, 1990.

Chapter 1

25 *Japan Architect* 7, no. 3 (summer 1992), announcing the Shinkenchiku Residential Design Competition "House with NO STYLE." *Japan Architect*/Shinkenchiku-sha Co., Ltd.

26 Yosuke Fujiki, first prize project in the 1992 Shinkenchiku Residential Design Competition "House with NO STYLE." With kind permission of Yosuke Fujiki.

28 First and second edition of Hermann Muthesius's *Stilarchitektur und Baukunst*, 1902 and 1903. Private collection.

30 Henry-Russell Hitchcock and Philip Johnson, *The International Style. Architecture since 1922*. New York: W. W. Norton, 1932.

32 Standard Sanitary Manufacturing Company's promotion for its "Neo-Classic" bathroom suite. *Country Life*, 1931. Private collection.

35 Walter Curt Behrendt, *Der Kampf um den Stil im Kunstgewerbe und in der Architektur*, 1920 and *Der Sieg des neuen Baustils*, 1927. Private collection.

38 Detail of the first issue of *De Stijl*, 1917, designed by Vilmos Huszár.

39 *De Stijl*, no. 2, 1922, with the first part of Theo van Doesburg's "Der Wille zum Stil." The International Advertising & Design DataBase (IADDB).

40 Theo van Doesburg, diagram of cultural and stylistic development. "Der Wille zum Stil," *De Stijl*, no. 2, 1922.

Chapter 2

54 Woman with wax tablet and stilus. Roman fresco from Pompeii, ca. 50 CE. Su concessione del Ministero della Cultura—Museo Archeologico Nazionale di Napoli. Photo: Luigi Spina.

55 Stilus as stylos. Left: Roman bronze stilus. © The Trustees of the British Museum. Middle: Medieval iron stilus. NumisAntica. Right: Undated bronze stilus. Bergen University Museum/DigitaltMuseum.

57 Christian Maurice Engelhardt's 1818 copy of the destroyed *Hortus Deliciarum* (ca. 1180), showing philosophy with the seven liberal arts. © Collection of the Bibliothèque Alsatique du Crédit Mutuel, Strasbourg.

95 East façade of the Gothic house in Wörlitzer Park. Undated
 postcard, photographer unknown. Private collection.

98 Gottfried Klinsky (attr.), designs for garden building in *Ideenmagazin
 für Liebhaber von Gärten, englischen Anlagen und für Besitzer von
 Landgütern*, vol. 1, nos. 2, 4, 5, and 6, 1796. Universitätsbibliothek
 Heidelberg.
 Top left: https://digi.ub.uni-heidelberg.de/diglit/
 ideenmagazin1_6/0031.
 Top middle: https://digi.ub.uni-heidelberg.de/diglit/
 ideenmagazin1_6/0075.
 Top roght: https://digi.ub.uni-heidelberg.de/diglit/
 ideenmagazin1_6/0093.
 Bottom left: https://digi.ub.uni-heidelberg.de/diglit/
 ideenmagazin1_6/0073.
 Bottom middle: https://digi.ub.uni-heidelberg.de/diglit/
 ideenmagazin1_6/0107.
 Bottom right: https://digi.ub.uni-heidelberg.de/diglit/
 ideenmagazin1_6/0109.

100 Left: Unknown artist, cattle trough in three different styles,
 Ideenmagazin, vol. 1, no. 1, 1796. Right: Johann August Heine, garden
 buildings in four different styles, *Neues Ideenmagazin*, vol. 1, no. 3,
 1806. Universitätsbibliothek Heidelberg. https://digi.ub.uni
 -heidelberg.de/diglit/ideenmagazin1_6/0018.
 Right: https://digi.ub.uni-heidelberg.de/diglit/neues
 _ideenmagazin1806/0050.

101 "Die verschönerte Natur," *Ideenmagazin*, vol. 1, no. 4, 1796.
 Universitätsbibliothek Heidelberg. https://digi.ub.uni-heidelberg.
 de/diglit/ideenmagazin1_6/0067.

102 Plan of Schloss Moritzburg. Staatliche Schlösser, Burgen und
 Gärten Sachsen.

104–105 "Mexican," "Jewish," and "Siberian taste," from Joseph Friedrich
 Freiherr zu Racknitz, *Darstellung und Geschichte des Geschmacks*, 1796–
 1799. Getty/www.archive.org.

106 "New Persian taste," from Joseph Friedrich Freiherr zu Racknitz,
 Darstellung und Geschichte des Geschmacks, 1796–1799. Getty/www.
 archive.org.

107 Karl Friedrich Schinkel, *Kirche im gotischen Stil hinter Bäumen*, 1810.
 bpk/Kupferstichkabinett, Staatliche Museen zu Berlin—Preußischer
 Kulturbesitz. Media-ID: 00043217. Photo: Jörg P. Anders.

111 Caspar David Friedrich, *Abtei im Eichwald*, 1809–1810. bpk/
 Nationalgalerie, Staatliche Museen zu Berlin—Preußischer
 Kulturbesitz. Media-ID: 00013682. Photo: Andres Kilger.

112–113 Karl Friedrich Schinkel, memorial chapel for Queen Luise
 of Prussia, 1810, façade and interior. bpk/Kupferstichkabinett,

Cyfrova URN: oai:dlibra.bibliotekaelblaska.pl:52382; *Allgemeine Bauzeitung*, vol. 8, 1843: Bayerische Staatsbibliothek, Munich. 4 A.civ. 17 h-7/8. URN: urn:nbn:de:bvb:12-bsb10479227-4; *Journal fuer die Baukunst*, vol. 6, 1840: Universitätsbibliothek Heidelberg. http://digi.ub.uni-heidelberg.de/diglit/journal_baukunst1833/0005.

166 Karl Friedrich Schinkel, proposal in classical style for the Friedrichswerdersche Kirche in Berlin, 1821. bpk/Kupferstichkabinett, Staatliche Museen zu Berlin—Preußischer Kulturbesitz. Media-ID: 70388892. Photo: Wolfram Büttner.

169 Karl Friedrich Schinkel, second classical proposal for the Friedrichswerdersche Kirche in Berlin, 1822. *Sammlung architektonischer Entwürfe*, vol. 8, 1826. Oslo School of Architecture and Design. Photo: Thomas I. Johansen.

170 Karl Friedrich Schinkel, Gothic proposal for the new Friedrichswerdersche Kirche in Berlin, 1824. bpk/Kupferstichkabinett, Staatliche Museen zu Berlin—Preußischer Kulturbesitz. Media-ID: 70389046. Photo: Wolfram Büttner.

172–173 Karl Friedrich Schinkel, four alternative proposals for the new Friedrichswerdersche Kirche in Berlin, 1824. bpk/Kupferstichkabinett, Staatliche Museen zu Berlin—Preußischer Kulturbesitz. Media-ID: 70388899. Photo: Wolfram Büttner.

175–176 Karl Friedrich Schinkel, final proposal for the Friedrichswerdersche Kirche in Berlin, 1830. *Sammlung architektonischer Entwürfe*, vol. 13, 1829. Oslo School of Architecture and Design. Photo: Thomas I. Johansen.

179 Karl Bötticher, Corinthian column. *Die Tektonik der Hellen*, 1844–1852. Universitätsbibliothek Heidelberg. http://digi.ub.uni-heidelberg.de/diglit/boetticher1873bd3/0044.

181 Raphael, allegory of Prudence. Detail of the fresco *Cardinal and Theological Virtues* on the south wall of the Stanza della Segnatura in the Apostolic Palace of the Vatican, 1511.

Chapter 6

186 August Voit, *Vedute eines Platzes im Maximilianstil*, 1850. Architekturmuseum der TU München. voit-9-2. http://mediatum.ub.tum.de?id=916904. CC BY-NC-ND 4.0.

187 Left: Schloss Hohenschwangau, rebuilt by Domenico Quaglio for Prince Maximilian, 1833–1837. Johann Poppel after Domenico Quaglio, 1842. bpk/Bayerische Staatsbibliothek, Munich. Media-ID: 50027990.
Right: Friedrich Gärtner, the Wittelsbacher palace in Munich, 1843–1848. Engraving by K. Gunkel. Private collection.

196 Wilhelm Stier, competition project for the parliament in Pest, 1846–1847. Architekturmuseum der TU Berlin, Inv. no. 7265.

197 Friedrich Bürklein, plan for the new Maximilianstrasse. *Zeitschrift für Bauwesen*, vol. 5, nos. III–V (1855): Blatt K, 364. Bayerische Staatsbibliothek, Munich. 2 A.civ. 260 0-5. URN: urn:nbn:de:bvb:12-bsb10933668-8. NoC-NC/1.0/

198 Friedrich Bürklein, façade proposals for the Maximilianstrasse, *Zeitschrift für Bauwesen* (Atlas), vol. 5, no. III–V (1855): Blatt 21 and 22. Zentral- und Landesbibliothek Berlin. URN: urn:nbn:de:kobv:109-opus-86926.

198 Rudolf Gottgetreu, façade proposal for the Maximilianstrasse, *Zeitschrift für Bauwesen* (Atlas), vol. 5, no. VI–VIII (1855): Blatt 34. Zentral- und Landesbibliothek Berlin. URN: urn:nbn:de:kobv:109-opus-86926.

200 Friedrich Bürklein, Bavarian Government Building on Maximilianstrasse, 1856–1864. Photographer unknown. Bildarchiv Foto Marburg.

202 Friedrich Bürklein, Maximilaneum, Munich, 1855–1874. Photographer unknown. Bridgeman Images.

203 Engelbert Seibertz, *Die imaginäre Einführung Alexander von Humboldts in einen Kreis berühmter Männer aus Kunst und Wissenschaft*, 1857. Fresco in the Academy Room of the Maximilianeum, Munich. Bayerischer Landtag.

Chapter 7

210 "Roman silk fabric from Sion, Switzerland." Gottfried Semper, *Der Stil in den technischen und tektonischen Künsten*, vol. 1, 1860, 192.

211 Title page of Gottfried Semper, *Der Stil in den technischen und tektonischen Künsten*, vol. 1, 1860.

212 Textile techniques. Gottfried Semper, *Der Stil in den technischen und tektonischen Künsten*, vol. 1, 1860, 186–189.

213 Lycian tomb. Gottfried Semper, *Der Stil in den technischen und tektonischen Künsten*, vol. 1, 1860, 230.

217 Hindu temple at Kumbakonam. James Fergusson, *Illustrated Handbook of Architecture*, 1855, 93. Universitätsbibliothek Heidelberg. https://digi.ub.uni-heidelberg.de/diglit/fergusson1859/0157.

218 Left: "Sculptured Pavement (Kouyunjik)." Austen Henry Layard, *Monuments of Nineveh II*, 1853, folio 56. Universitätsbibliothek Heidelberg. https://digi.ub.uni-heidelberg.de/diglit/layard1853/0013.
Right: "Assyrian carpet pattern engraved in stone (British Museum)." Gottfried Semper, *Der Stil in den technischen und tektonischen Künsten*, vol. 1, 1860, 54.

219 Left: "Assyrian vegetable entanglement." Gottfried Semper, *Der Stil in den technischen und tektonischen Künsten*, vol. 1, 1860, 78.
Right: "Entangled snakes on the aegis of Athena. Dresden

Museum." Gottfried Semper, *Der Stil in den technischen und tektonischen Künsten*, vol. 1, 1860, 80.

220 Snake ornaments from different cultures. Gottfried Semper, *Der Stil in den technischen und tektonischen Künsten*, vol. 1, 1860, 82–83.

227 Gottfried Semper, *Ueber Baustyle: Ein Vortrag gehalten auf dem Rathhaus in Zürich am 4. März 1869*, 1869. ETH-Bibliothek Zürich, Rar 6826, https://doi.org/10.3931/e-rara-11795.

Coda

236–237 Karl Friedrich Schinkel's Friedrichswerdersche Kirche and the DDR Ministry of Foreign Affairs by Josef Kaiser, Heinz Aust, Gerhard Lehmann, and Lothar Kwasnitza, Berlin. Photo: Gerd Danigel, 1990. CC BY-SA 4.0.

Index

The MIT Press would like to thank the anonymous peer reviewers who provided comments on drafts of this book. The generous work of academic experts is essential for establishing the authority and quality of our publications. We acknowledge with gratitude the contributions of these otherwise uncredited readers.

This book is set in Haultin.
Printed and bound in Canada.

Library of Congress Cataloging-in-Publication Data

Names: Hvattum, Mari, 1966– author.
Title: Style and solitude : the history of an architectural problem / Mari Hvattum.
Description: Cambridge, Massachusetts : The MIT Press, [2023] | Includes bibliographical references and index.
Identifiers: LCCN 2022014708 | ISBN 9780262545006 (hardcover)
Subjects: LCSH: Architecture—Aesthetics. | Architecture, Modern.
Classification: LCC NA2500 .H92 2023 | DDC 720.1—dc23/eng/20220720
LC record available at https://lccn.loc.gov/2022014708

10 9 8 7 6 5 4 3 2 1